JUN 1 9 2003

TRANS # 4760

GRAPHIC DESIGN SOLUTIONS

W9-BXZ-148

Online Services

Delmar Online
To access a wide variety of Delmar products
and services on the World Wide Web, point your
browser to:

http://www.delmar.com
or email: info@delmar.com

A Division of Thomson Learning™

GRAPHIC DESIGN
SOLUTIONS

SECOND EDITION

ROBIN LANDA

OnWord Press
Thomson Learning™

Africa • Australia • Canada • Denmark • Japan • Mexico
New Zealand • Philippines • Puerto Rico • Singapore
Spain • United Kingdom • United States

NOTICE TO THE READER

Publisher does not warrant or guarantee any of the products described herein or perform any independent analysis in connection with any of the product information contained herein. Publisher does not assume, and expressly disclaims, any obligation to obtain and include information other than that provided to it by the manufacturer. The reader is expressly warned to consider and adopt all safety precautions that might be indicated by the activities herein and to avoid all potential hazards. By following the instructions contained herein, the reader willingly assumes all risks in connection with such instructions.

The Publisher makes no representation or warranties of any kind, including but not limited to, the warranties of fitness for particular purpose or merchantability, nor are any such representations implied with respect to the material set forth herein, and the publisher takes no responsibility with respect to such material. The publisher shall not be liable for any special, consequential, or exemplary damages resulting, in whole or part, from the readers' use of, or reliance upon, this material.

Delmar Staff:
Business Unit Director: Alar Elken
Executive Editor: Sandy Clark
Development Editor: Jeanne Mesick
Editorial Assistant: Fionnuala McAvey
Executive Marketing Manager: Maura Theriault
Marketing Coordinator: Paula Collins

Executive Production Manager: Mary Ellen Black
Production Manager: Larry Main
Art/Design Coordinator: Rachel Baker

COPYRIGHT ©2001
Delmar is a division of Thomson Learning. The Thomson Learning logo is a registered trademark used herein under license.

Printed in Canada
 5 6 7 8 9 10 XXX 06 05 04 03 02

For more information, contact Delmar, 3 Columbia Circle, PO Box 15015, Albany, NY 12212-0515; or find us on the World Wide Web at http://www.delmar.com

International Division List

Asia:
Thomson Learning
60 Albert Street, #15-01
Albert Complex
Singapore 189969
Tel: 65 336 6411
Fax: 65 336 7411
Japan:
Thomson Learning
Palaceside Building 5F
1-1-1 Hitotsubashi, Chiyoda-ku
Tokyo 100 0003 Japan
Tel: 813 5218 6544
 Fax: 813 5218 6551
Australia/New Zealand:
Nelson/Thomson Learning
102 Dodds Street
South Melbourne, Victoria 3205
Australia
Tel: 61 39 685 4111
Fax: 61 39 685 4199
UK/Europe/Middle East:
Thomson Learning
Berkshire House
168-173 High Holborn
London
WC1V 7AA United Kingdom
Tel: 44 171 497 1422
Fax: 44 171 497 1426

Thomas Nelson & Sons LTD
Nelson House
Mayfield Road
Walton-on-Thames
KT 12 5PL United Kingdom
Tel: 44 1932 2522111
Fax: 44 1932 246574
Latin America:
Thomson Learning
Seneca, 53
Colonia Polanco
11560 Mexico D.F. Mexico
Tel: 525-281-2906
Fax: 525-281-2656
South Africa:
Thomson Learning
Zonnebloem Building
Constantia Square
526 Sixteenth Road
P.O. Box 2459
Halfway House, 1685
South Africa
Tel: 27 11 805 4819
Fax: 27 11 805 3648

Canada:
Nelson/Thomson Learning
1120 Birchmount Road
Scarborough, Ontario
Canada M1K 5G4
Tel: 416-752-9100
Fax: 416-752-8102
Spain:
Thomson Learning
Calle Magallanes, 25
28015-MADRID
ESPANA
Tel: 34 91 446 33 50
Fax: 34 91 445 62 18
International Headquarters:
Thomson Learning
International Division
290 Harbor Drive, 2nd Floor
Stamford, CT 06902-7477
Tel: 203-969-8700
Fax: 203-969-8751

All rights reserved Thomson Learning 2001. The text of this publication, or any part thereof, may not be reproduced or transmitted in any form or by any means, electronics or mechanical, including photocopying, recording, storage in an information retrieval system, or otherwise, without prior permission of the publisher.

You can request permission to use material from this text through the following phone and fax numbers.
Phone: 1-800-730-2214; Fax 1-800-730-2215; or visit our Web site at http://www.thomsonrights.com

Library of Congress Cataloging-in-Publication Data

Landa, Robin.
 Graphic design solutions / by Robin Landa.— 2nd ed.
 p. cm.
Includes index.
 ISBN 0-7668-1360-6
 1. Commercial art. I. Title.
NC997 .L32 2000
741.6—dc21
 00-030689

Dedication

To the memory of my very beautiful mother, Betty Landa,
and to the memory of my dear father, Hy Landa

Contents

Chapter 1 Introduction

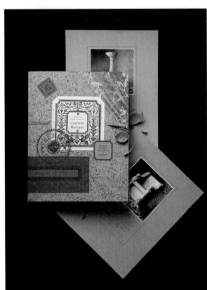

Chapter 2 Fundamentals of Graphic Design

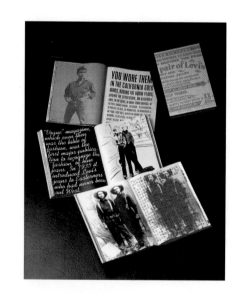

Chapter 3 Overview of Graphic Design

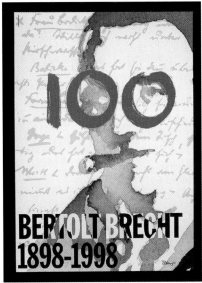

Chapter 4 Designing With Type

Chapter 5 Layout

Chapter 6 Logos, Symbols, Pictograms, and Stationery Systems

Contents

Chapter 7 Posters

Chapter 8 Book Jackets and CD Covers

Chapter 9 Packaging and Shopping Bags

GRAPHIC DESIGN SOLUTIONS

Chapter 10 Visual Identity and Branding

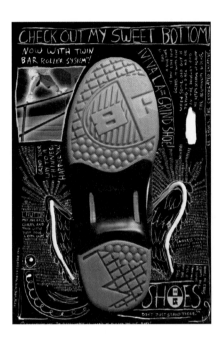

Chapter 11 Advertisements

Chapter 12 Annual Reports

Chapter 13 Web Design

Chapter 14 The Portfolio and Job Search

Appendix A Graphic Design Materials, Tools, and Processes

Appendix B Glossary

Appendix C Bibliography

Appendix D Endnotes

Index

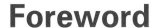

Foreword

Philip B. Meggs

Graphic design solutions. The title of this book addresses the essence of how graphic design has evolved as a discipline and profession. Graphic designers characterize themselves as problem solvers, and problem solvers by definition are hunters engaged in a search for solutions. Historically, designers have not always defined themselves in this way. Many graphic designers in earlier periods worked in the realm of handicraft. Their primary task was execution — hands for hire who laid out elements determined by a copywriter or client. Other designers made a more elaborate contribution by adding artistic attributes to the craft function, embellishing printed material with decorative qualities. As the machine age yielded to the information age, graphic designers working in recent decades have responded to the increased complexity of modern communications by forging greater comprehension about all aspects of their work. This has resulted in a body of theoretical information concerning form, message, and the interface between the visual and communicative aspects of a graphic design.

Compared to earlier times when many designers were content to be executors or decorators, contemporary graphic designers are engaged in a multifaceted activity. Design is now defined as a process. Its progress and sequence of steps from problem assignment to final solution can be studies, evaluated, and amended. Graphic designers and design-education programs have achieved professional maturity in an effort to keep pace with the more demanding information environment and advanced electronic technology. A theoretical underpinning for design problem solving has emerged. This expanded base of knowledge and information has a direct application to a designer's work.

Factoring the design process into its component parts demonstrates the compound nature of the enterprise. Designers are by definition form-builders, individuals who create concrete, tangible objects that are prototypes for mass production. While product, fashion, and architectural designers create three-dimensional objects, graphic designers invent prototypes for messages that are delivered in diverse formats. These include two-dimensional surfaces; three-dimensional structures including packages, signage, and exhibitions; and four-dimensional media such as film video, and computer animation.

Design prototypes are created by manipulation of physical attributes such as color, tonality, shape, spatial arrangements of elements in space, and texture. Graphic designers use the same visual language of two-dimensional design as painters and fiber artists, even when they veer into the three-dimensional world of the sculptor or the fourth-dimensional world of the musician and cinematographer. While the organization of forms in space is often a primary focus of fine art, it remains but one dimension of the overall problem confronting the graphic designer.

Form serves as a vehicle to convey meaning. All art has a communicative aspect, bearing intentional, implied, or even ambiguous messages. Graphic designers create specific messages; they use their culture's common communications currency — language, signs, and symbols — to forge a definite communication for a specific audience. This mandatory duality of form and message defines the essence of graphic design, separating it from traditional fine art.

The search for a design solution is a quest for synergy; the marriage of a distinctive visual arrangements with an appropriate message. Resolution occurs when form and message become interdependent and mutually supportive. Achieving this resolution is complicated by the need to bring unlike communicative elements such as words and pictures into a cohesive whole. Resolution is defined as emphasis, unity, and balance.

By writing this book, Robin Landa has attempted to address the complexity of graphic-design problem solving — or perhaps we should say solution finding — and reveal a cohesive body of knowledge to aspiring designers. This is a formidable task, for design fundamentals, communicative concepts, strategy, problem-solving processes, typography, and layout of the elements all must be clarified and explained. For practicing designers, comprehension of all of these aspects alone is not enough. This knowledge must be applied to the actual creative process used to find design solutions. To aid in this transformation of information into inspiration and production, Landa includes exercises and projects in every section of this book. These are tried and proven over a decade-and-a-half of design pedagogy.

The second half of this book scans a range of design categories — from symbols and visual identity to posters and advertisements — and discusses the unique issues and challenges inherent in each of these categories of design. Each category is illustrated by successful solutions created by many of America's most outstanding designers and art directors. These examples provide a demonstration of design excellence; they are imaginative solutions whose form and message answered the needs of a specific communications problem. Accompanying comments clarify the message and strategies for achieving an effective solution.

A most striking aspect of this book is author Robin Landa's ability to write with clarity, defining terms and concepts in language readily understandable by students just beginning their exploration of graphic design. Theory is linked to pragmatic solutions for typical graphic-design problems. This stands in marked contrast to arid theoretical concepts that are difficult for students to grasp because they lack any apparent connection to the real world of graphic-design problem solving. Landa's commitment and diligence as a design educator are apparent to the reader; her decision to document and publish her knowledge and experience is a fortunate event.

Preface

Graphic design is the application of art and communication skills to the needs of business and industry. *Graphic Design Solutions* is about visual communications. It is based on the conviction that graphic design and advertising design are visual arts disciplines that can be taught and learned. This book has grown out of my experiences over twenty years of teaching visual communications and foundation courses such as graphic design, advertising design and concepts, communication design fundamentals, two-dimensional design, color, and visual thinking. My courses and this book have four main goals: first, to provide students with a comprehensive foundation in design; second, to address basic problems and applications in graphic design and advertising; third, to encourage students to explore the discipline of graphic design; and fourth, to foster creativity and experimentation.

The approach of this book is significantly different from others in the field. It continually relates graphic design to the fundamental elements and principles of two-dimensional design. Recognizing that design is an active process, this book offers design problems for the reader to solve. This turns the reader into an active participant. Executing the projects yields high level work that can be used to compile a portfolio. Finally, this book integrates design, critical thinking, and communication skills, exploring the visual/verbal relationship in graphic design, covering advertising concepts and copywriting, and encouraging assessment. This text is based on the premise that when you learn why elements and principles are used as well as how they are used, you tend to retain knowledge. If you are encouraged to assess and question what you have learned, not just to accept it, then you will learn even more.

Graphic Design Solutions is structured to allow instructors to adapt the text to the particular needs of their students and courses. In the first five chapters, a foundation is laid with overviews of design fundamentals, the graphic design profession, type, and layout. The next eight chapters explore various graphic design applications: logos, symbols, pictograms, stationery, posters, book jackets, album covers, packaging, shopping bags, visual identity and branding, advertising, annual reports, and web design. The last chapter addresses the job search and the need and requirements for a professional portfolio.

There are two types of hands-on activities in this text: Exercises and Projects. Both are interactive, allowing you to experience a design element or principle. All of the Exercises and Projects develop design skills, and critical and visual thinking skills. The comments preceding the projects allow you to assess what you have learned.

The Exercises are so called because they are just that — a workout. Exercises are the kind of informal nudge you might need to stir your creative juices. The Exercises are intended to stimulate your imagination, develop your capacity for critical thinking, and foster an understanding of the creative process. They allow you to think about the idea rather than fretting over a finished piece.

Projects allow you to experience each topic in the text. The Projects provide a resource of experience and support your understanding of each design and concept and principle. Nothing can replace hands-on experience. The format of this text is flexible. There are plenty of projects for instructors to choose from and most can be modified to accommodate each instructor's style and goals. Successful execution of these projects will result in quality portfolio pieces. My colleagues and I have used all these Exercises and Projects in our classes over the years — they work, and work well.

Before you design logos, posters, CD covers, or advertisements, you must learn the basics of graphic design — two-dimensional design, layout, and designing with type. Only then can you focus on different graphic design applications. Like any other discipline, whether it's painting or music, there's a lot to learn. Certainly, the learning process can be an exciting one that stimulates and challenges. This text will inspire you to work hard and to experiment — to try things that you ordinarily would not try, to enjoy the design process, and be excited by it. This book has a number of components that will accomplish this:

- A full range of design applications
- Outstanding examples of design solutions by master designers
- Comprehensive review of two-dimensional design
- Comprehensive chapter on advertising design and copywriting
- Explanation of design procedure
- Explanations of *why* and *how* elements and principles are used
- Critique guides and methods of assessing work
- Objectives and suggestions for each topic
- Visual thinking concepts and principles
- Comments from professional designers about their work
- Creative Exercises
- Projects with comments

The information, explanations, concepts, critiques guides, suggestions, design solutions, exercises, and projects in this book will help you in many ways. This book will:

- Stimulate imagination and creative thinking
- Provide a friendly voice to encourage and coach you
- Develop your capacity for conceptual thinking
- Foster an understanding of the intellectual depth necessary for the subject
- Foster your willingness to experiment
- Provide many examples of contemporary and master works
- Provide a comprehensive foundation for further study
- Provide a wide range of portfolio pieces
- Prepare you for continuing professional and creative growth

Over the years, I have taught all types of learners, from the underprepared to the brilliant. What I found was that all students respond to accessible information and language, clearly stated goals, interesting exercises and projects, plenty of experimentation, good examples, clear challenges, and a positive atmosphere. The instructor and the text can provide this. People can be taught to be creative, to think visually, to think conceptually and critically, and to design well. This book is an attempt to package all these ideas in a coherent way.

Acknowledgments

Many gracious professionals — designers, art directors, illustrators, photographers, creative directors, and writers — allowed me to use their outstanding creative work in this book. They are individually acknowledged in the credits. Much thanks.

There are four people to whom I am deeply indebted: Denise M. Anderson, Rose Gonnella, Martin Holloway, and Alan Robbins, my great colleagues and friends.

Thanks to all my students who constantly provide inspiration and thanks to Tony Ciccolella whose outstanding student portfolio is in this book.. Great thanks to my former advertising teacher, Bob Mitchell… where ever you are.

At Delmar, great thanks to Tom Schin, Acquisitions Editor, who supported this revision in glorious color! Also, kind thanks to Jeanne Mesick, Rachel Baker, Larry Main and Susan Mathews/Stillwater Studio.

A special thanks to my family and friends who always inquired about this project. Much thanks to sweet Linda Freire who took great care of Hayley Meredith while I worked on this revision.

Loving thanks to my husband, Dr. Harry Gruenspan, and to my precious baby daughter, Hayley Meredith (It was very hard not being able to spend every minute with you!). And a final thanks to my mother, Betty, who I miss very much and who would have been very proud to see this published revision.

Graphic
Design
Solutions

Introduction

GRAPHIC DESIGN SOLUTIONS

OBJECTIVES

- understanding the purpose of graphic design
- becoming familiar with the job of the graphic designer
- learning the design procedure
- learning to critique your work

Defining graphic design

Graphic design is America's most pervasive art form. We don't have to go to a museum or gallery to see graphic design — it comes to us. Everything from television commercials to the label on the ketchup bottle is designed by a visual communications professional. This art form is an integral part of contemporary society. Since graphic design plays a key role in the appearance of almost all print, film, and electronic media, it becomes a primary creator of the visual artifacts of our environment and popular culture (Figures 1-1, 1-2, and 1-3). Imagine a world without television graphics or with blank compact disc covers; imagine all packaging looking the same. That would be a world without graphic design.

▼ Figure 1-1
Absolute Sterling Ad
Design firm: Jennifer Sterling Design, San Francisco, CA
Art director/Designer: Jennifer Sterling

(Below, right) Figure 1-2 ▶
"Fuel Gauge" Watch
Design firm: Drenttel Doyle Partners, New York, NY

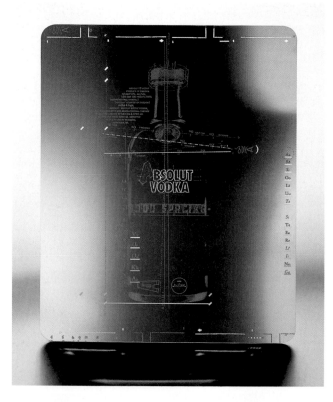

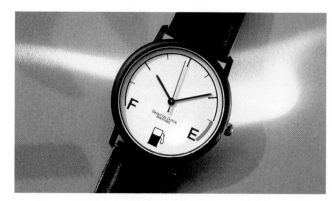

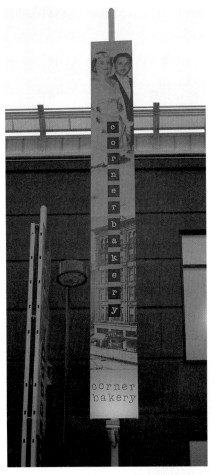

Figure 1-3
Maggiano's Bakery,
Blade Sign, Banners,
Corner Bakery Sign,
Outdoor Wall Sign
Design firm: Ema
Design Inc., Denver,
CO
Art director:
Thomas C. Ema
Designers:
Thomas C. Ema &
Prisca Kolkowski
Client:
Maggiano's Bakery

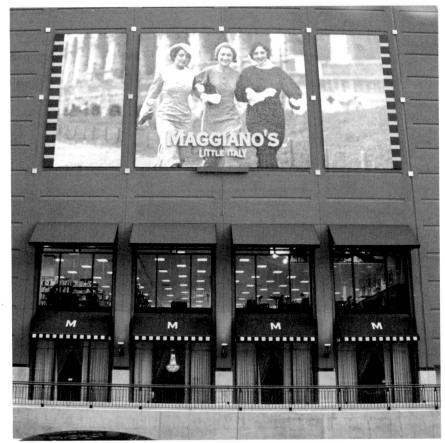

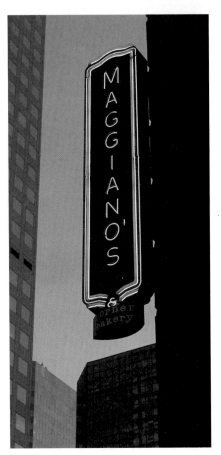

Graphic design can be defined as the application of art and communication skills to the needs of business and industry (which is why it was once called commercial art). These applications could include: marketing and selling products and services; creating visual identities for institutions, products, and companies; environmental graphics/signage; information design; and visually enhancing messages in publications. Mass communications media — print, film, and electronic — are the vehicles for these visual messages. Whenever you read an advertisement or see a logo, you are on the receiving end of communication through design (Figures 1-4 and 1-5). A design can be so effective that it influences your behavior; you may choose a particular product because you are attracted to the design of its package or to its advertisement.

The graphic designer's job

Graphic designers use words (type), and pictures and other graphic elements (visuals) to communicate. Their art is a visual-verbal expression. The graphic designer mediates between a client with a message to send and the audience. Visuals and words are used by the designer on behalf of the client in order to inform, persuade, or sell (Figures 1-6, 1-7, and 1-8).

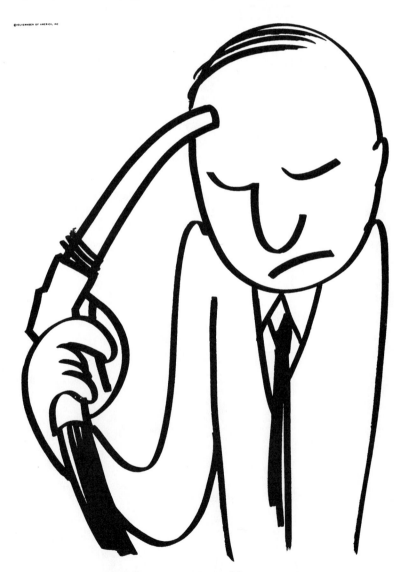

Or buy a Volkswagen.

Volkswagen makes the 3 highest mileage cars in America: the Rabbit Diesel 5-speed, Rabbit Diesel 4-speed and the Dasher Diesels.
Rabbit Diesel 5-speed est [41] mpg, 55 mpg est hwy Rabbit Diesel 4-speed, est [40] mpg, 50 mpg est hwy Dasher Diesels, est [30] mpg, 46 mpg est hwy
Compare these EPA est to the est mpg of other cars. Your mileage may vary with speed, weather and trip length. Hwy mileage will probably be less.)

Figure 1-4
Print Advertisement, "Or buy a Volkswagen"
Agency: Doyle Dane Bernbach, New York, NY
Art director/Artist: Charles Piccirillo
Writer: Robert Levenson
Client: Volkswagen

cyber*gourmet*.

Figure 1-5
"Cybergourmet" Logo for Internet Gourmet Marketplace
Design firm: Vrontikis Design Office, Los Angeles, CA
Creative director/ Designer: Petrula Vrontikis
Client: © Cybergourmet

Cybergourmet is an extensive Internet resource and marketplace for gourmet food items, beverages, cookware, supplies, and information. — Petrula Vrontikis

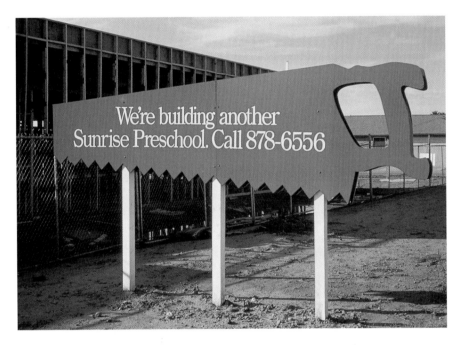

Figure 1-6
Construction Site Sign
Design firm: Richardson or Richardson, Phoenix, AZ
Designers/Writers: Forrest Richardson, Valerie Richardson
Client: Sunrise Preschools
The client had an immediate need for a sign to identify new construction sites. Rather than supporting the usual, non-creative, approach or projecting an architectural image of the building, the design team looked inward to the preschool's marketing program for a related icon. An existing program by Richardson or Richardson used a simplified shape of a shovel, a saw, and a key — all die-cut cardboard about 24 inches long — as a door hanger direct delivery program to the immediate neighborhood where new schools were being built. Taking the shape of the saw, the designers simply turned the shape on its side and communicated the simple message. More than 600 calls were placed as a result of the coordinated sign and delivery program as both marketing and signage tied together to support a single image and identity.
— Richardson or Richardson

Figure 1-7
Savona Suite Ad
Advertising agency:
Carmichael Lynch, Minneapolis, MN
Client: American Standard and Carmichael Lynch

5

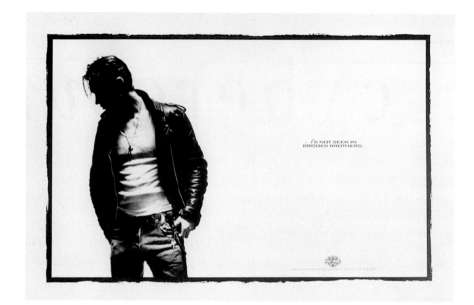

Figure 1-8

Ads, Harley-Davidson of Dallas
Agency: The Richards Group
Creative director/Writer: Todd Tilford
Art director: Bryan Burlison
Photographer: Richard Reens
Client: Harley-Davidson of Dallas

Warning: People don't like ads. People don't trust ads. People don't remember ads. How do we make sure this one will be different?

Why are we advertising?
To announce the introduction of a clothing line to the Harley-Davidson store in Dallas.

Who are we talking to?
Weekend rebels. Middle-class men who are not hard-core bikers (they may not even own motorcycles), but want a piece of the mystique.

What do they currently think?
"Harley-Davidson has a badass image that appeals to me."

What would we like them to think?
"Harley-Davidson now makes clothing that reflects that wild, rebellious image."

What is the single most persuasive idea we can convey?
Harley-Davidson clothing reflects the rebellious personality of the Harley-Davidson biker.

Why should they believe it?
Harley-Davidson bikers show for their clothes at Harley-Davidson.

Are there any creative guidelines?
Real and honest. Should be viewed favorably by hard-core Harley-Davidson bikers.

—The Richards Group

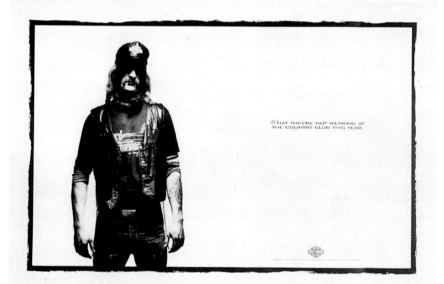

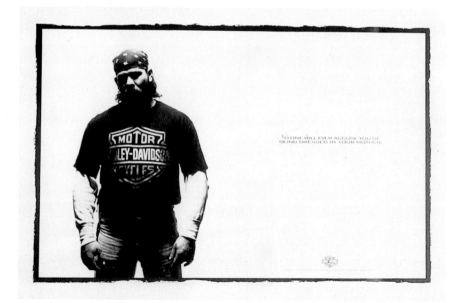

GRAPHIC DESIGN SOLUTIONS

Regardless of the specific task, the graphic designer has two interconnected goals. The goals are to communicate a message to an audience, and to create a compelling or pleasing design that will enhance the message (Figure 1-9). Like other communicators, the graphic designer works to make the message clear and, like any other artist, the graphic designer is concerned with aesthetics. Whether these goals are achieved depends on how well the designer understands the design medium and the design problem given.

Design is the arrangement of parts into a coherent whole. Graphic designers take parts — words, pictures, and other graphic elements — and arrange them into uni-fied communications in formats such as advertisements (See Figure 1-10). Graphic designers, therefore, need to fully understand the fundamental elements and principles of design. These elements include: line, shape, volume, texture, color, and format. These principles include: balance, emphasis, rhythm, unity, positive-negative space, and the illusion of three-dimensional space.

The fundamental elements and principles of design are the foundation of a design education — like understanding the basic parts of speech and the principles of composition before writing a novel. Ideally, these basics are studied before attempting practical applications. This book will cover the basics of graphic design.

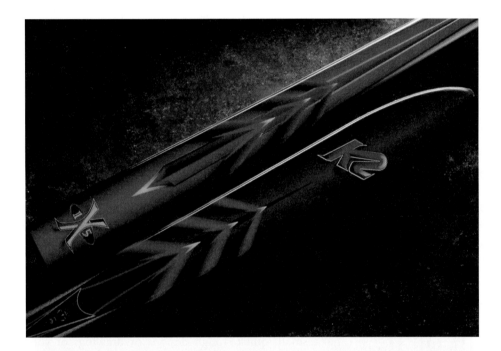

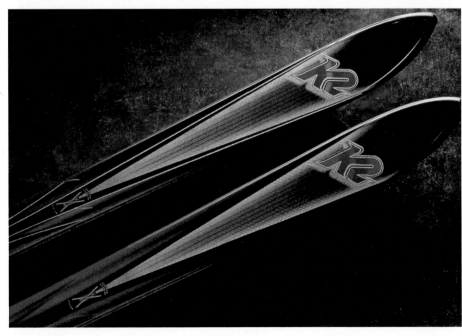

Figure 1-9 Skis
Design firm: Hornall Anderson Design Works Inc., Seattle, WA
Art director: Jack Anderson
Designers: Jack Anderson, David Bates, Sonja Max
Client: K2

Because graphics are a main factor in the successful marketing of skis, we work together closely with K2 to develop each season's look, while consistently representing K2 and leveraging the equity in its now well-established identity.

Early on, most ski manufacturers implemented a similar appearance for their skis, using color palettes consisting of a white base ski and black, blue, or red accent colors. As new energy and younger skiers began making up a larger part of the market and fashion trends in Europe began influencing what people wore on the ski slopes, K2 was one of the first companies to change its graphics to fit the times.

In order to capture a greater market share, the graphics are targeted specifically to the audience that would be using the skis. Each season begins with a study of which colors are "hot" for that year. Different color combinations, and in some cases different graphics, are produced for the American, Japanese, and European markets. Because colors and graphics look different on the snow than they do in a retail environment, the skis are designed to work well in both settings.

Other design considerations include different pricing points and ski construction/ features. Each year, several lines of skis are developed for the different markets of skiers — competition, high-end performance, recreational, and beginner skis, as well as special niche skis.

7

The design procedure

The best way to learn design is to learn to think like a designer. You need to question and experiment. Why did the designer arrange the page like that? Why did this designer choose that color? Learn to constantly ask *why* and *how* about designs you see. It is equally important to learn to experiment with the creative process — to learn by doing. In the beginning of a design course, it's difficult to know how to begin to solve a design problem. The following procedure will help you.

Step 1: Restate the problem in your own words.

Understand the goal. If you don't understand the assignment or goal, your solution will not be on target. Write the goal or problem on an index card and keep it in front of you as you work on the solution.

Step 2: Do any research that needs to be done.

Do you need to know more about your topic? If you do, obtain information, photographs, and materials at this stage of the process. Go to the library or internet. This is a crucial stage and most students mistakenly think they can do a good job without it. Researching your topic will provide many points of departure that might not have occurred to you off the top of your head. Finding photographs and visuals that relate to your assignment can be extremely useful.

It's a good practice to keep an "idea and source book," which is a collection of art reproductions, illustrations, photographs, advertisements, graphics, or any imagery you find stimulating and exciting. Complete ideas do pop into some designers' heads; however, most designers need to sketch in order to find a design solution. You can use this collection of materials as a source book because sometimes you may need references in order to create your design. Remember, an idea book is not for the purpose of plagiarism — it is for inspiration and reference. The inspirational imagery you keep in your book should be varied; it does not have to be graphic design. In fact, a wide range of visuals — anything from Venetian chimneys to ephemera — old machines — dog collars — textiles — anything can inspire an idea or help you solve a design problem.

Step 3: Think with your pencil or mouse in your hand!

Sitting and thinking is not enough most of the time. Draw something. Doodle. Sketch. One visual leads to another. It doesn't matter how good or bad your first sketch is — just sketch. Thumbnail sketches are preliminary, small, quick, rough designs or drawings of your ideas. Create many of them. Judging your sketches at this stage may inhibit your creative energy, so just keep sketch-

Figure 1-10
Opera North Summer Poster
Design firm: Harp & Company, Hanover, NH
Designers: Douglas G. Harp, Susan C. Harp, Robert C. Yasharian
Client: Opera North

The primary goal of this poster is to reach out to as broad an audience as possible and to portray opera in a different light: as something fun and accessible to all. The concept is simple. It would have been far too busy and complex to attempt to capture something about each of the three operas in one poster. Instead, by adding a bright, summery twist to the age-old comedy/tragedy cliché, we have created an overall impression about a summer of opera. The juxtaposition of these disparate elements — watermelon slices (modified by the words Savor it!) and the theater masks — delivers a colorful, eye-catching, witty solution that invites the viewer to think, discover, and pick up the phone.

ing. Thumbnail sketches allow you to think visually. Coming up with many thumbnail sketches may be frustrating at first, but the process will become more natural. (Unfortunately, many beginners are happy with their first and, often, only solution.) Thumbnails should be done to scale, if possible, and in the right proportion. For example, if your finished design solution will have to fit into a rectangular space, do your thumbnails in proportional rectangles. Whether you're thinking with a pencil, marker, mouse, or electronic pen in you hand, create lots of thumbnails.

Step 4: Choose your three best thumbnail sketches and turn them into roughs.

Roughs enable you to visualize your ideas more realistically. Roughs are sketches that are larger and more refined than thumbnails and show the basic elements in a design. Roughs allow you to test ideas, methods, techniques, tools, and colors. (Although some designers go directly from thumbnails to comps, it is better for students to work out their ideas more fully before going to a comp.) If the thumbnails you have chosen to turn into roughs do not work, go back over your other thumbnails and turn some of them into roughs. Here's a tip: Working on tracing paper will enable you to combine ideas by tracing parts of different roughs onto another page. Working on a computer will allow you to do the same, and also allows you to change typefaces and colors in an instant.

It is a good idea to wait a day or so between creating roughs and creating comps. The time in between will give you a fresh perspective on your work.

Step 5: Choose your best rough and turn it into a comp.

Make it look like the real thing. A **comp** or **comprehensive** is a detailed representation of a design. Type, illustrations, photographs, paper stock, and layout are rendered closely enough to the finished product to convey an accurate impression of the printed piece. The term mock-up is used to describe a facsimile of a printed three-dimensional design piece.

A comp is important — it is your solution to the design problem. This artwork must be extremely clean and accurate, as it represents both you and your work. You want people to notice your idea, not your fingerprints or uneven cut marks. Very often the comp is used as a guide or "blueprint" for the printer.

Critique guide

A **critique** is an assessment, an evaluation of your project. Assessing your solution maximizes your learning because it forces you to reexamine the problem, to evaluate the way you went about solving the problem, to determine how well you used the design medium, and to see if you fulfilled your objectives. Most design instructors hold a critique or critical analysis after students create solutions to a design project. Holding your own critique before you present your work to a class, an instructor, or a client allows you to check your thinking and gain insight into your particular style of problem solving. How do you hold a critique? Here's a guide:

Part I: The project

1. Restate the goal or aim of the project in your own words. Make sure you understand the project or problem.

2. Did you fulfill the goal or did you miss the point of the original problem? At times, you may come up with an approach to a problem that does not directly answer the problem, but you like it and pursue it regardless. Be aware that sometimes it pays to let go of a gimmick or approach that is not on target, even if you love it.

3. Is your solution appropriate for the purpose of the project? Often, it can be difficult for beginners to determine when a design or a design element is inappropriate. For example, if you design a business card for a banker, you certainly would not want to create a design that conveyed a playful or unstable spirit.

4. Is your solution appropriately executed? Is your choice of color, media, size, and style right for the purpose or goal of the problem?

5. Did you create a hierarchy of information? Have you designed your solution so that your audience knows what to read or look at first, second, and third?

6. Does your solution communicate the intended message to your audience? Ask people to tell you what message they are receiving from your design.

Part II: The process

1. Did you do any research? And if so, did you use it? If you did not do any research, how did you gather information about the subject matter? Do you need to do more? (Whether you go to the library, or access photo archives, or use an encyclopedia on CD-ROM, make sure you do research.)

2. How many thumbnail sketches and roughs did you do before creating the comp? How much time did you spend thinking about the problem? Did you go to the finish before working out any bugs in the solution?

3. Did you lock yourself into your own area of strength rather than experimenting with less familiar tools, techniques, or methods? For example, if you always use the computer to create your design, were you willing to try cut paper or another technique?

4. Did you make any false assumptions about what you could or could not do, or did you take a positive approach and assume you could do anything if you really tried? Did you experiment? Experimentation is very important; it can lead to exciting discoveries. Even mistakes can yield interesting results. For example, if you accidentally move an image while it is being photocopied, the copy will be distorted. The distortion may be interesting and appropriate for your needs. You can also use flip, sketch, or skew commands on the computer to experiment.

5. Did you really become involved with the problem? Did you use your intuition and feelings? Was your solution personal or removed? Not everyone finds the same subject matter or project exciting. Remember, it is not the subject or the project that is exciting, it is what you do with it.

6. Were you too judgmental? Did you give yourself a chance to be creative? Were you patient with the project and with yourself? Try to be as supportive of your own work as you would be of a friend's work.

7. Did you take chances? Were your solutions innovative? Did you dare to be different, or did you do what most people would do? When the critique is held in class, one way to test whether your solution is original is to notice how many others came up with similar solutions.

This critique guide is in the first chapter so you can use it for all the projects in this text. It will make a great deal more sense once you actually apply it to your projects. Make a photocopy so it is always handy. The process of assessing your own and others' work will become more natural with practice and you will see that critiques are essential to learning. You can learn an enormous amount about graphic design by studying your work and the work of others. In addition to assessing what you have learned from your own solution to a project, it is helpful to notice how others have successfully solved the same problem. Did they approach the problem the same way as you did? What did they do differently?

Another way to improve your analytical skills is to assess the advertisements you see, the design of logos and magazines that you come across, or any graphic design (Figure 1-11). One of the advantages of studying graphic design is that your are surrounded by examples, both good and bad. Turn on the television and you see commercials (Figure 1-12). Take a drive and you see outdoor boards (See Figure 1-13). Become a critical observer — you can always learn something through observation.

Figure 1-11
Logo, "Day Without Art"
Design firm: Matsumoto Incorporated, New York, NY
Art director: Takaaki Matsumoto

This logo was the first annual demonstration day titled "Day Without Art," sponsored by Visual AIDS, a non-profit AIDS awareness organization.

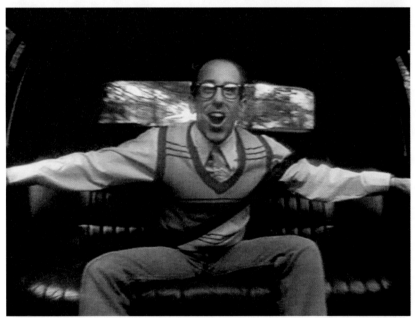

Figure 1-12

Television Commercial, "Faster, Faster"

Agency: Grey Advertising, New York, NY

Client: New York Lottery

You may begin to notice that you enjoy some styles or some areas of design more than others. Are you more attracted to classical or unconventional design? (Figures 1-14 and 1-15.) Noticing what you like may help you decide on the direction of your graphic design career.

Figure 1-13
ABC-TV Outdoor Board Campaign
ABC Television Network

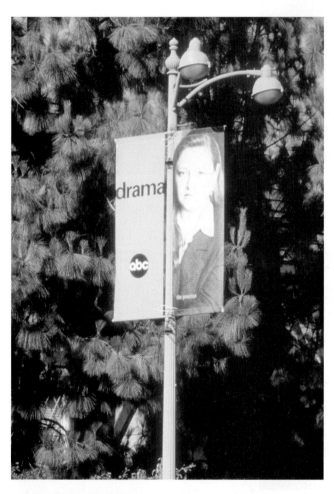

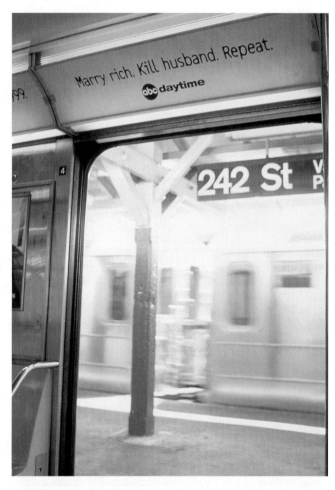

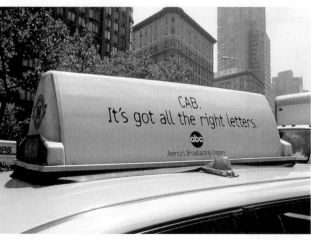

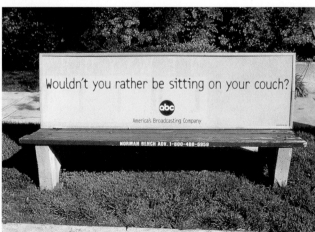

GRAPHIC DESIGN SOLUTIONS

Looking at the illustrations

As stated earlier, an enormous amount can be learned by studying the work of others. Whether you study the work of your peers in class, examine the examples of work in this text, closely observe your instructor's demonstrations, or analyze masterworks, you will enhance your learning by asking *how* and *why* others did what they did. The examples provided in this text are just that — examples. There are innumerable solutions to any exercise or project. The examples are here to give you an idea of what is possible and what is in the ball park; they are not meant to be imitated, nor are they by any means the only "correct" solutions. Creativity in graphic design, or any visual communications discipline, is not measured in terms of right and wrong, but rather by the degree of success demonstrated in problem solving, applying visual skills, and expressing personal interpretations.

When you look at the examples of the greats — the highly respected professionals in the various art fields — do not look at them and think, "Oh, I could never do that." Instead, think, "This is great stimulation. I could learn a lot from these people." We can and should learn from the creativity of others. Creativity can be enhanced by study. It is simply a matter of deciding you can be creative and having someone guide the way.

Figure 1-14
Logo
Designer: Paul Rand
Client: IBM Corporation

Figure 1-15
Jennifer Sterling Design Portfolio of Works
Design firm: Jennifer Sterling Design,
San Francisco, CA
Art director/Designer: Jennifer Sterling

Fundamentals of Graphic Design

OBJECTIVES

- understanding and being able to design with the formal elements — line, shape, color, value, texture, and format

- understanding and being able to employ principles of design — balance, emphasis, rhythm, and unity

- being able to manipulate graphic space

PART I: FORMAL ELEMENTS

Draw a line on a page (paper or electronic). Now add another line. This seems like a simple exercise, but here are a few questions. Where did you draw the first line on the page — at the top or at the bottom? Where did you draw the second line? Were they on angles? How long were the lines? How thick were the lines? Did the lines touch? Did the lines bend or curve, or were they straight?

How can drawing two lines on a page become so complicated? If you think of the two lines as the first two moves in a chess game, you can begin to see how important each is to the outcome. As soon as you draw one line on a page, you begin to build a design.

Lines are one of the basic building blocks of design. These building blocks of two-dimensional design are called the formal elements. They are:

- line
- shape
- color
- value
- texture
- format

These elements are at the foundation of all graphic design.

Line

You probably have been drawing with lines for years, and never stopped to define or analyze them — probably because a line seems like a simple element. When you look at an exquisite linear illustration, for example, the illustration by James Grashow on this package design by Louise Fili, you realize the potential of line as a graphic element (Figure 2-1).

Let's start with a definition. A **line** is a mark made by a tool as it is drawn across a surface. The tool can be almost anything — a pencil, a pointed brush, a computer and mouse, even a cotton swab. A line can also be cut into a hard surface — this practice is called engraving. Sometimes a

GRAPHIC DESIGN SOLUTIONS

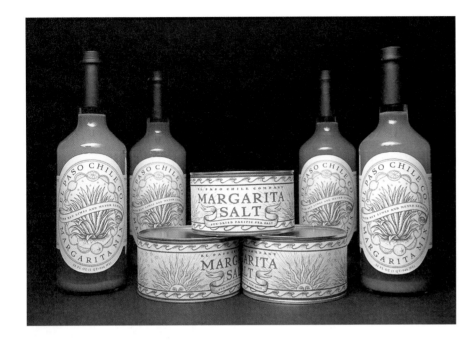

Figure 2-1
El Paso Chile Co. Margarita Mix Package Design
Design firm: Louise Fili Ltd., New York, NY
Art director/Designer: Louise Fili
Illustration: James Grashow

line is defined as a moving dot or point. In this sense, moving the point of a pencil across a page creates a line. A line can also be called an open path.

Considering a line as a moving point may prompt you to ask some questions. In what direction is the line moving? What happens if you move your mouse up and down or your hand up and down while moving the point of your pencil? If you use a rosebud dipped in ink to make a fat, short mark — is it a line? Are all lines the same? What you discover as you ask these questions and explore this element is that there are different types of lines and all lines have direction and quality. Establishing a vocabulary allows us to discuss the aspects of lines intelligently.

The first and most obvious category is line type. A line's **type** or **attributes** refers to the way it moves from its beginning to its end. Lines may be straight, curving, or angular. This is a simple difference that can be used to distinguish different types of line.

The second category is line direction. The **direction** of a line describes a line's relationship to the page. Horizontal lines move across the page, east to west or west to east. Vertical lines move up and down on the page, north to south and south to north. Diagonal lines look slanted in comparison to the edges of a page.

The final category that we will discuss is line quality. **Line quality** refers to how a line is drawn. The adjectives we use to describe the qualities of lines are the same we might use to describe music or a voice. A line may be delicate or bold, smooth or broken, thick or thin, regular or changing. All these adjectives, as well as many others, describe a line's visual quality.

It is important to remember that all three of these categories applied when you were asked to draw two lines on the page. For example, you may have drawn a thin, angular line that moved in a diagonal direction, or you may have drawn a smooth, curving line that moved in a horizontal direction. As you can see, these three categories — type, direction and quality — give us a vocabulary to completely describe the lines we draw.

Shape

You already know what a shape is. Looking at a jacket in the store, you may think, "Well I like the color, but I don't like the shape." Or you might like the shape of one car and not another. The general outline of something is a **shape**; it can also be defined as a closed form or closed path. There are many ways to depict shapes on a two-dimensional surface. One common way is with lines. Lines can be used to describe a flat shape, like a pyramid or a cube. A shape can be open or filled with color, tone, or texture. How a shape is drawn gives it a quality; a shape may be curving or angular, regular or changing, flat or volumetric, and so on.

We can translate the three-dimensional forms of the real world into representational two-dimensional shapes on a page by describing their particular edges using lines (Figure 2-2). We can also create non-representational shapes with lines (Figure 2-3). In this way, lines are used as outlines or edges, clearly defining the limits of forms. This method of describing shapes is termed *linear*. We apply this term to art when there is a predominant use of lines to describe shapes or when lines are used as a way to unify a design. The illustration for the Moving Announcement for Authors & Artists Group is linear; lines are used to describe the objects and map and to unify the illustrations (Figure 2-4).

There are ways other than using lines to create shapes on the two-dimensional surface. Color and collage are two examples. An area of color (or an area of gray created by black and white) that is *not* surrounded by a line, yet is clear and distinct, is considered to have a hard edge and can define a shape, as in this graphic identity by Harp & Company (Figure 2-5). The same is true for collage. **Collage** is the act of cutting and pasting different bits of materials, like lace, paper, sandpaper, or photographs, onto a two-dimensional surface.

Figure 2-2
San Francisco Performances Poster
Design firm: Jennifer Sterling Design, San Francisco, CA
Art director/Designer/Illustrator: Jennifer Sterling
Copywriter: Corey Weinstein
Client: San Francisco Performances

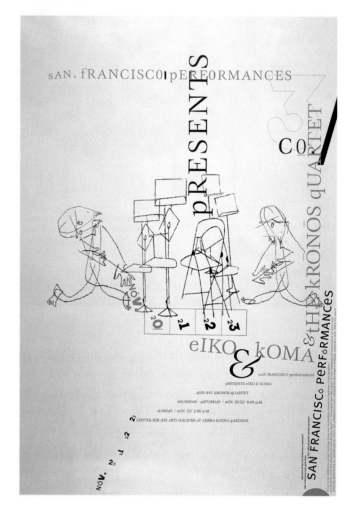

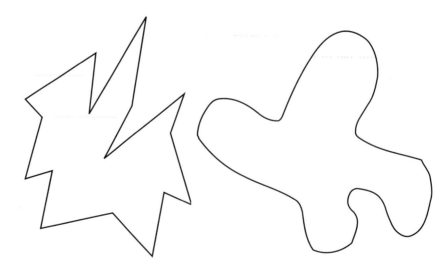

Figure 2-3
Diagram: Non-representational shapes
Illustration: William Stanke

Color

Do you always know which color shirt to wear with a suit, or do you have problems selecting colors for you wardrobe? Do you notice when people are wearing colors that do not suit their complexions? Do you have definite color preferences?

The whys and hows that relate to color come more easily to some than to others, but one thing is certain — the study of color deserves your attention. It is a powerful and highly provocative design element. If you have ever studied painting, then you know how difficult it is to learn to select and mix colors and create interesting and successful visual effects with color. Color is difficult to control when creating an original work, and even more so when a work is reproduced in print or viewed on the web or a computer screen.

We can discuss color more specifically if we divide the element of color into three categories: hue, value, and saturation. **Hue** is the name of a color, that is, red or green, blue or orange. **Value** is the range of lightness or darkness, that is, a light red or a dark red, a light yellow or a dark yellow. Shade, tone, and tint are different aspects of value. **Saturation** is the brightness or dullness of a color, that is, bright red or dull red, bright blue or dull blue. Chroma and intensity are synonyms for saturation.

In paint or pigment such as watercolors, oils, or colored pencils, the primary colors are red, yellow, and blue. They are called primary colors because they cannot be mixed, yet other colors can be mixed from them. Mix red and yellow and you get orange. Mix yellow and blue and

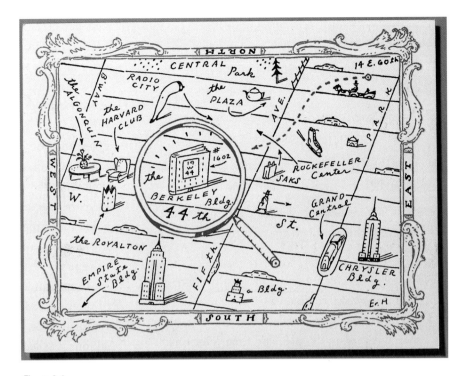

Figure 2-4
Moving Announcement
Design firm: The Valentine Group, Inc., New York, NY
Client: Authors & Artists Group

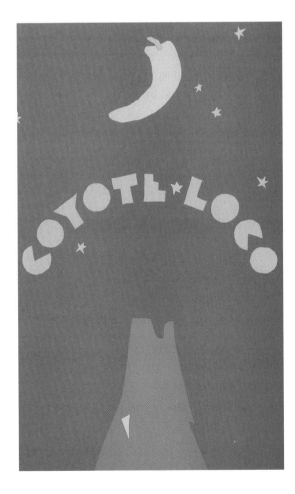

Figure 2-5
Graphic Identity
Design firm: Harp & Company, Hanover, NH
Designer: Douglas G. Harp
Client: Coyote Loco Restaurant and Cantina

The coyote is a worn-out cliche, it seems, for all things—food, clothing, etc.—to do with the Southwest. But its immediate association with this region is undeniable; our challenge, therefore, was to use this familiar icon, but to somehow give it a different spin. Here, the moon that the coyote is howling at is, in fact, a hot pepper.
—Douglas G. Harp, president, Harp & Company

SUGGESTIONS

- Choose colors appropriate for your design concept.

- Choose colors that will communicate your client's spirit or personality.

- Make sure the colors will enhance the readability of the type.

- Examine the amount of color contrast in your design. Is there enough contract to create visual impact?

- Create many color sketches (at least twenty). This is very easy to do on a computer. If you do not have a computer, make a line drawing, make several copies on a copier, and then color them with markers.

- Try to design the same piece with one color, two colors (a limited palette and budget), and then with full color.

- Analyze the use of color in successful contemporary and master design solutions.

- When designing with color on a computer, remember you are looking at an electronic page and the color will look different when printed on a reflective surface.

- Study the use of color in the history of graphic design.

- Study color symbolism in different cultures. Color symbolism is not universal — red may mean one thing in one culture and something else to another.

- Stay abreast of the trends in color. Look at recent CD covers, book jackets, magazines, and packaging.

- Visit a printer. Go to paper shows. Visit a design studio. Surf the web. Talk to printers, paper sales representatives, and professional designers about color and paper stock, special effects, special colors, and varnishes.

you get green. Mix red and blue and you get violet. Orange, green, and violet are the secondary colors. You can mix these colors and get numerous variations.

Color on a computer is made by mixing light, which acts different than pigment. When working with light, the three primaries are green, red, and blue. Mix red and green and you get yellow. Mix red and blue and you get magenta. Mix green and blue and you get cyan. White light is produced by mixing the three primary colors; these primaries are also called the additive primaries because when added together they create white light. When working on the computer's color palette, you can mix millions of colors.

In printing, yellow, magenta, and cyan are the colors of the process inks used for process color reproduction. A fourth color, black, is added to increase contrast. Using all four is called four-color process. Four-color process is used to reproduce color photographs, art, and illustrations. Printing inks can be matte, high gloss, metallic, fluorescent, transparent, opaque, or coated with varnish; printing inks also can be non-toxic, non-flammable, and non-polluting. There are books available that illustrate the various mixtures resulting from mixing two, three, or four colors. The Pantone Matching System, (PMS), offers many custom mixed colors with PMS books to illustrate the available colors.

There have been many scientific studies of color as well as many unscientific theories. (You may want to read the color theories of Josef Albers, Johannes Itten, and Faber Birren.) Most of what you need to know about color and its use in graphic design will come from experimentation, experience with print production, and observation. In graphic design, color depends on the use of printing inks, so color choices can be dictated by budget constraints, as well as a client's needs and a designer's or client's taste.

Allow your design solution to guide your color choices; some colors are more appropriate than others for certain problems or clients. For example, if you were to design a one-color logo for an insurance company you probably would not choose pink. In American popular culture, pink may be thought of as a frivolous color and therefore would not be appropriate. Notice the color choices that award-winning designers make and ask yourself why they made those choices.

If you make keen observation a habit when looking at existing package, poster, film, or any other design, it will become an integral part of your design education. You may have noticed that gold, for example, is often used in the package design of cosmetics; it is associated with luxury and quality. Try not to lock yourself into using your favorite colors in all your design solutions. Experimentation, experience, and keen observation will help develop your ability to use and control color.

Value

Look at this black and white photograph, by Jilda Morera (Figure 2-6), a commercial photographer, who works both in black and white and in color. Notice all the shapes, details, and textures and ask yourself which formal element gives them depth or dimension. It is value. Value is the term we use to describe the range of lightness or darkness of a visual element.

The relationship of one element (part or detail) to another in respect to lightness and darkness is called value contrast. This allows us to discern an image and perceive detail. We need value contrast in order to read words on a page. If the words on a page were almost the same value as the page, then it would be difficult, if not impossible, to read them. Most text type is black and the page white — it gives the most contrast.

Different value relationships produce different effects, both visual and emotional. When a narrow range of values, which is called low contrast, is used in a design, it evokes a different emotional response from the viewer than a design with a wide range of values, or **high contrast**. The **low contrast** of this catalog cover is achieved with a vellum overlay, a somewhat transparent covering over the photograph (Figure 2-7). The high contrast in

Figure 2-7
Bertil Valien Catalogue
Design firm: The Traver Company, Seattle, WA
Art director: Anne Traver and Margo Sepanski
Designer: Margo Sepanski
Client: The William Traver Gallery

these posters by Planet Design Company easily captures one's attention (Figure 2-8).

Texture

Sometimes you decide just by looking at a texture whether or not you want to touch it. Some textures are appealing, like velvet, while others, like rust, are not. Velvet, rust, linen, and hair all have texture. The tactile quality of a surface or the representation of such a surface quality is a texture. In art, there are two categories of texture — tactile and visual. Tactile textures are real; we can actually feel their surfaces with our fingers. Visual textures are illusionary; they simply give the impression of real textures.

Tactile textures can be created in many ways. You can cut and paste textures, like lace or sandpaper, to a surface; you can create an embossing (a raised surface) by impressing a texture in relief; or you can build up the surface of a board or canvas with paint, which is called **impasto**. Creating the illusion of a texture or the impression of a texture with line, value, and/or color is called **visual texture**. One way to create visual textures is by grouping various lines together. Varying line qualities, types or attributes, directions, and lengths will yield a wide range of textures. Different drawing instruments will yield different line qualities, and the way you use the instruments will increase the variety. Visual textures can be created with direct marks made with pens, markers, pencils, computer

Figure 2-8
Couch Flambeau/P'Elvis Posters
Design firm: Planet Design Company, Madison, WI
Art director: Kevin Wade
Designers: Michael Byzewski/ Kevin Wade
A set of posters designed and hand silkscreened by Planet Design to promote Co-Principal Kevin Wade's band P'Elvis.

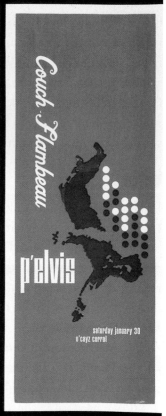

Figure 2-9
Poster for Rosarito to Ensenada
50 Mile Fun Bicycle Ride
Design firm: Studio Bustamante, San Diego, CA
Designer/Illustrator: Gerald Bustamante
Client: Bicycling West, Inc.

The client wanted to add another date to an already established ride, but did not wish to produce a separate poster. In order to convey all that information as simply as possible, I took the graffiti wall approach, painted a tandem bicycle, and surrounded the image with all the pertinent information, as condensed as possible. It is not unlike a wall one might find in Ensenada, Baja California, Mexico.
Materials: acrylic/spray paint on cardboard
—Gerald Bustamante, Studio Bustamante

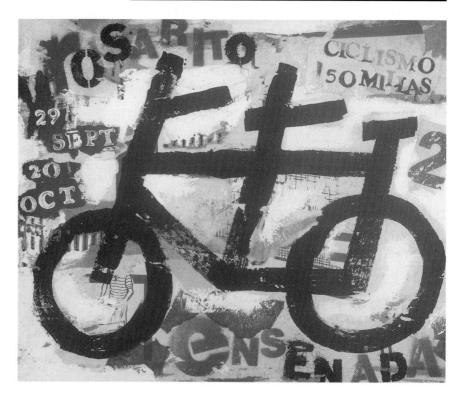

GRAPHIC DESIGN SOLUTIONS

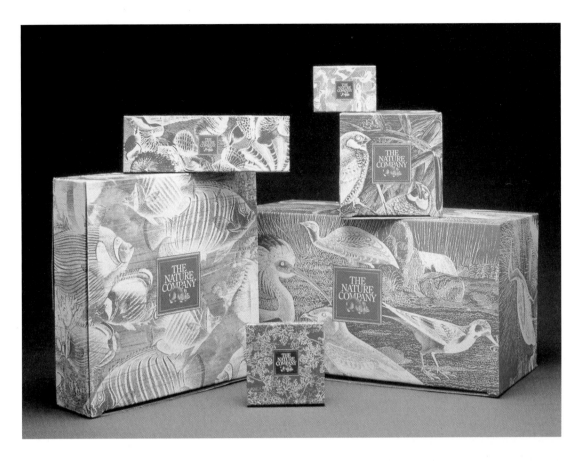

Figure 2-10
Gift box packaging for
The Nature Company
Design firm: Gerald
Reis & Company, San
Anselmo, CA
Art director:
Gerald Reis
Designers: Gerald
Reis, David Asari
Client:
The Nature Company

software, and paint or with indirect marks made by rubbing or blotting tactile textures. On the computer, you can digitize textures like lace or crumpled paper, or you can buy a CD of textures. Compare the rough visual textures of the type and visual in this poster to the many intricate visual textures in this package design (Figures 2-9 and 2-10).

The method for creating visual textures is closely linked to that for creating patterns. Pattern can be defined as a repetitive arrangement of elements, like a wrapping paper design or a plaid shirt. The unique and creative pattern in this poster by designer/illustrator Luba Lukova is an integral part of the visual message (Figure 2-11). Most textures create some sort of pattern, but patterns do not always have texture.

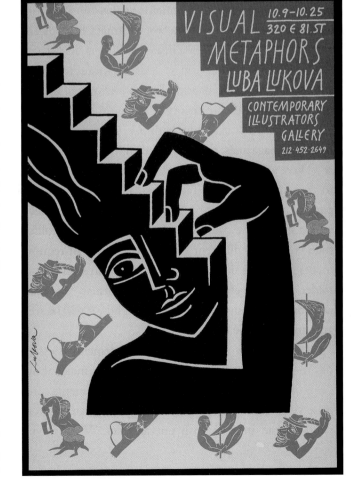

Figure 2-11
Visual Metaphors, Exhibition Poster
Design firm: Luba Lukova Studio, New York, NY
Designer/Illustrator: Luba Lukova
Client: Contemporary Illustrators Gallery

Format

Brochures, posters, business cards, book covers, shopping bags, envelopes, newsletters, magazines, and newspapers are just some of the many formats designers use. Whether it is a page or a business card, whatever you start out with is the **format**. The format is a vital element in two-dimensional design. Most beginning students take the format for granted, not realizing that it is an active element in design. If you think of an average page as two vertical lines and two horizontal lines joined at right angles, then the first line you draw on a page is actually the fifth line. Like that fifth line, all of the other formal elements are contained by, and interact with, the original shape of the format.

If you draw lines on a given format, like on a page or business card, the lines can be either parallel to the format or move in an opposing direction. For example, if you draw a horizontal line on a rectangular electronic screen, it will be parallel to the horizontal edges of the screen. However, if you draw a diagonal line on the same screen, the line moves in an opposing direction at the edges.

There are many categories of formats and each one — like shopping bags or magazines — has a different function, with advantages and limitations that must be considered in the design solution. Some formats, like posters, are meant to be seen from a distance. Others, like magazine advertisements or business cards, are meant to be seen up close. You need to consider how a format will be seen or used. Within each category of format there are differences as well. For example, both *TV Guide* and *Rolling Stone* are magazines, but they are different sizes.

There are as many different formats as there are ways to shape and fold paper. Take a regular 8½″ x 11″ sheet of paper. If you use the entire single sheet, you are working with a standard rectangle. If you fold it to create a folder, then you have a different format, with different requirements. Fold it a different way and you have yet anther folder with new challenges. For each format, you must consider its size, shape, and where and how it will be seen and how it will be used.

Knowing how to use these formal elements is essential to building a design. Every choice you make about color or shape is important. All the formal elements comprise your team of players on the page; they are interdependent and interact with one another. Whether you

want to design a newsletter or a logo, the formal elements are always the same.

PART II: THE PRINCIPLES OF DESIGN

Balance

You strive for balance in many aspects of your life: in your meals, in your budget, and between your work and play. When you arrange furniture and art objects in a room, you make decisions about balance. At times, you can be so sensitive to the position of things that you might move a couch or a vase for hours until it looks "right." This sense of balance functions similarly in graphic design.

Very simply, **balance** is an equal distribution of weight. When a design is balanced we tend to feel that it holds together, looks unified, and feels harmonious. When a design is imbalanced, it can make us feel uncomfortable. Understanding balance involves the study of several interrelated visual factors: weight, position, and arrangement.

When you make a mark on a page, that mark has a visual weight — it can appear to be light or heavy. **Visual weight** can be defined as creating the illusion of physical weight on a two-dimensional surface. To better understand this idea, imagine a mark on a page can be held in your hand and you can feel its weight. The size, value, color, shape, and texture of a mark all contribute to its visual weight.

Where you position the mark on the page also affects its visual weight. The same mark positioned at different points on a page — bottom right, bottom left, center, top right, or top left — will appear to change in visual weight because of its position. In visual perception, different areas of the page seem to carry more or less visual weight. For example, the center of the page is very powerful and can carry a good deal of weight. Several studies of this phenomena have been conducted, the most famous by Rudolf Arnheim.

There are basically two approaches to the arrangement of elements in a design. You can arrange all identical or similar visual elements so that they are evenly distributed on either side of an imaginary vertical axis, like a mirror image. This is called **symmetry**; it is always balanced.

GRAPHIC DESIGN SOLUTIONS

The design of this poster, "Between The Wars," is symmetrical (Figure 2-12). All the elements are centered. Imagine a vertical axis dividing the poster in half. You can seen an equal distribution of weight on either side of it. When you arrange dissimilar or unequal elements of equal weight on the page, it is called **asymmetry**. This spread from *Emigre* is asymmetrical but balanced (See. Figure 2-13). The arrangement of elements, their visual weight, and position contribute to the balance.

To achieve asymmetrical balance, the position, visual weight, size, value, color, shape, and texture of a mark on the page must be considered and weighed against every other mark. The arrangement of all the elements — the **design** or **composition** of everything in relation to one another — is crucial to achieving asymmetrical balance. It is almost impossible to list ways to achieve asymmetrical balance because every element and its position contribute to the overall balancing effect in a design solution. If you move one element, you may affect the delicate balance of the design. The decision of whether to use symmetry or asymmetry in your design solution should be dictated by the subject matter, the message, and the feelings you wish to convey.

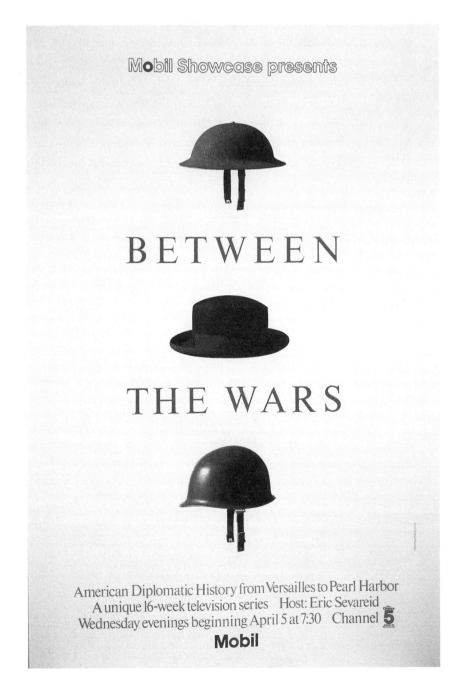

Figure 2-12
Poster, "Between the Wars"
Design firm: Chermayeff & Geismar Inc., New York, NY
Client: Mobil Corporation

This poster was designed to promote a television series on events during the period 1918-1940, with emphasis on the successes and failures of diplomacy. The hats symbolize the two wars, and the diplomacy between them.
— Tom Geismar, Chermayeff & Geismar, Inc.

Emphasis: Focal point and hierarchy

We constantly are bombarded by visual information; every poster, magazine, and brochure has plenty of it. How does the reader or viewer absorb this information? How does the audience know what is most important? Most people are passive recipients and depend upon the designer to direct their attention. It is this need for direction that brings us to the importance of **emphasis** in design. Emphasis is the idea that some things are more important than others and important things should be noticed.

When you look at a well-designed poster, what do you look at first? You probably look at what the designer (and possibly the client) thought was most important. We call this point of emphasis the **focal point** — the part of a design that is most emphasized. The focal point of this poster (Figure 2-14) is the white "c," and the words "new building." We are then led to all the other elements in the design because they have been arranged according to emphasis. How does the designer choose a focal point? A focal point

Figure 2-13

Spread from *Emigre* 19
Designer/Publisher: Rudy Vanderlans
Typeface designer: Barry Deck

Ever since I started conducting my own interviews, I have been intrigued with the idea of how to recreate the actual atmosphere or mood of a conversation. Usually, as a graphic designer, you receive a generic-looking, typewritten transcript, written by someone else, that you lay out and give shape to. Before I start the layout of an interview, I have spent hours transcribing the tape, listening to the nuances of the conversation, the excitement in someone's voice, etc. Much of the expressive/illustrative type solutions that I use in Emigre are a direct result of trying to somehow visualize the experience of having a conversation with someone. Although this approach is not always successful (some readers are put off by the often "complex-looking" texts), when it does work, and the reader gets engaged in deciphering and decoding the typographic nuances, the interview inevitably becomes more memorable.

— Rudy Vanderlans, *Emigre*

clichés, and are almost authorless. By repeatedly appropriating things that are out in the environment, without any identifiable source, they become part of a universal popular culture. They speak very clearly to the audience. Everybody knows what they mean, and the context that the designer puts them in will give them a certain slant. The "Loaf" poster is a good example. It says: "He is an idle man." and you have to decide whether you agree with that or not. When is he idle? Sitting in his lounger? Or is he an idle man who is working very hard physically, but not mentally? What does that mean? What do you think? What's your bias? ...**Edward Fella:** Or is he out of work? That was part of the discussion. The word "Loaf" has a double meaning. It is also a verb as in "Gee, all these people are loafing," when the truth might be that they're unemployed because there is no work, that masses of people are idle for other reasons than the fact that they themselves are somehow responsible. !Loud dog bark! There might be no demand for their physical labor. Those were the questions that Scott Zukowski was raising with that particular poster. Also, it is important to know that that poster was not meant to convey a particular message, the way Paul Montgomery's lunchbox was meant as a product. So the two, even though they use the same imagery, were done in a totally different context. However, in Montgomery's case too, it was hardly condescending. It was the idea of celebrating the working man or the idea of work, that this was not something that should be ignored or marginalized or somehow made invisible. **Kathy:** Hugh also touched on a related discussion about the use of French Post-Structuralism and literary theory. He assumes that because there is a Marxist element in the literary theory, it is strange for largely upper middle-class graduate students in the Midwest to be applying these ideas. He was questioning the appropriateness. I think probably a lot of those ideas are fairly workable without that particular brand of late 20th century European intellectuals' Marxism. I think these ideas bend fairly well to an American social democratic populace. It can be anti-authoritarian, but in an American popular ethic, or better yet, a frontier individualist ethic, as opposed to the European late Marxist ethic. Hugh might contend that you can't separate it from the Marxism, but we feel you can. !Loud dog bark!

Emigre: When I was in Switzerland, I met with many young Swiss designers who, each in their own way, were revolting against the legacy of designers such as Emil Ruder and Armin Hoffmann. They kept mentioning that Swiss Design "oversimplified" things, they mentioned that it "reduced the truth." My comments on some of the Cranbrook work would be that it often overstates the contents. Sometimes you can't see the trees for the forest. Is it possible to overstate the designs by using too much personal or cryptic or ambiguous meaning? **Scott:** Of course you can overstate messages. You try to draw a line, but there is a lot of work produced at Cranbrook that goes way over that line. But those are the things that shape you, and you can always pull back. If you don't go out far enough, you will never know what's possible. **Ed:** You know that adage about science taking very complex ideas and trying to simplify them, whereas philosophy takes fairly simple ideas and complicates them? Those are attitudes that exist within design, too. Sometimes, when there are

Book Format Design Concept.

The intention of this book format is to raise some questions about normal syntactic expectations in our readers. These ideas began in the essay "The New Discourse," published in ID (March/April 1988). The basic page proportion is based on a classical or traditional text block centered horizontally with generous margins on all sides. The Bodoni Book (by Bitstream) body copy face is generously leaded and justified, both also traditional book approaches. A centered axis runs through the copy block like a "fault line" that offsets the right half of the text from the left a fraction of a horizontal line space. In the essay, word pairs are interwoven through the copy block comes from the 1989 Design Department Poster.) The word pairs are dualities that describe to the range of possibilities in design: material/immaterial, geometric/poetic, critical/lyrical, etc. The tension point created by this central fault line refers to the creative tension found in design in the resolution of seemingly oppositional values, philosophies and forces such as art and science or the visual and verbal. This visual theme suggests the multivalent, ambiguous and continuously changing nature of design. This centered axis as referenced in the other essays as a thin vertical space (like a 'lazy line' on a Navaho blanket) that runs vertically through each centered copy block. The line should be almost subliminal, almost not noticed. On the other hand, it almost seems to indicate that the page's text is divided into two columns, so the reader must see if reading sense comes from reading the full line across the lazy line. The page numbers are reversed out of a small block that has also been fractured on the fault line of each page. Since the essays are all together at the beginning of the book, the centered text block of Bodoni is a constant in all the essays to unify the section. The book's title logotype continues the idea of the fault line. Although each word itself remains in horizontal alignment, the frames that carry the words are fractured slightly as they cross the central axes of the type sort. The head and subhead are deliberately intermixed to encourage alternate readings, including "The New Cranbrook Design" and "The Cranbrook Design Discourse." A Victorian era face called Egyptian (by Bitstream) is used in some of the heads, subheads and as part of the caption text. It has a 19th century book text look to it. It is frequently mixed with an early Modern face called Geometric (by Bitstream), a close relative of Futura. The text, quotes, captions and photos are positioned to just meet at their left or right edges, suggesting patches of type or photos 'pasted' onto the page. This sort of magnetic attraction between elements is also a departure from layout 'norms.' The images are generally centered in white space with generous margins, a traditional convention. The caption text faces are Geometric Bold, Bodoni Book and Egyptian; the various faces differentiate the various elements of the captions. The intention is a conservative format rooted in classical book design, but with subtle interventions to break the rules of normalcy. Hopefully, on a quick scan, the pages appear traditional, but when read will reveal subtle aberrations that make the reader conscious of the syntax or grammar of book text.

Katherine McCoy

fairly simple messages to convey, the philosophical approach, complicating them, makes them more interesting. Another approach to design when you have very complex messages to convey is to synthesize and simplify them. **Kathy:** Every project is different and requires a different kind of treatment. Once you leave Cranbrook, you have to be capable of doing the range of design approaches ...**Ed:** Right! And nobody is advocating this "overstating" approach for a manual for, let's say, brain surgery. This "overstated" approach frequently is done for things that are cultural messages that would include a time, place, date and name, and where there isn't really anything in the information that's very complicated. But the culture that surrounds it, the context, is very complex, and that is what's put into these pieces. !Baby cries!

Emigre: Part of the work produced at Cranbrook is explained as a reaction against Modernist ideas. In the book (Cranbrook Design: The New Discourse), it is stated that there are "serious doubts about the function of the International Style as a means of visual communication," and that students have "challenged the sterility of this 'universal design'." But most of the work that you do here, in a reaction to Modernist ideas, is worked out in very ideological projects. It is not played out, for instance, in corporate identities, which is really where, in your eyes, Modernism has failed. The Cranbrook book shows posters for the most part; there is not one corporate identity shown. **Kathy:** In the alumni part of the book there are several logotypes. But yes, we really chose to publish the more polemical work. People come to Cranbrook after doing very systematic, program-driven work as professional designers. The idea is that during the two years at Cranbrook, you can involve yourself in more personal, more culturally oriented work. One thing that might not show up, but is certainly embedded in my own personal process, and I think it probably comes out in a lot of the critiques I give of work, was in an ongoing project called the "Vernacular Message Sequence." This project was more or less the foundation of our approach to graphic design, although we didn't show too many examples of this in the book. This project's sequence goes from the extremely analytical, reductivist approach, where you are working on a message analysis and coming up with hierarchies and structure as the entry point, before proceeding to the more creative expressive personal phases of the project. The project covers the full range, from the highly objective to the highly subjective. I believe that today, everybody learns this in undergraduate school, or has learned it on the job, before they come to Cranbrook, so we don't spend too much time doing that anymore. It's embedded in their thinking. It might not be visible in the final manifestation, but hopefully, as you approach the content, as you are reading it, you will get an intuitive sense of that structure. Nobody is following grids much, currently, but that thinking is embedded in our students' methodologies. !Baby cries!

Scott: Are you saying that it might be interesting to see some work produced here that would challenge a more systematic approach? **Emigre:** Yes, I would find it interesting to see the experimental work that is done here be applied to, let's say, a huge corporate identity, instead of posters only. **Scott:** I think it is possible. It's one of many things possible, but it doesn't necessarily have to be studied here. Many of us have come to Cranbrook to more or less de-professionalize, and that means also ceasing to work on systematic projects for a while, to give our brain cells a little bit of a break and to look into other directions. **Kathy:** Scott Santoro has taken the experiments of his student work and is beginning to apply them to his professional work. Of course it is not quite as radical, but that is because he is working with different parameters, with strict program criteria. **Emigre:** But most of the work done by Cranbrook graduates is still for art institutions or culturally oriented projects. **Kathy:** Not all of it is, but yes, you will see that an awful lot of the work in the book is for somewhat culturally connected clients. One thing we talk about a lot here is the message, and how it is the designer's duty to take somebody else's message and give form to it, and how your design is only as interesting as the message. So one thing that people do when they leave here is look for the interesting clients who have something worth saying, as opposed to, for instance, discount shoe stores. If it's banal going in, it's going to be banal coming out, no matter how fine a designer you are. So on the one hand it's a process of natural selection. The work of the people that leave here is more appropriate for culturally connected things, but they're also very consciously seeking out interesting, worthy clients.

24

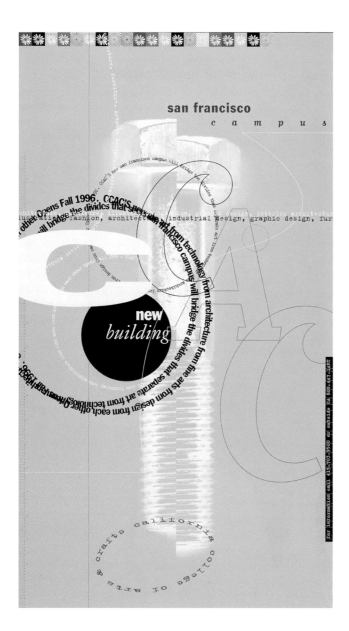

Figure 2-14

California College of Arts & Crafts New Building Poster
Design firm: Morla Design, San Francisco, CA
Art director: Jennifer Morla
Designers: Jennifer Morla & Petra Geiger
Client: California College of Arts & Crafts

California College of Arts & Crafts' new San Francisco Architecture and Design building required a recruitment announcement poster. The imagery of the large bolt and energetic typography collide to symbolize the process of creating the new campus. In addition, the measuring rules and printers registration bar act as a metaphor for the entirety of the design disciplines.

(or point of focus) is usually determined by the relative importance of the chosen element to the message and by what the designer believes will attract the viewer.

The designer usually has a main message to communicate and other peripheral information or messages. For example, on a poster promoting responsible drinking, the message "drive sober" is much more important than who is sponsoring the poster. A primary focal point can be established along with supporting focal points, which we call **accents**. Accents are not as strongly emphasized as the main focal point. You first notice the title of this gift portfolio for Country Matters because it is centered, framed, and lighter in value than the rest of the cover (Figure 2-15). The other typographic and decorative graphic elements — the subtitle, date, decorative square in the upper left — are all accents.

Figure 2-15
Catalog
Design firm: Pentagram Design Inc., San Francisco, CA
Art director: Kit Hinrichs
Designer: Susan Tsuchiya
Photographer: Barry Robinson
Client: Country Matters

Country Matters is a business that sources unique garden ornaments from around the world for sale to U.S. clients. They approached Pentagram for a catalog. The market is so exclusive, however, that an ordinary catalog would hardly have been appropriate. Instead, a "gift portfolio" was devised.

Each object was photographed and tipped into leaves of recycled paper with descriptions written in the manner of an art catalog and printed letterpress. The portfolios were individually numbered and addressed to clients.

—Alison Merkley, Project Manager, Pentagram Design Inc.

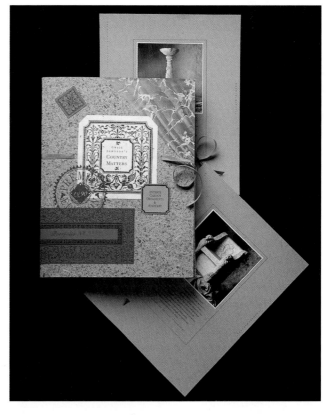

It is important to remember that if you give emphasis to all elements in a design, you have given it to none of them. You will just end up with visual confusion. How can you establish a focal point? What type of elements dominate a page and in what way? The position, size, shape, direction, hue, value, saturation, or texture of a component can make it a focal point. Here is a list of possible ways to make something a focal point:

- make it brightest
- make it a different color
- make it in color if everything else is in black and white or vice versa
- make it go in a different direction
- make it a different value
- position it differently
- give it a texture or a different texture than the other elements
- arrange all the elements to lead to it
- make it a different shape than the other elements
- isolate it
- make it clear and the other elements hazy
- reverse it
- make it an opaque color and other colors transparent
- make it glossy and the other elements dull

Establishing a **visual hierarchy**, which means arranging elements according to emphasis, is directly related to establishing a point of focus. It goes beyond a focal point to establish a priority order of all the information in a work.

A. Where do you look first?

B. Where do you look second?

C. Where do you look third?

John Rea, an advertising/creative director calls these questions the "ABCs" of visual hierarchy, where a few elements take emphasis or priority over other elements. To establish a hierarchy, decide on the importance of the elements that are part of your design. Use factors such as position, size, value, color, and visual weight to make sure your audience sees these elements in the order of impor-

tance. Create a flow of information from the most important element to the least. On this annual report cover, first you notice the photograph. In fact, your eyes go directly to the hands within the photograph. Then you read "Cancer Care, Inc." and then you go to the last element on the cover (Figure 2-16).

Figure 2-16
Cancer Care, Inc. Annual Report
Design firm: Lieber Brewster Design, Inc., New York, NY
Client: Cancer Care, Inc.

The special challenges we incurred included a limited budget allowing for three colors and saddle-stitch binding. Also, we were required to use Cancer Care's existing black and white photos showing people really touched by Cancer Care, rather than stock photos.

A usual challenge occurred on press when the solid color on the cover would not print without streaking. Pressmen worked for two days adjusting the press to correct this problem as the creative director stood by. In the end, with the problem resolved, the annual met the deadline and received compliments from the Cancer Care staff.
— Lieber Brewster Design

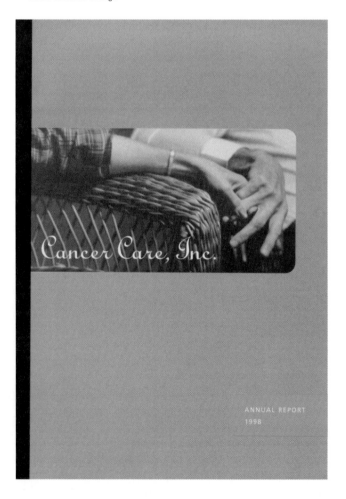

Rhythm

In music, most people think of rhythm as the "beat" — a sense of movement from one chord to another, a flow, accent patterns, or stresses. In design, you can also think of rhythm as the beat, but a beat established by visual elements rather than by sound. **Rhythm** is a pattern that is created by repeating or varying elements, with consideration given to the space between them, and by establishing a sense of movement from one element to another.

When you draw evenly spaced vertical lines on a page, you establish a steady repetitious rhythm because the lines have the same amount of space between them and our eyes move from one element to another consistently. If you vary the distance between the lines, you establish a different type of rhythm, one with variation or dynamics.

The key to establishing rhythm in design is to understand the difference between repetition and variation. Repetition occurs when you repeat visual elements with some or total consistency, as on this CHA CHA poster (Figure 2-17). Several elements — the heads, the repeat of the word "CHA CHA" create the rhythm along with the background colors and layers. Variation can be established by changing any number of elements, such as the color, size, shape, spacing, position, and visual weight of the elements in a design, as in this CD design (Figure 2-18).

Unity

When you flip through a magazine, do you ever wonder how the graphic designer was able to get al the type, photographs, illustrations, and graphic elements to work together as a unit? How does a designer successfully organize all the elements in an advertisement? There are many ways to achieve what we call **unity**, where the elements in

Figure 2-17
CHA CHA Beauty Parlor and Haircut Lounge Poster
Design firm: Planet Design Company, Madison, WI
Art director: Kevin Wade
Designer: Darci Bochen

CHA CHA Beauty Parlor and Haircut Lounge is a truly one-of-a-kind hair salon. To help create a fresh and funky image, we developed this poster. With budget being an issue, we also printed a direct mail campaign on the back of the poster, which was then cut into twelve ready-to-send direct mail cards.

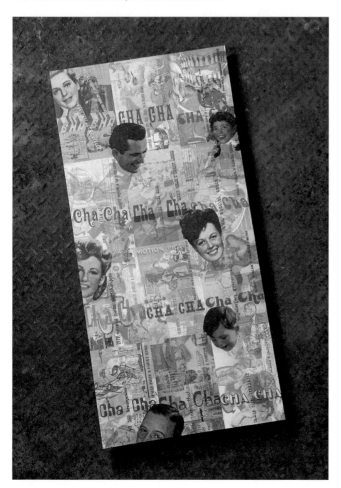

Figure 2-18
Bhoss "Trust Me" CD
Design firm: Jennifer Sterling Design, San Francisco, CA
Art director/Designer/Illustrator: Jennifer Sterling
Copywriter: Deonne Kahler

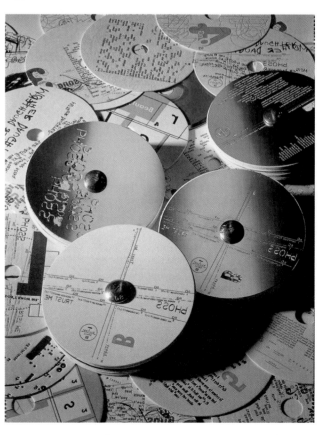

a design look as though they belong together. Achieving unity relies on a basic knowledge of the formal elements and an understanding of other basic design principles, such as balance, emphasis, and rhythm. In other words, the designer must know how to organize elements and establish a common bond among them.

Unity is one of the goals of composition. Unity allows the viewer to see an integrated whole, rather than unrelated parts. We know from studies in visual psychology that the viewer wants to see unity; if a viewer cannot find unity in a design, he or she will lose interest. We borrow the term *gestalt* from Gestalt psychology to describe this concept of visual unity and wholeness. Unity contributes to memorability, total effect, and clear communication; it is about how well a design holds together.

This packaging design system created by Louise Fili has unity, both as a system and as independent pieces (Figure 2-19). Each package design has unity on its own, through compositional movements — circular movements, in the typography and graphic elements — echoing one another. All the elements are used consistently on each package — typography, illustration, position, composition, and color.

One or more principles (or devices) may be employed to get the desired results for unity. Here are some of them.

Correspondence: When you repeat an element like color, direction, value, shape, or texture, or establish a style, like a linear style, you establish a visual connection or correspondence among the elements. The designers of

Figure 2-19
Bella Cucina Packaging
Design firm: Louise Fili Ltd., New York, NY
Art director/Designer: Louise Fili

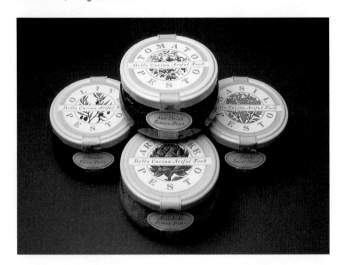

this folder and poster use several elements, type, lines, and a grid, to establish correspondence (Figure 2-20).

Continuity is related to correspondence. It is the handling of design elements, like line, shape, texture, and color to create similarities of form. In other words, continuity is used to create family resemblance. For example, if you were designing stationery, you would want to handle the type, shapes, colors, or any graphic elements on the letterhead, envelope, and business card in a similar way to establish a family resemblance among the three pieces. A certain level of **variety** can exist and still allow for continuity. Let's say, for example, you used the same design on the letterhead, business card, and envelope, except the letterhead is printed in red, the envelope in green, and the business card in blue. Your design would have both variety and continuity.

All the elements on the cover page for Marko Lavrisha's promotional piece are arranged on a central vertical axis (Figure 2-21). The other designs in this promotional incorporate an exciting variety of typographic arrangements, including "Volume 01" and "Volume 02," where the individual letters are aligned in vertical rows.

Grid: Subdividing the format into fixed horizontal and vertical divisions, columns, margins, and spaces establishes a framework for organizing space, type, and pictures in a design. This is called a grid. It may be used for single page formats or multipage formats. This grid gives a design a unified look. (The grid is examined in depth in Chapter 5.)

Alignment: Visual connections can be made between and among elements, shapes, and objects when their edges or axes line up with one another. The eye easily picks up these relationships and makes connections among the forms. All the elements on this label design for the California Grape Seed Co. are aligned on a central vertical axis (Figure 2-22). Besides the type alignment, other design decisions contribute to unity in Fili's design solution — color, fonts and patterns.

Flow: Elements should be arranged so that the audience is led from one element to another through the design. Flow is also called **movement** and is connected to the principle of rhythm. Rhythm, in part, is about a sense of movement from one element to another. In Jennifer Sterling's signage (See Figure 2-23) the arrangement of type and visuals move your eyes from one element to another across the elongated horizontal format and back again.

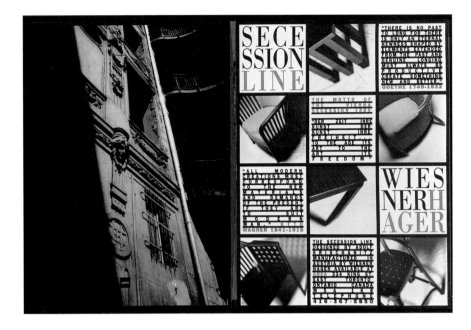

Figure 2-20
Area Secession Poster
Design firm: Concrete Design Communications Inc.
Toronto, Ontario
Designers: John Pylypczak, Diti Katona
Client: Area, Toronto, Contario, Canada

Manufactured by Wiesner Hager in Austria, this line of furniture was inspired by the Viennese Secession. The Canadian distributor, Area, needed a vehicle to promote the line.

We responded with a two-sided poster that folded down into a 10″ by 10″ folder. Printed economically in one color, the poster uses quotes by artists and architects of the secession.
—Diti Katona, Concrete Design Communications Inc.

Figure 2-21
Lavrisha/La Brecque Promotional
Design firm: Jennifer Sterling Design, San Francisco, CA
Art director: Jennifer Sterling
Designers: Jennifer Sterling, Amy Hayson
Illustrator: Jennifer Sterling
Photographer: Marko Lavrisha
Copywriter: Eric La Brecque
Client: Lavrisha/La Brecque

Figure 2-22
California Grape Seed Co.
Design firm: Louise Fili Ltd., New York, NY
Art director/Designer: Louise Fili

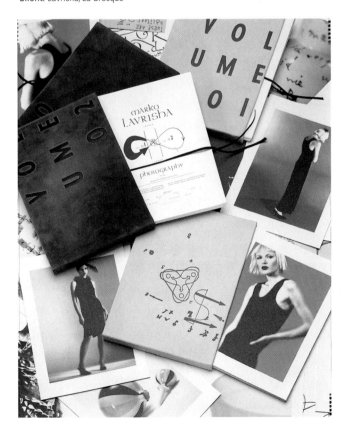

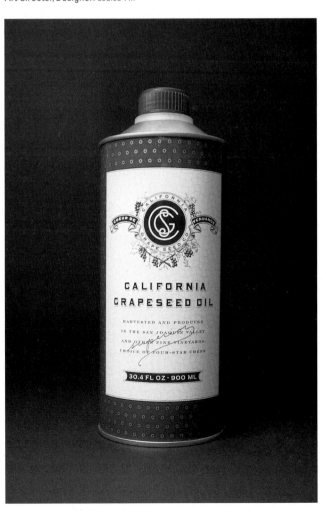

PART III:
THE MANIPULATION OF GRAPHIC SPACE

Positive and negative space

Let's say you are going to take a snapshot of a friend and you want to get some of the background into the shot. You frame your friend in the camera's viewfinder, which is a rectangular space. That rectangle is your format, your friend is the figure, and the space surrounding your friend is the background. Since you want the snapshot to look good, you'll probably try to create as interesting a relationship between the figure and background as possible. The same factors come into play when you have to solve problems of graphic space.

Try this. Draw a shape on a page. By doing so, you instantly create a positive/negative spatial relationship. The shape is the positive space, or figure, and the rest of the space on the page is the negative space, or ground. This sounds simple enough, but there is a lot more to it. In a successful positive/negative relationship, the positive and negative space is interdependent and interactive. In other words, no space is dead or leftover. Dead space refers to blank areas that are not working in the overall design. Leftover space does not mean that all blank space must be filled with clutter or meaningless forms. It means the designer must be constantly aware of the blank spaces and make them work in the design. All space, both positive and negative, should be considered active. Considering all space active forces you to consider the *whole* space. Again,

the term gestalt, the concept of visual unity and wholeness, applies to positive and negative space. The viewer wants to see unity, not unrelated elements or spaces.

The arrangement of the figures of Godzilla and King Kong is this "Peace" poster (Figure 2-24) creates interest-

Figure 2-24

Poster, "Peace • Commemoration of the 40th Anniversary of Hiroshima"
Design firm: Chermayeff & Geismar Inc., New York, N.Y.
Designer: Steff Geissbuhler
Poster: Peace — Godzilla and King Kong

Godzilla is a modern folk hero and a symbol of Japanese superpower called upon in times of crisis and invasion by other superpowers such as King Kong. Apparently, Godzilla emerged from the volcanic emptiness afte a nuclear blast. Therefore, it is even more of a symbol relating to peace. King Kong was used as the American counterpart of Godzilla.

The centered red sun on a white background is another symbol of Japan (Japanese flag, etc.). The color palette of red, black, and white is classic, and typical in Japanese calligraphy, painting, and woodcuts. The red-to-white gradation in the background relates directly to contemporary airbrush techniques frequently used in Japanese design. Meaning of the poster:

The friendship of Godzilla and King Kong makes them mightier than any other single beast. Friendship does not mean that one has to eliminate the other. It means coexistence with mutual respect and understanding. Nobody has to be the winner — nobody has to lose.

— Steff Geissbuhler, Designer, Chermayeff & Geismar Inc.

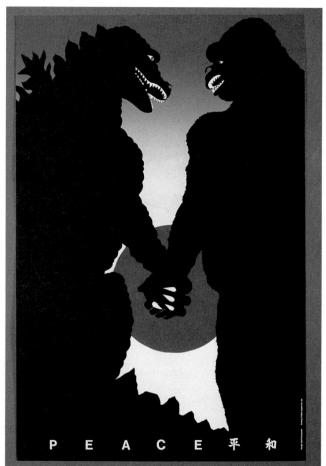

Figure 2-23

American Institute of Graphic Arts (AIGA) Signage
Design firm: Jennifer Sterling Design, San Francisco, CA
Art director/Designer: Jennifer Sterling
Client: American Institute of Graphic Arts (AIGA)

GRAPHIC DESIGN SOLUTIONS

PEACE 平和

ing and powerful negative shapes. The negative shapes are so powerful that they become positive — like the positive message of hope and survival communicated by the design concept. The cover of this catalog published by the Avia Group presenting its footwear collection for athletes makes dynamic use of positive and negative space. Notice the loose triangular shapes created within the figure in relation to the format (Figure 2-25). Both figure and ground, fish and water, are given great consideration in this logo design for the Baltimore Aquarium (Figure 2-26). Tension exists between the negative and positive space because the designer, Lanny Sommese, thought of the figures, objects, type, and background as active shapes (See Figure 2-27) in this ingenious poster.

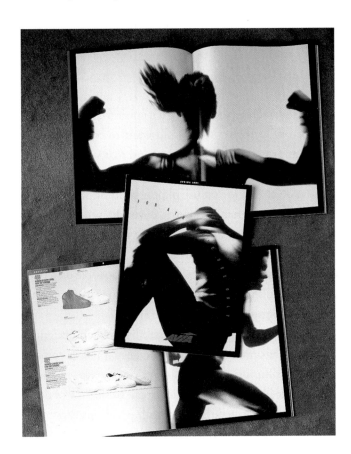

Figure 2-25
Catalog, "For Athletic Use Only"
Agency: Sandstrom Design, Portland, OR
Designer: Steven Sandstrom
Photographer: C. B. Harding
Client: Avia Group International, Portland, OR

Avia's advertising campaign used the slogan "For Athletic Use Only." The photographic style used in this catalog attempted to reflect the emotions and passion of that positioning line. We specifically avoided "fashion" shots of attractive models using or wearing Avia Athletic shoes and apparel. Through the use of hand-tinted black-and-white Polaroids we attempted to capture the intensity of sports participation — giving viewers a chance to project themselves into the photos.
— Rich Braithwaite, President, Sandstrom Design

Figure 2-26
Logo
Design firm: Chermayeff & Geismar Inc.,
New York, NY
Designer: Tom Geismar
Client: The National Aquarium, Baltimore, MD

The National Aquarium in Baltimore is about fish and aquatic animals, but also about the waters they inhabit. The symbol combines images of fish and water in the figure/ground relationship.
— Tom Geismar, Chermayeff & Geismar Inc.

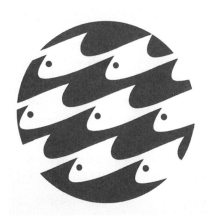

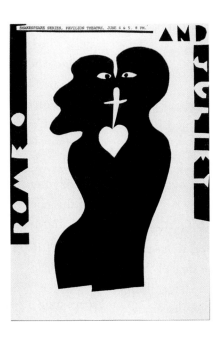

Figure 2-27
Romeo & Juliet Poster
Design firm: Sommese Design, State College, PA
Art director/Designer/Illustrator: Lanny Sommese
Client: Penn State Theater

The Theater at Penn State needed a poster for the play quickly and cheaply. I cut image and headline type out with scissors (low-tech). The concept of the play lent itself to boy/girl with the negative areas between becoming heart and dagger. It also seemed appropriate. At the time, everyone seemed to be doing high-tech, computer-generated stuff. I decided to go low-tech. The simplicity of the image also made it very easy to silk-screen.
— Lanny Sommese

Every format has a limited amount of space and a shape of its own. A thoughtful designer will always see the format as an active force in the creation of positive or negative space. Each shape or object should be considered in relation to the format and to one another. The space around and between each shape or object must be carefully considered. Some designers call this "charging the negative space." Becoming conscious of the negative space forces you to consider your whole design — to organize the space as a total unit.

Illusion

Let's say you are asked to design a cover for a book about the history of flight. You would want to create a design that is appropriate for the subject and that would capture the attention of someone browsing in a book shop. How do you do that? Do you use photographs or illustrations? Do you create a flat, geometric cover design or a design where airplanes look like they are flying off the page? In order to make an intelligent decision, you would have to know what your options are and what is possible on a two-dimensional surface, and also how to manipulate graphic space — the space on any given surface.

In general, there are two possibilities when designing a two-dimensional surface: you can keep it flat or you can create the illusion of three-dimensional space or spatial depth. The illusion of spatial depth can be shallow or deep, recessive or projected. In order to learn about these possibilities, let's try some experiments.

Draw evenly spaced vertical lines of the same line quality from top to bottom on a page. The result is that the page looks flat. Why? You kept the surface of the page flat because all you did was repeat the page's edges. The identical vertical lines that you drew do not suggest or give the illusion of depth.

Now try another experiment. Draw five vertical lines on one page and vary the length of the lines. The lines do not have to touch the page's edges. Unlike the first experiment, this page should not look flat. The shortest line should appear to be further away from you and the longest line should appear to be closer to you.

Now try this. Draw five squares on one page; vary the size of the squares. Does your design appear to have spatial depth? Why? In visual perception, the smaller things are, the farther away they appear to be. The larger things are, the closer they appear to be. Therefore, the size and scale of shapes or objects play an important role in creat-

ing the illusion of spatial depth. Used effectively, the size of one shape or object in relation to another, what we call **scale**, can make elements appear to project forward or recede on the page. Overlapping shapes or objects can also increase the illusion of spatial depth. When you overlap shapes, one shape appears to be in front of the other.

Here is the last experiment. Draw a cube at the bottom corner of the page. Then draw vertical lines behind it. The cube will appear to project forward off the surface defined by the vertical lines. A cube is a volumetric shape. **Volume**, on a two-dimensional surface, can be defined as the illusion of a form with mass or weight (a shape with a back as well as a front).

In all of these experiments, you have been playing with what we call the **picture plane**. When you set out to do a design on a two-dimensional surface, like a board or a piece of paper, you begin with a blank flat surface. That surface is called the picture place. It is your point of departure; it is where you begin to create your design.

As soon as you make one mark on the surface of the page, you begin to play with the picture plane and possibly create the **illusion of spatial depth**. The illusion of spatial depth means the appearance of three-dimensional space, where some things appear closer to the viewer and some things appear further away — just as in actual space.

You can suggest the illusion of depth very easily. Draw a diagonal line on a piece of notebook paper. By doing so, you are suggesting that the page is not flat. Why do diagonals create the illusion of depth? Their direction imitates the appearance of three-dimensional forms in space, like the side of a table or a box. If you draw diagonal lines and connect them with horizontal and vertical lines, you create a tilted plane on the surface — and you begin to enhance the illusion of spatial depth. This is a traditional Western convention for creating depth. It is a very simple version of what is called perspective.

Think of the common image of train tracks. If you are standing on train tracks, the tracks appear to converge in the distance. You know the tracks do not converge, but actually remain parallel. Perspective is a way of mimicking this effect. **Perspective** is based on the idea that diagonals moving toward a point on the horizon, called the vanishing point, will imitate the recession of space into the distance and create the illusion of spatial depth. Perspective is a schematic way of translating three-dimensional space onto a two-dimensional surface (Figure 2-28).

GRAPHIC DESIGN SOLUTIONS

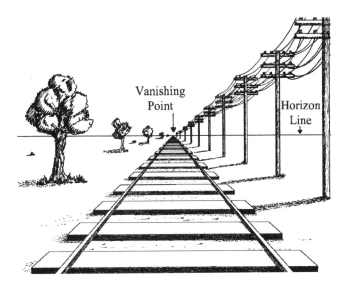

Figure 2-28
Diagram
Illustration: William Stanke

Figure 2-29
Chestnut Park Brochure, Cover
Design firm: Teikna Graphic Design Inc., Toronto, Canada
Art director/Designer: Claudia Neri
Client: Chestnut Park

We were asked to design a brochure for a luxury real estate company in the residential market, which would not sell any houses, but present the real estate company and its people. We used archival images from 1500-1600 Italian architects' drawings because they were both elegant and affordable. This was a low-budget project.
—Claudia Neri, Teikna Graphic Design Inc.

A perspective drawing is used on this cover for Chestnut Park brochure (Figure 2-29). Volumetric shapes, such as cubes, cones, and cylinders, can also create the illusion of spatial depth.

You can create such impressive illusions that the viewer, at first sight, is in doubt as to whether the thing depicted is real or a representation. This effect is called **trompe-l'oeil**. The use of shadows and overlapping shapes can create wonderful trompe-l'oeil effects, as on this cover for *Design Quarterly 110,* and this book jacket design, *Graphic Design USA:12* (Figures 2-30 and 2-31). In both examples, you feel as though you might be able to pick elements off the surface because of the illusion.

Figure 2-30
Cover, *Design Quarterly 110,* "Ivan Chermayeff: A Design Anatomy"
Design firm: Chermayeff & Geismar Inc., New York, NY
Designer: Ivan Chermyeff

A collage of personal images, notes, type proofs, etc., used for the cover of a magazine special issue devoted to the work of Ivan Chermayeff.
—Tom Geismar, Chermayeff & Geismar Inc.

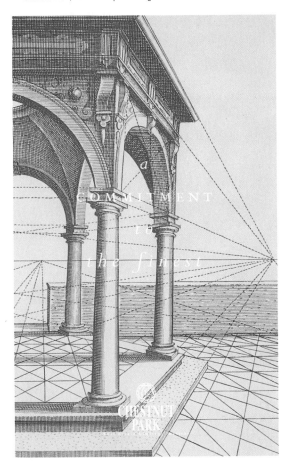

Figure 2-31

Book Jacket, *Graphic Design USA: 12*
Design firm: Muller + Company, Kansas City, MO
Art director/Designer: John Muller
Collage photographer: Michael Regnier
Client: A.I.G.A.

When asked by A.I.G.A. to design the cover for their design annual, the goal was to create an interesting, powerful image. The collage image is actually a compilation of some famous A.I.G.A. medalists: Alvin Eisenman, Frank Zachary, Paul Davis, and Bea Feitler.

The photos supplied by A.I.G.A. were reprinted in toned colors, cut and torn apart, and reassembled (with Scotch tape, etc.). For example, Paul Davis' mole is right next to Bea Feitler's mouth, below Frank Zachary's nose, flanked by Paul Davis' right eye, Bea's left eye, and Alvin Eisenman's hair; the neck and torso belong to John Muller, the designer.
— John Muller, president, Muller + Company

Creating the illusion of depth on a two-dimensional surface is something that fascinates many designers and their audiences. Look at this cover design by Paul Rand for *Direction* Magazine (Figure 2-32). Rand uses the horizontal stripes as a back wall or backdrop behind the dancer. The stripes seem to hold the surface in a fixed position — they define the picture place. Rand has created the illusion that the picture place is no longer on the surface of the page, but has moved back behind the dancer. However, the picture place does not seem to be too far away from us; the illusion of spatial depth seems shallow. Shallow space can have great impact. Why? Because it immediately engages our attention; our eyes cannot wander off into deep space. We tend to think of writing or lettering as flat elements drawn on a flat surface. Seeing letterforms that seem to have depth is a visual surprise, as in Le Monde Logo (Figure 2-33).

Remember, as a designer manipulating space you have many choices. You can maintain the flatness of the picture place or create the illusion of spatial depth. You can create a shallow or deep space, or create the illusion that forms are projecting forward. Understanding the illusion of spatial depth will enlarge your design vocabulary and enhance your ability to affect an audience. A good way to begin to learn about this is to analyze advertisements and designs to see how other artists manipulate graphic space.

The foundation of a solid graphic design education begins with a study of two-dimensional design — the formal elements, principles of design, and the manipulation of graphic space. This study provides the necessary basic perceptual and conceptual skills to go on to study typography, layout, and graphic design applications.

Figure 2-32
Magazine Cover, *Direction*
Designer: Paul Rand

Figure 2-33
Le Monde Logo
Design firm: Louise Fili Ltd., New York, NY
Art director/Designer: Louise Fili

Varying the distances between the lines and the thickness of the lines creates the illusion of swelling or warping on the surface of the page. The areas where the lines are light and close together may seem to recede and the areas where lines are heavier and further apart may seem to advance. Using line, you created an optical illusion.

EXERCISE 2-1
Exploring lines

- Divide a page into four units.

- Draw a curving line from corner to corner in each square.

- Draw different types of lines of varying direction and qualities in the divided areas.

PROJECT 2-1
Creating illusion with lines — a warp

- Using a black marker or the line tool on your computer's software, draw horizontal lines of varying thickness completely across the page.

- Vary the distance between the lines.

- Do several versions or thumbnails before going to the comp.

Note: This project is well-suited for the computer

Presentation

Create a comp on an 11″ x 14″ smooth board using black marker, or mount a computer-generated comp on an 11″ x 14″ board.

It is important to be able to recognize and create shapes that have similar qualities so that your ability to discern shapes becomes more acute. Composing the shapes introduces you to the process of designing elements on a page.

EXERCISE 2-2
Designing shapes

- Design ten shapes that have similar qualities, for example, curving shapes or angular shapes. Design your own or choose from a software palette.

PROJECT 2-2
Shape

- Draw four 5″ x 7″ rectangles, two in a horizontal format and two in a vertical format (or flip to a vertical format or direction).

- Within each rectangle, design four shapes that have similar qualities, for example, four geometric shapes or four free-form shapes.

GRAPHIC DESIGN SOLUTIONS

- Arrange the shapes so that the viewer's eyes will move from one shape to the other with ease.
- Produce several thumbnail sketches (or versions) and roughs before creating the comps.

Presentation

Present each of the four comps on an 8½″ x 11″ board.

comments

If someone asked a group of people to think of the color blue, each person would probably think of a different blue. Some would think of a blue with green in it, and some would think of a blue with red in it. Being able to make subtle distinctions among hues will enhance your ability to create successful color solutions.

EXERCISE 2-3
Use of color in graphic design

- Find ten examples of color usage in graphic design applications, such as logos, labels, and packages.
- Analyze the use of color in these examples in terms of appropriateness for the subject matter, the audience, and the feelings and ideas expressed or communicated.

PROJECT 2-3
Hue analysis

- Divide a 9″ square into nine equal sections.
- Look through magazines and pull out every red you can find. Or create a color palette on the computer.
- Select one hue that you believe to be a pure red, with no blue or yellow in it, and place it in the center section.
- Find eight different reds and arrange one in each of the remaining sections.
- Repeat the process with blue, green, and violet.

Presentation

Present the finished project on an 11″ x 14″ board.

comments

It is essential for any designer to be able to see differences among values. You can use your gray scale as a ruler — try to guess values and test them against your gray scale.

EXERCISE 2-4
Low contrast and high contrast

- Find two examples of graphic design solutions that use low contrast and two examples that use high contrast.

PROJECT 2-4
Value scale

- Look through magazines (or use your CD-ROM library) for photographs and tear out all the different grays you can find, as well as a black and a white value. Print out what you find on the CD-ROM.

- Create a ten-step scale of grays ranging from white to black.

- Cut the grays into shapes.

- Arrange the gray shapes on a page to create the effect of moving back into space.

- Create another scale using grays created by typography.

- Compare the gray scale of photographic fragments to the one of typographic grays.

Note: This project also can be executed on the computer, in paint, or with colored paper.

Presentation

Present the comp on an 11″ x 14″ board.

comments

Graphic designers need to be aware of all the textures available to them. Paper has tactile texture. Inks and varnishes can create tactile textures. Visual textures, including indirect marks like rubbings and blottings and direct marks like the ones in this project, should become part of any designer's vocabulary.

EXERCISE 2-5
Rubbings and blottings

- Using tracing paper and pencils or crayons to make rubbings (also called frottages) of textured surfaces. For example, place tracing paper on the bark of a tree and pick up the texture by rubbing it with the side of a crayon.

- Create blottings by dipping several objects with interesting textures into black paint or ink and blot them on paper.

Note: These textures can be simulated with computer software.

PROJECT 2-5
Creating visual textures

- Draw an object, face, or landscape. Using a drawing instrument and technique, for example, stippling or cross-hatching, create shading. The shaded part of the drawing should have a texture.

- To create a stippled effect, draw with dots.

- To cross-hatch, draw a series of lines that move in the same direction and then another series of lines in an opposing direction that cross over the others.

- Produce at least ten visual textures before creating the finished comp.

Presentation

Present your comp on an 11″ x 14″ board.

It is crucial to remember the format is a full participant in any design. Other components, like shapes, types, or photographs are not the only ones to be considered. The format is more than a frame — it is an important formal element.

EXERCISE 2-6
Rectangular formats

- Draw rectangles of different sizes and shapes.
- Draw a horizontal line, a vertical line, a diagonal line, and a curve in each rectangular format.
- Analyze the relationship of each line to the different formats.

PROJECT 2-6
Designing in different shape formats

- You will need four different shape formats: a large circle, two extended rectangles (much longer in one dimension than the other) — one vertical and one horizontal, and a standard page.
- In each one, arrange three shapes.
- Consider how each shape looks and is arranged in relation to the others and to the format.
- Produce at least five sketches for each of the four formats.

Note: This project may be executed on the computer, with cut paper, or with markers.

Presentation

Present each format on a separate 11″ x 14″ board.

Arranging a symmetrical design is not difficult. You divide the page in half with a vertical axis and evenly place similar or identical shapes on either side of the axis. Each side mirrors the other. Arranging a balanced asymmetrical design is a challenge because it is not a mirror image and each element's position and visual weight must be decided and become crucial to the overall effect.

EXERCISE 2-7
Creating a balanced design

- Find a headline, a visual (photograph or illustration), text, type, and a photograph of a product from different advertisements.
- Arrange them into a balanced design on an 8½″ x 11″ page.

PROJECT 2-7
Destroying symmetry and retaining balance

- Create a symmetrical design on a 10″ square format using solid black shapes.
- Make a copy of it.
- Cut the copy into 1″ horizontal strips.
- Cut the strips in half vertically.
- Rearrange the strips to create a balanced asymmetrical design.

Presentation

Present the finished comp on an 11″ x 14″ board.

Learning to arrange elements in order of their importance is critical to good graphic design. Visual hierarchy helps the audience glean information. You must direct your audience's attention in order to communicate a message effective.

EXERCISE 2-8
Creating a focal point

- On a 10″ square format, draw ten arrows that all lead to one point or area on the page.

- The arrows should be visually interesting; they may vary in quality and texture, and they may bend, curve, or intersect.

- On an 8½″ x 11″ page, draw seven arrows that lead to a main focal point and three arrows that lead to a secondary focal point. Make sure the arrows are visually interesting; give them texture, tone, various line qualities, and vary the directions and lengths.

PROJECT 2-8
Creating a visual hierarchy

- Draw seven shapes of varying sizes.

- Use color or texture on some of them; leave some in outline.

- Cut them out.

- Decide which shapes should be seen first, second, third and so on.

- On an 8½″ x 11″ page, arrange them in hierarchical order.

- Produce ten sketches and one rough before creating a comp.

Presentation

Present the comp on an 11″ x 14″ board.

Varying the type, direction, quality, and position of the lines, as well as the size, position, and visual weight of the dots, squares, and type will give your design rhythm.

EXERCISE 2-9
Creating rhythm

- Using vertical lines and dots on a page, establish a steady rhythm.

- Using vertical lines and dots on a page, establish a rhythm with variation.

PROJECT 2-9
Rhythm

- On an 8½″ x 11″ page, create a rhythm with great variation.

- Use vertical, horizontal, and diagonal lines, dots, squares, and type.

- Create ten sketches and one rough before going to the comp stage.

Note: This project can be executed on the computer, with marker, or with cut paper.

Presentation

Present the comp on an 11″ x 14″ board.

Unity is all-encompassing. If the design is not unified — if it does not hold together — then not much else is going to work. You need to be aware of the total effect of your design. Sometimes it helps to take a break from your work and look at it a day or two later. When you come back to it, ask yourself if it looks as if all the elements belong together.

EXERCISE 2-10
Using alignment to achieve unity

- Look through a magazine and find headline type, text type, and a visual (photograph or illustration).

- Using the principle of alignment, align all the elements on a page.

Note: Photographs can be scanned into a computer and size and shape can be altered.

PROJECT 2-10
Achieving unity

- Choose a group of objects, like tools or chess pieces, and photocopy or draw them.

- Cut them out.

- Arrange them on a page with type (found type or hand-lettered).

- To achieve unity, use the principles of flow and correspondence. For example, repeat colors in the design to create visual relationships among the elements.

- Create at least ten sketches and two roughs before going to the comp.

Note: This project may be executed on the computer using a scanner.

Presentation

Present the comp on an 11″ x 14″ board.

Letters are forms; they are composed of positive and negative spaces. The negative spaces they create when positioned next to one another are crucial to designing with type. The spaces between letters are impor-tant; they affect readability, legibility, and the memorability of design.

EXERCISE 2-11
Positive and negative space

- Paint a black shape on a board. Use water-based paint, such as poster paint or acrylics

- The shape should be big enough to touch the edges of the board in places. (The black shape is the positive space and leftover white area is the negative space.)

- Paint a bold white X entirely across the black shape.

- With white paint, paint the remaining white areas of the board so that they are connected to the X.

- This should result in four pie-like shapes.

- Now, it should be difficult to tell what is positive and what is negative. Do you see black shapes on a white board or white shapes on a black board?

Note: This project may also be executed with cut black and white paper or on the computer.

PROJECT 2-11
Letterforms as positive and negative spaces

- Using your initials, design the letters on an 8½″ x 11″ page so that both the positive and neg-ative space is carefully considered.

- The letters should touch all the edges of the page.

- The letters may be cropped or reversed.

- Create at least ten thumbnail sketches and two roughs before going to the comp.

Note: This project can be executed on the computer, with marker, or with cut paper.

Presentation

Present the comp on an 11″ x 14″ board.

Project 2-12 is designed to develop an understanding of how to create the illusion of spatial depth on a two-dimensional surface. As soon as you draw one volumetric shape on a flat surface, you begin to create the illusion of spatial depth. If the shapes you create overlap or vary in size, the effect will be greater.

EXERCISE 2-12
The picture plane

- Draw vertical and horizontal lines that oppose one another on an 8½″ x 11″ page.
- Every line you draw must touch another line. Imagine your lines are like string and that you are tying a package.
- Touch all edges of the page.

Note: This exercise can be done with pencil, marker, black tape, or drawing software.

PROJECT 2-12
The illusion of spatial depth

- With a light pencil, draw a 1″ grid on a 10″ square.
- Using either a black marker or black ¼″ tape, draw volumetric shapes such as cones, cubes, and pyramids.
- Use the grid as a guide for the vertical, horizontal, and diagonal lines.
- Fill the entire board.
- Avoid creating flat shapes such as squares and triangles.
- Produce at least two roughs before creating the comp.

Presentation

Present your comp on an 11″ x 14″ illustration board.

Overview of Graphic Design

OBJECTIVES

- becoming familiar with the four components of a graphic design solution: strategy, concept, design, and craft
- being able to write an objectives statement
- becoming familiar with the graphic elements of a design: format, type, and visuals
- understanding the importance of craft
- gaining a basic understanding of the design profession

Four components of graphic design solutions

A successful graphic design solution is, as the old saying goes, the result of perspiration and inspiration. As much as people would like to believe it, designers are not born designers. People are born with intelligence, visual acumen, and inclinations (or what most people call talent). Designers must spend years learning and practicing graphic design in order to become successful at it. Even after years of study and practice, each graphic design solution requires research, work, and focused creative energy.

Sometimes a graphic design solution comes very quickly; at other times, solving a design problem can be very frustrating. Most often, finding a solution is a matter of following a few tried and true steps and understanding the vital components of a graphic design solution. Strategy, concept, design, and craft are the four main components in the creation of a graphic design solution.

Strategy

Design solutions must be relevant to stated objectives and clear in the communication of messages. The visual message must fit into a larger marketing, promotion, or communication plan to achieve the goal.

The graphic designer works in collaboration with a client. Whether the client is a local business owner or a large corporation, the graphic designer's role is to provide solutions to visual communication problems. The problem may be to create an identifying mark (logo) or an extensive visual identity system involving the design of a logo, packaging, stationery, posters, labels, and reports. Sometimes the client is not sure of his or her own needs, so the designer must help the client clarify the design problem. In addition to collaborating with a client, the graphic designer works with a printer and may work with other visual communications professionals, such as commercial photographers, illustrators, copywriters, and art directors. Sometimes the graphic designer also works with editors, marketing experts, industrial designers, interior designers, film directors,

stock photography and illustration houses or web technicians.

During the first step of the process, the client and the designer work together to establish the objectives. In a classroom situation, you will work with your instructor to establish these objectives — a verbal account of what needs to be accomplished and what problems need solving. It helps to write an objectives statement for each graphic design problem. Write a clear, succinct description of your objectives. This statement should summarize the key messages that will be expressed in the design, for example, facts or information, desired personality or image, and position in the market. This statement is the narrative or verbal version of the visual you need to create. Once the design is roughed out, you can evaluate your design on how well it expresses this objectives statement. The following set of questions will help you clarify your design objectives for each project.

What is the purpose or function of the design? All graphic design serves a purpose. The three basic types of graphic design are information design, editorial design, and promotional design. **Information design** informs and identifies; it includes logos, identity systems, symbols, web sites, pictograms, charts, diagrams, maps, signage, retail guides, informational booklets, catalogs, "and anything that guides our greater understanding," says designer Steven Brower (Figures 3-1 and 3-2). **Editorial**

Figure 3-1

University of Southern California

Executive Healthcare Management Masters Program Catalog and Direct Mail Piece

Design firm: Vrontikis Design Office, Los Angeles, CA

Creative director/Designer: Petrula Vrontikis

Client: ©University of Southern California

Figure 3-2

Levi's National Fixture Program

Design firm: Zimmerman Crowe Design, San Francisco, CA

Creative director: Dennis Crowe, Zimmerman Crowe Design

Art director: Anderson Gin

Designer: MaryAnne Mastandrea, Mastandrea Design, Inc., San Francisco, CA

Photographers: Henrik Kam, Holly Stewart

Client: Levi Strauss & Co.

©Zimmerman Crowe Design

The Levi's National Fixture Program Guide is a 152-page catalog used by retailers to

purchase fixtures to display Levi's products in-store. The challenge was to design a clear, easy-to-use product presentation, yet give it visual excitement and energy. The fixture photos and information were designed in an organized layout that is consistent throughout the piece. Inspired by the fixtures' industrial materials (metal, wood, confetti board), we ran strips of the materials along the page edges. On the divider pages, we created large halftone dot patterns of the Levi's models to convey energy and attitude. The catalog is encased in a translucent plastic binder with images silk-screened on both the inside and outside to achieve a see-through, layered effect.

—Mary Anne Mastandrea, Mastandrea Design, Inc.

design is the design of publications such as magazines, newspapers, books, and newsletters (Figures 3-3 and 3-4). **Promotional design** essentially is meant to promote sales, or to persuade. It includes advertisements, internet banners, packaging, web sites, point of purchase display, brochures, sales promotions, posters, book jackets, and covers (Figures 3-5 and 3-6). These applications often overlap. A package design, for example, identifies a product, its ingredients, and its manufacturer, however it is also intended to promote the sale of the product; a poster promotes and informs; a web site can be informational or promotional. The purpose of these design applications is to provide accessible information about ideas, products, and services; to create or reinforce a product/service/client image; to create a bond between the consumer and the client; to promote sales; or to enhance communication. Promotional design has the highest degree of persuasive intent and information design the lowest degree. Always remember that graphic design is functional and it must meet the client's and audience's needs.

Who is the audience? Graphic design is aimed at a mass audience that may vary in size and demographics. A design may be intended for a local, national, or international audience. It may be intended to communicate with a specific professional or trade group. Defining your audience will help you to understand who you are designing

Figure 3-3
Levi's Jeans Box
Design firm: Morla Design, San Francisco, CA
Art director: Jennifer Morla
Designers: Jennifer Morla and Craig Bailey
Client: Levi Strauss & Co.

This is a pair of Levi's Jeans… is the definitive history of the Levi's 501 Brand. The book lavishly illustrates the past 140 years of Levi's 501 jeans with the people, places, movements, and marketing that turned one brand into an American icon. Eclectic typography, historic letters, western imagery, and pull-out spreads add to its visual interest. What began as a small project turned into a 300-page book of which Morla Design handled all aspects of production, from concept inception to delivery of 40,000 books.

Figure 3-4
"Circuits" section of the *The New York Times*
Design firm: Steven Brower Design, New York, NY
Art director/Designer: Steven Brower
Illustrator: Kati Beddow Brower
Photographer: Naum Kazhdan for *The New York Times*
Client: *The New York Times*

for, while keeping their collective preference, culture, taste, and income in mind. Every audience presents different considerations.

What is the competition and marketplace? A client's product or service may be unique, but most often it will be competing with similar products or services in the marketplace. You need to know a product or service's position in the marketplace; know the competition and how they have solved similar problems. You want your design solution to stand out and you do not want it to look like or to be confused with the competition. Find out how the client's product or service compares in price, quality, uniqueness, special offers, and consumer ratings with the competition. Find out where (environment, context, type of store) and when it will be seen. For example, there are many travel guides on a bookstore shelf. Fodor's Travel Guides (Figure 3-7), by the design firm of Vignelli Associates, stand out because of successful clean design.

Figure 3-5
E! Entertainment Television Holiday Promotion
Design firm: Vrontikis Design Office, Los Angeles, CA
Creative director: Petrula Vrontikis
Designer: Susan Carter
Client: © E! Entertainment Television

Giving, no matter the language, was the idea behind the E! Entertainment Television holiday promotion. We designed unique patterns and palettes to coordinate gift tags and wrapping paper. The size of the paper was perfect for standard small boxes and CDs. It is so important to us that we created gifts at the holidays that enhance the recipients' gift-giving experience.
— Petrula Vrontikis, Vrontikis Design Office

Figure 3-6
"Fluff" Mohawk Paper Promotion Book
The Planet Design Company, Madison, WI

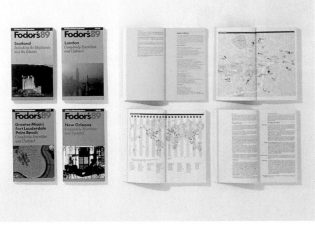

Figure 3-7
Travel Guides
Design firm: Vignelli Associates, New York, NY
Designer: Massimo Vignelli
Client: Fodor's Travel Guides

What message needs to be communicated? Remember, designs have at least two levels of meaning. The first is the primary meaning, which is the direct message of a word, sign, or image. The secondary meaning is what is conveyed or suggested by the overall design. Keep both of these in mind while you work. (Philip B. Meggs, a noted design historian and critic, calls these two levels of meaning denotation and connotation.) Because of the clear presentation of information in the design of the identity program for Aetna Life and Casualty (Figure 3-8), soundness and intelligence are suggested, which is the secondary meaning.

What kind of personality should be conveyed? The purpose and appearance of a product or service begins to establish its personality. The graphic design created for that product or service further establishes its personality. Make a list of descriptive words that you would use to describe a client's product or service. These words will help you establish a personality or image for the product and give you a direction in which to move.

All the formal elements of color, line, shape, texture, value, and the way they are put together using the principles of graphic space, balance, rhythm, and unity contribute to a design solution's personality. What kind of response is desired from your audience? If you can get the audience to react, to feel, to think, then you have made a connection with them — you have communicated.

Concept

The design concept is the creative solution to the design problem. A concept is the underlying logic, thinking, or reasoning for how you design a piece — the primary idea behind the piece. Essentially, it means you have a reason for what you are doing, for the imagery and the colors you select, for cropping something, or for using a particular font. The design concept is the framework for all your design decisions. The concept is expressed through the combination and arrangement of visual and verbal (typographic) materials. Successful concepts are innovative and creative, not stereotypical or commonplace.

Graphic design begins with a visual concept. You formulate a creative idea — a design concept — and put it into visual form. How do you come up with a concept? It can happen in a variety of ways. Sometimes you immediately visualize a solution in your mind. At other times, you may struggle until the last minute trying to find an appropriate and original design concept.

There is no one way to find or formulate a design concept; it is a very individual process. There are, however, tried and true steps that designers take to work it out. It all begins with knowing what needs to be accomplished — defining your design objectives (strategy). The next step is research. Finding material, information, and visuals about your subject can open up possibilities. Then you start sketching, drawing, doodling — thinking with a

Figure 3-8
Logo, Corporate Identity
Design firm: Vignelli Associates, New York, NY
Designers: Massimo Vignelli and Michael Beirut
Client: Aetna Life and Casualty, Hartford, CT

marker in your hand. If you are having trouble, try any or all of the following methods.

Brainstorm. Make a list of anything and everything related to your subject. If you do not want to do it alone, get someone to talk it out with you. The brainstorming list or session may conjure up some ideas or visuals.

Fool around. Find some visuals related to your subject. Try cropping them or cutting them and putting them back together in a different way. Photocopy them in strange or unusual ways. Change colors. Add textures. Combine images. Use paper or find paper that you would not ordinarily employ. Use the process of trial and error.

Let it be. Go do something else. Get away from it, but do not forget about it. Take your mind off the work itself. Just think about it for a few days before returning to sketching. Sometimes concepts come to people when they are relaxed or doing something unrelated to their assignment.

Get some visual stimulation. Look at award-winning designs in professional magazines or annuals. Research how other designers have solved similar problems. Go to the movies. Go to a store and look at package design. Look at old or antique labels, woodcuts, etchings, typefaces, and drawings. Go to a museum or gallery.

Think of the wrong answer. You are probably so worried about the right answer that you cannot find it — so try to find the wrong one. At least you will know what *not* to do.

Change directions. If you have been exploring one type of solution and nothing is happening, drop that direction and explore a new one. Try not to get stuck in a line of reasoning or in anything if it is not working for you. Go in a totally different direction to find a solution.

Formulating a design concept — whether easy or difficult — is simply part of the designer's task. It is something you are trained for in school or get used to through practice. You will learn to rely on your intuition, intellect, training, and experience. *(Also see the Suggestions at right.)*

SUGGESTIONS

- Know your objectives. You need to know the purpose and function of the design. Design solutions must be relevant to the strategy.

- Do a lot of research. The more research you do, the greater your flexibility. Note: CD-ROM technology and the Internet bring great quantities of information to you. Tap all resources.

- Develop an understanding of your subject. You need to understand a subject in order to develop a design concept for it and to choose appropriate graphic elements.

- Graphic design communicates messages on several levels. Have a social conscience. Do not use racist, sexist or biased ideas or visuals.

- Work your concept out in thumbnail sketches and roughs. If a concept does not work as a sketch, it certainly will not work as a comp. Try to work out the bugs in the early stages of the design process.

- Be willing to modify your original concept. In the process of working on a design problem, you may need to make changes. This may mean extra work, but if it yields an original or appropriate solution, then it is worth it.

- Be willing to give up your concept if it is not working. Inevitably, you will develop a better one.

- Save your thumbnail sketches. You may need to go back to them if your concept does not work out or if the client or your instructor is not satisfied. Also, you may be able to use them for another project. If you are working with computer software, do not keep all your thumbnails or ideas on disk. Print them out and look at them on paper. It is a good idea to include your working sketches in a separate binder in your portfolio to demonstrate your ability to think visually and conceptually.

Design

The way you put everything together — how you arrange the elements — is the design. Design solutions should be consistent with principles of visual organization and graphic space. Your solutions may express a personal aesthetic and a point of view (a style, perhaps), although this point of view should not interfere with the client's message; it should enhance it.

You have already developed your strategy and design concept; your next task is to translate them into visual communication. Writing the objectives statement may stimulate a visual response in your mind.

Research may also help you develop visual ideas. Now it is time to design, to visualize, to develop design concepts and small quick sketches. Explore concepts and design options, as many as time permits. Remember, this is the step where concepts are explored; this is not the time to refine your design. Develop the design only to the extent that the ideas can be clearly visualized. If you can visualize in small sizes, it is a great plus at this point. Sketching and drawing skills are critical. All of your concepts should be evaluated on how accurately they communicate the objectives established.

Graphic designers can take a concept and make it visual and comprehensible in a design. There are three fundamental steps to designing: sketches, roughs, final comps.

1. Sketches

A designer does thumbnail sketches. These are small, rough drawings of your visual ideas. Type is generally indicated. Visuals are very sketchy. Black and white or color. At this point, try to focus on visualizing ideas and composing, rather than focusing on type choices. The point of this stage in the design process is to generate as many different ideas as possible.

Some still choose to create thumbnail sketches by hand, usually with a finepoint marker and paper. Others go straight to the computer. If you do go straight to the computer, please make sure that you sketch rather than create a finished piece at this point.

2. Roughs

The next phase is making roughs, which yields a clearer picture of the design. Usually, a rough is done in actual size or in scale to the desired final piece. Here, type is rendered or generated so that a decision about the appropriate face, spacing, and sizes can be made. Colors are clearly indicated. Imagery is clear. Everything is clear enough to make a decision about which concept, composition, type, and visuals work.

Most people create their roughs on the computer and because of this, a rough tends to look like a finished piece. Even though it may look slick, it is not finished at this point. The purpose of this stage in the design process is to flesh out a few of your best ideas — to work on each concept and how it is executed using type, visuals, and layout.

The client does not see this phase. Roughs are for the designer's and/or design director's eyes. A client is shown a more refined comp — the final comp.

3. Final comps

Comps are the next stage and usually look as close to a printed or finished piece as possible. Computers allow a designer to create great comps, and now, most clients expect to see comps that look like finished pieces.

The point of this stage is to make sure everything works for your design concept, that all the design elements — including the imagery or visuals, graphic elements, and type or lettering — are just as you want them. Every line of type should be adjusted, all the letter spacing perfect. Everything should be spelled correctly.

The graphic elements

Every graphic design problem involves decisions about graphic elements. These elements are format, type, and visuals.

The format is the support for the graphic design, for example, a brochure, a poster, a business card, or a shopping bag. There are many types of formats and, of course, there are variations within each format. For example, there are a variety of brochures in different sizes and shapes and each may open up differently. Each format presents its own problems and restrictions.

You must consider the shape and proportions of the format. Both the shape and its proportions can affect the impact of your design. Sometimes the design objectives will determine the shape, size, and proportions of a format. There also may be constraints concerned with where and how the design will be seen, for example, magazine or outdoor board advertising, as well as monetary limits.

SUGGESTIONS

There are many schools of thought in graphic design. Many styles last for years and at the same time, trends come and go. Trends in music, politics, popular culture, literature, and fine art, influences from different cultures, countries, and technology all affect graphic design. Some famous designers have rules about design; some say there are no rules and if there are any, they should be broken. Students, however, need a point of departure. Here are some useful suggestions:

On graphic principles

- Maintain balance. It makes a design feel harmonious.

- Establish emphasis. The viewer should see the most important element first.

- Establish rhythm. Understand the difference between repetition and variation.

- Establish correspondence. Using the same or similar elements creates a sense of continuity.

- Establish alignment. Elements in a work should make visual connections. Edges or axes should line up.

- Establish a visual path. Allow the viewer's eyes to move from one element to the other with ease.

- Establish unity. Do whatever it takes to make your work hold together visually. Think about establishing some variety yet maintaining unity.

On style

- Stay in touch with contemporary culture. It is important to be aware of what is going on in the world in terms of style and content.

- Be eclectic. Look to many time periods and to world culture for inspiration.

- Learn the history of art and graphic design to understand style and movements. Know what is possible, what has happened, and why it happened that way.

- Stay current with trends in typography.

- Stay current with technology and tools. It is wise to have every possible technological advantage.

In general

- Only use one visual trick per piece. It is best to have one creative focal point and not overwhelm or distract the viewer.

- Break lines of type in logical places. Type should follow natural speech patterns.

- Create a meaningful or cooperative relationship between type and image.

- Take great care in the selection of typefaces. They have distinct personalities and styles and not every face is appropriate to every design concept. Avoid novelty faces.

There are standard sizes for some formats. CD covers, for example, are all the same size. Posters have standard sizes, however, you can print a poster in almost any size, too. Any size format is available to the designer at varying costs. When working with three-dimensional formats, like packaging, the shape and size can greatly affect the cost and methods of production. The size of a graphic design solution should be determined by the needs of the client, the design concept, function and purpose, appropriateness for the solution, and cost.

A designer works with **typography** or **type**. Type communicates a literal message by carrying information directly to the audience. However, type also conveys a connotative message — it suggests something more than its explicit or literal meaning. Typefaces have distinct styles and personalities. The type you select should be appropriate for your design concept.

Graphic design is an expression of an idea in visual form. In combination, visuals and type work together to communicate messages and meaning to an audience. There are basically three types of visuals available to designers — photographs, graphics (graphics include visual elements such as borders, arrows, bullets, graphic illustrations, charts, graphs), and illustrations. Most graphic designers

Figure 3-9
Virgil, Theater Poster
Design studio: Luba Lukova Studio, New York, NY
Designer/Illustrator: Luba Lukova
Client: Theater for the New City

Notice how the linear elements used to delineate the details of this illustration brilliantly correspond in quality to the type in this theater poster for a play by Victoria Linchon presented by the Theater for the New City.

Figure 3-10
Avila Weeks Dance, Theater Poster
Design studio: Luba Lukova Studio, New York, NY
Designer/Illustrator: Luba Lukova
Client: Pace Downtown Theater

create their own graphics, and hire illustrators and photographers or use stock photography. Sometimes photography or illustration is supplied by the client.

Students do not have the resources to buy visuals or hire professionals. Many students take their own photographs and create their own graphics or illustrations. It is perfectly acceptable to use found visuals; professionals looking at your portfolio understand the constraints of a student's budget and resources. Caveat on found visuals: A visual which you find — which you did not create — should *not* carry your design. Why not? You did not create it or art direct it. Found visuals should be minor players in your design. Suggestion: Try significantly modifying

Figure 3-11
Harmony Theater Poster
Design studio: Luba Lukova Studio, New York, NY
Designer/Illustrator: Luba Lukova
Poster for the Broadway premiere of Barry Manilow's musical.

a found visual so that it becomes yours. Visuals can be combined or modified with the proper technology — cameras, computers, photocopiers, video, or film — to create unusual or hybrid imagery. Deciding what type and style of visuals to use and whether to create or find them is usually determined by the design objectives, your skills as a photographer or illustrator, the design concept, technological resources, and appropriateness to the design concept.

Your job is to send a message to an audience, but how that message is communicated is a matter of creative expression. Graphic design is understood on at least two levels. The first is the direct message of a word or visual, which is the primary meaning. What is conveyed or suggested by the design — through the type, visuals, arrangement, color, format, and materials — is the secondary meaning. For example, you see the word "house," or a photograph of a house, and you understand the direct message of the word or visual. You know what it means. However, the style of the typeface or the lighting in the photograph communicates to you on another level.

All of these components — the format, shape, size, and proportions, the arrangement and style of type, the visuals and materials and the way they are all put together — visually express the design concept. The designer's job is to find the best *way* to do this. There are two main factors involved with this kind of creative expression: style and the creative leap.

The way elements are used together suggests style, the quality that makes something distinctive. Creating a style depends on the particular use of many elements: type, illustration, graphics, color, materials, format, shape, and proportions. "A style is like a language, with an internal order and expressiveness, admitting a varied intensity or delicacy of statement," stated Meyer Shapiro in his quintessential article entitled "Style." Luba Lukova, designer and illustrator, has an immediately recognizable and unique style; her particular way of rendering form, drawing with white lines inside solid forms and her corresponding typography and compositional ideas all contribute to her style (Figures 3-9, 3-10, and 3-11). The best way to learn about style is to study the history of graphic design and fine art. There are excellent texts available on the history and development of style in graphic design. Refer to the bibliography.

When you solve a graphic design problem in a routine way, you are merely getting the job done. When you go beyond a perfunctory solution you take a creative leap — you make art. You can take a mundane problem and turn it into art when you synthesize the formal, technical, practical, and conceptual components of that design problem into a personal vision. Then the solution addresses both the functional requirements of the design (the right design for the market and audience) and your personal aesthetic. You will have presented a personal point of view while meeting your design objectives. Your design can reflect your individuality while still solving your design problem. There are no uninteresting assignments, only uninterested designers. Also, no tool, not even the computer, can take a creative leap. The computer makes it easier for you to work and produce; only you can take the creative leap.

Craft

Craft refers to the physical handling of materials. It includes the use of papers, inks, varnishes, cutting and pasting, and the use of software programs as well as hardware. Well-crafted work is always a plus. You might put your whole portfolio on disk, but most potential employers will prefer to see hard copies; clients like to see comps or mock-ups. People respond to the visceral impact of your

SUGGESTIONS

- Make it neat. You want people to notice your design, not how poorly something is cut or pasted.

- Present it professionally. A good and thoughtful presentation can enhance your design solution and a poor presentation can only detract from it.

work. Therefore, design solutions should be neat, clean, accurate, functional (from a production viewpoint), and ecologically safe (recyclable if possible and not wasteful).

You should familiarize yourself with as many materials, tools, and processes as possible. Papers, boards, inks, adhesives, cutting tools, and drawing tools (markers, pens, pencils, chalks, brushes, crayons) and graphic aids (ruling guides, rulers, triangles, T-squares) are readily available. Research materials by going to art supply stores and looking at paper stock and getting paper samples from printers and paper suppliers. Go to paper shows. Learning about paper is crucial. Learn about the different types of inks, finishes, and printing techniques. Visit a printer and see how things are done. In addition to the basic materi-

Figure 3-12
Spread, *French Fries*
Designer/Co-author:
Warren Lehrer
Co-author:
Dennis Bernstein
Client: Visual
Studies Workshop

*This double-page
spread from* French
Fries *shows how each
character is typecast
into a distinct color
and typeface.*
— Warren Lehrer,
Designer/Co-author

GRAPHIC DESIGN SOLUTIONS

als listed, there is a wealth of presentation materials. Access to a computer and knowledge of several software programs is essential. Almost anything that can be done by hand can be created on the computer. Although most comps are computer-generated, it is advantageous to be versed in other tools, materials, and techniques.

The materials you use, whether for a comp or a printed graphic design solution, are critical parts of the design and contribute to effective communication, expression, and aesthetics. Craft and presentation are directly related to materials. The skill with which you craft your solution and present it can enhance or detract from it. Learning to cut, glue, mount, and mat is essential for a design student.

Presentation, the manner in which comps are presented to a client or in your portfolio, is important. The method of presentation should be determined by the type of work being presented and by who will see it. Do not underestimate the importance of presentation; it is as important as the work being presented. A good presentation can make ordinary work look great and a poor presentation can make great work look ordinary. Until you get to your portfolio, the rule is: simple and inexpensive but professional. You usually have to spend more money and time presenting the work that goes into your portfolio.

If you were working on a paid job for a client, the next step would be getting your design solution produced. This is called **production**, which is usually preparing the electronic file, collecting all needed photographs and/or illustrations and having them scanned, and proofreading (with or without the client). The designer must give explicit instructions to the printer, check laser proofs and other pre-press proofs, and deliver the job to the client.

Preparing an electronic file:

1. Collect all high-resolution images.
 - have images scanned or already on electronic file
 - create any necessary art
2. Design in a page layout program.
3. Proof job with laser proofs.
 - internally proof job
 - final proofs go to client for sign-off (very important)
 - laser proofs can be printed out in separation to check that the file will print correctly.
4. Laser proofs and disk with file, art, and fonts go to client or printer.

Critique guide revisited

Once you finish your graphic design solution, or even while you are creating roughs, you can use this expanded critique guide to help you make sure you are on the right path.

Strategy and concept development

- What is the purpose of the design?
- What information must be communicated?
- Does the design meet the objectives?
- What is the design concept?
- Does the design concept fit the strategy?

Design

- Did you use principles of graphic space such as balance, emphasis, rhythm, and unity?
- Did you experiment? Is your design solution merely competent or were you willing to take creative leap?
- What kind of visuals did you use and why?
- Did you express a point of view?
- Did you employ any creative approaches?
- Is the design solution (design, color, type, style, personality) appropriate for the client's product or service?

Craft

- Did you use techniques and materials that would best represent your design concept?
- Is it well-crafted?
- Is it presented professionally and appropriately?

The design profession

Imagine if all the products in a supermarket looked pretty much the same. That would be visually dull, and it wold make differentiation very difficult. One of the main things that designers do is visually enhance information, products, and services. They make things look attractive so that potential consumers will want to read them or buy them. Graphic design is part of the free market system; it promotes and aids competition. It also enhances our visual environment.

Although all graphic designers are concerned with aesthetics or graphic impact, not all graphic designers do the same type of work. There are designers who solve all types of design problems, however, many graphic designers and studios specialize in information, editorial or promotional design. Some design studios specialize in even more specific areas, such as packaging or visual identity. Not all designers find the same areas of specialization in graphic design equally rewarding. How will you know which career path to choose? It is best to try all types of design problems in school and see which area(s) you prefer. It also helps to look through design annuals and magazines and try to notice what attracts you most.

Graphic design is part of a larger visual communications field that also includes illustration (the creation of imagery) and commercial photography (photography that serves commerce). When a design concept is decided on, graphic designers and advertising art directors hire illustrators and photographers or buy stock illustration and photography. When working on television commercials, advertising art directors and creative directors hire directors, location scouts, and post-production experts and may also be involved in the selection of actors, costumes and sets. It is important for graphic designers and art directors to recognize successful illustration and photography and be aware of styles and trends.

Most often, graphic designers work closely with their clients. From developing a strategy to negotiating a fee, the client and graphic designer collaborate. Together they may study the market and competition, develop strategies for meeting objectives, budget, format, check stages of production, and choose and hire other professionals, such as photographers, illustrators, and printers.

Graphic designers can work in design studios, corporate art departments, publishing houses, or advertising agencies. Many designers are self-employed. It is advisable to work for someone else to gain design experience and to learn all the aspects of running a small business before going out on your own. It is also beneficial to try to get part-time work, such as an internship or a cooperative educational experience in the design field while still in school. Attend the meetings of local art directors' clubs, the AIGA (The American Institute of Graphic Arts), and as many professional conferences or lectures as possible.

Designing With Type

OBJECTIVES

- being able to differentiate among calligraphy, lettering, and typography

- becoming familiar with type terminology

- being able to identify parts of letters

- understanding how the principles of design apply to designing with type

- learning to use type creatively and expressively

You are designing a poster. A title, text, date, time, address, and sponsor's name have to be included. How will you arrange these typographic elements in order to inform and interest the reader? When designing with type, there are several general factors you must consider: the message, the audience, the format, the letterforms, and the other visual elements.

Message, audience, and format

The **message** is what needs to be communicated. In any design using type, there is almost always a specific message to communicate, for example, the title of a book, the selling point of a service, or the ingredients of a product. In most cases, there is more than one piece of information to communicate. You must establish a hierarchy of information, ranging from the most important to the least. Each piece of information should be weighed in importance in relation to every other and to the overall message.

The **audience** is the readers or viewers to whom your message is directed. Defining your audience will help you to understand who you are designing for, while keeping their collective references, culture, taste, and income in mind. Every audience presents different considerations.

The **format** is the surface on which the type will be designed, the vehicle or medium of your message. There are many different formats that a graphic designer uses — posters, web pages, brochures, newsletters, charts, covers, packages, advertisements, and stationery. Remember to consider the function, size, and shape of the format as well as where it will be seen (in a display, on a wall, on a shelf, outdoors) when selecting or designing with type.

Letterforms

The letterform is the particular style and form of each individual letter of our alphabet. Each letter of the alphabet has unique characteristics that must be preserved to retain the legibility of the symbols as representing sounds of speech. Letterforms are used by designers in three primary forms:

- Calligraphy: drawn by hand, it is a stroke or strokes of a drawing instrument, literally "beautiful writing" (Figure 4-1).

- Lettering: letters that are custom designed and executed by conventional drawing or by digital means (Figure 4-2).

- Typography: letterforms produced mechanically, usually with a computer. This is by far the most common means of using letterforms for visual communication.

Figure 4-1
Calligraphy
Design firm: Martin Holloway Graphic Design, Warren, NJ
Calligrapher: Martin Holloway

Figure 4-2
Custom Lettering
Design firm: Martin Holloway Graphic Design, Warren, NJ
Lettering/Designer: Martin Holloway

Type is available in an infinite number of styles for the designer's use simply by selecting a font size and style. Nearly every graphic design solution illustrated in this book is an example of typography.

Nomenclature

Today almost all type is produced electronically, but many of the terms we use in reference to type originated in the days when type was made of metal. A letterform was cast in relief on a three-dimensional piece of metal, which was then inked and printed.

When working with type, there are basic terms you must be familiar with:

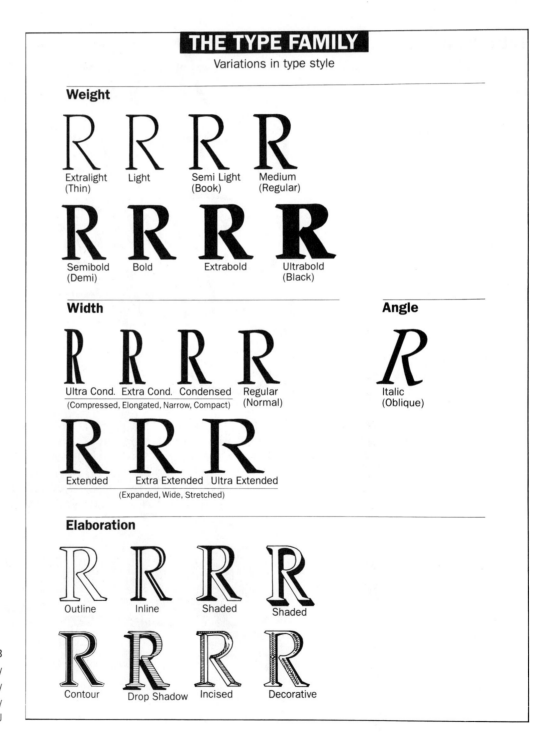

Figure 4-3
The Type Family
Chart by Martin Holloway
Design firm: Martin Holloway
Graphic Design, Warren, NJ

Typeface: the design of a single set of letterforms, numerals, and signs unified by consistent visual properties. These properties create the essential character, which remains recognizable even if the face is modified by design.

Type style: modifications in a typeface that create design variety while retaining the essential visual character of the face. These include variations in weight (light, medium, bold), width (condensed, regular, extended), and angle (Roman or upright, and Italic), as well as elaborations on the basic form (outline, shaded, decorated) (Figure 4-3).

Type font: a complete set of letterforms, numerals, and signs, in a particular face, size, and style, that are required for written communication (Figure 4-4).

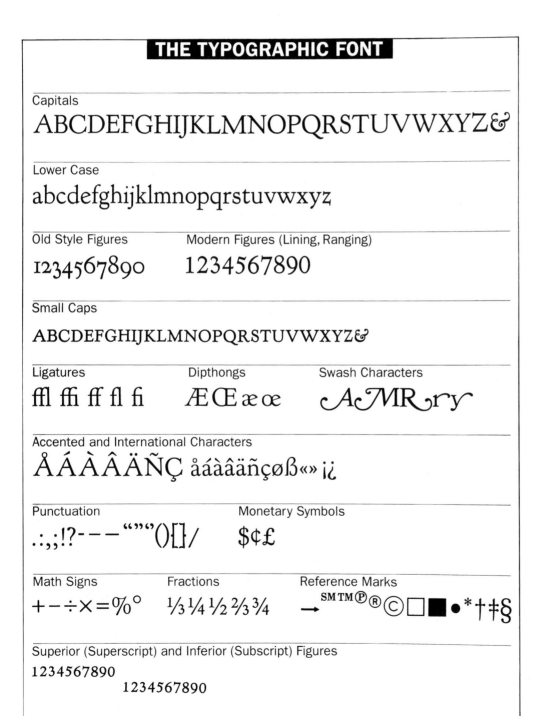

Figure 4-4
The Typographic Font
Chart by Martin Holloway
Design firm: Martin Holloway
Graphic Design, Warren, NJ

Type family: several font designs contributing a range of style variations based upon a single typeface design. Most type families include at least a light, medium, and bold weight, each with its italic (See Figure 4-3).

Guidelines are imaginary lines used to define the horizontal alignment of letters (Figure 4-5).

Ascender line: defines the height of lowercase ascenders (often, but not always, the same as the capline).

Baseline: defines the bottom of capital letters and of lowercase letters (excluding descenders).

Capline: defines the height of capital letters.

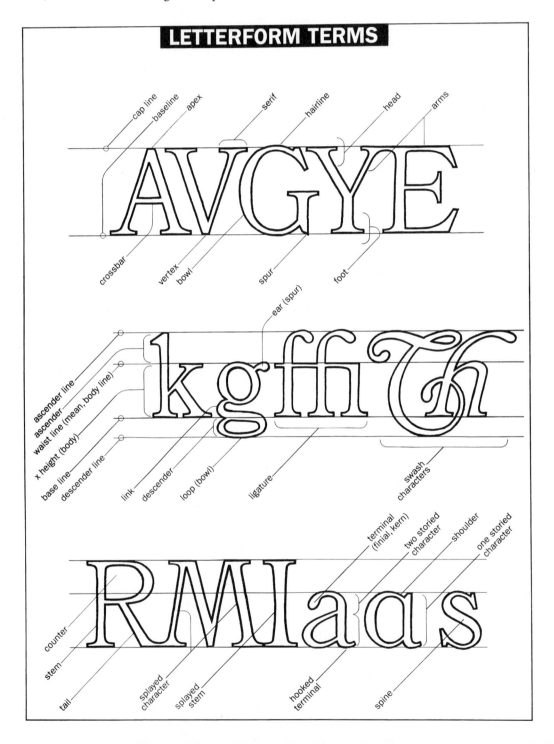

Figure 4-5
Letterform Terms
Chart by Martin Holloway
Design firm: Martin
Holloway Graphic Design,
Warren, NJ

62

Descender line: defines the depth of lowercase descenders.

x-height: the height of a lowercase letter excluding ascenders and descenders.

A nomenclature exists that defines the individual parts of letterforms and how they are constructed (Figure 4-5). Here are some basic terms:

Apex: the head of a pointed letter.

Arm: a horizontal or diagonal stroke extending from a stem.

Ascender: the part of lowercase letters, b, d, f, h, k, l, and t, that rises above the x-height.

Bowl: a curved stroke that encloses a counter.

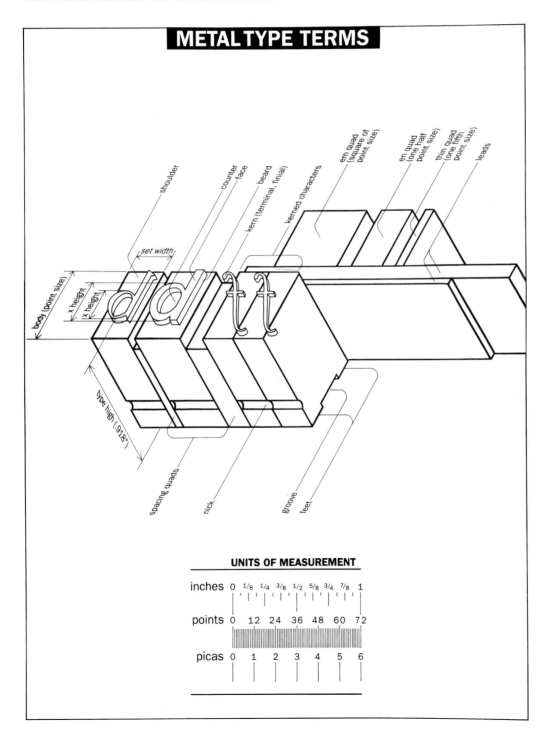

Figure 4-6
Metal Type Terms
Chart by Martin Holloway
Design firm: Martin Holloway
Graphic Design, Warren, NJ

Character: a letterform, number, punctuation, mark, or any single unit in a font.

Counter: fully or partially enclosed negative spaces created by the strokes of a letter.

Crossbar: the horizontal stroke connecting two sides of a letterform, as in an "A."

Descender: the part of lowercase letters, g, j, p, q, and y that falls below the baseline.

Foot: the bottom portion of a letter.

Hairline: the thin stroke of a Roman letter.

Head: the top portion of a letter.

Ligature: two or more letters linked together.

Lowercase: the smaller set of letters, a name derived from the days of metal typesetting when these letters were stored in the lower case.

Serifs: ending strokes of characters.

Stem: the main upright stroke of a letter.

Stroke: a straight or curved line forming a letter.

Terminal: the end of a stroke not terminated with a serif.

Uppercase: the larger set of letters or capitals. These letters were stored in the upper case.

Vertex: the foot of a pointed letter.

Typographic measurement

The traditional system of typographic measurement utilizes two basic units: the point and the pica. The height of type is measured in points and the width of a line of type is measured in picas. Most type is available in sizes ranging from 5 points to 72 points. Type that is 14 points and under is used for setting text or body copy, and is called **text type**. Sizes above 14 points are used for **display type**, such as titles, subtitles, headlines, and subheadlines (See Figure 4-6). A third typographic measurement, a unit, is used to measure the width of type. Note: points and picas are specific units of measure (pica = 1/6 inch, point = 1/72 inch), whereas units are proportional to type size and will vary depending upon the typesetting system.

10/10 Gather material and inspiration from various sources and bring them together. Examine other cultures and draw inspiration from diverse styles, imagery, and compositional structures. Go to the movies, look at magazines, listen to comedians, read humorists' works, watch music videos, look at all graphic design, observe human behavior.

10/11 Gather material and inspiration from various sources and bring them together. Examine other cultures and draw inspiration from diverse styles, imagery, and compositional structures. Go to the movies, look at magazines, listen to comedians, read humorists' works, watch music videos, look at all graphic design, observe human behavior.

10/12 Gather material and inspiration from various sources and bring them together. Examine other cultures and draw inspiration from diverse styles, imagery, and compositional structures. Go to the movies, look at magazines, listen to comedians, read humorists' works, watch music videos, look at all graphic design, observe human behavior

Figure 4-7

Indication of type size and leading. The type size and the amount of leading you choose will enhance or detract from readability.

Here are some terms you should learn:

Leading: in metal type, strips of lead of varying thickness (measured in points) used to increase space between lines of type; line spacing; interline spacing.

Line length: horizontal length of a line of type (measured in picas).

Line spacing: distance between two lines of type measured vertically from baseline to baseline, interline spacing, leading.

Point size (body size): in metal type, the height of the body (or slug) of lead the typeface is set upon (See Figure 4-6); the height of the type.

Set width: in metal type, the width of the body (or slug) of lead that a particular character is set upon, in other words, the width of type. This is measured in units. The size of a unit — thin, equal, vertical measurements — is governed by the em.

approximately 6 picas = one inch
12 points = 1 pica
approximately 72 points = one inch

Basic type specifications

When a designer wants to indicate the type size and the leading (or line spacing), the following form is used: 10/11 indicates a type size of 10 with one point leading; 8/11 indicates a type size of 8 with 3 points leading. The amount of leading you choose depends on several factors, such as the type size, the x-height, the line length, and the length of the ascenders and descenders. When a designer does not want additional space between lines, type is set solid, that is with no additional points between lines, for example, 8/8 (Figure 4-7).

Classifications of type

Although there are numerous typefaces available today, there are some major categories (Figure 4-8) into which most fall:

Roman: 1) letterform designs having thick and thin strokes and serifs. Originated with the ancient Romans.

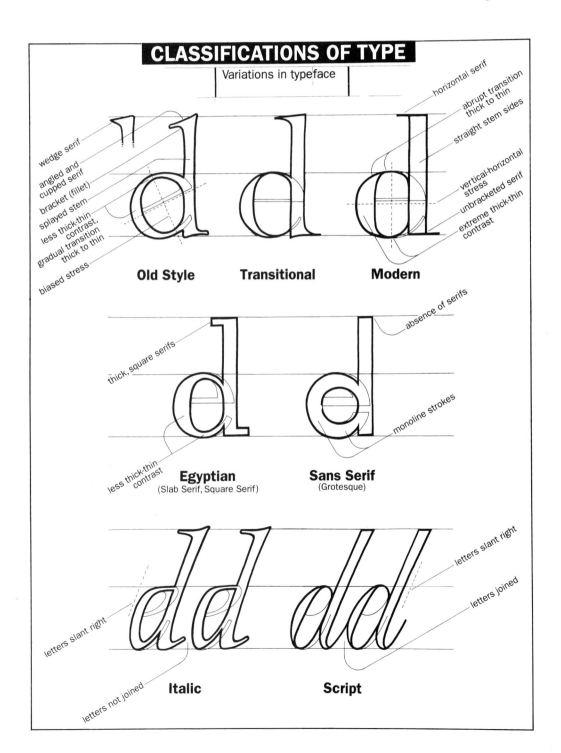

Figure 4-8
Classifications of Type
Chart by Martin Holloway
Design firm: Martin Holloway
Graphic Design, Warren, NJ

2) Letterforms that have vertical upright strokes, used to distinguish from oblique or italic designs, which slant to the right.

Old style: a style of Roman letter, most directly descended in form from chisel-edge drawn models, retaining many of these design characteristics. Characterized by angled and bracketed serifs, biased stress, less thick and thin contrast. For example, Caslon, Garamond, Palatino, and Times Roman.

Transitional: a style of Roman letter that exhibits design characteristics of both Modern and Old Style faces. For example, Baskerville, Century Schoolbook, and Cheltenham.

Modern: a style of Roman letter whose form is determined by mechanical drawing tools rather than the chisel-edge pen. Characterized by extreme thick and thin contrast, vertical-horizontal stress, and straight, unbracketed serifs. For example, Bodoni, Caledonia, and Tiffany.

Egyptian: a style of Roman letter characterized by heavy, slab-like serifs. Thin strokes are usually fairly heavy. It may have Modern or Old Style design qualities; also called **square serif** or **slab serif**. For example, Clarendon, Egyptian, and ITC Lubalin Graph.

Sans serif: letterform design without serifs and usually having monoline stroke weights (no clearly discernable thick and thin variations). For example, Futura, Helvetica, and Univers. Some letterforms without serifs have thick and thin strokes. For example, Optima, Souvenir Gothic, and Baker Signet.

Italic: letterform design resembling handwriting. Letters slant to the right and are unjoined. Originally used as an independent design alternative to Roman. Now used as a style variant of a typeface within a type family.

Script: letterform design most resembling handwriting. Letters usually slant to the right and are joined. Script types can emulate forms written with chisel-edge pen, flexible pen, pencil, or brush. For example, Brush Script, Shelley Allegro Script, and Snell Roundhand Script.

Many typefaces may not fit precisely into one of these historical classifications of type. In order to help you discern various features and make informed and appropriate choices, here are some common traits or characteristics to look for.

SUGGESTIONS

- Carefully consider the format; if type is designed for a poster it should be readable from a distance.

- Design type in a visual hierarchy. People tend to read the biggest elements first; they tend to read headlines or titles first, subtitles or pull quotes second, then captions, and finally text type.

- Type arrangement or alignment should enhance readability.

- Letterspacing, word spacing, and line spacing all factor into readability, communication and expression. Never depend on automatic spacing — adjustments are almost always necessary to enhance typography.

- Consider letterforms as pure forms; think about them as positive/negative space relationships.

- Color should enhance the message and expression and not hinder readability.

- Word spacing and line spacing establish a rhythm, a pace at which the viewer reads the message.

- The typography should be appropriate for the message and audience.

- Typography should enhance a message, not detract from it.

- When mixing typefaces, think about appropriateness to the message, contrast, weights, visual hierarchy, and scale.

- Become very familiar with, and learn to use, at least five classic faces, for example, Bodoni, Caslon, Futura, Univers, and Times Roman.

- Avoid novelty or decorative typefaces.

Serifs: There are many different types of serifs, for example, bracketed, hairline, oblique, pointed, round, square, straight, and unbracketed. It is a good idea to become familiar with their historical origins.

Stress: the stress of letterforms is the axis created by the thick/thin contrast; stress can be left-slanted, right-slanted, or vertical.

GRAPHIC DESIGN SOLUTIONS

Figure 4-9
Examples of Typefaces

BAMO hamburgers BAMO hamburgers

Garamond, Palatino: Old Style

BAMO hamburgers

New Baskerville: Transitional

BAMO hamburgers

Bodoni: Modern

BAMO hamburgers **BAMO** hamburgers

Clarendon, Egyptian: Egyptian

BAMO hamburgers BAMO hamburgers

Futura, Helvetica: Sans Serif

BAMO hamburgers *BAMO hamburgers*

Bodoni, Futura: Italic

B A MO hamburgers

Palace Script: Script

Figure 4-10
Ads
Art director: Kevin Weidenbacher
Writer: John Young, Bellport, NY
Client: The Bellport Restaurant

Thick/thin contrast or strokes: the thickness of the strokes varies in typefaces, that is, the amount of weight differs between thick and thin strokes.

Weight: the thickness of the strokes of a letterform, determined by comparing the thickness of the strokes in relation to the height, for example, light, medium, and bold.

Type and visuals

Type is usually designed with other visual elements, such as photographs, illustrations, graphs, and graphics (elemental visuals — both pictorial and abstract, rules, patterns, textures, etc.). The relationship between type and visuals is crucial — it should be synergistic. When a cooperative action between type and visuals is created, a design becomes a cohesive unit. In these advertisements for The Bellport Restaurant and for Giro, type and visuals cooperate to communicate the ad messages (Figures 4-10 and 4-11).

The message, which needs to be communicated, will help you determine which visuals and typefaces are appropriate. Some things to think about when designing with type and visuals:

While you may espy the occasional celebrity in our restaurant, there's a place across the street where they all hang out.

THE BELLPORT RESTAURANT. 159 SOUTH COUNTRY ROAD. BELLPORT VILLAGE. 516.286.7550

On the evenings we serve Cajun, you'll appreciate the service provided by our neighbor next door.

THE BELLPORT RESTAURANT. 159 SOUTH COUNTRY ROAD. BELLPORT VILLAGE. 516.286.7550

Always drink in moderation. However, if you insist on getting hammered, may we suggest a cozy little place around the corner.

THE BELLPORT RESTAURANT. 159 SOUTH COUNTRY ROAD. BELLPORT VILLAGE. 516.286.7550

- Consider the format in the design.

- Establish a visual hierarchy.

- Maintain balance.

- Carefully consider the size relationship (scale) of the type to the visuals.

- Determine the amount of type (both text and display) and the number of visuals.

- Consider the spirit, tone, and meaning of the visuals in relation to the spirit, style, and historical meaning of the typeface(s).

- Consider how the type and visuals look together, whether they are complementary in form and style.

Figure 4-11
Ad, "Bug"
Agency: Stein Robaire Helm, Los Angeles, CA
Art director: Chuck Bennett
Writer: Clay Williams
Client: Giro

The hardest part of doing this ad was getting the bug to hold still long enough to photograph. Actually, the bug in the ad was created using the body of one deceased insect and the wings of another. (Note: the insects mentioned all died of natural causes.)

In terms of concept, we wanted to create an ad that looked at bicycle helmets in a totally unique and unusual way, namely, from the point of view of an insect.
—Stein Robaire Helm

The principles of design and type

The fundamental organizational principles that apply to all of the visual arts also apply to typographic design. When arranging typographic elements, you should consider balance, emphasis, rhythm, unity, positive and negative space, and the manipulation of graphic space to create illusion. Equally, you should consider the interrelated visual factors of visual weight, position, and arrangement. On this exhibition poster, notice where the type is positioned and its relationship to the format and to the inner shape containing the type. This positioning is crucial to the creation of balance (Figure 4-12). If the inner shape were not there, the design would not be balanced. In contrast to Armin Hofmann's asymmetrical poster design, symmetry is used to achieve balance in this typographic design for a book cover by Michael Doret (Figure 4-13). On either side of an imaginary vertical axis, type and shapes almost mirror each other in visual weight, position, color, and arrangement.

Figure 4-12
Exhibition Poster, Armin Hofmann,
"Robert Jacobsen & Serge Poliakoff," 1958
Collection: Museum of Modern Art, New York, NY
Gift of the designer

When typographic elements are arranged according to emphasis, most often there is a focal point. This is the element that is most prominent and most important to the communication of the message. Once you have decided which typographic element is most important, you must make decisions about all the others — what should be read first, second, third, and so on. You must direct the reader's attention, as on this poster by Harp & Company (Figure 4-14). First you read the number "100" in red. Then you read "Bertolt Brecht 1898-1998," and finally the handwriting that is part of the illustration. Lastly, you read the remaining type. Of course, the arrangement, visuals, and color all are contributing factors to the visual hierarchy. Even though this photograph (of the Metro-

Figure 4-13
Book Cover for Trademarks of the 20's & 30's/Eric Baker, Tyler Blik
Cover design: Michael Doret
Publisher: Chronicle Books, San Francisco, CA

Figure 4-14
Bertolt Brecht Poster
Design firm: Harp & Company, Hanover, NH
Designers: Douglas Harp, Susan Harp, Robert Yasharian
Illustration: Susan Harp
Client: Berliner Ensemble, Berlin, Germany
This poster celebrates the 100th anniversary of the birth of Bertolt Brecht.

pole Hotel building in New York, 1909) is a very active visual, Chwast was able to make you notice the title first (Figure 4-15). Then, you look at the photograph, subtitle, and remaining text.

When creating emphasis with typography, consider:

- position,
- rhythm,
- color contrast,
- size contrast,
- weights of the type: the lightness or boldness of a typeface; weights usually are light, medium and bold,
- initial caps: a large letter usually used at the beginning of a column or paragraph, and
- Roman vs. italic: Roman type is upright as opposed to italic, which is slanted to the right.

You direct the reader from one typographic element to another by using visual hierarchy and rhythm (a pattern that is created by repeating or varying elements), by considering the space between elements, and by establishing a sense of movement from one element to another.

Some designers call it flow, some call it the beat. Whatever it is called, it is all about moving the reader's eyes from element to element so that they get all the necessary information and messages. This spread from Westvaco "Inspi-

Figure 4-15
Exhibition Poster for Graphic Design In America
Seymour Chwast, The Pushpin Group, New York, NY
Client: IBM Gallery, New York, NY

This poster, for an exhibit of all aspects of American graphic design, had to be developed without my expressing any specific design idiom. The image also had to be neutral. My design has a little bit of everything and no style in particular.
— Seymour Chwast, The Pushpin Group

GRAPHIC DESIGN SOLUTIONS

rations," Vol. 192, entitled "M is for Men" utilizes two different styles of type-setting or alignment (Figure 4-16).

The style or arrangement of setting text type is called **type alignment**. (The term alignment here is used more specifically than its broader definition in Chapter 2.) The primary options are as follows:

- **Flush left/ragged right:** text that aligns on the left side and is uneven on the right side
- **Justified:** text that aligns on the left and right sides
- **Flush right/ragged left:** text that aligns on the right side and is uneven on the left side
- **Centered:** lines of type are centered on an imaginary central vertical axis
- **Asymmetrical:** lines composed for asymmetrical balance — not conforming to a set, repetitive arrangement

There are many ways to ensure that all the type is interrelated, integrated into a whole design, and not seen as unrelated elements. To establish unity in a typographic design, consider:

- choosing typefaces that complement each other visually. Use contrasting styles, faces, and weights, rather than using faces that are similar; typefaces with pronounced or exaggerated design characteristics seldom mix well; avoid mixing two or more sans serif typefaces in a design,
- establishing harmonious size relationships,

Figure 4-16
Spread from Westvaco "Inspirations 192," 1953
Designer: Bradbury Thompson
Copyright by Westvaco Corporation, New York, NY

Seldom is there logic in using two different styles of typesetting in a design. But here, to provide a symmetrical relationships to symmetrical graphics, the type is set in centered style on the left page, while on the right page the text type is set flush right and ragged left to accompany asymmetrical graphics.
— Karen M. Elder, Manager, Public Relations, Westvaco Corporation

WEST VIRGINIA INSPIRATIONS FOR PRINTERS 192

IN EVERY TIME, MEN OF PRACTICAL ABILITY HAVE SERVED AMERICA. AS A FARMER, GEORGE WASHINGTON PIONEERED IN METHODS THAT INCREASED THE YIELD OF HIS PLANTATION. AS A SOLDIER, HE SOLVED PROBLEMS IN LOGISTICS WITHOUT LEAVING THE SADDLE.

M STANDS FOR MEN

KNOW-HOW IS ESSENTIAL IN A SUCCESSFUL OPERATION. THE PRINTING CRAFTSMAN, FOR EXAMPLE, ALWAYS DRAWS ON EXPERIENCE AND SKILL TO ACHIEVE OUTSTANDING GRAPHIC RESULTS. TAKE A PRACTICAL TIP FROM YOUR PRINTER: USE FINE PAPERS.

PRINTED BY LETTERPRESS
ON VELVO ENAMEL COATED TWO SIDES, 25 x 38 - 70

Chapter 4 Designing With Type

- determining how the size and choice of typefaces will work with the visuals,

- creating a cooperative action between type and visuals,

- creating tension between type and visuals,

- establishing color connections, harmonies, complementary relationships,

- establishing correspondence,

- using a grid (the term "grid" here is used in the traditional sense. Note the "grid" in electronic page design has a different meaning than the traditional graphic design term; in electronic page design software, different nomenclature may be used. For example, in QuarkXPress the grid is called the Master Page.),

- establishing alignment,

- establishing rhythm or a flow,

- positive and negative shape relationships, and

- type as an integral player in the communication of meaning.

Unity is established in different ways in both of these designs by Alexy Brodovitch. In this famous magazine spread, the text is masterfully designed to echo or correspond to the shape of the photographic image (Figure 4-17). This correspondence, repeating a visual element, establishes a visual connection. The heavier weight of all the type along the left-hand edge also echoes the values of the photograph. In these poster designs by Tudhope Associates, the type echoes the centered target-like visual; correspondence is established (Figure 4-18). Similarly, correspondence is established in the way the type follows the form of the globe on these packages for CD Software (Figure 4-19).

Figure 4-17
Magazine Spread from *Harper's Bazaar,*
15 March 1938
Art director: Alexey Brodovitch
Photographer: Hoyingen-Huene
Courtesy of *Harper's Bazaar,* New York, NY
Photograph courtesy of the Walker Art Center, Minneapolis, MN

GRAPHIC DESIGN SOLUTIONS

Figure 4-18
Poster
Design firm: Tudhope Associates Inc., Toronto, Ontario, Canada
Designer: Peggy Rhodes
Writer: Kelvin Browne
Client: T-D Centre, Cadillac Fairview, Toronto, Ontario, Canada

The objective was to create interest and add energy to the underground concourse. The design approach was "less is more" to complement the simplicity of the Mies Van Der Rohe architecture.
—Ian C. Tudhope, Principal, Tudhope Associates Inc.

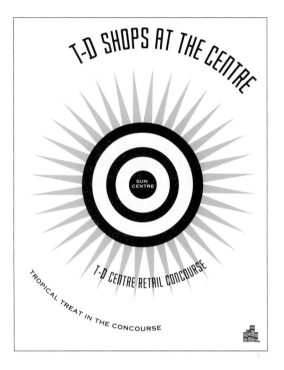

Figure 4-19
Package Design
Design firm: Muller + Company, Kansas City, MO
Client: CE Software

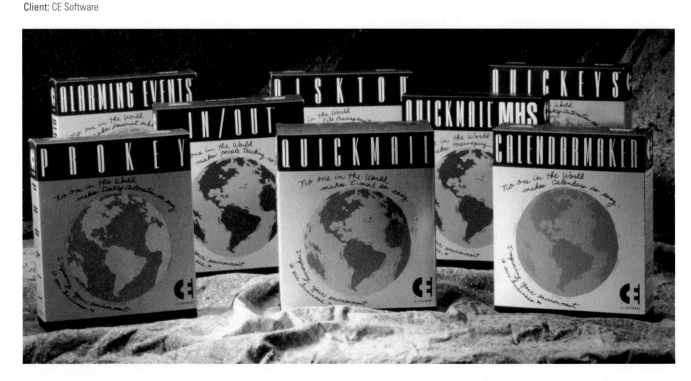

Understanding positive and negative space is crucial to designing with type. The spaces between letters, between words, and between lines of type must be carefully considered if you want your design to be legible and memorable. Once you lose legibility, you lose meaning. Factors that enhance legibility are:

- positive and negative shape relationships
- distinctiveness of individual letters
- thoughtful letter, word, and line spacing
- strong value contrast between letters and background
- word placement to encourage eye movement in the correct reading sequence.

There are three types of spacing you have to worry about when designing with type: letterspacing, word spacing, and line spacing or leading. **Letterspacing** is the space between letters. **Word spacing** is the space between words. **Line spacing, interline spacing,** or **leading** is the distance between lines of type. (In electronic page design, the terms *auto leading, absolute leading,* and *incremental leading* also are used.) Spacing should enhance legibility and reader comprehension. If people have difficulty reading something, they probably will lose interest.

When a character is produced, digital typesetting machines or computer software automatically advance in units before generating the next character. It is not a good idea to rely on automatic spacing when designing with type. The designer can control the world spacing or letterspacing by tracking or kerning, which is the process of subtracting space between letters to improve the letterspacing. *You should always judge the letterspacing optically.* In setting display type, it is feasible to adjust letterspacing of individual characters since the number of words in headlines is limited. This fine tuning of negative space is a hallmark of typographic excellence. In text settings, since individual letterspace adjustment is impractical, the designer selects the letterspacing mode that the computer follows automatically. In electronic page design, what you see on the monitor's screen is what you get when it is printed. This is referred to as WYSIWYG (what you see is what you get).

Word spacing and line spacing also can be done automatically when typesetting. Once again, it is important to make any necessary adjustments by eye, not by measurement. There are some general considerations to keep in mind:

- spacing between words and lines of types should enhance legibility, readability, and overall comprehension of the message. Legibility refers to how easily the shapes of letters can be distinguished (usually refers to larger sizes) and readability refers to how easily type is read (usually refers to text type),
- the size of the type in relation to the amount of spacing,
- the length of the lines in relation to the amount of spacing, and
- spacing in relation to the characteristics of the typeface.

Large, cropped numbers, aligned in a vertical axis, create a bold graphic effect with pleasing positive and negative shape relationships in this wine label design (Figure 4-20). Tight letterspacing, used in this title for an art exhi-

Figure 4-20
The Traver Company Holiday Wine Gift
Self-promotional Piece
Design firm: The Traver Company, Seattle, WA
Designer: Sarah Nixon
© The Traver Company

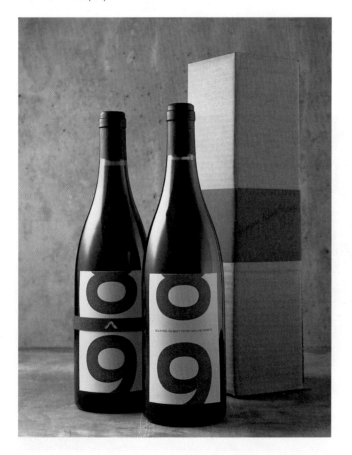

bition announcement, brings all the letterforms and numbers together as one unit (Figure 4-21).

You might think it would be difficult to create interesting positive and negative shapes when there are only two numbers involved. It can be done effectively, as in this logo (Figure 4-22). It was designed for KXTX Channel 39, a Christian format television station in Dallas, Texas. Similarly, dynamic positive and negative space is created in this logo for CE Software; the "E" is formed by the negative space (Figure 4-23).

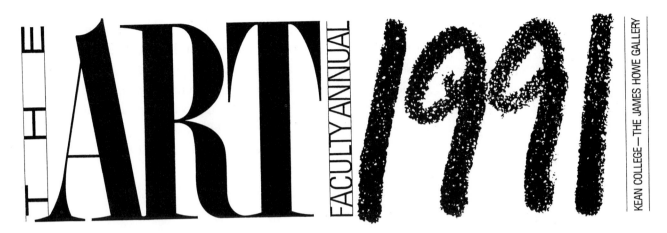

Figure 4-21
Poster Title, "The Art Faculty Annual 1991"
Design firm: Martin Holloway Graphic Design, Warren, NJ
Lettering/Designer: Martin Holloway
Client: James Howe Gallery, Kean University, Union, NJ

Figure 4-22
Logo, Channel 39
Design firm: Sibley Peteet Design, Dallas, TX
Client: KXTX Channel 39

This mark was selected from a group of about thirty alternatives presented. The mark's interest lies in the juxtaposition of a positive three with the negative shape of the nine, bleeding the common shapes of the two number forms.
— Don Sibley, Principal, Sibley Peteet Design

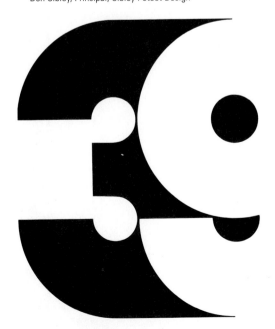

Figure 4-23
Logo
Design firm: Muller + Company, Kansas City, MO
Client: CE Software

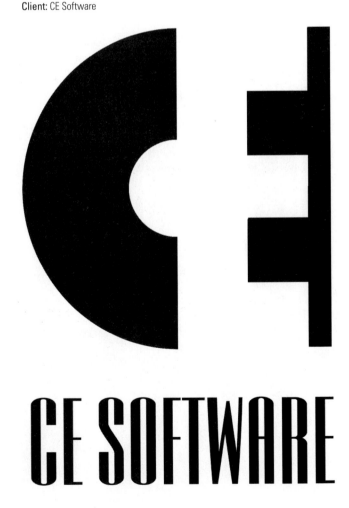

Using type, you can maintain the flat surface of a page or you can create the illusion of spatial depth. The weights, color, size, position, and arrangement of type all are factors in the creation of illusion. In all the following five designs (Figures 4-24 through 4-27) there are varying degrees of the illusion of spatial depth. The letter "C" appears to be closest to the viewer and defines the picture plane in this spread (Figure 4-24). The overlapping letters, along with the word "communication" defines the other layers of spatial illusion.

Subtle elements, such as the red line of type, the "drop out" line of type over the photograph, and the photograph of the road, create the illusion of spatial depth on this annual report spread (Figure 4-25).

The overlapping of type of this spread from "French Fries" gives the effect of several layers of space (Figure 4-26). The variation in the range of values enhances the illusion and adds atmosphere. Size and value contrast are used to create the illusion of spatial depth in the pages of this sales portfolio by Petrula Vrontikis (See Figure 4-27).

Figure 4-24
Expeditors International Annual Report,
"Communications" Spread
Design firm: Leimer Cross Design Corporation, Seattle, WA
Client: Expeditors International of Washington, Inc.

A global logistics company, Expeditors continues to distinguish itself from competitors by building a worldwide, proprietary logistics management network. In 1994, that principal EDI network was called exp.o—named by Leimer Cross Design. The message confirmed the many benefits customers could expect from exp.o and, by extension, the strong growth potential for investors. "Communication" in real time, in the form Expeditors' customer specified was the theme.
— Leimer Cross

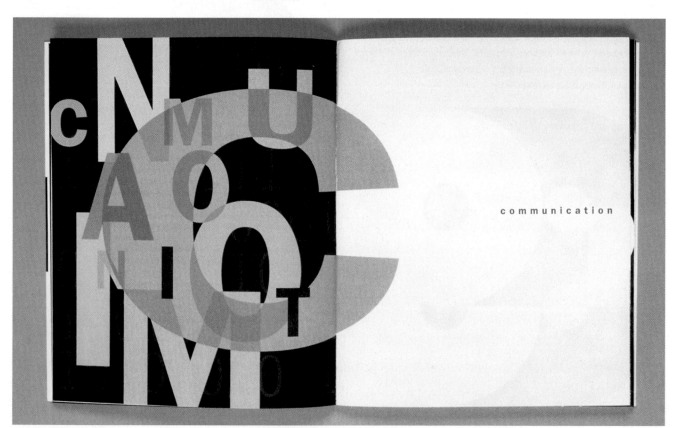

▲ Figure 4-25

AARP Annual Report

Design firm: AARP Creative Group, Washington, D.C.

Designer: Melanie Alden-Roberts

Client: AARP

We created an intimate look at people, rather than a list of AARP's accomplishments, that the reader wouldn't be able to relate to on a personal level.

By using diverse images of boomers, midlife and older persons, we hope readers will see themselves in this report; or see someone like themselves who inspires them to become involved in their own communities.

— Melanie Alden-Roberts, Designer, AARP Creative Group

▼ Figure 4-26

Spread, "French Fries"

Designer/Co-author: Warren Lehrer

Co-author: Dennis Bernstein

Client: Visual Studies Workshop

The book called French Fries *takes place inside the third largest burger chain in the Western Hemisphere.* French Fries *is a visual translation of a play written by Dennis Bernstein and me. It is a quick service circus of culinary discourse, dream, memory, and twisted aspiration. In this double page spread from* French Fries, *a political argument breaks out between patrons and staff at Dream Queen. Overlay of works and images reveal the sonic and psychological cacophony of argument in the context of a fast-food joint.*

— Warren Lehrer, **Designer/Co-author**

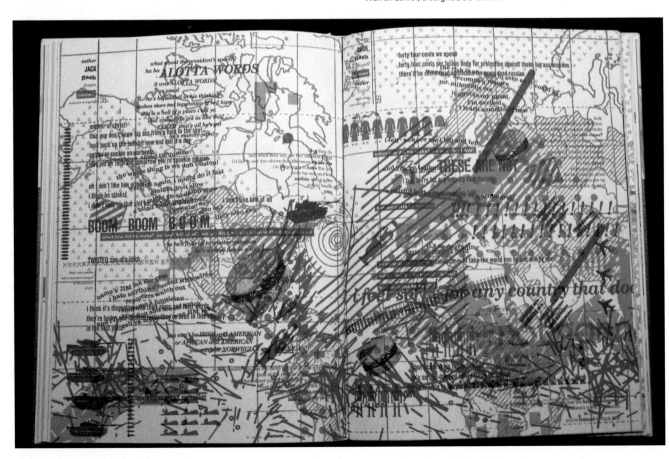

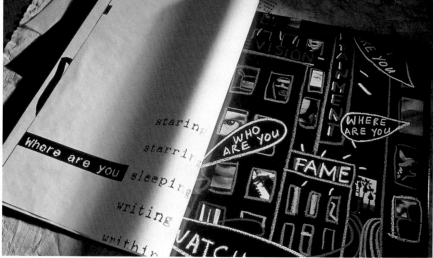

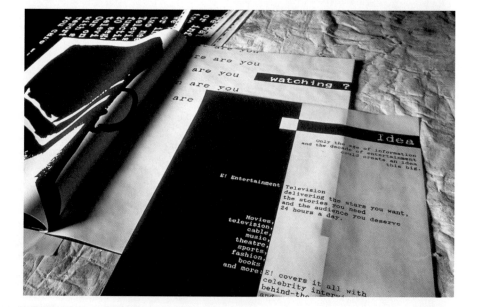

Figure 4-27

Sales Portfolio for E!

Design firm: Vrontikis Design Office,
Los Angeles, CA

Designer: Petrula Vrontikis

Illustrators: Huntley & Muir

Writer: Jonas Livingston

Client: E! Entertainment Television

© E! Entertainment Television

*The purpose of this sales kit was to present the
concept of E! Entertainment Television to local cable
operations around the country. The design reflected
a layering of words and images being shown 24
hours a day. The channel was to be exciting and
progressive. The typography was created by using
plain "word processor" type run through a fax
machine, then enlarged to show its roughness. Basic
design principles such as contrast in color and
contrast in size were key to the success of the
layouts.*
— Petrula Vrontikis, Owner, Vrontikis Design Office

Type and expression

In addition to understanding the fundamentals of design and how they relate specifically to designing with type, it is essential to understand how type can be used creatively and expressively. The following design concepts use type in a structural way in order to express meaning. The ampersand (symbol for the word "and") inside the letter "o" and the word "child" inside the ampersand symbolize a fetus in the womb. This seems like a natural solution once we see how Herb Lubalin did it (Figure 4-28). The design concept, the spacing, the positive and negative space, and the typeface all lend to the success of this design. Here are two creative typographic design solutions by Alexander Isley Inc. (Figure 4-29). The Mesa Grill logo is a play on the word "mesa" which means "flat-topped mountain." In the *Spy* Chappaquiddick spread

Figure 4-28
Logo, "Mother & Child"
Designer: Herb Lubalin
The Design Collection at the Herb Lubalin Study Center, The Cooper Union, New York, NY
Courtesy of the Lubalin Family

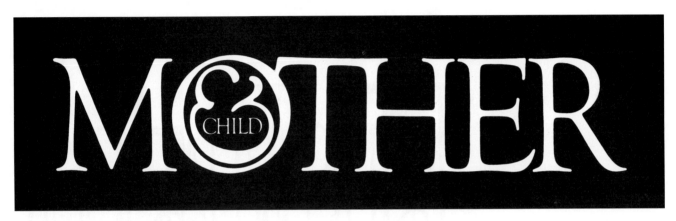

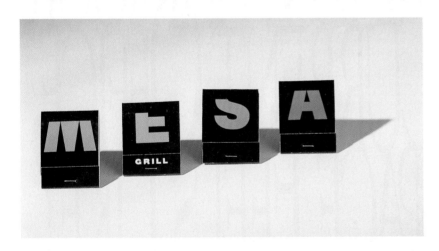

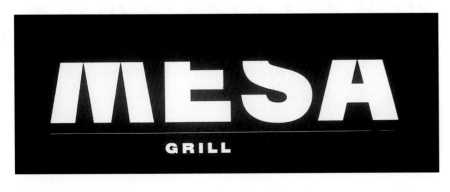

Figure 4-29
Mesa Grill Logo
Design firm: Alexander Isley Inc., Redding, CT
Client: Mesa Grill

GRAPHIC DESIGN SOLUTIONS

Figure 4-30
"Chappaquiddick" Spread, *Spy* Magazine
Design firm: Alexander Isley Inc., Redding, CT
Client: *Spy* Magazine

What ever happened to Mary Jo Kopechne's five girlfriends who had the good fortune *not* to drive off with Ted Kennedy? See page 37. Why has there never been a best-seller or a movie or even a television docudrama about Chappaquiddick? See page 40. In the age of Everythingscam and Whatevergate, how, after 18 years, can the Chappaquiddick cover-up remain so airtight? Good question. And why won't anybody publish an impressive new investigative book that for once gets a Kennedy cousin and Chappaquiddick witness *on the record* about the incident? Read this article.

CHAPPAQUIDDICK

The Unsold Story

BY TAD FRIEND

EARLY IN THE MORNING of July 19, 1969, after attending an intimate party of male political cronies and female political aides, Senator Edward Kennedy drove his Oldsmobile off Chappaquiddick Island's Dyke Bridge and into Poucha Pond. His passenger, Mary Jo Kopechne, drowned.

This is not exactly news. Most of us recall that after a considerable public rumpus, Senator Kennedy took the extraordinary step of going on television to explain—altogether unconvincingly—this latest Kennedy tragedy. Kennedy pleaded guilty to leaving the scene of an accident after causing personal injury and later promised to consider resigning his Senate seat (*Nahhh*, he evidently decided, instead going on to win reelection three times).

After receiving a two-month suspended sentence, he clammed up. And so did everyone else in a position to fill in some of the blanks—the five women at the party who did not drown in Ted Kennedy's car, the five men at the party who did not swim away from a submerged Oldsmobile and then lie about it. So the inquiries have blundered along without Kennedy's help, or the help of his loyal friends at the party. And so, naturally, strange Chappaquiddick theories abound. Kennedy was driving; Kennedy wasn't driving; Kennedy murdered Kopechne because she was pregnant with his child, and jumped out of the moving car in the nick of time; and so on.

What is news—or should be—is that Joe Gargan, a cousin of Kennedy's who spent much of that fatal evening with the senator, finally did unburden himself of his Chappaquid-

Figure 4-31
Ad
Agency: Williams & Rockwood, Salt Lake City, UT
Creative director: Scott Rockwood
Art director: Bonnie Caldwell
Writer: Chris Drysdale
Client: The Triad Center

We wrote this ad in an office the size of a shoe box on 2nd South in Salt Lake City. It went on to win many awards. But what pleased us most was that the ad was so effective. The Triad Center reached 95% occupancy in about a year. Just working on the ad had us convinced. We moved to the Triad Center six months later.
— Williams & Rockwood

IS THIS WHAT YOUR CURRENT OFFICE SPACE FEELS LIKE?

Everyone knows a downtown office is good for business. Too bad it's also good for wall-to-wall buildings, crowded parking, and plant life of the plastic and silk varieties.

At Triad Center, things are different. No other downtown location provides you with so much fresh air, green grass, earth, sky and water. It's like a mini-oasis in the concrete jungle.

Best of all, the price at Triad Center gives you room to breathe as well. Inspite of the beautifully-manicured grounds, $11 a square foot buys a level of prestige worth $18-$20 a few blocks east.

To see how Triad Center can improve your working environment, call 575-5050.

Chris Matthews & ASSOCIATES

Figure 4-32
"The Diva Is Dismissed," Poster
The Public Theater Season Posters
Design firm: Pentagram Design, New York, NY
Partner/Designer: Paula Scher
Designers: Ron Louie, Lisa Mazur, Jane Mella
Photographer: Teresa Lizotte
Client: Public Theatre, NY
When Joseph Papp was producer at the Public Theater, Paul Davis produced a memorable series of illustrated posters which set the standard for theater promotion for nearly a decade. In keeping with the expanded vision of new producer George C. Wolfe, a new identity and promotional graphics program have been developed to reflect street typography: active, unconventional, and graffiti-like. These posters are based on juxtapositions of photography and type.

The Diva Is Dismissed was Jennifer Lewis's one-woman show.

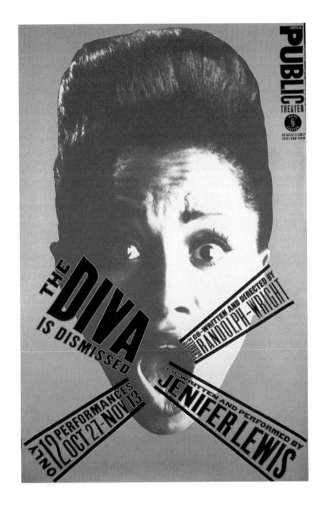

(Figure 4-30), to represent a tragic drowning, the words are shown sinking into water.

Used in conjunction with a visual, type is often the verbal part of the design message. However, type can also be the visual itself and can express the entire message. By designing the type to look cramped, Bonnie Caldwell expresses meaning through this typographic design (Figure 4-31). When a still medium like print can evoke the idea of sound it is very exciting. Paula Scher designed the typography in this poster for the Public Theatre to create the illusion of sound (Figure 4-32).

The open spacing of the letters and the position of "Rock and Roll" in this spread, designed by Bradbury Thompson, moves our eyes across the page in syncopation with the circular visuals (Figure 4-33). The remaining type acts like accents, enhancing the rhythm. The rhythm is further enhanced by the

Figure 4-33
Interior spread from Westvaco "Inspirations 210," 1958
Designer: Bradbury Thompson
Copyright by Westvaco Corporation, New York, NY

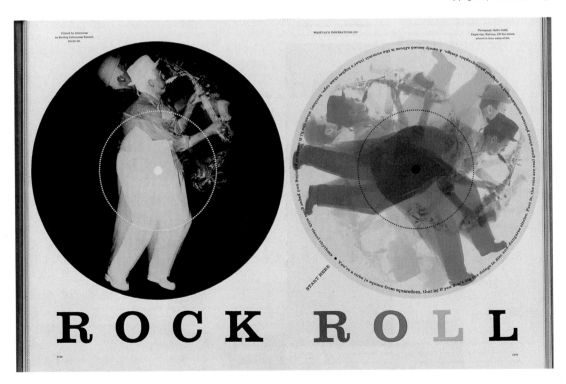

This graphic design puts forth the illusion of color in motion as the saxophonist comes alive on the whirling record. Process printing plates were not employed, as just one halftone plate was printed in three process inks and on three different angles to avoid a moire pattern.
—Karen M. Elder, Manager, Public Relations, Westvaco Corp.

illusion of motion. Letters represent spoken sounds, and in this poster for "Project Read", type is used to evoke the sound of someone learning to read (Figure 4-34).

Martin Holloway uses custom lettering and low contrast (created with a technical pen on graph paper) to express the rustic meaning of the words "Country Things" (Figure 4-35). In Jennifer Morla's "AIGA: Environmental Awareness" poster (Figure 4-36), Morla uses type as a vehicle to express subtle shades of meaning that go beyond the written expression of the message.

Designing with type

Perhaps the most difficult part of any graphic design education is leaning to design with type. Maybe it is because we tend to be literal. We concentrate on the literal meaning of words, and give their form short shrift. In order to design with type, you must consider four main points:

GRAPHIC DESIGN SOLUTIONS

There's...nuh...thing

quite...as...re...ward

ing...as...hear....ing

an...ad...dult...read

for.....the........vair

ree......first....time.

Teach an adult illiterate how to read. You don't need any special skills or experience. All you need is the desire to make a difference in someone's life. Call us at 491-8160 to find out how you can become a volunteer teacher. Only then will you discover the true joys of reading. PROJECT READ

Figure 4-34
Poster for "Project Read"
Design firm: The Ralphus Group, Atlanta, GA
Art director: Joe Paprocki
Writer: Rich Paschall
Client: Project Read

Figure 4-35

"Country Things"

Design firm: Martin Holloway Graphic Design, Warren, NJ

Lettering/Designer: Martin Holloway

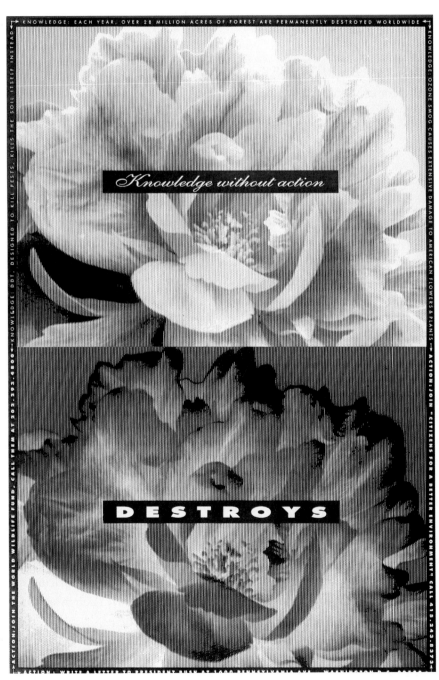

Figure 4-36

San Francisco AIGA: Environmental Poster

Design firm: Morla Design, San Francisco, CA

Art director: Jennifer Morla

Designers: Jennifer Morla, Jeanette Arambu

Client: San Francisco AIGA

Figure 4-37

Comparison of
Letterforms in Various
Typefaces

1. type as form,

2. type as a direct message — its primary meaning,

3. the secondary meaning (or connotation) of type, and

4. graphic impact.

Form

Let's say you are visiting a foreign country and the national language uses a different alphabet than yours. You might be more inclined to view the characters of that alphabet as forms since you cannot read them (see Figure 4-20). Pretend you cannot read English, and look at the letterforms as pure form. When we consider letterforms as positive and negative forms, we will be more aware of the visual interest they create. The stronger the positive and negative space relationships, the more dynamic and aesthetically pleasing the design.

Each letterform has distinguishing characteristics. Some letters are closed forms, like the "O" and "B," and some letters are open forms, like the "E" and "M." The same letterform can vary in form depending on the typeface, like this lowercase "g" in "Times" and this lowercase "g" in "Helvetica." Have you ever noticed the variations of the form of the letter "O" from typeface to typeface? For example, the "O" in some typefaces is circular and in others it is oval (Figure 4-37). You may want to compare letterforms in a few classic typefaces, like Bodoni, Garamond, Century Old Style, Futura, Times Roman, and Univers. (In this case, classic means a typeface that has become a standard because of its beauty, grace, and effectiveness.) It is a great idea to be so familiar with at least two classic typefaces that you know every curve and angle by heart.

Each letterform is made up of positive and negative forms. The strokes of the letterform are the positive forms (sometimes just called forms), and the spatial areas created and shaped by the letterform are the negative forms (or counterforms). When two letterforms are next to one another, negative forms are created in between them, which are also called counterforms. Try to be as sensitive as possible to the forms of each letter and the counterforms between them. Remember that the negative forms are as important as the positive forms. In other words, interletter spacing is a crucial aesthetic consideration. Leading must also be considered. You must have enough space for ascenders and descenders and consider the negative space between lines of type.

Direct message

Both today and in the past, designers utilize and have utilized letterforms as purely decorative forms, ignoring their symbolic content. Most often, however, type is meant to be read. For the viewer to read display or text type and get the direct message, you must consider legibility and emphasis. Legibility contributes to readability and is the quality that makes type easily comprehensible. Many things contribute to readability: letterspacing, word spacing, line spacing, line breaks, line length, typeface, type size, width, weight, capitals and lowercase letters, type alignment, italics, and color. Let's examine some of these.

Just as letterspacing, word spacing, and line spacing (or leading) are crucial to the creation of interesting and harmonious positive and negative form relationships, they also are vital to readability. Too much interletter, interword, and interline spacing may detract from readability; conversely, too little space may make words difficult to read. As stated earlier, you must not trust automatic spacing — always make adjustments. Also, uneven letter spacing and word spacing may cause unwanted pauses or interruptions that make something more difficult to read. Here is a test: read the words aloud and see if there are any unwanted pauses or spaces. Similarly, if the line length is too long or too short, it will detract from readability. When designing display or text type, always ask yourself, "Can I read it with ease?"

There are many theories and rules of thumb about spacing, aesthetics, and readability. For example, some designers say that if you have open letterspacing, the word and line spacing should be open. Conversely, if you have tight letterspacing, the word and line spacing should be tight as well. Consistency is important. Of course, other factors come into play, such as the typeface, type size, and weight. Try to read several books about designing with type in order to learn as many points of view as possible. Refer to the bibliography of books about type.

Obviously, when considering spacing, much depends upon the typeface(s) you are using and the type sizes, weights, and widths. Some typefaces seem to lend themselves to more open spacing because of their form. Some lend themselves to tight spacing. Study type specimens of display and text type to get a "feel" or "eye" for typefaces, weights, and widths. Some things to consider:

- Faces that are too light or too heavy may be difficult to read, especially in smaller sizes.

- Typefaces with too much thick/thin contrast may be difficult to read if they are set too small — the thin strokes may seem to disappear.

- Condensed or expanded letters are more difficult to read because the forms of the letters change. You may, however, choose to use a condensed width, if, for example, you are designing a narrow column of type.

- Larger sizes require tighter spacing than smaller sizes. If the type is a display size, you will have to space it differently than a text size.

- In both display and text sizes, type set in all capitals is generally more difficult to read. A combination of capitals and lowercase letters provides maximum readability.

- In general, type that is flush left, ragged right is easiest to read. That does not mean you should not use any other type alignment. Base your decision on several factors: the type size, the line length, the leading, the meaning, the audience, and the amount of type. Reading a short message in flush right, ragged left is not too difficult.

- Where you break the lines of type depends on two basic factors: aesthetics (appearance) and editorial meaning. Line breaks should be aesthetically pleasing. Break lines in natural places to enhance meaning. Indentations and leading between paragraphs also enhance legibility. Paragraphs that are too long are difficult to read. The use of initial capitals also can enhance readability.

- Remember: Italics are best used for emphasis, rather than for large blocks of text, which may be difficult to read.

- When the lines in a paragraph are too long or too short, they are hard to read. Around forty-five characters to a line is usually comfortable to read.

Color also is an important consideration. When a lot of text is involved, most designers choose black type on white or light backgrounds. The more value contrast between type and background, the greater the legibility. If the type and background colors are similar in value, the type will be difficult to read. Highly saturated colors may interfere with legibility as well.

We use **emphasis** to determine the importance of information in a design. Viewers tend to read headings first, like titles or headlines, then subheadings, and finally other typographic elements such as paragraph headings, pull quotes (quotes pulled from the text and enlarged in size), type in panels or feature boxes, captions, and text or body copy. The designer must design the typography into a visual hierarchy.

Let's take an example. If you are designing a book cover, you will have to decide whether you want the viewer to read the book title first or the author's name first. If the author is well known, someone like John Grisham, you may want the viewer to see the author's name first. Of course, you would want to emphasize Grisham because John is a common name — or give the first and last name equal emphasis, but you certainly would not emphasize John. In a more difficult layout, like a newsletter, you must use type size, weight, and width to control the order in which the viewer reads the information. Elements like initial caps, paragraph indents, rules, and icons will aid in establishing emphasis. Contrasts in size and weight will lead the eye from one element to the next. We tend to read larger, darker elements first.

Here is a tip: When designing something with a lot of information, sort out the information on index cards or individual sheets of paper. Type or print out the heading one one card, the subheading on another card, the date of the event on another card, and so on. Stack the cards in order of importance. This will help you to establish tiers of information.

Secondary meaning

Let's say you have to design the following sentence: "It looks like a storm is brewing." Which typeface would you choose to enhance the direct message? What size, weight, and width? Would color enhance the meaning and if so, which colors? The direct message of the sentence is the primary meaning, the denotation. The way the type is designed suggests a secondary meaning, a connotation.

Each classification of typefaces has a different spirit or "personality," and the differences among the typefaces within each category give each typeface an individual spirit as well. Typefaces that defy categorization, and there are many, have individual spirits. Sometimes it is easier to determine the spirit of a novelty typeface because it is more illustrative.

In addition to having personality, type has a voice. Type can scream or whisper. As you will see later in this chapter, type can communicate the same way as the spoken word. Consider the typeface, size, scale, and position in the layout when determining the typography's "voice."

Here is a standard example of secondary meaning. Most designers consider Old Style and Transitional typefaces more "conservative" or "serious" than Sans Serif faces. Perhaps it is because Old Style is based on Roman and 15th century humanistic writing. Perhaps it is because Sans Serif typefaces are from the modern era and considered newer. The first Sans Serif typestyle appeared in the early 19th century, long after the initial Old Style typestyle appeared in the late 15th century. It is important to study the history and origins of typefaces so you can make informed decisions.

Every typographic element (weight, width, stress, thick/thin contrast, size) and design element (color, texture, value) contributes to the secondary meaning. Whether the type is heavy or light, Roman or italic, black or red, carries meaning beyond the direct message. For example, picture the words "heavily armored combat vehicle" in your mind's eye. Most people would probably think of Sans Serif heavy capitals. Using a light script would suggest a meaning contrast to the direct message. If the designer did use a light script, he or she would be suggesting an ironic meaning.

In order to become sensitive to the secondary meaning of typography, study the work of successful designers like the ones in this text. Ask yourself why they choose the typefaces, weights, and widths they did to solve their design problems. Try to figure out the relationship between the primary and secondary meanings in their works.

Graphic impact

You are designing with type and you have considered form, the direct message, and the secondary meaning. Now, how does it look? Yes, after all that, you have to consider aesthetics — the underlying beauty of the typography. Today, we use the term "beauty" loosely. In reference to contemporary graphic design, and especially to typography, the terms "aesthetically pleasing" and "beauty" seem archaic. What is beautiful to one designer is ugly to another. Some contemporary designers believe typography must be legible, balanced, and harmonious, while randomness, obscured type, and disjointed forms appeal to other contemporary designers. Graphic impact is a better term.

One way to determine the graphic impact of a typographic solution is to measure the "texture" or "color" of the solution. The terms texture and color have different meanings here. Some designers use these terms to refer to the tonal quality of type. The texture or color of typography is established by the spacing of letters, words, and lines, by the characteristics of the typeface, the pattern created by the letterforms, the contrast of Roman to italic, bold to light, and the variations in typefaces, column widths, and alignment. Here is a tip: Stand back and squint at typography to get a sense of its "lightness or darkness," its tonal quality.

Another way to measure graphic impact is to determine the appropriateness of the style for the client, the message, and the audience. Which style is appropriate for a serious message? Are certain styles appropriate for certain types of clients? Would you design in the same style for a young audience and for a mature audience? The style you choose should be appropriate for the client, message and audience. You would not design an ad for MTV the same way you would design an ad for a commercial bank; they are different clients with different needs and probably different audiences.

Some designers are very aware of trends in music, fashion, art, and of course, in graphic design. Typefaces can be trendy as well. Trendy typefaces are difficult to use because their design can overpower the message. There are times when certain typefaces are more popular; everyone seems to be using one or two faces. Then a typeface can get played out; it loses efficacy because of overuse. There are many novelty or decorative typefaces that students seem to be attracted to but should avoid because they are difficult to design with; it is difficult to mix them with other typefaces, and they usually do not lend themselves to legibility. They tend to take over a design.

Years ago, most designers would have thought twice about using more than two typefaces in the same design solution. Although many good designers still would not use more than two, others believe using more can have great graphic impact. Try this experiment to become sensitive to mixing typefaces and using more than one typeface: Find an advertisement or any other design with a lot of type, both display and text. First, redesign the ad using only one typeface, one size, and one weight. Print out a copy and keep it as a control. Then change the heading to another typeface. Next, change the size of the heading and subheadings. Try various combinations. Experimenting with type is one of the best ways to learn about it.

Graphic design students usually take at least two courses in typography and then spend their careers trying to master designing with type. Entire books are devoted to type and to designing with type. Consider this chapter a point of departure for further study.

TIPS FROM DESIGNERS

Alexander Isley, president,
Alexander Isley Design,
Redding, Connecticut
"Read the manuscript. It is surprising how easy it becomes to design when you understand what the writer's message is."

Thomas Courtenay Ema,
Ema Design Inc.,
Denver, Colorado
Designing with type in general
"For me, designing with type is one of the most important and pleasurable aspects of graphic design. If design were visual music and layout, composition and grids are the structural elements of the music, then typographic elements are the notes. With these notes, an accomplished musician can write beautiful music. It is possible to create visual music that can express any emotion or communicate any ideas."

Designing with type and visuals
"To fully express a visual communications message with type and image the designer must pay particular attention to the relationship between those two elements. The most effective design solutions exhibit a unique connection between the type and the visual that communicates something more than either one alone. This connection can sometimes be made by letting the type reflect or contrast the form, composition, pattern, or color of the visual image. Remember that the type and image are all individual pieces of a whole design that should not be thought of alone, but in terms of how they work together to create the overall design and visual communications message."

Designing with display type
"One of the biggest traps for a student of typography to fall into in selecting and designing with type is giving in to the use of special display faces to communicate different ideas. If one truly understands the method of creating good typography, wonderful design solutions can be created with a limited group of

proper type families such as Garamond No. 3, Helvetica, univers, Times Roman, and Bodoni. If we use a musical analogy it is like playing different instruments. Do not try to play a hundred different instruments; learn to play a few instruments well!"

Tom Geismar,
Chermayeff & Geismar Inc.,
New York, New York

"Typography forms the basis of almost all our design work. It is the way we express ourselves. It is the cornerstone of our practice."

Martin Holloway,
Professor of Visual Communications, Chairperson, Department of Design
Kean University, New Jersey

"There are at least two qualities that are always present in successful typographic design.

First is form: type should work in a purely formal manner. All visual elements, including letterforms, possess design properties such as line, texture, shape, and mass. These elements are configured into compositions — the arrangement of elements to achieve visual equilibrium.

Second is function: type should work as the visual counterpart of language. In spoken communications, factors such as syntax, inflection, and the emotional quality of the voice are inseparable from message content in terms of the impact the spoken word has upon the listener. Similarly, the selection of typeface, style, and size — and their placement relative to other visual elements — is equally inseparable from message content."

Mike Quon,
Mike Quon Design Office,
New York, New York

- *"So often, people get so involved in the non-readability of things, ways to cover up words. Type is meant to be read. If we are not encouraging reading, we are missing one of the better ways to communicate."*

- *"Do it the way you want to — trust your first instinct, then do it several more ways. Then put them all in front of you and compare them. The more successful solution will stand out. Develop a rationale; be able to explain why one is better than another."*

- *"The rules about designing with type are being broken. You have to find your own style and vision — what feels right for you."*

- *"I like headlines — because people look something over in seconds."*

- *"There is a lot of entertainment value in what we do."*

- *"There is a blur between the lines of good typography and bad typography. It is hard to say what is good or bad because it is a value judgement. Design and beauty are in the eye of the beholder, but there are different styles that people like. There is no one way, however — make it tasteful, simple, and not too hard to read."*

Chapter 4 Designing With Type

comments

One of the greatest challenges facing a designer is to organize typographic elements into a visual hierarchy. Establishing a visual hierarchy is central to clear communication. The designer must order elements so the reader can comprehend the message.

EXERCISE 4-1
Design your name

- Get a book of typefaces.
- Write down two or three adjectives that describe your personality or spirit.
- Find typefaces that express your personality or spirit.
- Design your first and last name. Middle name is optional.
- Give careful consideration to the positive and negative forms in between the letters and the spacing between the letters.

PROJECT 4-1
Design a poster entitled "Taking a Stand"

Step I

- Research the civil rights movement in the United States.
- Write an objectives statement. Define the purpose and function of the poster, the audience, and the information to be communicated. On an index card, in one sentence, write the objective of this poster.
- Find typefaces that express the spirit of the subject.

Step II

- Design a poster for a public television program entitled "Taking a Stand." The program is a documentary on the civil rights movement in the United States.
- The poster should include the title and television station or channel. Optional: date and time of broadcast.
- Your solution should be typographic, with no visuals.
- Produce at least twenty sketches.

Step III

- Produce at least two roughs.
- Use a vertical format.
- Be sure to establish emphasis.
- Carefully examine your spacing between letters, among words, and between lines of type.

Step IV

- Create a comp.
- The poster should be no larger than 18″ x 24″.

Presentation

Present the comp either matted or mounted with a 2″ border all around.

comments

It is important to remember that type can be the visual! You do not have to rely on photographs or illustrations to grab the audience's attention.

EXERCISE 4-2
Expressive typography

- Look through a few magazines.

- Find typefaces used in articles or advertisements that express the following: light-heartedness, seriousness, humor.

- Find typefaces that you think are classics, retro (reminiscent of an era gone by), and trendy.

- Defend your choices. (See Figure 4-38.)

PROJECT 4-2
All type

Step I

- Design a poster or invitation for a natural history exhibition or foreign film festival.

- The design solution should be solely typographic with no visuals or visual accents.

- Produce at least twenty sketches.

Step II

- Produce at least two roughs.

- Use a vertical format.

- Carefully examine letterspacing, word spacing, and line spacing.

Step III

- Create a comp.

- The invitation should be 4″ x 6″; the poster should be no larger than 18″ x 24″.

Presentation

Present the comp either matted or mounted with a 2″ border all around.

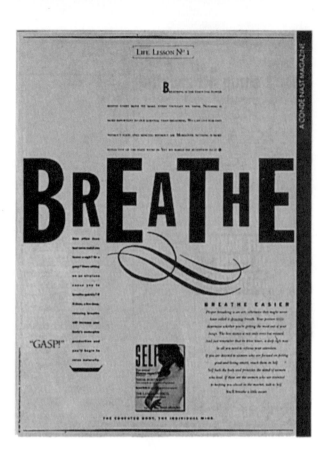

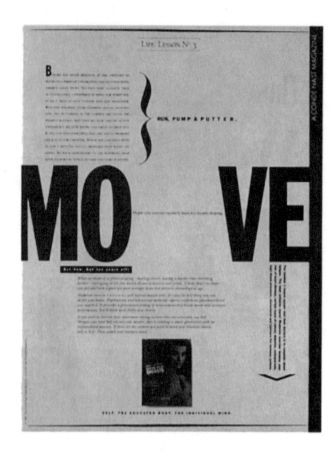

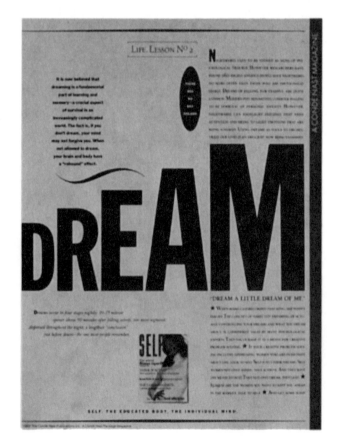

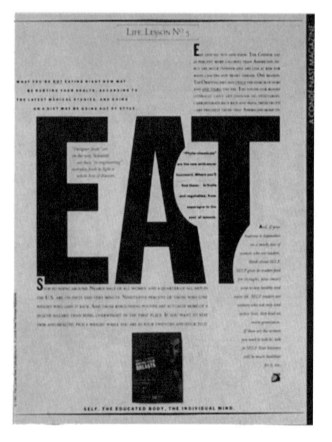

Figure 4-38
Series of Trade Ads for *Self* Magazine
Design firm: The Valentine Group Inc., New York, NY
Art director/Designer: Robert Valentine
Designers: Robert Valentine, Tracy Brennan
Writers: Shari Sims, Dean Weller
Courtesy of Condé Nast Publications

chapter

5

Layout

OBJECTIVES

■ understanding the fundamental principles governing the layout of a page

■ becoming familiar with the grid as a layout device

■ being able to construct and design simple grids

Layout

If you have ever arranged furniture in a room, then you know how complicated a process layout can be. There are several goals — to fit the elements into a limited space, to arrange them so that they are functional and accessible, and to place them attractively. Designing a page is very similar. It is about arrangement. Layout is about arranging type and visuals on two-dimensional surfaces so all information is legible, clear and attractive. A **layout**, therefore, is the arrangement of type and visuals on a printed or electronic page.

How do you design a successful layout? As always, you begin by asking yourself a few questions: Who will be looking at or reading this? What style is appropriate for this audience? What is the purpose of the design? What information or message has to be communicated? Where will it be seen? Once you have answered these questions, you can begin to produce thumbnail sketches in order to consider various layouts.

There are innumerable ways to arrange elements on a page. Once you have considered the previous questions and begin sketching, there are some basic factors to keep in mind. The most important design principles governing layout are emphasis (focal point and visual hierarchy), unity, and balance. Although they all have to be considered as you work, let's go through them one by one.

Emphasis. When you establish a focal point, you create a main area of interest on the page. Choosing which element should be the focal point, whether it is type or a visual, should be based on several factors:

■ what primary message or information needs to be communicated

■ which element is the most interesting

■ which element is most important

For example, it is most likely that either the main visual component or the main verbal message (type) would be the focal point. It is unlikely that a secondary or tertiary point of information,

such as the time of an event or a zip code, would be the focal point. In a layout the focal point can be established in the following ways:

- make it the brightest

- make it a different color, create a contrast in colors

- move it in a different direction, contrast of position/direction

- make it the biggest

- make it a different value, create value contrast

- make it a different texture, create a contrast of textures

- have all other elements lead to it

- make it a different shape

- isolate it

- make it dull if everything else is bright

- make it sharp if everything else is hazy

- position it carefully

Using a strong, saturated color for the title of this book, Steven Brower attracts the audience's attention (Figure 5-1). In addition to the color of the title, its position on the page clearly makes it the focal point of this book jacket design.

Figure 5-1
The Transparent Society by David Brin
Design firm: Steven Brower Design, New York, NY
Designer: Steven Brower
In contrast I gave this jacket a high tech ominous feel to convey the warning within,
that Big Brother is here and technology has made it possible.
— Steven Brower

Even though this high contrast, startling visual grabs your attention, on this cover, the fuchsia circle containing the type is the focal pint because of its color and difference from the other visuals on the page (Figure 5-2).

Without a doubt, the most important design principle for a student to keep in mind is visual hierarchy, which means arranging elements according to emphasis. Establishing a visual hierarchy sets a priority order for all the information in design. Usually, any graphic design piece has several elements, such as a title, subtitle, text, and visuals. You must decide which elements take priority over other elements. This is crucial. You must ask yourself: What should the viewer see first? What should the viewer see second? What should the viewer see third? And so on.

The position of elements on the page, the relationship of one element to another, and factors including size, value, color, and visual weight all must be considered. Here are some general points to keep in mind when establishing visual hierarchy:

Figure 5-2
Grubman Animals
Design firm:
Liska + Associates Inc., Chicago/New York
Art director: Steve Liska
Designers: Kim Fry, Andrea Wener
Photography: Steve Grubman
Client: Grubman Photography

As part of our continued marketing efforts for this photography studio, Liska + Associates designed this brochure to demonstrate Grubman Photography's expertise at animal photography.

- position: because we read English from left to right and we begin to read at the top of a page, we naturally tend to move our eyes the same way when looking at a design

- size: we tend to look at bigger things first and smaller things last

- color: we tend to be attracted to brighter colors but also to look at the color that stands out or is different from the surrounding colors

- value: a gradation of values, moving from high contrast to low contrast, can establish a flow from one element to the next

- visual weight: we tend to look at "heavier" elements first

Sometimes designers have to arrange a great number of elements on a page. Often, a client insists that a good deal of text and visuals be included, or a designer may choose to include multiple elements. In either case, the designer must be up to the challenge. In this advertisement for the Container Corporation of America, Herbert Bayer organizes a lot of text by encapsulating it in shapes that flow from one to the other (Figure 5-3). The shapes create a visual vertical axis; visuals and text are balanced on either side.

Figure 5-3
Advertisement, "Great Ideas of Western Man: Ralph Waldo Emerson," 1952
Designer: Herbert Bayer
Client: Container Corporation of America
Collection: Denver Art Museum, Herbert Bayer Collection and Archive, Denver, CO

Figure 5-4

Potlach #4 "Situation Critical" - Now Is Not the Time to Compromise

Design firm:

Vrontikis Design Office, Los Angeles, CA

Creative director/Designer: Petrula Vrontikis

Photographers: Tim Jones, Everard Williams, Jr., Paul Ottengheime, Abrahs/Lacagnina

Writer: Victoria Branch

Client: The Kuester Group/Potlach Corporation

© Potlach Corporation

To promote Potlach's commitment to quality and creativity, the company asked six nationally recognized designers to provide personal expressions on one of their grades of paper.

Vrontikis and Branch chose to illustrate stream-of-consciousness monologues of select people in times of compromise.

Figure 5-5

Spread from a New Edition of *Aesop's Fables*, Artwork created in 1947

Design firm: Milton Glaser, Inc., New York, NY

Artwork: John Hedjuk, architect

Publisher: Rizzoli International Publications, Inc.

The Four Oxen and the Lion

A LION used to prowl about a field in which four Oxen used to dwell. Many a time he tried to attack them; but whenever he came near, they turned their tails to one another, so that whichever way he approached, he was met by the horns of one of them.

At last, however, the Oxen fell a-quarreling among themselves, and each went off to pasture alone in a separate corner of the field. Then the Lion attacked them one by one and soon made an end of all four.

United we stand, divided we fall.

Unity. In order for a layout to be successful, it must hold together. It must be unified. There are many ways to achieve unity. Four of the most important devices are correspondence, alignment, flow, and the grid.

When you repeat an element such as color, a visual, shape, texture, or establish a style, you establish a visual connection or correspondence among the elements.

Petrula Vrontikis uses color and alignment to establish unity in this promotional piece for Potlach Corporation (Figure 5-4). Visual connections can be made between and among elements, shapes, and objects when their edges or axes line up with one another. The eye easily picks up these relationships and makes connections among the forms.

Balance. We take comfort in balanced design. When a design is imbalanced it will look uneven, as though something about it is not right. Balance is an equal distribution of weight in a layout. Like visual hierarchy, it is crucial to a successful layout. To balance a design, you must consider visual weight, position, and arrangement.

Try a little experiment using this spread, designed by Milton Glaser, from an edition of *Aesop's Fables* (Figure 5-5). Cover the graphic element (artwork) in the lower right-hand corner. You'll notice that the layout is no longer balanced. Similarly, if you cover one of the oval portraits on the upper left of this imaginative poster design, the right-hand side becomes heavier (Figure 5-6). Each element in this poster design is dependent upon the other; each element was thoughtfully positioned. This demonstrates just how important the arrangement of every element is to a successful layout.

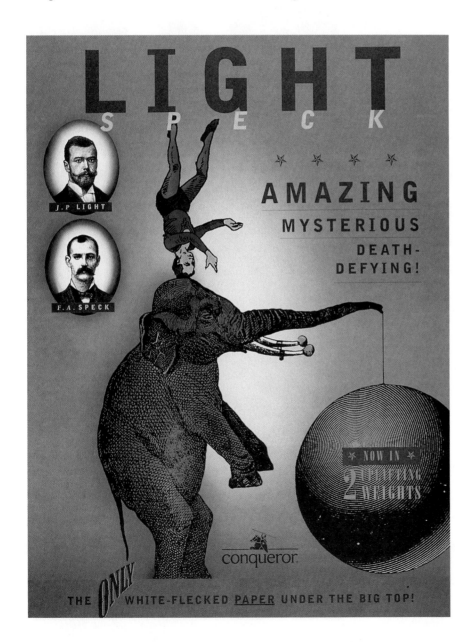

Figure 5-6
Conqueror LightSpeck Poster
Design firm: Viva Dolan Communications and Design Inc., Toronto, Ontario, Canada
Designer/Illustrator: Frank Viva
Writer: Doug Dolan
Client: Conqueror Fine Papers

This poster was created to introduce Conqueror LightSpeck, a new range of pale-flecked paper, to the North American market. The chief design goal was to achieve a memorable visual impact that would carry through in the accompanying swatchbook and other collateral, giving this unique product a distinctive image while clearly positioning it as part of the overall Conqueror range.

Figure 5-7

Fritz Gottschalk Poster

Design firm: Ema Design Inc., Denver, CO

Art director/Designer: Thomas C. Ema

Client: Art Directors' Club of Denver, CO

Having studied with Gottschalk in 1984, Ema arranged for his mentor to speak to the Art Directors' Club of Denver. Ema used international passport stamps as the announcement's random design elements — and later learned that Gottschalk's topic was his design of the new Swiss passport!

— Thomas C. Ema, Owner, Ema Design

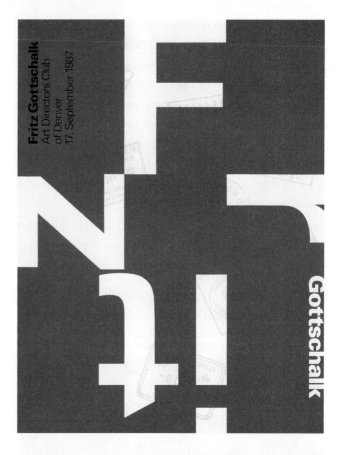

Figure 5-8

NienKamper, Unesco Chair Brochure (inside spread)

Design firm: Teikna Graphic Design Inc., Toronto, Canada

Art director/Designer: Claudia Neri

Client: NienKamper

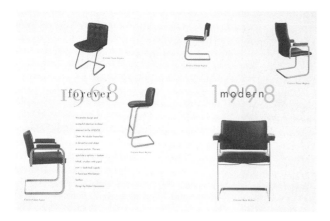

Figure5-9

Our Living World Poster

Design firm: Sommese Design, State College, PA

Art director/Designer/Illustrator: Lanny Sommese

Client: Penn State College of Agriculture

The poster was sent to all of the high schools, middle schools, and elementary schools in Pennsylvania. The intent was to broaden awareness in the students concerning the interdependence of all the living things in Pennsylvania. All the imagery — insects, plants and animals — are indigenous to the state. The Tree of Life aspect of image with mother nature in the center seemed appropriate and essential to image the use of the positive/negative. The stylistic approach, I felt, promoted the interdependence idea. Images were drawn or found and then pasted into the tree by hand. (Can you find them all?) The search was intended to appeal to the young audience.

— Lanny Sommese

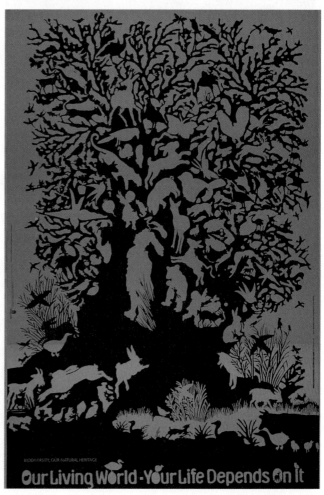

The term "format" has two related meanings: the actual thing or substrate you start out with — like a poster or brochure — and the limits of that substrate, such as the edges and overall shape of a poster. Never forget a primary player in any layout is format. All elements respond to the shape of the page. Each letter of the name "Fritz" touches the edges of the format in this poster design announcing Fritz Gottschalk's lecture at the Art Directors' Club of Denver (Figure 5-7). The designer, Thomas C. Ema, creates dynamic positive and negative shape relationships between the typographic elements and the format. We start with the letter "F" and move clockwise, reading the name and the other information.

Here are three very different examples of using the page or format as an active player in a design (Figures 5-8 through 5-10). The positioning of the chairs on this layout for the Unesco Brochure creates a unique layout (Figure 5-8). Sommese's whimsical figure/ground designs make all the space active in this poster (Figure 5-9). Using ancient images of currency, Liska + Associates designs powerful spreads, that look much larger than their physical size (8″ x 5″), because of the layout design, scale (size of visuals to the format), and resulting positive and negative space (Figure 5-10).

All the principles of graphic design apply to layouts. Once you feel comfortable with the fundamentals of graphic design, you can begin to lay out a single page. Many graphic designers work on multi-page designs, such as books, magazines, newspapers, brochures, newsletters, and reports. This is called editorial or publication design. When a designer has to maintain balance, emphasis, rhythm and unity throughout a series of consecutive pages, the task becomes very difficult. For this reason, most designers use a grid.

Figure 5-10
The AIGA Salary Survey of Graphic Designers
Design firm: Liska + Associates, Inc. Chicago/New York
Art director: Steve Liska
Designer: Susanna Barrett
Photography: Frederik Lieberath
Copywriters: Ric Grefe, Roz Goldfarb, Jessica Goldfarb
Client: AIGA, National Chapter
The AIGA produced a survey on standards of compensation within the graphic design field. Liska + Associates designed a booklet to make this information available to AIGA members and non-members interested in comparing salary packages. The design includes images of currencies from other cultures, reinforcing the concept that compensation is more than a dollar amount and should be considered a whole package with a relative value.

The grid

Open up a magazine. How many columns do you see? Are there photographs on the page? Is there a title and subtitle? If so, how are they organized? All the elements, display and text type, and visuals (illustrations, graphics and photographs), on the pages of a magazine, book or newspaper are almost always organized on a grid. A **grid** is a guide — a modular compositional structure made up of verticals and horizontals that divide a format into columns and margins. Note: "grid" is a traditional layout term. When working in some electronic page design software programs, the term used is "master page," or "template." Margins are the spaces around the type and other design elements. A grid's proportions and spaces provide a consistent visual appearance for a design; a grid underlies all the design elements. It is a way for a designer to establish unity for either a single page or multi-page format.

Your assignment, strategy, concept, and budget will help you determine whether you will be designing a single or multi-page piece, what kind of image should be established, what needs to be communicated and how it should be communicated, and what size and shape it should be. The size and shape of the paper is an important consideration in establishing a grid. There are many standard size papers and traditional ways of dividing them into workable spaces.

When you have many elements to organize — display type, text type, and visuals — you usually need to establish an underlying structure that can provide help in maintaining clarity, legibility, balance, and unity. This is especially true when you are working with a multi-page format where you need to establish a flow or sense of visual consistency from one page to another. There are many systems for dividing up space, but here is one way to begin experimenting with grids.

Take an 8½″ x 11″ page (paper or electronic) and place a margin around the entire format (think of it as a border). Decide on the number of inches for the margin. The margins can be adjusted to any size you find aesthetically pleasing and functional. Now you are left with a central space or "live area" within which to place and arrange design elements. That central space may be thought of as a single-column grid.

Now try another experiment. Take two pieces of an 8½″ x 11″ paper and place them next to each other to form a two-page spread (17″ x 11″). Create a single column on

each page (using the method described above). Are the columns the same? Do they repeat one another? Or are they mirror images? Now divide the columns with horizontals.

Now try this. On an 8½″ x 11″ page, create a margin and divide the remaining area into two columns. Now divide the two columns into four. Divide them again into eight. Divide the columns with horizontals. Analyze the differences in appearance and function.

You have just created a few very simple grids. There are many grid options. There are even and odd number grids, usually two and four column grids and three and six column grids. A grid need not be iron clad. You can break with the grid occasionally for the sake of drama or dynamics. If you break it too often, however, the visually consistent structure it provides will be lost. How do you know which grid to use on a design? The best way to begin is to consider your design concept, format, and the amount of information that needs to be designed. Each format has a different structure and presents different considerations.

Looking at these designs — a brochure for Klein Bicycles (Figure 5-11) and an MHEAC annual report — you

Top spread (Figure 5-11)

www.kleinbikes.com

‹• Mantra Pro

Engineered for extreme trail conditions and high speeds, the Mantra Pro is a light, super-stiff rocket that comfortably handles obstacles and rough terrain. Like the Mantra Race, the Mantra Pro features a carbon composite boom for weight savings and increased strength, and it comes with Shimano's top-of-the-line XTR component package. Weighing less than 25 pounds, the Mantra Pro is one of the lightest full suspension bikes available.

Frame Klein's Hexcel Carbon Honeycomb composite boom further reduces frame weight and saves the rider's energy on longer ascents

Wheel System Bontrager's RaceLite comes with ceramic coated sidewalls and offers reliable braking performance through all trail conditions, wet or dry

Suspension Klein's Spot-On Pivot design, Mars CL suspension fork with 80mm of travel and Cane Creek AD-10 shock create one of the lightest, most efficient full suspension systems available

Components Durable Shimano XTR shift and brake system offers best performance at the lightest weight attainable

Points of Contact Time ATAC Carbon pedals, new ICON Gradient MC3 mountain handlebar and S.D.G. Satellite saddle with lightweight Ti rails provide world-class, pro-level performance

MTB Racing

As long as I have competed and explored with my Klein bikes, the frame was the last area that needed attention. From Belgium to Australia, my Kleins have endured constant abuse. And they've never let me down. Through five seasons of riding (way too many) miles, across brutal terrain, Klein has held me up without a problem. Even at the '98 24 Hours of Moab race.

It's three a.m. and the night is freezing. The air is filled with a cloud of thick, lung-choking dust. The dust makes it hard to concentrate on my light beam. There are a couple of riders hovering near me. They pass me, only to be caught and passed again. Their lights are all over the place, which makes it tough to follow my own.

Soon the sun begins to rise. The dust cloud begins to clear. I have a great view of the snow-covered La-Sal Mountains. I am in Moab. Going at it solo. Around mile 120, I try to stay awake and to get my momentum and motivation up. This is my first 24-hour race. My longest stop will be 20 minutes; a meal and cup of green tea served up by Tammy Jacques, my wife, mechanic and crew chief.

I did not get new bikes for Moab. I was issued two bikes at the start of the year. By the time Moab started in October, one had a Brazil nut size dent in the top tube and the other had a dent in the seat tube from the flight coming home from the Budapest World Cup Race. Next to the Attitude Races are a pair of new Mantra Race suspension bikes. I am getting older and the Mantra is smooth and light. All in all, it's the best trail bike

around. It's exciting to ride a super-efficient suspension bike and be competitive.

Mile 240. It's getting harder to stay in the middle ring on climbs. My legs are tired. I'm getting dehydrated. I stop for five minutes to add a water bottle to my Klein. Tammy says I can do three more laps. I'll do two more, bringing my final distance to about 270 miles. Hard to believe this is possible, but as long as I have to try, I'm glad I'm riding a Klein.

Professional mountain bike racer Rishi Grewal has been riding with the Klein team for more than five years. Rishi is a six-time USA World Team member.

Top 24 Racer of Moab Solo Champion and Klein aficionado, Rishi Grewal

24 Hrs of Moab · 16

Figure 5-11
Klein Bicycles 2000
Design firm:
Liska + Associates Inc.
Chicago/New York
Art director:
Steve Liska
Designer:
Mary Huffman
Photography:
Steve Grubman
Client: Klein Bicycles

Liska + Associates designed the Klein 2000 product catalog, part of our complete marketing campaign, to build brand confidence and increase sales. We created a catalog that functions as the essential dealer tool for selling bikes. It offers clear illustrations of Klein's bike lines, their specific features and recommended uses. We positioned the bikes to appeal to the elite consumer, expanding from Klein's traditional market base of professional racers, while educating consumers about the history and range of the Klein brand.

Bottom spread

Quantum® road bike series

Gary designed the Quantum series to offer road bikes that are light, stiff and surprisingly well mannered, allowing you to ride longer, farther and faster. What makes Quantum models different from other road bikes is that they combine a light, super-stiff and responsive frame with comfort and handling. The real joy of owning a Quantum comes from the miles you put on it. The first time you take a corner, you'll be amazed at how well it handles. Eighty miles into the ride, you'll be praising its remarkable comfort.

The Klein Quantum Road Bike Series

Quantum™ The standard Quantum comes loaded with features usually reserved for elite road models. The Quantum features a traditional Klein road racing design, internal cable routing, Micro dropouts, smooth welds and a rich paint finish with debossed graphics. It's also equipped with Shimano's 105 STI group and Rolf Vector Aerodynamic wheels. The Quantum is also available with triple front chain rings for extended gear range. Even with these features, the Quantum still weighs less than 20 pounds.

Quantum Race™ The Quantum Race shaves more than a pound from the Quantum by upgrading to Shimano's Ultegra group and Rolf Vector Comp wheels, for increased performance and weight savings. This model is also available with triple chain rings for extended range and hill climbing capabilities.

Quantum Pro™ At a mere 18 pounds, the Quantum Pro features professional level Shimano Dura Ace components and Rolf Vector Pro wheels. Klein's proprietary AirHeadset steering system sheds additional weight and delivers the ultimate smooth steering control. Gary Klein has worked for years to extract the highest level of performance from the Q-Pro (as it's affectionately referred to by professional racers), resulting in an incredibly silky ride from a laterally rigid frame. This is one of the lightest road packages available.

Quantum Race™ Frameset The Quantum Race is also available as a frameset with Klein's Gradient aluminum frame and Icon's Air Rail fork.

Quantum Pro™ Fuselage With Klein's proprietary Aeros fork, AirHeadset and Icon's MC3 stem, the Quantum Pro fuselage is strong, lightweight and race-ready.

www.kleinbikes.com

‹• Quantum

Engineered for the serious road rider who wants a lightweight, strong, responsive road machine, the Quantum is quick, nimble and race ready. It's also extremely comfortable even on rough roads and on long rides.

Frame Klein full Gradient aluminum provides a lightweight, strong and durable, stiff and responsive frame platform. Gary's unique design makes the Quantum frame fit like no other road bike.

Wheel System Rolf Vector's proprietary paired spokes reduce weight without sacrificing strength or durability

Fork Icon Air Rail carbon fork is lightweight, strong and durable, and it comfortably handles any road condition

Components 105 STI is a user-friendly shifting system available in both double and triple chain rings for extended range

Contact Points ICON Onyx 6061 Ergo road handlebar and Flite Ti saddle offer lightweight, fast and comfortable contact between bike and rider

11

Figure 5-12
Annual Report
Design firm: Stoltze Design, Boston, MA
Designers: Clifford Stoltze, Kyong Choe
Illustrator: Tim Carroll
Client: Massachusetts Higher Education Assistance Corporation

This is the fourth report we have done for this client, and it was our first opportunity to do something really different. They had come up with the theme for the copy — a report that would describe the process of getting a student loan. The primary audiences are lenders, schools, and students. We wanted the audience to understand what is involved, and we wanted to make the lending process seem as user friendly as possible. It was a theme that would have been difficult to do photographically, so we suggested Tim Carroll's line-art style, which also worked well with the budget. The client liked the cartoon aspect of the illustration, while we responded to the layered shapes Tim incorporates in his drawings.
— Clifford Stoltze, Principal, Stoltze Design

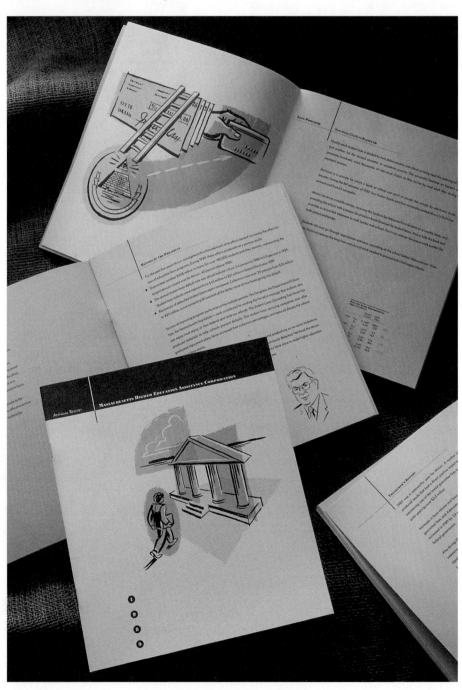

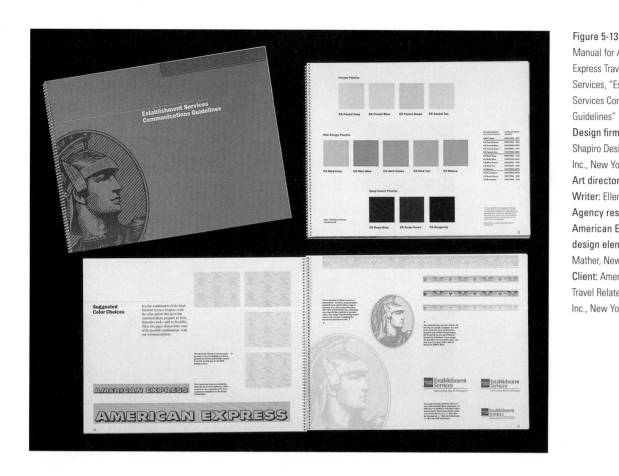

Figure 5-13
Manual for American
Express Travel Related
Services, "Establishment
Services Communications
Guidelines"
Design firm:
Shapiro Design Associates
Inc., New York, NY
Art director/Designer/
Writer: Ellen Shapiro
Agency responsible for
American Express Card
design elements: Ogilvy &
Mather, New York, NY
Client: American Express
Travel Related Services, Co.
Inc., New York, NY

can clearly see the column structures (Figure 5-12). Although the design concepts are very different, both designs are balanced and consistent. Consistency is a very important element in multi-page design; it provides flow from one page to the other. The respective design concepts and styles in these works are reflective of considerations such as the audience and the purpose of the design.

A four-column grid is used in the manual for American Express Travel Related Services (Figure 5-13). Although designer Ellen Shapiro uses four, somewhat narrow columns, she establishes a strong horizontal emphasis that echoes the extended horizontal format of the manual. Newspaper grids are particularly crucial since there is so much text, especially in a paper like *The Wall Street Journal*, where photographs are usually at a minimum. Ellen Shapiro's was used for more than five years by *The WSJ* (Figure 5-14).

Figure 5-14
New Section Design for *The Wall Street Journal,* Second Front Page
Design firm: Shapiro Design Associates Inc., New York, NY
Art director: Ellen Shapiro
Publisher: Dow Jones & Co. Inc., New York, NY

THE

BEST

SERVICE

AT THE

LOWEST

COST

HUMANA'S TELECOMMUNICATIONS

The 1980s have brought no short-
age of challenges to the health care
industry, the toughest being declin-
ing admissions and higher vacancy
rates resulting from a federal drive
to hold the line on Medicare costs.
➤ But out of this difficult period,
some healthy competitors have
emerged. One of them is Humana
Inc., the Louisville-based health care giant that operates more than 80 acute care hospitals providing more
than 17,500 beds, and a health care division that has over 900,000 members. Fiscal 1988 earnings were up
21.2 percent to $227 million on sales that increased 15.5 percent to $3.4 billion. ➤ Humana's encouraging
prognosis stems in part from the company's ability to integrate insurance and hospital care, a synergy that
has created a successful link between coverage and care. But improvement comes also from the fact that
Humana is one of the health care industry's most efficient innovators, and one of its most successful con-
trollers of costs. ➤ The latter focus is evident when Humana's vice president of telecommunications, Bill
Lawrence, talks about the Humana telecommunications system. Even though it's the industry's largest
dial-up voice network, linking 135 locations, his concern isn't the bigness of the system. It's the smallness
of Humana's telephone bill. ➤
"Humana will spend $23 million on
telecommunications in 1989,"
Lawrence explains, "including carri-
er charges, depreciation on the
equipment we own, and the cost of
the Corporate Telecommunications
Department, nearly everything
except employee salaries. ➤ "That's

By Ronald Denney

Figure 5-15 (facing page, top)
IN magazine, Fall
Design firm: Frankfurt Balkind Partners, New York, NY
Creative director: Kent Hunter
Designer: Riki Sethiadi
Photography: Mark Jenkinson
Client: MCI Communications

In this spread from a story about telecommunications at Humana Inc., the health care corporation, the designers at Frankfurt Balkind used the icon of a cross in a classic positive/negative layout where the type became an integral design element.
— Kent Hunter, Executive Design Director and Principal, Frankfurt Balkind Partners

Figure 5-16 (facing page, bottom)
Time Warner 1990 Annual Report, 1991
Design firm: Frankfurt Gips Balkind, New York, NY
Creative directors: Aubrey Balkind, Kent Hunter
Designers: Kent Hunter, Ruth Diener
Photographers: Charles Purvis, Scott Morgan, Lorraine Day, still from Time Warner Video
Client: Time Warner, Inc.

Photographic icons represent the four pieces of Time Warner, the world's largest entertainment and information company. A color palette and layout grid is established here for the rest of the annual report. The spread is actually die cut horizontally at the center grid, so readers can create their own layout with the next two spreads.
— Kent Hunter, Executive Design Director, Frankfurt Gips Balkind

Designer Riki Sethiadi had fun with the text on this spread from *IN*, a quarterly published by MCI Communications (Figure 5-15). The text in the three-column grid echoes the white space on the opposite page.

A spread for the Time Warner annual report successfully balances and juxtaposes four strong and colorful visuals (Figure 5-16).

Some designers have such a strong sense of layout they can abandon a grid, as in this contents spread for *Emigre* magazine (Figure 5-17). The designer's only grid was the cropmarks. A grid is not readily apparent in these imaginative spreads (see Figure 5-18). It is obvious, however, that the layout has been carefully planned; correspondence and unity have been estab-

Figure 5-17
Contents Spread for *Emigre* #5
Designer/Publisher: Rudy Vanderlans

Figure 5-18

"Alternative Pick" Illustrations, Divider Spreads for "Alternative Picks Spirit" Book

Design firm: Planet Design Company, Madison, WI

Art director/Designer/Illustrator: Kevin Wade

Storm Music Entertainment's "The Alternative Pick" is the standard 400-page sourcebook for the music and entertainment industries, speaking to progressive photographers, design firms, illustrators and directors. Planet crafted the image and theme for the Spirit Campaign. Our assignment: design and write the editorial portion of the book, as well as develop a direct mail campaign, logos, calendar, gift package, and other ancillary items. The intent was to create materials that would catch the eye and imagination of a design-savvy entertainment industry audience.

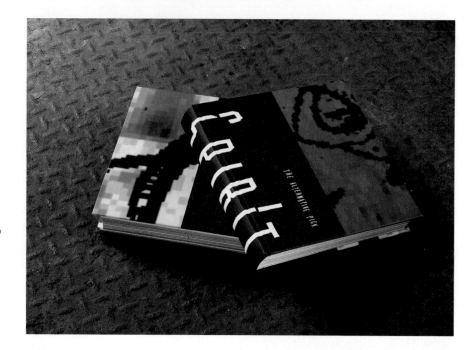

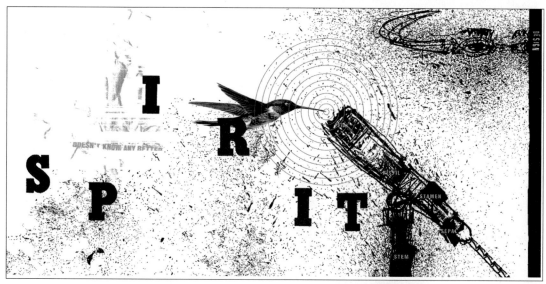

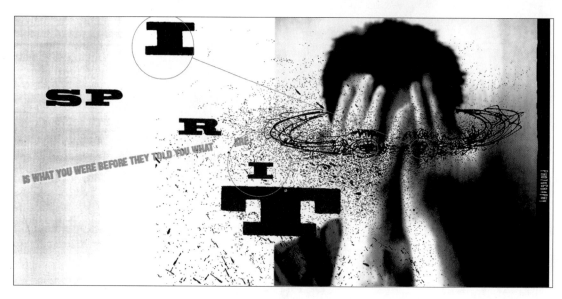

GRAPHIC DESIGN SOLUTIONS

lished. These spreads for the Worcester Art Museum, "where art celebrates life," demonstrate how one can utilize a grid, have variety within the grid structure, yet maintain unity and flow (See Figure 5-19). Viva Dolan's spread for the Paragon Entertainment Company's annual report entitled "Balanced," clearly proves, both literally and figuratively, how the illusion of deep space (left-hand page of the spread) can be juxtaposed against the flat surface (right-hand page of the spread) to create a dynamic composition (See Figure 5-20). Nesnadny + Schwartz's design for the WorldCare Capabilities Brochure teaches that a spread is more than two pages joined together (See Figure 5-21). These spreads remind us that a spread is a unit that must be designed with flow and unity in mind.

There are many ways to approach layout and many schools of thought. Consider this chapter a point of departure. Read texts devoted to the grid system. Studying the history of graphic design and analyzing layouts will increase your knowledge in this area.

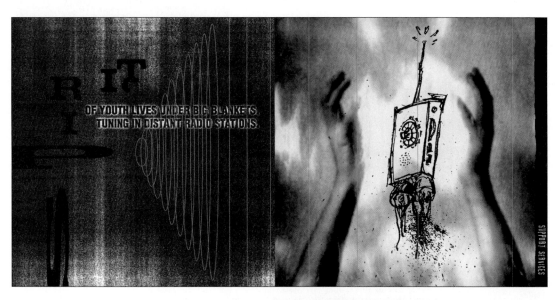

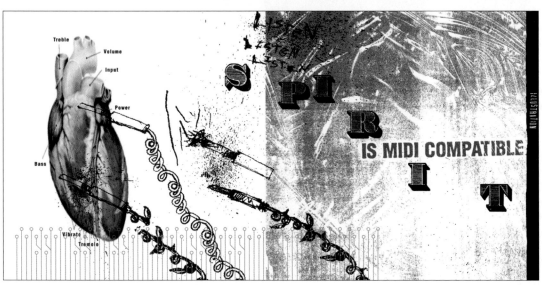

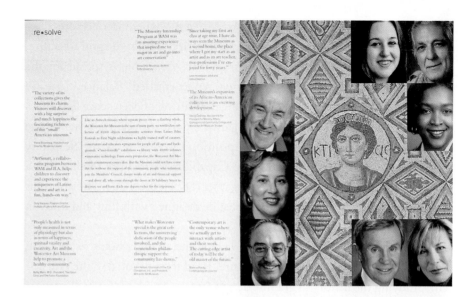

Figure 5-19

Worcester Art Museum — *Where Art Celebrates Life*, Centennial Campaign Brochure

Design firm: Nesnadny + Schwartz, Cleveland + New York + Toronto

Art directors: Joyce Nesnadny and Mark Schwartz

Designers: Joyce Nesnadny, Mark Schwartz, and Brian Lavy

Artists: Various

Photographers: Various

Client: Worcester Art Museum

Worcester Art Museum (WAM) embarked on a five-year campaign to raise $30 million, the largest fundraising effort in the museum's history. This brochure was created in response to the museum's need for a piece that articulates its story in a very compelling manner. The goal of this campaign is to increase investment income, thereby strengthening the museum's endowment, providing greater long-term financial stability, fueling current and new programs, improving upon its facility, and expanding community activities. Our quest was to produce a piece that re-establishes the museum's commitment to the community and presents a vision that compels donors to step forward and join the Centennial Campaign.

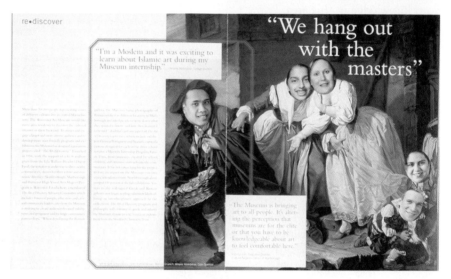

Figure 5-20

Paragon Entertainment Corporation Annual Report

Design firm: Viva Dolan Communications and Design Inc., Toronto, Ontario, Canada

Designer: Frank Viva

Writer: Doug Dolan

Photographer: Paul Orenstein

Client: Paragon Entertainment Corporation

In its annual report, Paragon Entertainment Corporation wanted to deal head-on with the perception that it was more a collection of autonomous boutique businesses than a cohesive corporate whole. So rather than show the products of each division (as had been done in the past), we created a series of conceptual photographs embodying themes common to all members of the Paragon family...Balance, Responsibility, etc. The photographs were heavily art directed to reflect the imaginative basis of Paragon's TV and film business. Just as importantly, they give a unifying visual thread to the annual report — and, by implication, to the company itself.

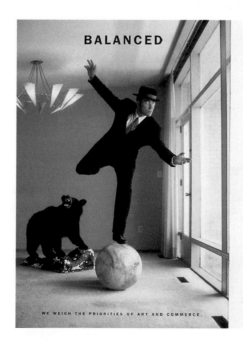

when failure is not an option

imagine a world without boundaries

a reservoir of *excellence*

Figure 5-21

WorldCare Capabilities Brochure

Design firm: Nesnadny + Schwartz, Cleveland + New York + Toronto

Art directors: Mark Schwartz, Joyce Nesnadny, and Tim Lachina

Designers: Joyce Nesnadny and Michelle Moehler

Photographers: Design Photography, Inc. and Stock

Client: WorldCare

Our client, WorldCare, required a brochure that would offer a comprehensive, compelling introduction and an overview of their services. WorldCare provides an innovative service that promises to change the face of medicine in many parts of the world. Using the latest technology, WorldCare establishes a worldwide connection between patients in need and medical experts who can help them.

WorldCare wanted a "branding" piece to underscore the quality of the institutional consortium, the tangible humanitarian benefits, and the leadership role that they seek to play. This brochure describes all aspects of WorldCare's business, from telemedicine capabilities to clinical trial services to the "global HMO." It includes the company's mission statement, core business, list of offices and goals for using telemedicine to overcome many of the world's obstacles to providing the best health care services.

If someone put an open magazine in front of you, would you be able to identify the magazine by its design? There are some magazines so distinctive in design that one can identify them by format, layout, and typography. A spread is an extended rectangular format. Remember, you must establish unity across the entire format. A successful layout is legible, aesthetically pleasing, and offers information in a hierarchical order.

EXERCISE 5-1
Designing with a simple grid

- Using the single-column and two-column grids you created earlier, design a layout.
- Cut display text, subheadline, text type, and some visuals out of a magazine, or use a computer and page layout program.
- Make a few photocopies of each element, reducing and enlarging a few. Also make several photocopies of your grids. Use a scanner and computer, if available.
- Try different arrangements of the elements on the grids.
- Remember the principles of balance, emphasis, rhythm, and unity.

PROJECT 5-1
Design a magazine spread

Step I

- Buy a music or entertainment magazine.
- Analyze the grid system used in the magazine.
- Choose an appropriate subject for your spread, for example, an article on a musician or celebrity.
- Write an objectives statement. Define the purpose or function of the spread, the magazine's audience, and the information that needs to be communicated. On an index card, write a one-sentence statement about the article.

Step II

- Design an opening spread (two pages) for an article in a music or entertainment magazine.
- Use the magazine's grid system for the spread.
- Include the following elements: display text, visual(s), and text type.
- Produce ten sketches.

Step III

- Produce two roughs.
- Establish emphasis, balance, and rhythm.

Step IV

- Refine the roughs. Create a comp.
- The dimensions of the spread should be the same as those of the magazine you chose.
- You may use black and white or full color.

Presentation

Mat the spread on a board with a 2″ border all around.

Logos, Symbols, Pictograms, and Stationery Systems

OBJECTIVES

- understanding and being able to design logos, symbols, pictograms and stationery systems
- addressing the needs of the client and audience when designing logos, symbols, pictograms, and stationery
- being able to successfully combine type and visuals
- being able to design an elemental visual
- expressing meaning and conveying information
- being able to develop a design concept and follow it through

Logos

If you go shopping for athletic footwear, you need only glance at the logo to know a lot about the shoe — who manufactures it, the quality, the price range, and perhaps even which athletes wear it. Brand name logos such as Nike and Reebok are designed consistently so the consumer will recognize them instantly. Not only does the logo serve as a label, but it conveys a message about the spirit and quality of the product, one that is reinforced through marketing, advertising, and product performance.

An identifying mark, such as a logo or a trademark, communicates a great deal about a product, service, or organization. When you create a logo, you are faced with the task of creating a design that will identify your client's product or business and distinguish it from the competition. Therefore, a logo should be unique, memorable, and recognizable at a glance; it should become synonymous with the company, product, or service it represents. It also is important for a logo to be used in a consistent manner. For this reason, some designers develop extensive guidelines for logo use and reproduction.

A logo must be designed appropriately in terms of style (characteristic manner or appearance), type, shapes, and symbols. For example, what might be appropriate for an insurance company might not be appropriate for an amusement park. A logo should express the spirit or personality of the product, service, or organization.

Since most logos are used for long periods, you need to create a logo that will stand up to the test of time in terms of style and trends. Of course, a logo should be aesthetically pleasing, have

graphic impact, and be designed according to sound principles. There are innumerable applications for a logo: packaging, stationery (letterhead, business card, envelope), signage, advertisements, clothing, posters, shopping bags, menus, forms, covers, and more. A logo should work for all applications that would suit the client's needs.

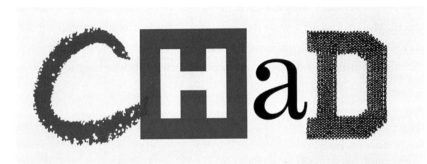

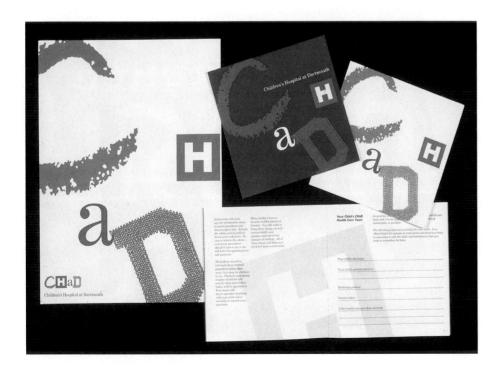

Figure 6-1
Graphic Identity
Design firm: Harp & Company, Hanover, NH
Designers: Douglas G. Harp, Linda E. Wagner
Client: Children's Hospital at Dartmouth, Dartmouth-Hitchcock Medical Center, Lebanon, NH

For the Children's Hospital at Dartmouth's identity, it was necessary to strike the proper balance between playfulness and dignity. It has to be appropriate for audiences ranging from young children to teenagers, and also their parents. It is an identity that has to survive in the context of the parent medical center's existing identity, as well.

The "C" is meant to capture the spirit of a child, but does not pretend to be drawn by one. Selecting the Dartmouth-Hitchcock Medical Center "H" and the Dartmouth varsity letter sweater "D" seemed to be the obvious choice for this playful solution. The lowercase Century Expanded "a" plays no less vital a role, and helps to hold the other three forms together.

— Douglas G. Harp, President, Harp and Company

The following list of criteria, a test by which you can judge your work, may help you to establish some basic objectives when designing a logo. Your objectives are:

- to design clear and legible type

- to create a distinctive look for your client

- to differentiate the product, service, or organization from the competition

- to create a logo that is appropriate for your client's business

- to express the product's, service's, company's or organization's spirit or personality

- to create a design with graphic impact

- to create a design that is consistent with the principles of balance and unity

- to create good positive/negative shape relationships

- to design a memorable logo

- to design a logo that works well in both black-and-white reproduction and color

- to design a logo that reproduces well when reduced and enlarged

A logo may be designed in any of the following configurations.

Logotype: the named spelled out in unique typography

Initials: the first letters of the name

Pictorial visual: representation of object or objects that symbolize the produce, service or organization

Abstract visual: non-pictorial visual forms to symbolize the product, service or organization

Combination: any of the above used together

Four different typefaces were used to distinguish the initial letters, CHAD, of each word in Douglas G. Harp's design for the Children's Hospital at Dartmouth (See Figure 6-1). One example of a logotype is Martin Holloway's design for Restaurante Brasil (Figure 6-2). Holloway's unique hand lettering and use of texture give the Restaurante Brasil logo its personality.

The Learning Curve logo combines an abstract visual, representing a curve, with the name of the company (Figure 6-3).

A pictogram is incorporated into this fitting and witty logo for Kozmo.com (Figure 6-4). Hornall Anderson Design Works' design concept is perfect for the client, the makers of a voice-recognition, conversational computing system (Figure 6-5). The logo implies conversation; a conversation bubble replaces the "o." Combining type and visuals is a popular way of designing logos, as in

Figure 6-2
Logotype for Restaurante Brasil
Design firm: Martin Holloway Graphic Design, Warren, NJ
Designer: Martin Holloway
Client: Restaurante Brasil, Martinsville, NJ

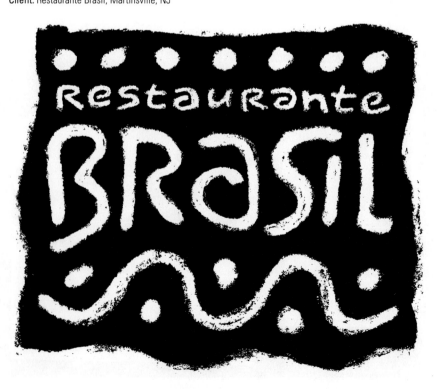

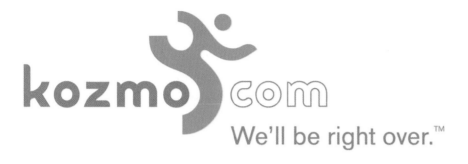

Figure 6-3

LearningCurve Logo

Design firm: Liska + Associates Inc.,
Chicago + New York

Art direction: Steve Liska

Designer: Holle Andersen

Client: Learning Curve International

*Liska + Associates designed this logo as a part
of our complete identity program for Learning-
Curve International, an educational toy company.*

Figure 6-4

Kozmo.com Logo

Design firm: DiMassimo Brand Advertising,
New York, NY

©Kozmo.com

*The bright and energetic Kozmo.com logo symbolizes
fast delivery and user friendliness.*

Figure 6-5

Conversá Logo/Stationery

Design firm: Hornall Anderson Design Works,
Seattle, WA

Art director: Jack Anderson

Designers: Jack Anderson, Kathy Saito,
Alan Copeland

*The main objective was to develop a proprietary
wordmark for "Conversá" which incorporated a re-
stylized saycon icon. The marketing goal created a
compelling, proprietary identity that appropriately
positions the company, appeals to its audiences and
graphically interprets and expresses its personality.
Because the client produces a voice-recognition,
conversational computing system, it was necessary
to emphasize a more futuristic look and feel
throughout the corporate branding program.*

*This design look was applied to a stationery
program, corporated capabilities brochure, and a
marketing folder.*

We wanted to create a logo that implied gourmet food that was good and you could get quickly. The clientele is mostly at lunchtime when people don't have a lot of time to spare.

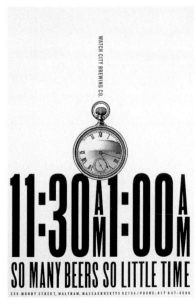

Figure 6-8
Logo/Masthead,
Design firm: Bernhardt Fudyma Design Group, New York, NY
Designer: Craig Bernhardt
Client: *Electrical Digest,* New York, NY

When I put the uppercase "E" and "D" next to one another and saw the negative spaces in the "E" as the prongs on an electrical plug, which the shape of the "D" resembled, the solution was obvious.
— Craig Bernhardt, Bernhardt Fudyma Design Group

Figure 6-9
Watch City Brewing Co. Logo
Design firm: Pentagram Design, New York, NY
Partner/Designer: Woody Pirtle
Art director: John Klotnia
Designer: Seung il Choi
Client: Frank McLaughlin

Watch City Brewing Co. is an upscale, 180-seat restaurant microbrewery located in the Boston suburb of Waltham, Massachusetts, or "Watch City" for its turn-of-the-century production of world-famous watches and clocks. The brewpub refers to the names of some of these watches in its beers and menu items.

The logo is an engraving of an old watch filled with beer. The time reads after five, when the workday ends and people stop watching the clock, relax, and have a beer. The logo appears on the brewpub's stationery, signage, glassware, menus, advertising, and promotional items.

this whimsical logo for children's shoes and accessories shops (Figure 6-6). Notice how well the type and illustration cooperate in terms of style and weights in this logo design (Figure 6-7).

Another successful example of combining type with an image in a meaningful way is this logo and masthead for *Electrical Digest* (Figure 6-8).

This whimsical merge of a beer mug and a watch conveys a mirthful spirit (Figure 6-9). Woody Pirtle's famous design, combining type and visual in a cooperative way, is a personal logo for Mr. and Mrs. Aubrey Hair (Figure 6-10). The Quaker Oats Company logo is one that many of us see every morning at breakfast. The pictorial part of this logo is an excellent example of high contrast shapes used to create light and shadow yielding a memorable image (Figure 6-11).

Creating a unique identifying mark is very important. A logo should become synonymous with the client, as the AMMI logo has (Figure 6-12). Here is a wonderfully colorful and rich set of pieces for the Monsoon Cafe, including the logo, poster, and invitation (Figure 6-13).

Figure 6-10
Logo
Design firm: Pentagram Design, New York, NY
Designer: Woody Pirtle
Client: Mr. and Mrs. Aubrey Hair

Figure 6-11
The Quaker Oats Company Logo
Logo used permission of The Quaker Oats Company

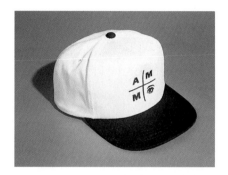

Figure 6-12
AMMI Logo
Design firm: Alexander Isley Inc., Redding, CT
Client: American Museum of the Moving Image

The client is the American Museum of the Moving Image, which is a very long name, so we came up with a shorter symbol for the museum. We did not want to use a cliche film symbol. We looked at more than one hundred eyes before we settled on the one we liked best.
— Alexander Isley, President,
Alexander Isley Design

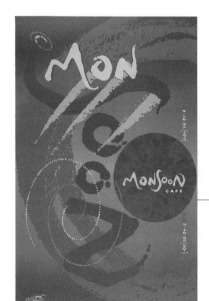

Figure 6-13
Monsoon Cafe
Design firm: Vrontikis Design Office, Los Angeles, CA
Creative director: Petrula Vrontikis
Designers: Christina Hsaio (logo) and Kim Sage (poster and invitation)
Client: © Global-Dining, Inc.

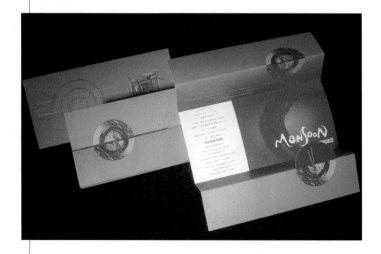

SUGGESTIONS

Here is a checklist of things to think about when designing a symbol. Your objectives are:

- to create a simple visual
- to convey information or express meaning
- to create a distinctive sign
- to create a design that can be recognized quickly
- to design an appropriate symbol for the idea or thing it represents
- to design a symbol that will work well in black-and-white reproduction
- to design a symbol that will work in various sizes

Symbols

It is hard to think of anti-war protest posters without thinking of the nuclear disarmament symbol designed by Gerald Holton in 1956. This graphic, a circle with a few lines in it, stands for something as profound as the abstract idea of peace (Figure 6-14). Similarly, it would be hard to think of Christianity without thinking of the cross. These graphics are symbols. A **symbol** is a sign, a simple (elemental) visual, that stands for or represents another thing. For example, an object such as a dove can be used to represent an abstract concept: peace. A symbol can be a printed letter meant to represent a speech sound, or a symbol may be a non-pictorial visual such as a question mark. There is an enormous range of visual symbols, from arrows and exclamation marks to software icons and scientific symbols. Symbols may be simple visuals, but they are a powerful graphically when used to convey information and express meaning.

A symbol may be designed in any of the following configurations.

Pictorial visual: representation of an object or objects

Abstract visual: a non-pictorial visual

Typographic: letter(s) or word(s)

Figure 6-14
Peace Symbol

Figure 6-15
Logo, "Preserving our past ... Building our tomorrow"
Design firm: David Meyer Design and Illustration, Memphis, TN
Client: Memphis Jewish Community Center

This logo for the Memphis Jewish Community Center Capital Funds Campaign needed to work on two levels. On the surface, it needed to symbolize the actual building renovations and additions that were taking place. On another level, it needed to communicate that the Center was achieving this growth by building on the traditions of its past. The only way to assure that these traditions continued to be passed down was to create an environment that would permit the Center to grow and thrive in the future. By "preserving our past" we were "building our tomorrow."

Designer David Meyer multiplied and stacked the Star of David, the traditional symbol for Judaism (Figure 6-15). Starting from the lower left, each star gets progressively more defined and more three-dimensional.

Arrows, which are traditional symbols for direction, are used in different configurations as symbols for Sun Microsystems Worldwide Operations program, a program of standards and guidelines providing a unified direction for Sun Microsystems' global operations (Figure 6-16). Each symbol, in combination with words, evokes imagery — the glove, a torch, a target, and a building. George Tscherny has said that one of the directions he pursues in his work is "to extract the essence of a subject and present it simply and dramatically," which is what he does in his SUNPARK logo design solution (Figure 6-17).

Figure 6-16
Symbols for Sun Microsystems
Design firm: Gee + Chung Design, San Francisco, CA
Client: Sun Microsystems

The symbols convey the chairman's belief in "putting all the weight behind one arrow."
— Earl Gee, Principal, Gee + Chung Design

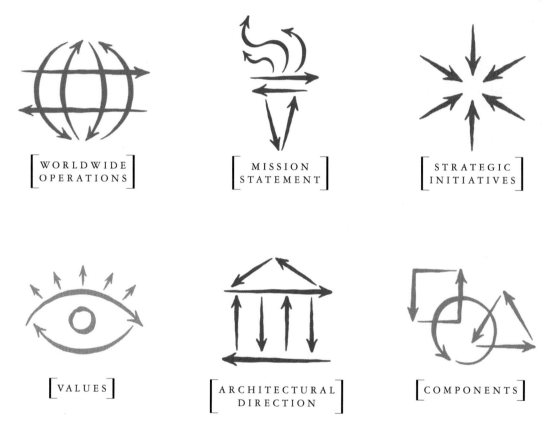

Figure 6-17
Logo, SUNPARK
Design firm: George Tscherny, Inc., New York, NY
Client: SUNPARK
SUNPARK is a company offering parking facilities, mostly adjacent to airports. Hence the "P" in a red circle, which is the universal symbol for parking.
— George Tscherny

Transforming messy strokes into a clean, straight arrow, designer Martin Holloway created a symbol of conflict resolution for a human relations conference. This symbol was used for several applications including sinage (Figure 6-18). Diana Ford designed this symbol for the Food Bank of Alaska (Figure 6-19). Many people think of bread as a food staple that is needed to sustain life; in combination with a heart, a symbol most understand to represent love, we get a new symbol about giving food to the needy.

"QuickTime allows for the integration of video, sound, text, and animation for computer multi-media. The imagery used is representative of all the facets of this platform," says Jennifer Morla of the symbolic imagery on this promotional CD (Figure 6-20). With

Figure 6-18
Symbol, "Human Relations on New Jersey Campuses"
Design firm: Martin Holloway Graphic Design, Warren, NJ
Designer: Martin Holloway
Client: New Jersey Department of Higher Education in cooperation with The National Conference of Christians and Jews (New Jersey Region)

food bank of alaska

Figure 6-19
Symbol
Design firm: Northwest Strategies, Anchorage, AK
Designer: Diana Ford
Client: Food Bank of Alaska

My first step in designing a logo is to make a list of words that correspond to the title. Then I break down the title and make a separate list for each word. Then I bring words from different lists together and see what kind of image they create. Usually its very obvious when the right combination of words creates the perfect image. The Food Bank of Alaska logo came together in about ten minutes using this method.

I chose a very simple technique to illustrate the logo because I did not want to overpower the concept, and I chose a common lowercase typeface in keeping with the humility of the organization.
— Diana Ford, Northwest Strategies

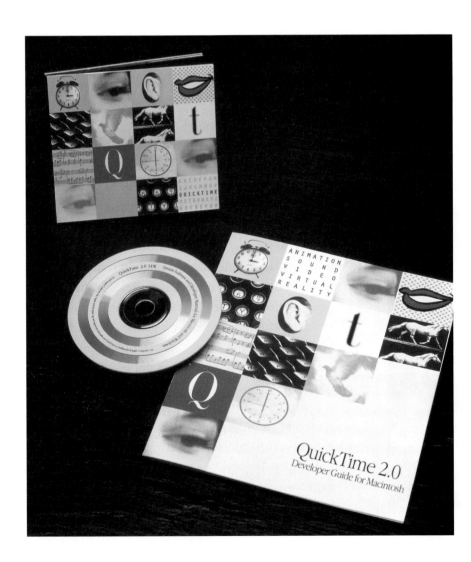

Figure 6-20
Apple Quicktime CD Digipak
Design firm: Morla Design, San Francisco, CA
Art director: Jennifer Morla
Designers: Jennifer Morla & Craig Bailey
Photography: Holly Stewart
Client: Apple Computer

The CD is distributed to software developers to promote the use of QuickTime in their programs.

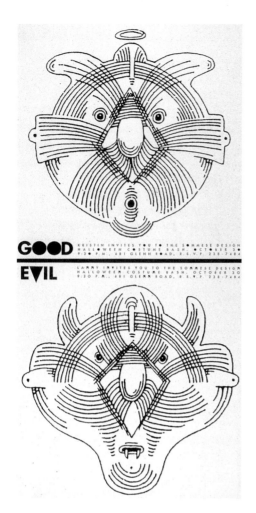

Figure 6-21

"Good/Evil" Party Invitation

Design firm and client: Sommese Design, State College, PA

Art director: Kristin Sommese

Designer/Illustrator: Lanny Sommese

My wife, Kristin, and I have an annual Halloween party to which we invite our clients, friends, etc. (Sommese Design is our studio.) The idea was to create two separate invitations—one for her (good) and one for me (bad), which we could send out individually or together. They are 18" square, so if someone wanted to cut the masks out and wear them they could. We also used them together as a poster. In her version, "O's" are filled in (soft, wonderful, good, etc.). In my version, the angular letters are filled in and appear as fangs (evil, vile, etc.). Actually in real life, this is reversed (Ha ha).

— Lanny Sommese

tongues-in-cheeks, Sommese Design used symbols of good and evil for their annual Halloween party invitation (Figure 6-21).

April Greiman's compelling design for the Sci Arc website (Figure 6-22) utilizes off-planet looking icons to denote different menu items.

The front cover the Tree Top annual report illustrates four embossed icons used to represent each season and the missions during those times — the apple represents "Harvest," the branch represents the time to "Prune," the flower represents the time to "Protect," and the leaf represents the time to "Fertilize" (Figure 6-23).

Pictograms

We are so used to the simple graphic visuals on restroom doors denoting the sexes that we may forget that these visuals are symbolic — they stand for men and women. These signs communicate quickly, and because they are purely visual (non-verbal), they cross language barriers. This type of sign is called a **pictogram**, which is a simple picture representing an object or person. Although most pictograms are simple, like the ones on restrooms, some have more detail or are more illustrative. Whether the pictogram is elemental or illustrative, essential information should be communicated in a glance. There is much crossover among logos, symbols, and pictograms; sometimes the nomenclature is not as important as the function of the design.

The primary objective of the Disability Access Symbols Project is for organizations to use these symbols to better serve their audiences with disabilities (Figure 6-24).

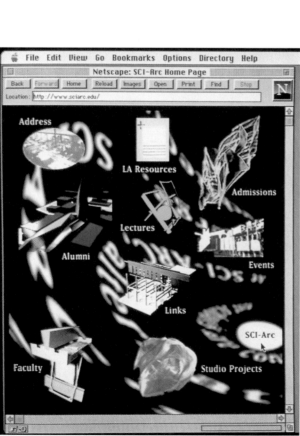

Figure 6-22

Web Site

Sci Arc website

Design firm: April Greiman, Los Angeles, CA

Figure 6-23
Tree Top Annual Report
Design firm: Hornall Anderson Design Works Inc., Seattle, WA
Art director: Katha Dalton
Designers: Katha Dalton, Jana Nishi
Illustrator: Jana Nishi, Denise Weir (icons)
Copywriter: Evelyn Rozner
Client: Tree Top

Unlike past Tree Top annual reports, this year's version focused specifically on the product itself, more than only the financials. The goal was to showcase the product—the apples and the process of growing them.

The front cover illustrates four embossed icons used to represent each season and the missions during those times—Harvest, Prune, Protect, Fertilize.

Figure 6-24
Disability Access Symbols Project
Symbols courtesy of Graphic Arts Guild Foundation
Produced by the Graphic Artists Guild Foundation with the support and technical assistance of the National Endowment for the Arts, Office for Special Constituencies
Design firm: X2 Design, New York, NY

The project was extremely challenging in terms of design because the client insisted on having organizations representing people with various disabilities review and comment on the proposed symbols. With the help of a disability consultant, we were able to reach consensus among all these groups and still achieve the primary objective — for organizations to use these symbols to better serve their audiences with disabilities.

Several existing symbols did not meet the standards we established and needed redesign. For example, the old symbol for Assistive Listening Systems focused on the disability (an ear with a diagonal bar through it). The new symbol focuses on the accommodation to the disability, i.e., a device that amplifies sound for people who have difficulty hearing. Other upgraded symbols include Sign Language Interpreted, Access (Other than Print or Braille) for Individuals Who Are Blind or Have Low Vision, and the International Symbol of Accessibility. A new symbol for Audio Description for TV, Video and Film was developed which, through design, proved less likely to degenerate when subjected to frequent photocopying.
— GAG Foundation

SUGGESTIONS

Here are some design considerations for the creation of a pictogram. Your objectives are:

- to create a simple or elemental visual
- to clearly and quickly communicate a message or information
- to design a pictogram that has graphic impact
- to create a design that is consistent with the principles of balance and unity
- to create a pictogram that works in black-and-white reproduction
- to create a pictogram that works when enlarged or reduced
- to create a pictogram that would be expanded into a system of pictograms

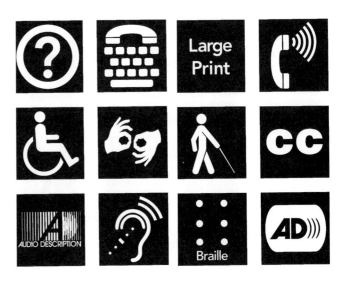

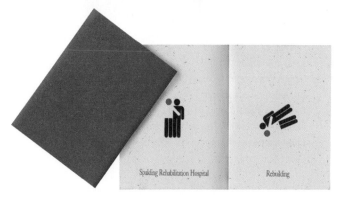

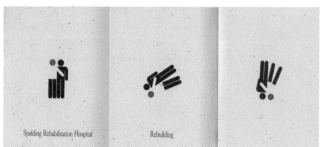

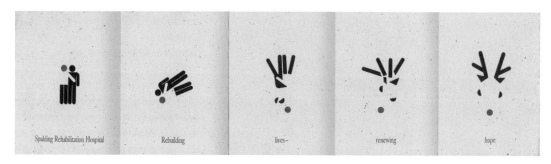

Figure 6-25
Christmas Card
Design firm: 601 Design, Inc. Denver, CO
Art director: Bruce Holdeman
Designers: Bruce Holdeman, Ann Birkey
Client: Spalding Rehabilitation Hospital, Denver, CO

Figure 6-26
Pictograms for a Planned Community
Design firm: The Rockey Company, Seattle, WA
Client: Port Blakely Mill Company

GRAPHIC DESIGN SOLUTIONS

On this holiday greeting for Spalding Rehabilitation Hospital, you see graphic pictograms representing two people changing into one pictogram of a reindeer (Figure 6-25). These pictograms, for Port Blakely planned community, are illustrative and detailed; however, they communicate quickly, and share a common style and format (Figure 6-26). For Oquirrh Park Fitness, Dave Baker and Dave Malone used a linear style to create a series of activity symbols (Figure 6-27). Dots and triangular strokes used to connote movement make these symbols unique. Diamond shapes are used as an element of continuity in the store sinage (pictograms) for the Safety Zone (Figure 6-28).

Figure 6-27
Symbols
Design firm: The Baker Group, Salt Lake City, UT
Art director: Dave Baker
Designer: Dave Malone
Client: Oquirrh Park Fitness Center

THE *SAFETY* ZONE

SPY TECH · OFFICE SECURITY · HOME SAFETY · CHILD SAFETY · PERSONAL SECURITY · LOCKS AND SAFES · SPORTS AND PROTECTIVE CLOTHING · CAR SAFETY AND SECURITY · HOME SECURITY · PERSONAL SAFETY · PET SAFETY

Figure 6-28
Store Signage
Design firm: Doublespace, New York, NY
Client: Safety Zone, White Plains, NY

Figure 6-29
Title: The TalkChart
Description of work: A communication device
utilizing icons
Creative director: Alan Robbins/The Design Studio,
Kean University, NJ
Designers: Various dedicated students
Client: self-initated

The TalkChart is a communication device for patients
in hospitals and nursing homes.

Using the 8 1/2" x 11" laminated chart, patients
with aphasia, throat tubes, or other impairments to
their speech, can now make their needs known to
family and staff by pointing to the graphic symbols
or letters of the alphabet that appear on the chart.
The graphic symbols represent 15 basic patient
needs and figures of the human body for pinpointing
problems.

The TalkChart was created and designed by
college students in The Design Studio at Kean
University under the direction of Professor Alan
Robbins and donated to local hospitals.

Thanks to articles about the project in The
Newark Star Ledger and The New York Times, many
hospitals throughout the state of New Jersey are
currently using this helpful device.
— Kean University

Designing a system requires a clear design concept and a consistent use of shapes, scale, and all the formal elements. The pictograms in a system look as if they belong to the same family. At times, more than one designer in a design firm or studio will work to produce a system. It is imperative to establish a firm design concept, style, and vocabulary of shapes in order for the system to look like it was created by one hand and mind (Figure 6-29).

Stationery

Look through your wallet. You probably have a business card in it. Look through your mail. You probably received correspondence on letterhead that was enclosed in a design-coordinated envelope. Of course, a business card or letterhead is meant to provide you with pertinent information such as a person's phone or fax number. Stationery, however, also is meant to project an image for a company — one that will attract potential customers and make them remember the employee or the company *because of the design.*

Stationery usually consists of letterhead, envelopes, and business cards. The company's logo, name, address, telephone and fax numbers, e-mail address, web address, and the owner or employee's name are included on the letterhead and business card. (The telephone and fax numbers and e-mail and web address are excluded from the envelope.) A rolodex card may also be included in stationery. Stationery is often part of a larger visual identity program (see Chapter 10).

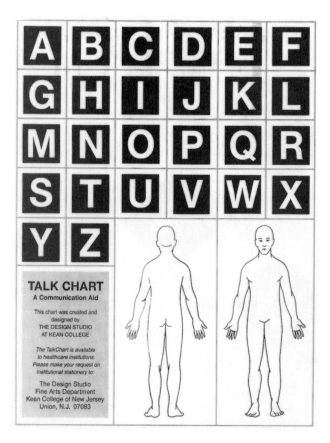

Most designers position much of this information at the head, or top, of the page, which is why we call it letterhead. That kind of arrangement leaves ample room for correspondence. Some designers split the information and position some type at the foot, or bottom, of the page. Others break with tradition and position type, graphics, or illustrations in any number of ways — in a vertical direction at the left or right side, all over the page in light or ghosted values or colors, or around the perimeter of the page.

Any arrangement is fine, as long as it works. You can design anything you want as long as it is a sound solution to a visual communication problem. The arrangement should leave a good amount of space for a message and it should be appropriate for the client. Information should be accessible. It should be in a visual hierarchy; for example, the zip code should not be the first thing the viewer notices. The logo is usually the most prominent element on the stationery; all other type and visuals should be arranged accordingly, from most to least important. An element other than the logo can be the most prominent element in your design, as long as your solution is logical and stems from your strategy and concept.

Choosing paper for your letterhead, envelope, and business card is part of a design solution. There are many paper companies and numerous qualities, styles and colors of paper. The weight of the paper is very important because the letterhead and envelope must stand up to typewriters, computer printers, pens, and markers. Letterhead must be sturdy enough to withstand being folded. A business card is usually inserted into one's wallet and therefore must be a heavier weight paper than the letterhead. When choosing paper, think also about texture, how the color of the paper will work with the ink's color, and whether the shape will fit into a standard envelope. Most paper companies provide paper samples and have shows to promote their products. They also advertise in leading graphic design periodicals.

Papers and envelopes come in standard sizes. Anything other than standard size is more expensive. A business card should be of a size and shape that fits into a wallet — usually the size of a credit card. If someone has to fold a card to fit it into their wallet, the design is being compromised. (Folded cards are an exception.) A designer must also be aware of the printing processes available, including special technical processes such as die-cuts, varnishing, and embossing. Research the printing process by visiting a good print shop.

The design — the arrangement of the elements, the creation of a visual hierarchy, the use of the logo, the selection of colors and typefaces — usually is consistent on all three parts of the stationery. Any design system, whether it is stationery or an extensive visual identity program, should have continuity — that is, similarities in form. Some designers feel it is perfectly acceptable to have slight to moderate variations in color, type, or arrangements among the letterhead, envelope, and business card. You can design a unified stationery system that incorporates variety.

Think of all the business cards or letterheads you have seen. Do any come to mind? Were any of them unique or particularly well-designed? A well-designed piece is usually memorable, such as this one designed for Maha Yoga

(Figure 6-30); the type and visuals have been thoughtfully chosen and arranged in relation to the format.

Hornall Anderson Design Works created this memorable logo and stationery system (Figure 6-31). Cleverly, an image is printed in the same color as the logo on the reverse side of the business card; the color helps to unify the design. Vrontikis Design Office is known for its extremely intelligent design solutions and this stationery is a prime example of creative thinking manifesting itself in conceptual typography (Figure 6-32).

Figure 6-30
Maha Yoga Logo, Schedule and Business Card
Design firm: Vrontikis Design Office,
Los Angeles, CA
Creative director/Designer: Petrula Vrontikis
Client: © Steve Ross

Maha means "great" or "supreme" in Sanskrit. The concept was to cleverly combine old and new, and simple and complex—this dichotomy is part of bringing this ancient wisdom to the modern world.
— Petrula Vrontikis

Figure 6-31
Hammerquist & Halverton Stationery
Design firm: Hornall Anderson Design Works Inc.,
Seattle, WA
Art director: Jack Anderson
Designer/Illustrator: Mike Calkins
Client: Hammerquist & Halverton

The marketing objective behind the Hammerquist & Halverton stationery program was attributed to the redesign of the client's original logo and identity. After years of enlisting the image of a bulldog standing before a target in their corporate identity, the advertising agency decided it was time to update their image.

Rather than eliminating the idea behind their original look, it was decided that the new logo would continue to retain these images. The logo, itself, was altered to reflect a dog's paw. Elements of the "target" are employed in the design of the paw. The business cards alternate with full-bleed images of a bulldog and of a bull's-eye target printed on the backs.

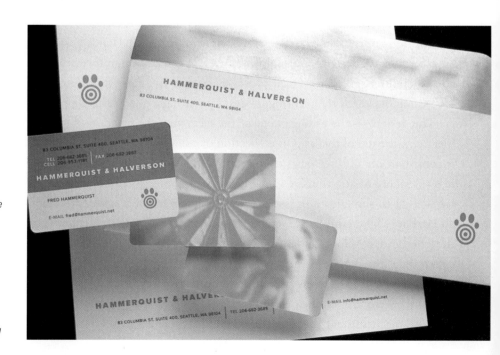

SUGGESTIONS

Although every rule in graphic design can be broken with a successful creative solution, here are some that a novice should keep in mind. A letterhead design should provide ample room for correspondence, and should not interrupt the correspondence. The design on the envelope should meet with postal regulations for the positioning of information. The design should work equally well on all pieces of the stationery. Your objectives are:

- to develop a unique, appropriate, and interesting concept

- to create a design that is immediately identified with the sender

- to coordinate the letterhead, envelope, and business card; establish unity

- to design and use legible typography

- to clearly display the address, telephone and fax numbers, e-mail and web addresses

- to express the spirit or personality of the company or client

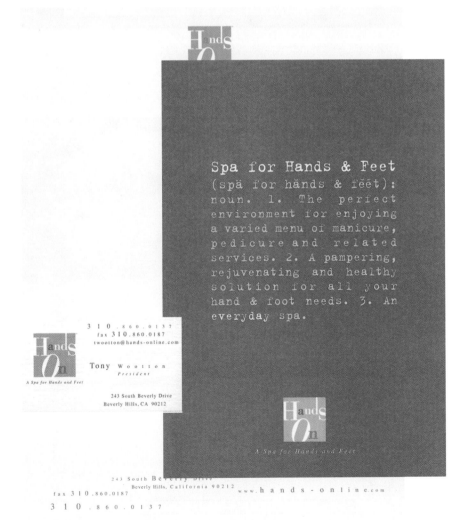

Figure 6-32

Hands on Stationery, Press Kit, and Logo
Design firm: Vrontikis Design Office,
Los Angeles, CA
Creative director: Petrula Vrontikis
Designers: Peggy Woo (logo), Eena Kim (stationery)
Client: © Wolper, Wootton and Company, Inc.

The design for Hands on, a day spa, is upbeat, fresh, and easy. The dancing text changes scale against a square background reminiscent of a canvas. The client asked us to stay away from any cliche imagery of hands or fingernails. They challenged us by asking for a "type only" solution.
— Petrula Vrontikis

*The project was one of those rare instances where,
from the moment the idea comes to you, you know it
is perfect. From that point, it is a matter of getting
the piece produced the way you see it in your mind's
eye. In this case, that included making a metal plate
and doing dozens of pencil rubbings to have as a
starting point for the artwork. I was able to achieve
the effect I wanted even though it was a one-color
piece.*
— Tommie Ratliff, Crestwood, KY

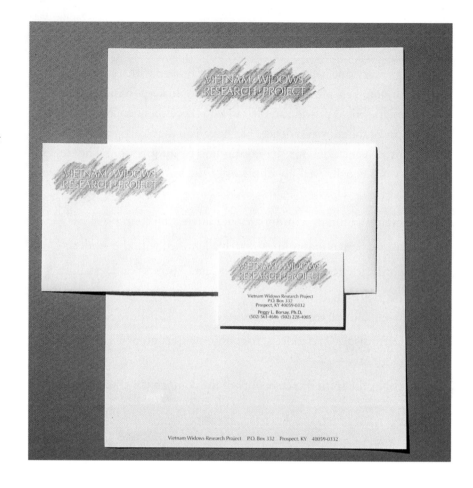

Figure 6-34
Lieber Brewster Design Stationery System
Design firm: Lieber Brewster Design Inc.,
New York, NY
Creative director: Anna Lieber
Client: Lieber Brewster Design
*Lieber Brewster Design was inspired by the old
monograms and insignias forming a coat of arms;
however, the intent was to create an identity that
was clean, contemporary, and versatile. An unusual
color jolt of violet on the ivory stock helps to give it
distinction in a sea of corporate button-down blues
and grays on crisp white. The logo has morphed into
another form in a photogenic treatment on our
quarterly promotional postcards.*

*On a serendipitous note, a medical expert
recently wrote us a letter pointing out that our logo
is also the biological symbol for the right and left
sides of the brain. Being graphic designers, our
knowledge of biology is quite limited and this was a
big revelation. As people who rely on both sides of
our brains, we were charmed by the coincidence.*
— Anna Lieber, Creative director,
Lieber Brewster Design Inc.

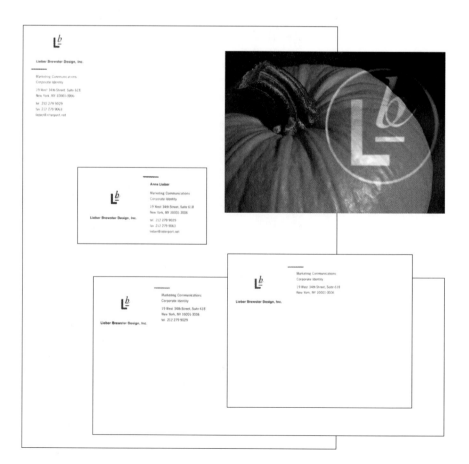

Figure 6-35
Laughing Dog Creative Stationery, "Top Dog"
Design firm: Laughing Dog Creative Inc.,
Chicago, IL
Creative director: Frank E.E. Grubich
Designer: Joy Panos

*The primary objective here was to exploit the sounds
in the phrase "Bow Wow Tee Hee."*
— Frank E.E. Grubich, Laughing Dog Creative Inc.

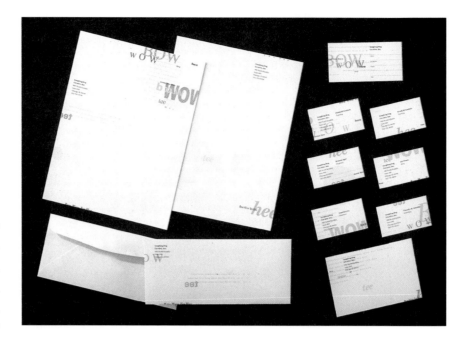

The type on this stationery for the Vietnam Veterans Widows Research Foundation appears to be a rubbing taken from a memorial, such as the Vietnam Veterans' Memorial in Washington, D.C. (Figure 6-33). By centering the title at the head of the page and aligning it with the type below, unity is established.

Designing stationery for yourself is particularly demanding. Even though you are the subject, you still have to follow the usual steps in formulating a strategy and concept. Since you are a designer or design student, people will look at your stationery as an example of your capabilities, as a piece in your portfolio. After all, if you design a great piece for yourself, you will probably come up with a great solution for someone else. Leiber Brewster Design's logo and stationery system reflect their design studio's style; potential clients can get a sense of their work by looking at their stationery (Figure 6-34).

The stationery for Laughing Dog Creative uses overlapping type of varying weights to create the illusion of three-dimensional space and to conjure up sounds (Figure 6-35). The design firm of Richardson or Richardson came up with a playful stationery solution of J.W. Tumbles, a chain of children's gymnasiums (Figure 6-36).

Figure 6-36
Stationery
Design firm: Richardson or Richardson, Phoenix, AZ
Designers: Forrest Richardson, Rosemary Connelly
Client: J.W. Tumbles, San Diego, CA

*The client's trademark is a series of symbols, or glyphs, that may be tumbled to any position while still
communicating the primary business — a children's gymnasium. The six different symbols combined with the
various positions and six color options create an almost endless choice of looks for use on stationery and cards.
Each symbol is an actual label that is self-adhesive and is applied by the client at the time of use to the single
color, pre-printed stationery paper.*
— Richardson or Richardson

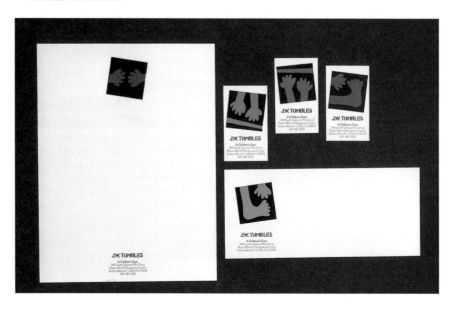

A logo is the central part of an identity system. Sometimes a logo can stand alone, apart from the stationery system or program. At other times, it is completely interwoven with the entire stationery system design. Jennifer Sterling's stationery system stands apart from most others in the way she combines elements, such as embossing, dates that require a hole-puncher, linear elements with embossings, and a perforated bottom edge (Figure 6-37).

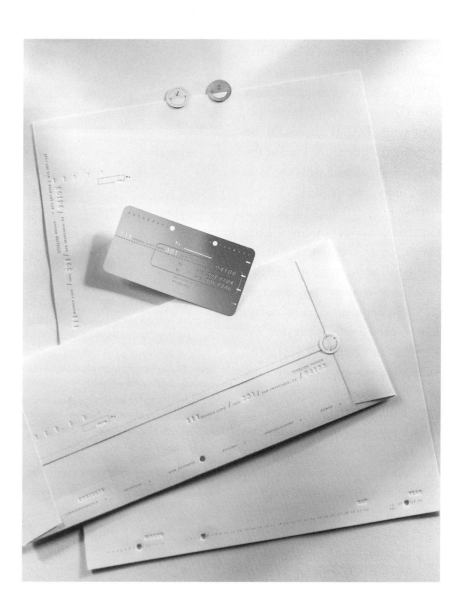

Figure 6-37
Jennifer Sterling Design Identity System
Design firm: Jennifer Sterling Design, San Francisco, CA
Art director/Designer: Jennifer Sterling
Client: Sterling Design

comments

The logo is the signature of a company, product, service, or organization; it is a visual image of the client's goals and spirit. It must be memorable, legible, appropriate, and visually and conceptually effective. The decision to use a logotype, initials, pictorial, or abstract visual should be dictated by the objectives statement and your analysis of the client's needs and image. Use the adjectives you choose as a test for your logo's success. Your solution should reflect the critical thinking and research that went into the design process.

EXERCISE 6-1
Examples of logos

- Find examples of logos that appear in the different configurations listed in this chapter. Maintain an ongoing collection. Keep a file or paste the logos into a book as source material

PROJECT 6-1
Logo design

Step I

- Choose a company, product, service, or organization.

- Research your client. Gather information on your subject. Find related visuals that you could use as references. Find examples of logos with the style or look you think is appropriate for your client.

- Write an objectives statement. Define the purpose and function of the logo, the audience, the competition, the message that needs to be communicated, and what kind of personality should be conveyed. It helps to write two or three adjectives on an index card that describe and summarize the spirit or personality that your logo should communicate. Keep the index card in front of you while sketching.

Step II

- Design a logo in any of the following configurations — logotype, initials, pictorial visual, abstract visual or any combination of these. The logo should be self-contained. It should be able to "float" anywhere; for example, it should not be dependent upon being positioned in the corner of a page. There should be no bleeds — nothing running off the edge of a page. Note: If your final choice is an abstract or pictorial visual, you will have to choose type to work with it for the stationery.

- Produce at least twenty different sketches before choosing a solution. At least four sketches should be devoted to each of the various configurations. In other words, you should make four sketches of initials, four sketches of an abstract visual, and so on. If a computer is not available, you may want to work on tracing paper so you can tract parts of one sketch and incorporate them into another (Hold onto the sketches for future reference and for your portfolio sketchbook.)

Step III

- Refine the sketches into three roughs on 8½″ x 11″ paper.

Step IV

- Create a comp using computer-generated type or hand-lettering. The logo should be no bigger than 5″ in any direction.

Presentation

The logo should be shown by itself in black and white on an 11″ x 14″ board.

Optional: Design the logo on stationery: a letterhead, envelope and business card. Present the stationery on an 11″ x 14″ board, held vertically. Mount the letterhead first. Overlap the envelope and business card.

EXERCISE 6-2
Building an image making vocabulary — xerography

- Go though a magazine or newspaper and find a few black-and-white photographs of people or objects.

- Look at the Quaker Oats Company logo (Figure 6-11). This logo uses high contrast shapes to depict shadows and forms.

- Make copies of the photographs on a copier. If possible, adjust the lightness/darkness control on the copier to result in an image with extreme values or high contrast. Or use a scanner, a computer, and either page layout or drawing software. Scan in a photograph and apply the high-contrast setting to the image.

- With a black marker, draw over the copies to increase the value contrast. Your objective is to convert light and shadow into black and white.

- Trace the high contrast copies, picking up only the most essential black-and-white shapes to depict the image.

- Choose your best drawing. Make a copy of it. Refine it. Present it as a comp on 8½″ x 11″ paper.

comments

In order to graphically symbolize an idea, person or thing, you must analyze it and reduce it to its most fundamental level. Though time and tradition play a great role in imbuing symbols with meaning, it is essential a newly designed symbol be the result of a valid design concept. This is a good lesson in developing a vocabulary of similar forms. Experimenting with various ways of developing shapes and images will greatly increase your ability to think visually and to design.

EXERCISE 6-3
Symbols

- Write down three adjectives that describe your personality. Write down three adjectives that describe the personality of a celebrity.

- Design an exclamation mark to express your personality.

- Design an ampersand or question mark to express the personality of a celebrity.

- Create twenty thumbnail sketches for each design.

- Refine the sketches into two roughs for each.

- Refine the sketches into comps. Present one comp for each problem on 8½″ x 11″ paper, held vertically. You may use color or black and white.

PROJECT 6-3
Symbol design

Step I

- You are going to design four symbols to represent the four seasons (spring, summer, fall and winter), or four activities (hiking, biking, skiing, boating) for use on a travel bureau located on the world wide web.

- On an index card, write down a simple, three- or four-word definition of each of the four you have chosen to represent.

Step II

- All four symbols should be designed in either circular, square, or rectangular formats.

- Create twenty thumbnail sketches. Try designing within the different formats.

- Explore different ways of developing shapes and images. Try geometric shapes, shapes created with torn paper, linear shapes, photographically derived images, the style of woodcuts, or posterized images.

- The four symbols should share a common vocabulary of shapes, lines, or textures.

Step III

- Refine the sketches and create three roughs on 8½″ x 11″ paper. Remember, all four symbols should share a common vocabulary.

Step IV

- Refine the roughs and create a comp.

- The circular or square formats should be 3″ and the rectangular formats should be no larger than 3″ in any direction.

Presentation

Present all four symbols on one 11″ x 14″ board, held vertically. The symbols all should be the same size and in black and white. When mounting, allow ½″ of space between the symbols. **Alternate presentation:** one symbol per board, 3″ symbols on 8½″ x 11″ boards, held vertically.

EXERCISE 6-4
Building an image making vocabulary — printmaking

- Go to the library and find books on printmaking: woodcuts, etching, drypoint, lithography, aquatint, and monotypes. If available, use a CD-ROM library or the Internet.

- Choose three types of printmaking. Try imitating the printmaking media style with black markers on white paper. In other words, try to imitate the look of a woodcut without actually doing a woodcut.

- Choose an image, such as a tree or a shoe.

- Depict the image in all three styles.

EXERCISE 6-5
Building an image making vocabulary — painting

- Buy some fruit for reference.

- Go to the library and find monographs on three modern painters, for example, Henri Matisse, Diego Rivera, Romare Bearden, and Georgia O'Keefe.
- With any kind of water-based black paint that is available, imitate the style of one or two of the artists you choose, using the fruit as your subject matter.
- When the paints are dry, make copies of them on a copier or scan them.
- You may have to "clean them up" or make adjustments.
- Present two finished illustrations on separate sheets of 8½″ x 11″ paper, held vertically.

comments

The pictograms should be in the same style, having similar distinctive characteristics. There should be a consistent use of the formal elements — line, shape, texture. They should be understood in an instant by the viewer. This project promotes two important objectives — the ability to maintain a vocabulary of shapes and style, and the ability to communicate through simple visuals.

EXERCISE 6-6
Pictogram design

- Buy some vegetables for reference.
- Using geometric forms, design pictograms for two vegetables.
- Create twenty thumbnail sketches, ten for each.
- Create two roughs for each pictogram.
- Refine the roughs. Create one comp for each pictogram and present it in black and white on 8½″ x 11″ paper, held vertically.

PROJECT 6-3
Designing pictograms for an airport

Step I

- Choose an airport, for example, the Heathrow in London, or your local airport.
- Research it. Find out what type of stores, format and services the airport has.
- Choose four subjects from among baggage claim, rest area, restaurants, information, gift shops, or anything you would find at an airport.

Step II

- Design four pictograms for an airport. Do not use any type.
- Produce twenty different sketches, at least five for each subject.
- Explore different ways of developing shapes and images. Try free-form linear shapes, geometric shapes, high-contrast images, or child-like images.
- The pictograms should share a common vocabulary of shapes, lines, or textures; they all should be in the same style, that is, all geometric or all free-form. Note: Creating pictograms is made easier with a scanner and computer. Scan in a photograph and trace the essential elements of the form. Remove the scanned photograph from the image, and you are left with an accurate

tracing. You can then manipulate the image in any number of ways to make it work; for example, fill it with black and then stretch or skew.

Step III

■ Refine the sketches and create two roughs on 8½″ x 11″ paper, held vertically.

Step IV

■ Make changes. Create a comp

■ The pictograms should be no more than 3″ in any direction.

Presentation

Present all four pictograms on one 11″ x 14″ board, held vertically. The pictograms all should be the same size and in black and white. When mounting, allow ¼″ of space between the pictograms. **Alternate presentation:** one pictogram per 8½″ x 11″ board. **Option:** You may want to present a colored version as well.

comments

In one way this is an easy project. You do not have to do any research because you are your own client. On the other hand, it may be difficult to define or develop an image for yourself. If your design is conservative, potential clients may think your work is conservative. If it is very trendy, they may think all your work is trendy. More importantly, if it is not well designed — and well thought out — it will say a lot about you. Make sure you apply everything you have learned about design fundamentals and the components of a design solution. Do not underestimate the importance of this piece. You may eventually want to coordinate your resume with your stationery.

EXERCISE 6-7
Stationery design (for fun)

Design stationery for a fictional character or a famous individual, such as Sherlock Holmes or Mahatma Ghandi.

PROJECT 6-4
Your own stationery design

Design stationery for yourself, including letterhead and envelopes. You may want to add a business card, rolodex card, or a label that can be attached to the back of your portfolio pieces or boards.

Presentation

Present the letterhead and envelope on one 15″ x 20″ board.

Posters

OBJECTIVES

▪ understanding the purpose of a poster

▪ understanding the role of type and visuals in poster design

▪ being able to design a poster

Posters

It is not unusual to walk though a public space, see a poster and think, "I would love to hang that in my home." And people do. Whether the poster is a promotion for an art exhibit or a musical group, it is common to see posters tacked on walls or framed and hanging in people's homes and offices alongside paintings, photographs, and prints.

Posters featuring attractive models and celebrities advertising The Gap clothing stores or Calvin Klein underwear adorn bus shelters. Posters promoting musical events and films hang in subway stations. Theatrical events, public service announcements, sporting events, rallies, museum exhibits — all are subjects for posters. Since the 19th century, the poster has been used to advertise events and inform the public.

No other graphic design format has been so successful in capturing the attention and hearts of museum curators, art critics, social historians, and the public. The American and European fine art worlds have embraced the poster; famous artists like Oskar Kokoschka and Ben Shahn have designed them (See Figures 7-1 and 7-2). Perhaps it is because the poster was popularized by the French artist Henri de Toulouse-Lautrec that fine artists have accepted this art form that also serves industry and commerce (See Figure 7-3).

A **poster** is a two-dimensional, single-page format used to display information, data, schedules, or offerings, and to promote people, causes, places, products, companies, services or organizations. Most posters are meant to be hung in public places and to be seen from a distance. It is essential to remember a poster must catch the attention of passersby. Do not forget a poster also competes for attention with surrounding posters, billboards, signs, and any other visual material.

Understanding the subject matter, ordering information so it can easily be gleaned, attracting the audience's attention, and then keeping it long enough to communicate the information or message is essential to designing a successful poster. If you were designing a poster for a heavy metal

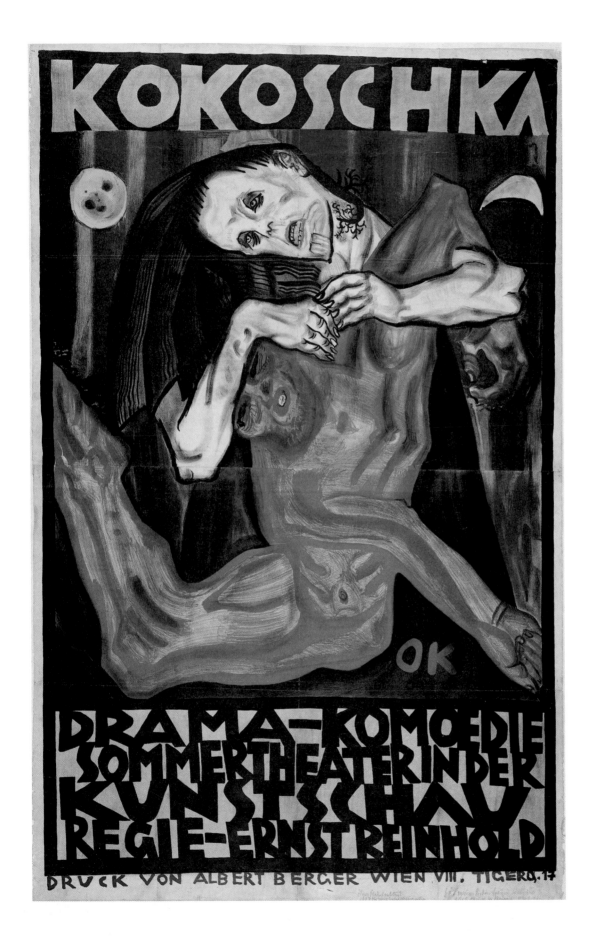

Figure 7-1
Poster, Oskar
Kokoschka, *Drama-
Komoedie*, 1907
Collection:
Museum of Modern
Art, New York, NY
Purchase fund

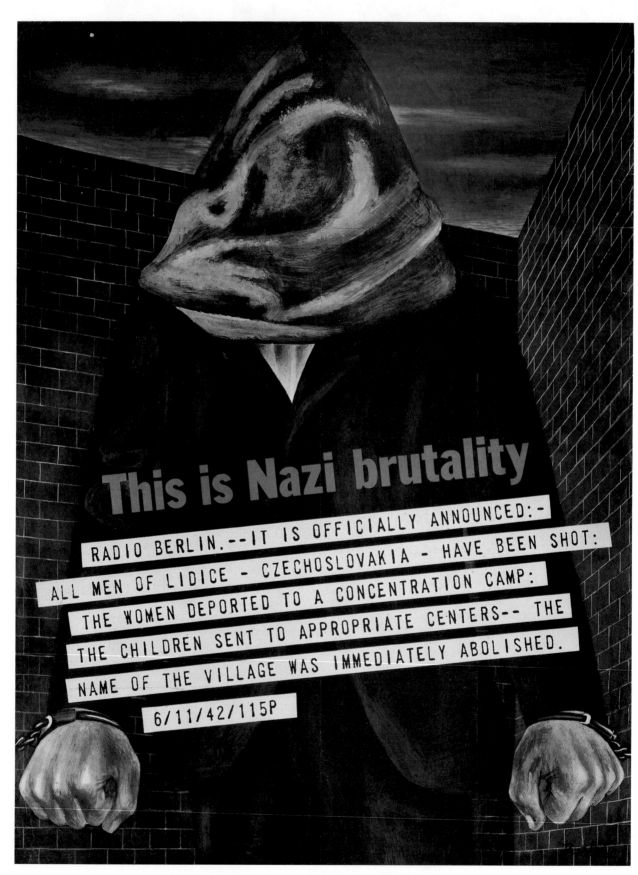

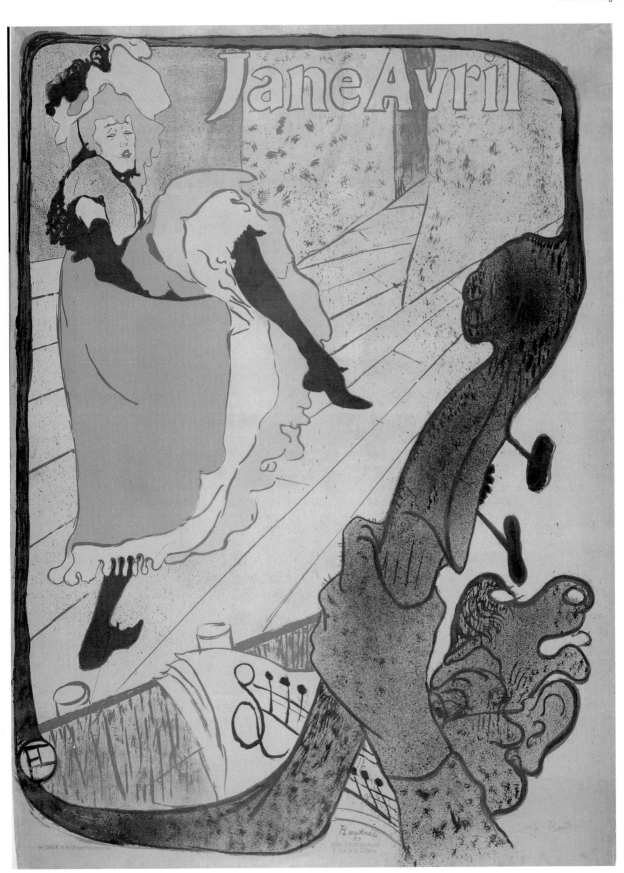

band, you probably would want to reflect the musical style in the design. Alexander Isley's vanguard poster is designed to reflect, as the designer says, the "exciting, engaging, and fun" nature of the Brooklyn Academy of Music's festival, "New Music America" (Figure 7-4). The smiling face, with words coming out of its mouth and words going into its ear to symbolize sound, is as hip as the concert series. Similarly, when Jan Tschichold designed a poster for an art exhibition of Constructivist work, he reflected the Constructivist style in his poster design (Figure 7-5).

Figure 7-4

New Music America Poster

Design firm: Alexander Isley Inc., Redding, CT

Art director: Alexander Isley

Designer: Alexander Knowlton

Client: Brooklyn Academy of Music "New Music America" Festival

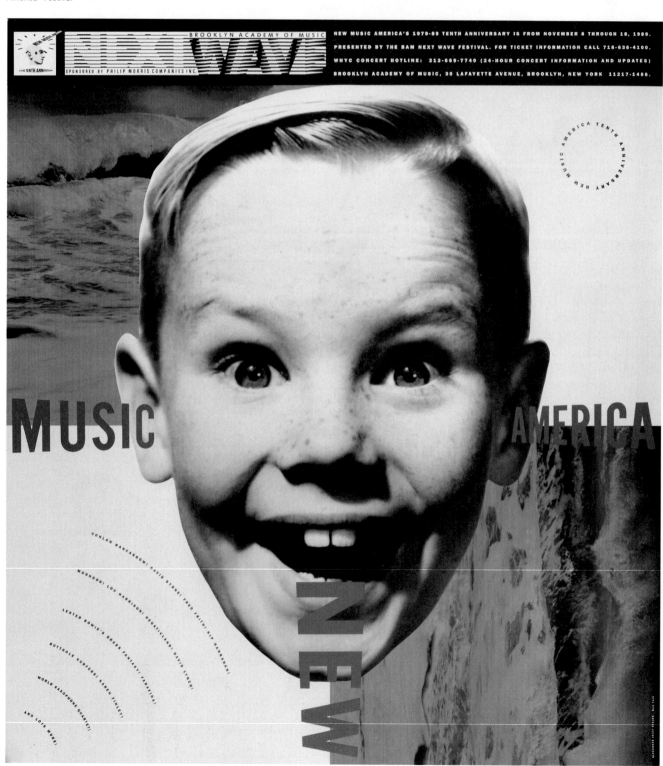

GRAPHIC DESIGN SOLUTIONS

● vom 16. januar bis 14. februar 1937

kunsthalle basel

konstruktivisten

van doesburg
domela
eggeling
gabo
kandinsky
lissitzky
moholy-nagy
mondrian
pevsner
taeuber
vantongerloo
vordemberge
u. a.

Like all other graphic design, the success of a poster depends upon the right combination of word and image. The word and image — also called the verbal and visual — must complement one another, as they do in this work by Josef Muller-Brockmann, *Less Noise* (Figure 7-6). The visual dramatically shows someone suffering from noise pollution and the verbal message suggests a solution. Notice the visual hierarchy. You see the visual first, and then you read the words. The visual is thoughtfully designed in terms of positive and negative space and scale. The size of the image in relation to the format yields a powerful effect.

Understanding scale can give a designer an edge in creating the illusion of spatial depth, creating surprise, and creating visual dynamics or variations. This famous poster by Herbert Matter is a good example of a designer using extreme differences in size to create a strange mood and a somewhat disjunctive space (See Figure 7-7). In an homage to Matter, Paula Scher sets up a similar scale relationships (See Figure 7-8).

SUGGESTIONS

A poster may be designed with just typography or with a combination of type and visuals. The visuals may be abstract, pictographic, symbolic, illustrative, graphic, photographic, or a collage, or hybrid. Type may be designed within the visuals or there may be a fusion of type and visuals. Designing a poster is a challenge in terms of both design principles and message communication. This list of criteria will help you. Your objectives are:

- to communicate a clear and easily understood message

- to create a design that is immediately understandable and readable

- to create a design that is legible from a distance

- to include all pertinent information

- to establish a clear hierarchy of information

- to establish a visual hierarchy and unity

- to thoughtfully arrange elements according to the principles of graphic design

- to design appropriately for the subject, audience, and environment

- to express the spirit of the subject or message

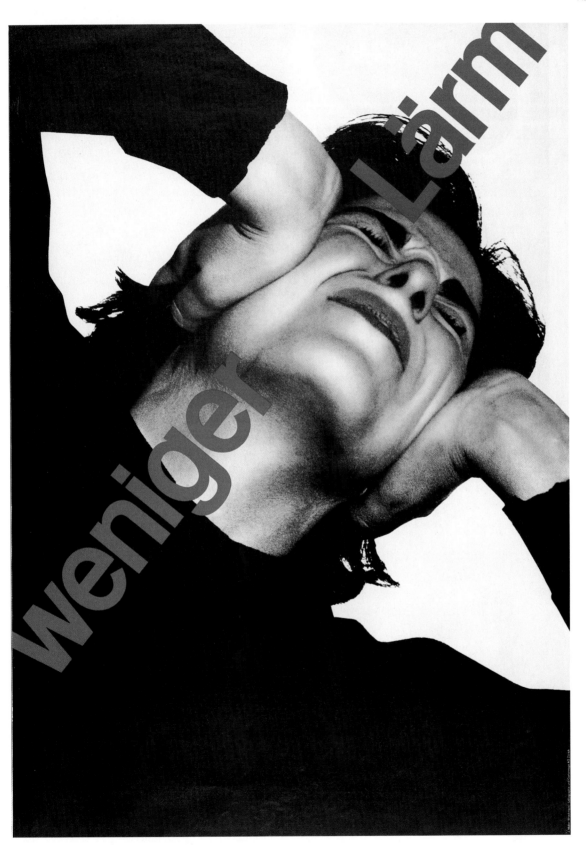

Figure 7-7
Poster, Herbert Matter,
Pontresina Engadin,
1935
Collection: Museum of
Modern Art, New
York, NY
Gift of the designer

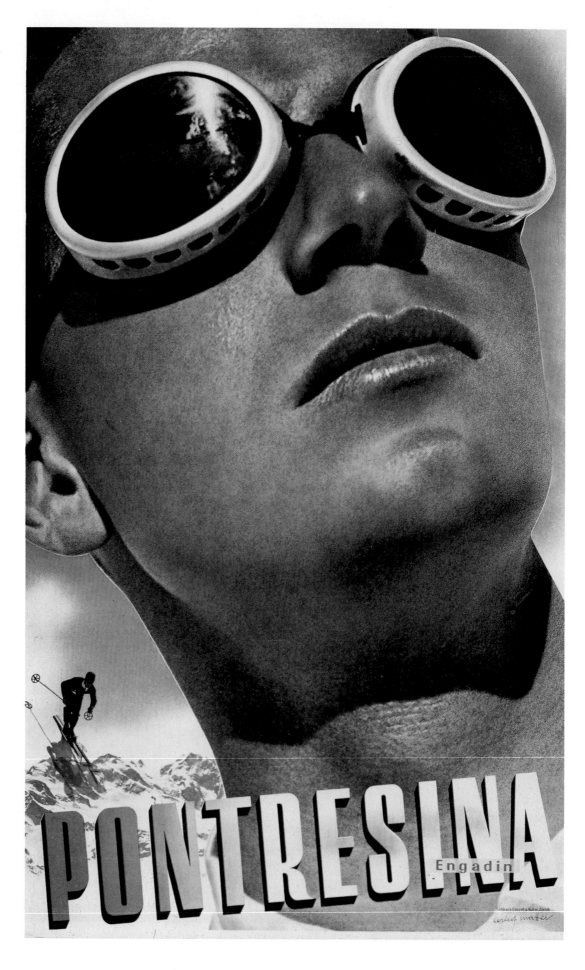

In keeping with Swatch's irreverent, trendy marketing identity,
Paula Scher designed a series of advertisements and posters
parodying graphics from earlier design styles. Herbert Matter's
poster from the 1930s was modified for one execution.
— Sarah Haun, Communications Manager, Pentagram Design Inc.

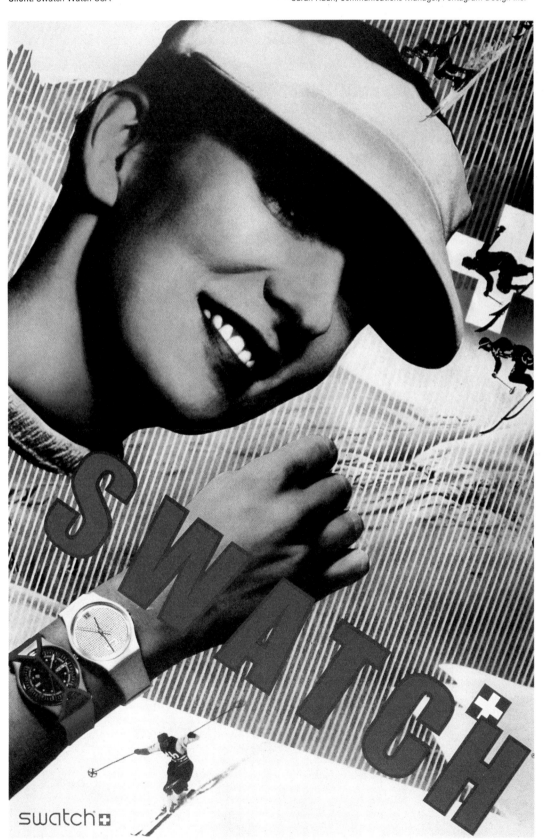

Stefan Sagmeister takes a very familiar face and reinvents it in this poster for *The New York Times Magazine* (Figure 7-9). "Yes, that is Albert Einstein hidden in all those molecules," says Sagmeister of "Quantum Weirdness."

Figure 7-9
"Quantum Weirdness" Poster
Design firm:
Sagmeister Inc.,
New York ,NY
Creative director:
Janet Froelich
Art directors:
Stefan Sagmeister &
Joel Cuyler
Designers:
Stefan Sagmeister &
Veronica Oh
Digital art: John Kahrs
Client: The New York Times
Magazine

Compare the way these two designers use letterforms, Seitaro Kuroda uses many small characters, some handwritten and some typeset, to produce an energetic surface with a lighthearted effect (Figure 7-10). Grapus combines set type and handwriting for a very different spirit (feeling) and message in his political poster (See Figure 7-11).

Figure 7-10

Poster for an exhibition at a department store, Seitaro Kuroda, *Seibu*, 1981
Collection: Museum of Modern Art, New York, NY
Gift of the designer

When a designer uses new technology to serve the design concept, innovative and imaginative things can happen. In these poster designs by April Greiman, hybrid imagery takes on symbolic meaning. For example, in her poster design for the Museum of Modern Art (Figure 7-12), the rectangular gradation represents time and evolution as the media evolved.

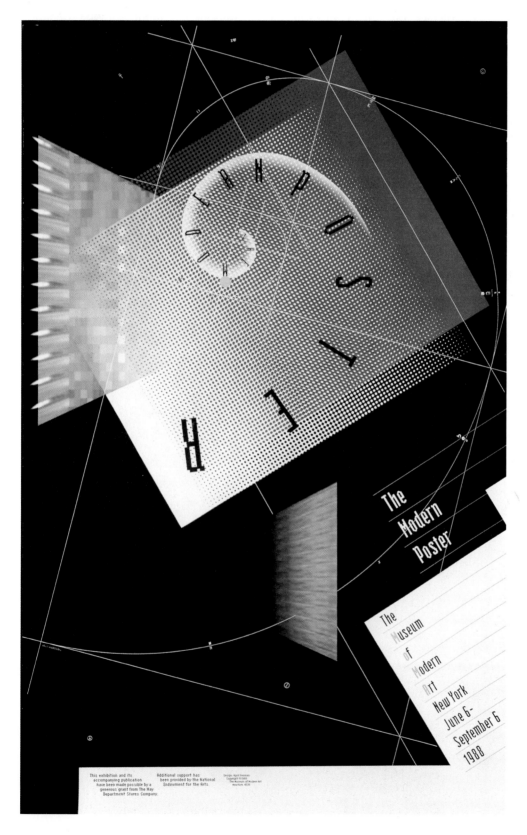

Figure 7-12
Exhibition Poster, *The Modern Poster*, 1988
Designer: April Greiman, Los Angeles, CA
Client: The Museum of Modern Art, New York, NY

This was an invited competition to design the poster for an exhibition on "The Modern Poster." We won!

The poster is a true "hybrid image." It utilizes state-of-the-art technology and is a composition of still video, live video, Macintosh computer art, traditional hand skills, typography, and airbrush.

The rectangular gradation represents time and evolution as graphic media have evolved from photomechanical means to the dynamic moving poster of TV (the video rectangles that are seen in perspective).
— April Greiman

155

This poster by designer Woody Pritle is a hybrid of agriculture and architecture. Pirtle traveled from Pentagram's New York office to lecture on graphic design in Iowa. His announcement poster fuses an icon of the midwest, corn, with an icon of Manhattan, the Chrysler building (Figure 7-13). Paul Rand uses icons as a visual pun in this poster for IBM (Figure 7-14). As it states on the poster, "An eye for perception, insight, vision; a bee for industriousness, dedication, perseverance; and an "M" for motivation, merit, moral strength," represent the spirit of the corporation.

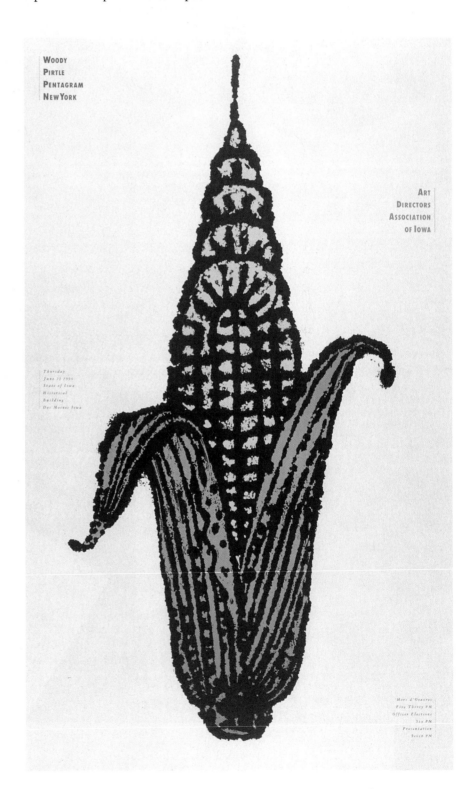

Figure 7-13
Chrysler/Corn Poster
Design firm: Pentagram Design, New York, NY
Partner/Designer/Illustrator: Woody Pirtle
Client: Art Directors Association of Iowa

This design was developed from a sketch Woody Pirtle made with a fountain pen on a napkin during a lecture trip to Iowa.
— Sarah Haun, Communications Manager, Pentagram Design

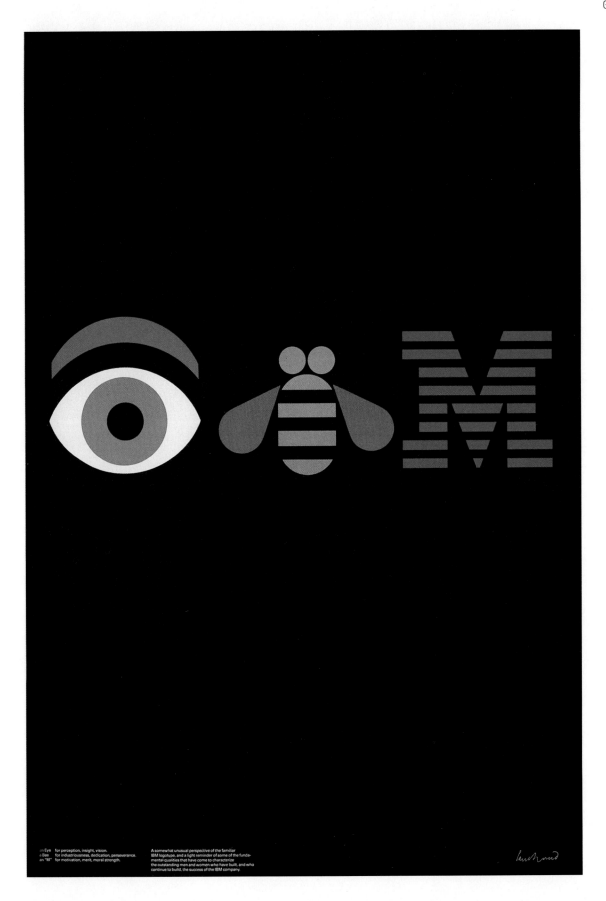

an Eye for perception, insight, vision.
a Bee for industriousness, dedication, perseverance.
an "M" for motivation, merit, moral strength.

A somewhat unusual perspective of the familiar
IBM logotype, and a light reminder of some of the funda-
mental qualities that have come to characterize
the outstanding men and women who have built, and who
continue to build, the success of the IBM company.

Figure 7-15
Poster, Man Ray, *Keeps London Going,* 1932
Collection: Museum of
Modern Art,
New York, NY
Gift of Bernard Davis

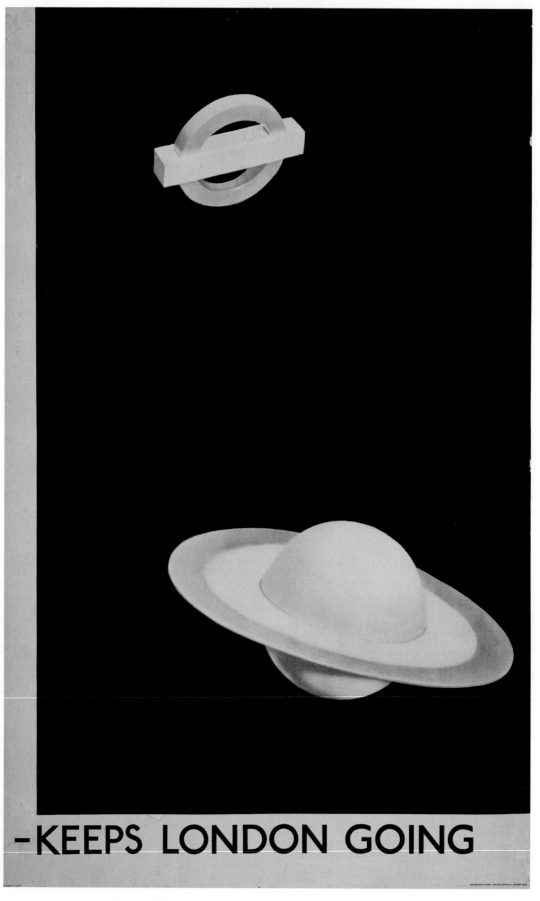

Comparing these transportation posters by artists who were contemporaries demonstrates the stylistic range open to a graphic designer. Man Ray's poster for the London Underground has a surreal quality; its simplicity and the cooperative action between the visuals give it power (Figure 7-15). A.M. Cassandre's poster for the Nord Express gets its power from the size of the visual and title, the value contrast, and the complexity of the overall design (Figure 7-16).

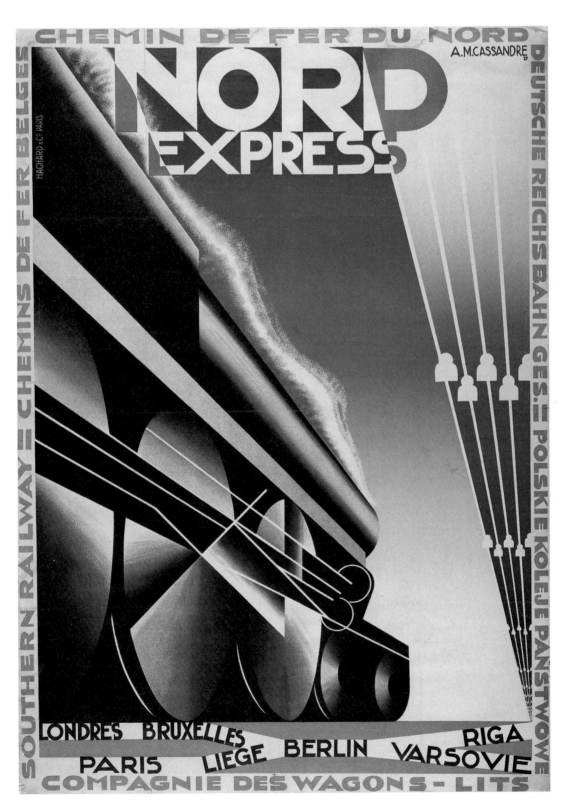

Figure 7-16
Poster, A.M. Cassandre, *Nord Express*, 1927
Collection:
Museum of Modern Art, New York, NY
Gift of French National Railways

Sometimes we can almost see the designer thinking, and in these cases, the design concept is very clear. George Tscherny divides the poster into a grid and uses eight of the nine subdivisions to promote a new press capable of printing eight colors plus coating in one pass (Figure 7-17). The poster, "Reflections from the Crystal City," was designed for a conference held by the Glass Art Society (Figure 7-18); transparency and reflection are communicated through the design of the type and the layout.

Figure 7-17
8 + 1 Poster
Design firm: George Tscherny Inc., New York, NY
Designer/Illustrator: George Tscherny
Client: Sandy Alexander Inc., Clifton, NJ

Figure 7-18
Poster, "Reflections from the Crystal City"
Design firm: Harp & Company, Hanover, NH
Art director: Douglas G. Harp
Designer: Linda E. Wagner
Client: Glass Art Society, Corning, NY

Our aim was to combine typography and imagery in a way that communicates the vitality, color, and reflectivity represented by this diverse group of glass sculptors.
— Douglas G. Harp, President, Harp & Company

"The Radical Response" poster is an appropriate solution for its subject — the lines of type break in atypical places, the type is difficult to read over a patterned ground, and the visual is exciting (Figure 7-19).

A visual hierarchy is established in this poster using both interesting typography and graphic visuals (Figure 7-20). The ordering of the elements is logical, moving our attention, in order, from the most important information to the least. Tiers of information are established. Using a trompe-l'oeil effect can

Figure 7-19
Poster, "The Radical Response"
Design firm: Morla Design, San Francisco, CA
Art director: Jennifer Morla
Designers: Jennifer Morla, Sharrie Brooks
Client: The Museum of Modern Art, San Francisco, CA
The Radical Response was the focus of a San Francisco Museum of Modern Art Design Lecture Series. The series investigated the qualities that make design radical, featuring four individuals whose approach to design have tansformed the context of the ordinary into the realm of the extraordinary. We created an image for the Design Lecture Series that aggressively portrays the title of the series.
— Morla Design

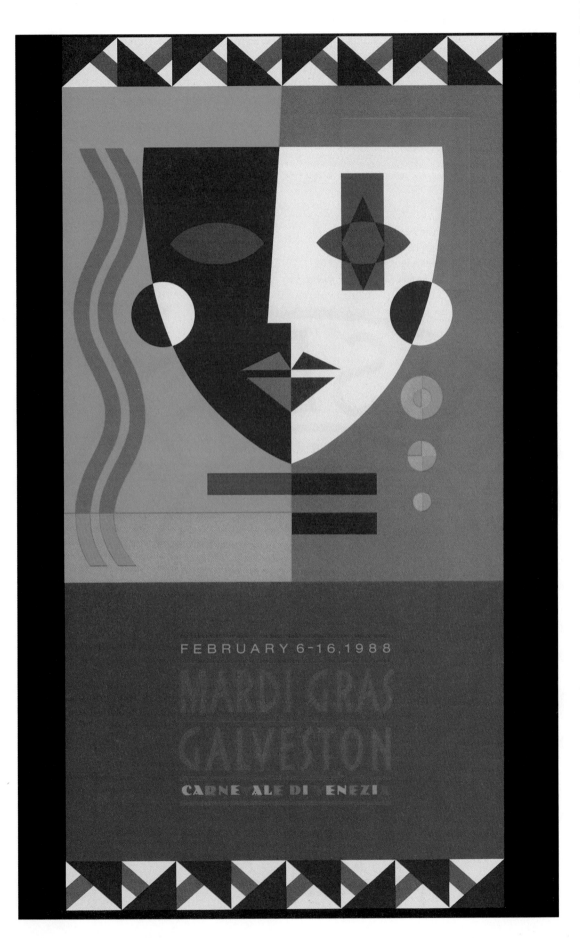

Figure 7-20
Mardi Gras Galveston/
Carnevale de Venezia
Design firm: Sibley
Peteet, Dallas, TX
**Art director/
designer:** Don Sibley
Client:
Galveston Park Board

FEBRUARY 6-16, 1988

MARDI GRAS
GALVESTON

CARNEVALE DI VENEZIA

yield both entertaining and dramatic results, as in this clever poster of Louise Fili (Figure 7-21).

Often, posters stand alone, as a single unit. Sometimes they are applied as barricade posters, used in multiples, as this series for the CCAC Institute (Figure 7-22). The entire Mission Mall was wallpapered with these fun and nostalgic posters by Muller + Company, to create a barricade effect (See Figure 7-23).

Figure 7-21
Louise Fili Cincinnati Poster
Art director/Designer: Louise Fili
Design firm: Louise Fili Ltd., New York, NY

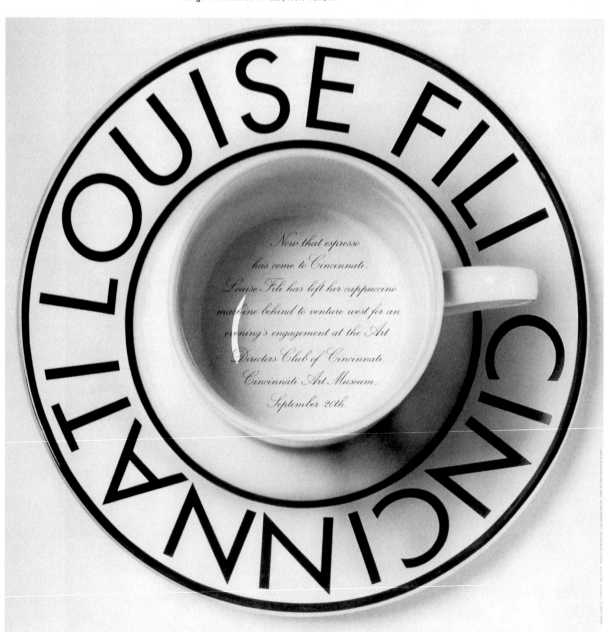

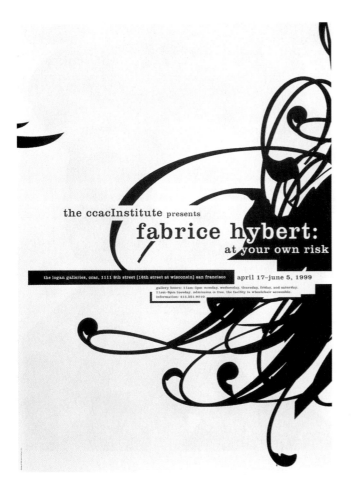

Figure 7-22
CCAC Institute: Poster (Fabrice Hybert)
CCAC Institute: Poster (Spaced Out)
CCAC Institute: Poster (Big Soft Orange)
Design firm: Morla Design, San Francisco, CA
Art director: Jennifer Morla
Client: California College of Arts & Crafts

This series of exhibition announcements was designed for the CCAC Institute, one of San Francisco's newest experimental art venues. Working with extreme budget constraints, each poster incorporates letters from the show's title to create dynamic graphics that give each show a unique visual voice. Applied as barricade posters, they create a dynamic presence when used in multiplicity. The experimental typographic vocabulary reflects the nature of the art shown and creates a recognizable identity for the CCAC Institute.
— Morla Design

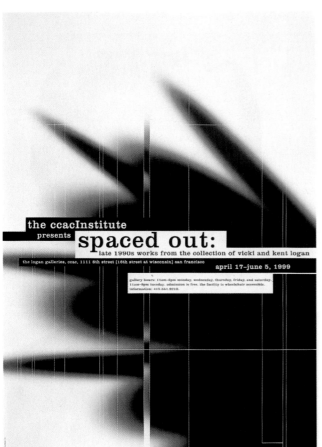

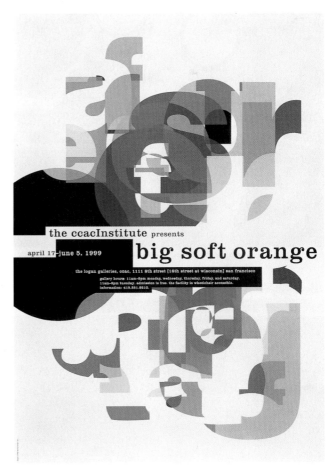

Chapter 7 Posters

Figure 7-23

Posters

Design firm: Muller + Company, Kansas City, MO

Creative director/Designer: John Muller

Writer: David Marks

Production art: Kent Mulkey

Client: Mission Mall, Mission, KN

A regional shopping mall was going to open in two weeks. The developer of the mall called me and said, "We have 150,000 square feet of blank storefront barricades and it looks desolate in here!" So, in order to get something produced and installed in two weeks and respond to a limited budget situation, I designed a series of three-color silk-screen posters. We printed 75 each of the posters on cheap billboard paper 40˝ x 60˝ and simply wallpapered the entire mall. These posters quickly became collector's items.

— John Muller

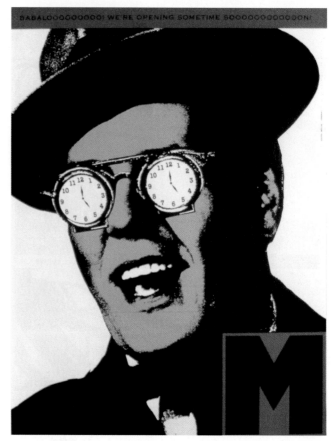

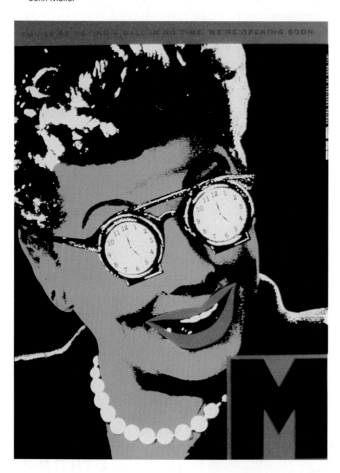

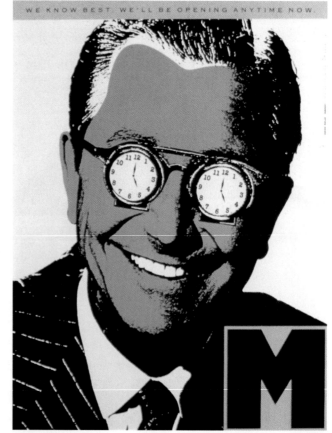

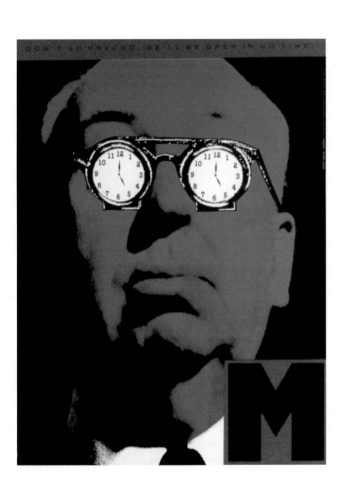

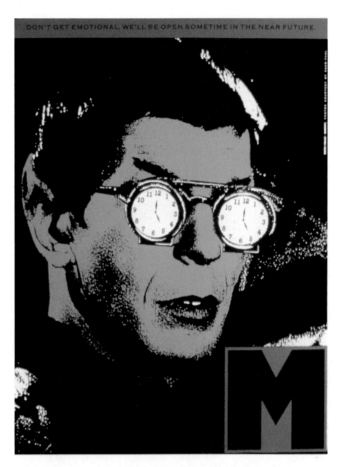

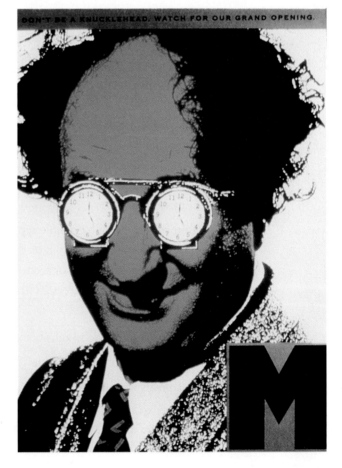

Unlike an advertisement in a magazine which is seen up close, a poster has to grab attention from a distance. Since this poster is promoting a play, you have to carefully select visuals and words that will interest people; you have to motivate them to see the play. Try to create a meaningful relationship between what is being said (the verbal) and what is being shown (the visual). This is a good opportunity to use imagery or visuals that are essential or provocative without being a literal translation of the subject. Remember: Your goal is to communicate a message to an audience.

EXERCISE 7-1
Poster design variations

Step I

- Find a poster; analyze its design concept and execution.

Step II

- Redesign it three different ways: first, using only type.

- Redesign it so the visual is the dominant element and the type is secondary.

- Redesign it so the type is the dominant element and the visual is secondary.

- Produce about twenty sketches before going to the rough stage.

- Create one rough for each design problem.

PROJECT 7-1
Poster design for a play

Step I

- Choose a contemporary play. Read it. Research it.

- Find related visuals you could use as references.

- Write an objectives statement. Define the purpose and function of the poster, the audience, and the information to be communicated. On an index card, write down three adjectives that describe the spirit of the play, one sentence about the play's theme or plot, and images or visuals that relate to the play. Keep this card in front of you while sketching.

Step II

- Design a poster to promote a play at your college or at a local theater. The poster should include the following copy: title, credits (author, producer, director, etc.), date, place, time, and admission prices.

- Your solution should include type and visuals. The key to developing your design concept may be a visual that is symbolic of the play's spirit, message, or mood. Visuals do not have to be photographs of the cast or scenes from the play.

- Produce at least twenty sketches.

Step III

- Produce at least two roughs before going to the comp.

- Be sure to establish visual hierarchy.

- The poster should be in either a vertical or a horizontal format.

Step IV

- Refine the roughs. Create one comp.

GRAPHIC DESIGN SOLUTIONS

- The size, shape, and proportion should be dictated by your strategy, design concept, and where the poster will be seen (environment). The maximum size is 18″ x 24″ — no larger in any dimension.

- You may use a maximum of two colors. **Optional:** design a playbill.

Presentation

Present the comp in one of two ways:
- Matted on an illustration board with a 2″ border.

- Mounted on an illustration board.

comments

Designing a poster series demonstrates your ability to develop a design concept and follow it through in several ways or versions. It also provides you with an opportunity to develop a "look" or style for a series. Though each poster should stand on its own and send its own message, there should be a visual connection throughout the series; there should be continuity. You may want to design companion pieces for this poster series, such as an invitation to events or a promotional button.

PROJECT 7-2
Poster series

Step I
- Find out about a series of events on your campus or at a local library or community center.

- Find visuals related to the events.

- Write an objectives statement. Define the purpose and function of the poster series, the audience for the events, and the information to be communicated. On an index card, write one sentence explaining each event.

Step II
- Design a series of posters for the campus or other events.

- The posters should have a similar style, looking as if they belong to a series.

- Produce at least twenty sketches for the series.

Step III
- Refine the sketches and produce one rough for each poster in the series.

- Be sure to maintain visual hierarchy.

Step IV
- Create a comp for each poster in the series.

- There should be a minimum of three in the series.

- Each poster should be no larger than 18″ x 24″. All the posters should be the same size.

- You may use a maximum of two colors.

- All the posters should be in a consistent format.

Presentation

The posters should be presented as tight comps in one of two ways:
- Matted on a board with a 2″ border.

- Mounted on a board.

chapter
8

Book Jackets and CD Covers

OBJECTIVES

- understanding the purpose of book jackets and CD covers

- defining objectives when designing book jackets and CD covers

- designing book jackets and CD covers

Have you ever flipped through a bin of CDs and stopped to look more closely at one because the cover was attractive? When browsing in a book store, have you ever picked up a book because the jacket looked interesting? Many people do. The design of a CD cover or book jacket may influence your decision to purchase the product. At the very least, it gives you a clue as to what is between the covers of the book or what type of music is on the disc.

Every book, magazine, or CD in a store is in competition. All are vying for the potential consumer's attention, though not every book or CD is aimed at the same audience. All the rules about developing a strategy apply here; you design with your audience and the marketplace in mind. A jacket or cover should give the consumer a sense of what the book or CD is about. You can think of it as a trailer or preview for a film. For example, if you are designing a book jacket for a murder mystery, you would want to convey a sense of the excitement, setting, time period, drama, and mystery in the book — but you would not want to give away too much information (especially not the ending). A book jacket or CD cover must communicate its message quickly and clearly, and arouse interest. The impact is similar to a poster's — it must attract attention, communicate a message, be aesthetically pleasing, and compete in the marketplace.

Like any other graphic design piece, a book jacket or CD cover most often combines type and image. In the case of the front cover of a book, we usually see the title of the book and the author's name; sometimes, the price and series logo are included on the cover. Whether you design with type alone, type and photography, type and illustration, or type and graphics, depends on your strategy, concept, and whether or not the book belongs to a series. If a book belongs to a series, the series should be visually coordinated.

Type and image should complement one another. Consideration must be given to the combination of these elements — how well they work together to convey a message and the spirit of the book or CD. When choosing type or visuals, it is crucial to make your selections based on your concept, the style or image you wish to convey, and the appropriateness to the subject matter. There are many approaches to choosing imagery. The front of many CD covers shows photographs or

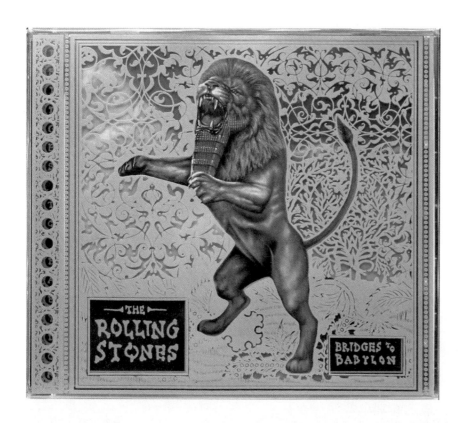

Figure 8-1

"Bridges to Babylon"

Design firm: Sagmeister Inc., New York, NY

Art director: Stefan Sagmeister

Designers: Stefan Sagmeister & Hjalti Karlsson

Photography: Max Vadukul

Illustration: Kevin Murphy, Gerard Howland (Floating Company), Alan Ayers

Client: Promtone B.V.

The "Bridges to Babylon" cover for the Rolling Stones features an Assyrian lion embedded into a special manufactured filigree slipcase. The interior reveals a long strip of desert to fit the accompanying tour/stage design.

— Stefan Sagmeister

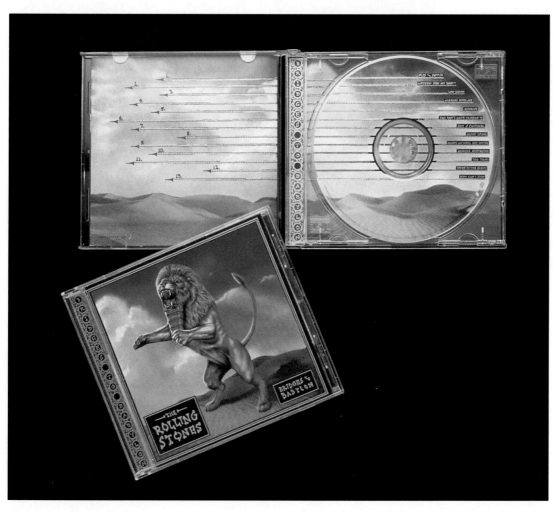

Chapter 8 Book Jackets and CD Covers

illustrations of the recording artist(s) or imagery related to the theme of the CD. We are less likely to see a photograph of the author on the front cover of a book, unless it is a biography, autobiography, or the complete works of the author. More often, the imagery relates to the subject matter or story. Your task as a designer is to translate the written words of a book or the music on a CD into visual communication. Whatever type and imagery is chosen should catch the potential audience's attention. Remember: Book jackets and CD covers are displayed — they promote the product.

Figure 8-2
Harvey Mason "Ratamacue" CD Package
Design firm: Vrontikis Design Office,
Los Angeles, CA
Creative director/Designer: Petrula Vrontikis
Client: © Atlantic Recording Company

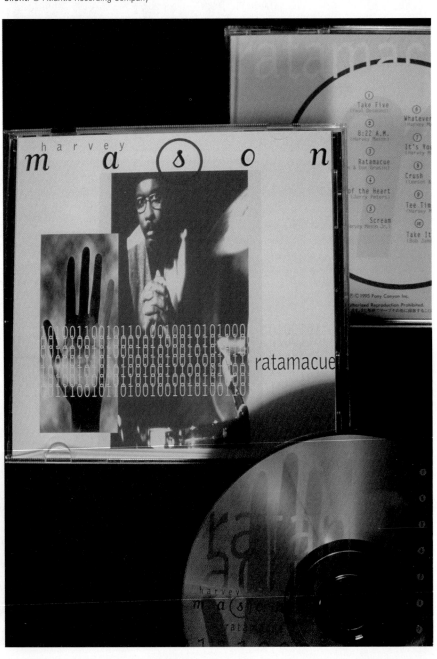

CD covers

A clear visual hierarchy is established on this daring CD cover designed by Sagmeister Inc. (See Figure 8-1). Engaging typography mixed with visuals communicates the style of Harvey Mason on this CD design (Figure 8-2).

"All type on the 'Imaginary Day' cover for the Pat Metheny group has been replaced by code. The images connect to the songs and mood of the album and can be decoded by using the diagram printed onto the CD itself," says Stefan Sagmeister of his innovative design solution (Figure 8-3).

Figure 8-3
"Imaginary Day"
Design firm: Sagmeister Inc., New York, NY
Art director: Stefan Sagmeister
Mechanical: Mathias Kern
Designers: Stefan Sagmeister & Hjalti Karlsson
Photography: Tom Schierlitz/Stock
Client: Warner Jazz

SUGGESTIONS

Book jackets or CD covers present similar design considerations. When designing a book jacket or CD cover, your objectives are:

- to attract potential consumers (readers or listeners)
- to express something about the contents of the book or CD
- to create a design that will stand up against the competition
- to communicate clearly and quickly
- to create something that is attractive and that has graphic impact

The strong color combinations and imagery on the cover of David Byrne's "Rei Mono" CD instantly grab one's attention; the spirit of the design is carried through on the disc, inside booklet, and back cover (Figure 8-4). The recurring circular motif, reds and greens, and visuals create unity throughout the CD package.

CD covers, cassette covers, and book jackets are similar in their design requirements; they must appropriately identify and capture attention. At times, a designer must coordinate several design pieces, as in this case for the project *Children First* — a 100-page book and CD (Figure 8-5). "I could not crop or manipulate color in any of the images. This opened up more possibilities in experimenting with juxtaposition and scale to support the narrative," says Petrula Vrontikis of her exuberant design solution for *Children First*.

Figure 8-4

CD Package, David Byrne, "Rei Mono"

Design firm: Doublespace, New York, NY

Client: Warner Brothers Records, Burbank, CA

Figure 8-5

Children First — A 100-page Book and CD

Design firm: Vrontikis Design Office, Los Angeles, CA

Creative director/Designer: Petrula Vrontikis

Client: © Little Brown and Company

Children First *is a book containing images and writings as a* *celebration of children donated by the top fashion photographers and recordings of children-related music from top recording artists. The challenge was to emotionally sequence the images for maximum impact. All proceeds of the sale are donated to "Homes for the Homeless," an organization assisting homeless kids and families.* — Petrula Vrontikis

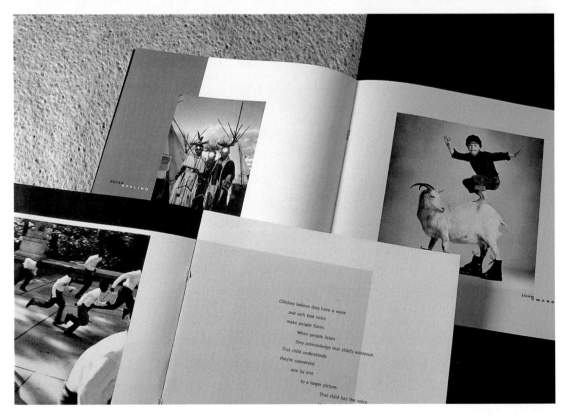

Book jackets

Louise Fili's style is apparent when you look at her body of work, and yet, like any good designer, she is able to adapt her personal vision to communicate the spirit of each project. Compare these two book jackets by Fili (Figures 8-6 and 8-7). Both have Fili's distinctive typography and yet she is able to maintain the distinctiveness of each project's personality.

Rather than choose a firm with a history of designing textbooks, the Houghton Mifflin Co. selected Carbone Smolan Associates for their broad range of work and creative solutions. The design program for The Literature Experience (Figure 8-8), resulted in a series of highly acclaimed and unconventional children's textbooks for kindergarten through eighth grade. The books translate the excitement of a bookstore into each volume by capturing the diversity and spontaneity of individual books. An array of page-turning devices makes the books playful, funny, and interesting, quite beyond the textbook norm.

Figure 8-6
Typology Cover
Design firm: Louise Fili Ltd., New York, NY
Art director/Designer: Louise Fili

Figure 8-7
Belles Lettres Cover
Design firm: Louise Fili Ltd., New York, NY
Art director/Designer: Louise Fili

GRAPHIC DESIGN SOLUTIONS

Figure 8-8

Book Jackets, "The Literature Experience"
Design firm: Carbone Smolan Associates, New York, NY
Designer: Leslie Smolan
Client: The Houghton Mifflin Company

The Houghton Mifflin Company, long regarded as the industry leader in reading textbooks, had recently lost ground to one of its prime competitors. With 65 percent of its revenue dependent upon reading, a lot was at stake. The company had a bold idea: the key to success was to reevaluate the role of design in its books.

The books translate the excitement of a bookstore into each volume by captureing the diversity and spontaneity of individual books. An array of page-turning devices makes the books playful, funny, and interesting, quite beyond the textbook norm. After the books were in production, we were invited to design the marketing materials and kindergarten packaging. The gamble seems to be paying off — the program is in use in all fifty states and sales represent 25 percent of the industry-wide reading text market.
—Leslie Smolan, Principal, Carbone Smolan Associates

John Chaffee's significant book, *The Thinker's Way*, offers eight steps to a richer life; the jacket design appropriately focuses on the number eight (Figure 8-9).

Brower's clever design for the *Feyman's Lost Lecture* book jacket combines a colorful graphic with a subtly colored photograph for an unusual effect (Figure 8-10).

Often, people think of a book jacket as just the front cover. The entire cover must be considered to be given due respect. Here are four intelligent and interesting examples of designs that address the book jacket, both front and back, as a continuous piece (See Figures 8-11, 8-12, 8-13, 8-14).

Figure 8-10
Feynman's Lost Lecture by David L. Goodstein and Judith R. Goodstein
Book Jacket
Design firm: Steven Brower Design, New York, NY
Art director: Debra Morton-Hoyt
Designer: Steven Brower
Client: W.W. Norton

I had a much better solution to this, with the title, subtitle, and author written on the blackboard, but the client selected this one where the lecture Feyman is giving comes to life.
— Steven Brower

Figure 8-9
The Thinker's Way by John Chaffee, Ph.D.
Designers: Michael Ian Kaye and Amy Goldfarb
Publisher: Little, Brown and Company

Figure 8-11

JFK by L. Fletcher Prouty

Design firm: Steven Brower Design, New York, NY

Art director/Designer: Steven Brower

Photography: Arnold Katz

Client: Birch Lane Press

Three entrance wounds in the back and three exit wounds in the front ripping through the American flag pretty much sum it up. Who done it? Damned if I know.

— Steven Brower

Figure 8-12

Walkin' The Dog by Walter Mosley

Publisher: Little, Brown and Company

Figure 8-13
Careless Love by Peter Guralnick
Publisher: Little, Brown and Company

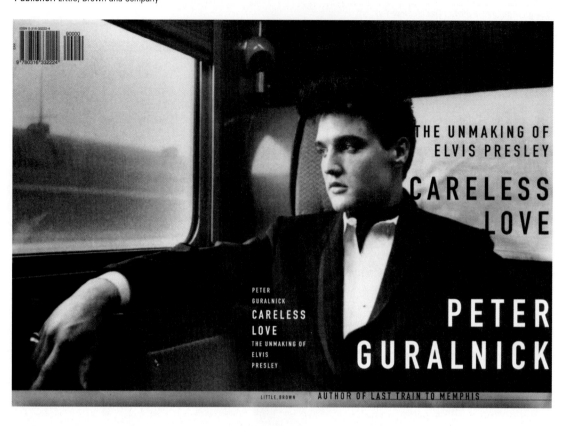

Figure 8-14
Assuming The Risk: The Mavericks, The Lawyers, And The Whistle-Blowers Who Beat Big Tobacco by Michael Orey
Publisher: Little, Brown and Company

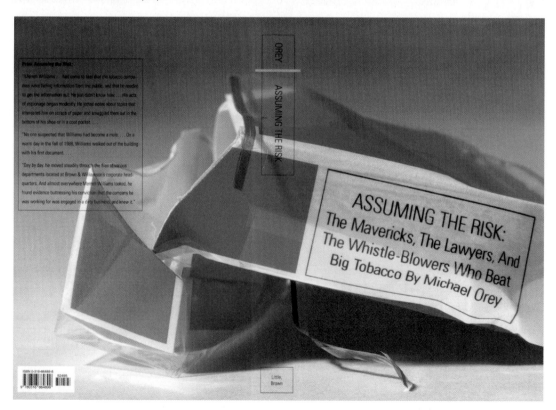

GRAPHIC DESIGN SOLUTIONS

When designing for a series, you must establish a "look" for the series, so people recognize the books as belonging together. A series should be identifiable as such. There should be visual similarities among the covers or jackets, for example, placement of the elements, type treatments, color, use of visuals. The author's name, book title, and visuals are usually placed in the same position on each jacket or cover, or with slight variations in position. Often, if one has photographs, they all do. If one is a purely typographic solution, they all are, as in these designs by Jo Bonney for a Grove Press series of William Burroughs' books (Figure 8-15).

Figure 8-15
Book Jacket Designs,
William Borroughs
Series
Designer: Jo Bonney
Publisher: Grove
Press, New York, NY

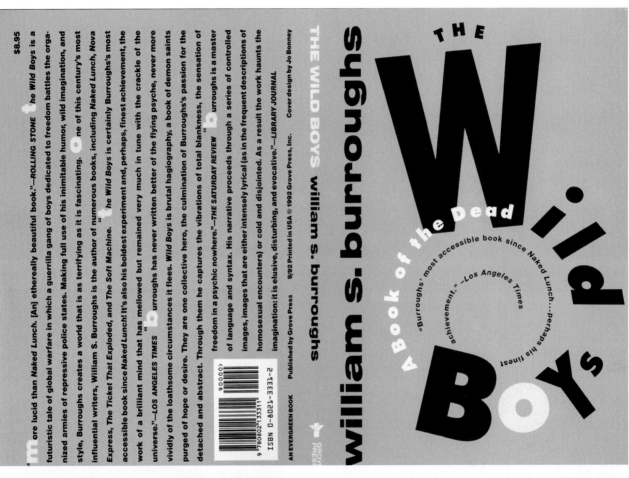

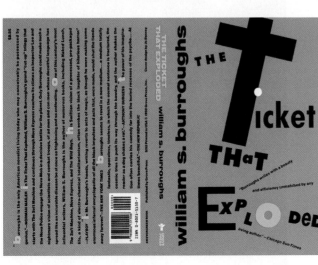

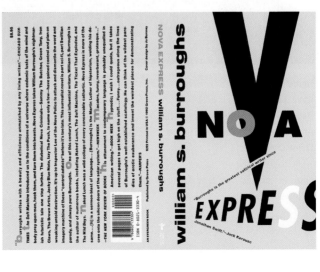

Similarly, Steven Brower used the same Indian rug motif and one photograph of Kahlil Gibran to tie this series together (Figure 8-16). Many designers are in favor of as much variety as possible within a series. Here, Brower establishes unity within the series, yet varies each cover so as to express the individuality of each book's content (Figure 8-17).

Figure 8-16

Kahlil Gibran, A Series of Book Covers forthe Spiritual Prose and Poetry Author

Design firm: Steven Brower Design, New York, NY

Art director/Designer: Steven Brower

Client: Citadel Press

I used an Indian rug motif to tie it all together.
— Steven Brower

Figure 8-17
Power Game by Perry Henzell
Watching by John Fergus Ryan
In Broken WigWag by Suchi Asano
Design firm: Steven Brower Design, New York, NY
Art Director/Designer: Steven Brower
Photographers: Langdon Clay (*Watching*)
Barnaby Hall (*Power Game*)
Astrid Myers (*In Broken WigWag*)
Client: Fox Rock Books

Three very different types of novels required a loose format to hold them together.
The triptych approach worked as a strong enough indicator that these worked
together and independently.
— Steven Brower

The covers should reflect the period and style of the music. It is important that the covers appeal to the appropriate listening audience. Remember: A wide variety of visuals may be used; you are by no means limited to using pictures of the recording artists. Go to music shops and analyze the different designs. You may want to design collateral materials for this project, for example, a CD or cassette booklet, a CD longbox, the CD itself, a promotional T-shirt, a website, or a poster.

EXERCISE 8-1
Analyzing book jackets and CD covers

- Find five examples of book jackets or CD covers that express the spirit or personality of their contents. Justify your choices.

PROJECT 8-1
CD and cassette cover design

Step I

- Choose a recording artist or group. Listen to the music.

- Find visuals that relate to the music and recording artist or group.

- Write an objectives statement. Define the purpose and function of this problem, the audience, and the information to be communicated. On an index card, write five adjectives that describe the music on this CD. Keep this card in front of you while sketching.

Step II

- Choose or invent a recording label and design a logo for it. Have a clear idea of the type of music recorded on this label. The logo should reflect the type of music recorded on the label or in the series. (See Chapter 6 on designing logos.)

Step III

- Design a compact disc cover (called a tray card) and a cassette cover (called a J card).

- The cover's design should include the recording label or series logo, name of the CD, and name of the recording artist.

- Your solution may be purely typographic or combine type and visuals. The visuals may be photographs of the recording artist or group or a visual related to the music's theme or spirit. The visuals should create or set a mood.

- Produce at least twenty sketches. Reminder: Design with any or all tools that are appropriate — computer, pencils, markers — but do not lock yourself into using one tool for all projects.

Step IV

- Create two roughs for each cover.

Step V

- Refine the roughs. Create one comp for each cover.

- It is advisable to buy a CD and cassette to see how your covers look in the plastic trays.

- You may use black and white or full color. **Optional:** Design inside booklets for the CD and cassette.

Presentation

The covers should be matted or mounted on 11″ x 14″ boards or slip them into CD and cassette containers.

The best way to begin is to read the books in order to have a clear sense of your subject. Your designs must reflect the writer's works. It is crucial for a designer to learn to do research and to learn to translate editorial content and ideas into graphic design. Like the poster series, each book jacket should be able to stand on its own, but also belong to the series. Any book in the series should be identifiable as such. There should be visual similarities among the books, for example, placement of the elements, type treatments, color, and use of visuals.

PROJECT 8-2
Book jacket design series

Step I

- Select three writers of short stories. Read their works. Research them. Ask a literary expert or professor about them.

- Write an objectives statement. Define the purpose and function of the problem, the audience for the books, and the information to be communicated. On an index card, write adjectives that describe the work of each writer.

Step II

- Name the series. Design a logo for the short story series. (See Chapter 6 on logo design.)

Step III

- Design three book jackets — one for each writer in your series. Design front covers only.

- The covers must be similar in style and yet express the individuality of each writer.

- The logo must appear on each jacket in the same position.

- Produce at least ten sketches for each jacket that could be expanded into a series format.

- Your solution may be purely typographic or it may include visuals.

- Think about the various ways the series could be tied together:

 - through the use of similar visuals: illustrations, graphics, photographs

 - through the use of a technique: woodcut, mezzotint, torn paper, xerography

 - through the use of typography

Step IV

- Refine the sketches. Create two sets of roughs for the series.

- Remember: Book jackets or covers are very much like posters — they must attract the potential consumer. They should have initial impact. Your book jacket design must compete against other books sitting next to it on a shelf.

Step V

- Refine the roughs and create one comp per book.

- The covers should be 6″ x 9″, held vertically.

- You may use black and white or full color.

Presentation

Each book jacket should be matted or mounted on a separate 11″ x 14″ board.

Packaging and Shopping Bags

- understanding the purpose of package design
- understanding the requirements of package design
- designing a package
- understanding the form and function of a shopping bag
- seeing shopping bags as part of a larger identity design system
- designing a shopping bag

Packaging

Packaging affects you more than you realize. If you walk into a store and see a package on display that is attractive, you pick it up. An attractive package can seduce you into purchasing a product at least once. A well-designed package can make an inexpensive product look expensive, and conversely, a poorly designed package can make a superior product look inferior.

In addition to its decorative, promotional formal display aspect, packaging is functional. A **package** encloses a product and it must function; it must enable you to pour from it, open it easily, reclose it, and so on. Although packaging is essentially a three-dimensional design discipline, the two-dimensional design on the surfaces of a package is an integral part of the overall impact. A package has several surfaces and all must be considered in the design. Most packages are displayed on shelves where we see the cumulative effect of several packages lined up next to one another.

Packaging is a specialized area of the graphic design profession. Package designers must be knowledgeable about a range of construction and technical factors. They must be familiar with materials and their qualities, like glass, plastic, cardboard, paper, and metal, and with manufacturing, safety, display, recycling, and packaging regulations, as well as printing.

The packaging design system for Barneys New York reflects the sophisticated image of the store (Figure 9-1). Using simple, legible uppercase letters, subtle colors, and a classic simplicity of design, art director Nancye Green and designers Julie Riefler and Jenny Barry convey an image of quality merchandise.

"A palette of warm colors adds to the desirable shelf presence, tempting the shopper to take a package of the coffee home with him/her. The high quality of the packaging graphics, made up of the blend of color palette and illustrations, yields a product that is a popular gift as well as a source of coffee for personal consumption," says Hornall Anderson Design Works of their packaging for Nordstrom Debut coffee (Figure 9-2).

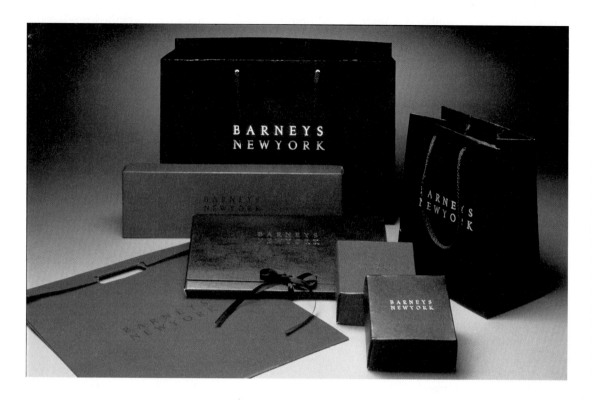

Figure 9-1
Packaging Design,
Barneys New York
Design firm:
Donovan and Green,
New York, NY
Art director:
Nancye Green
Designers: Julie
Riefler, Jenny Barry
Photographer:
Amos Chan
Client: Barneys
New York

Figure 9-2
Nordstrom Debut Coffee Packaging
Design firm: Hornall Anderson Design Works, Seattle, WA
Art director: Jack Anderson
Designers: Jack Anderson, Debra Hampton, Margaret Long, Heidi Favour
Illustrator: Celia Johnson
Calligrapher: Geri Anderson
Copywriter: Client
Client: Nordstrom

The packaging for Debut Coffee, a new Nordstrom branded product, was designed to be sold throughout their restaurants with Starbucks Coffee Company as the vendor. The packaging is designed to portray the cycle of a full day in which to enjoy the coffee blends. The packaging illustrations depict a morning scene with the sun coming up and the morning paper, in addition to a croissant. As the package rotates, the illustration changes to a scene of a midday coffee break. The scene continues to evolve, turning into evening, which includes coffee by candlelight beneath the crescent of a moon overhead.

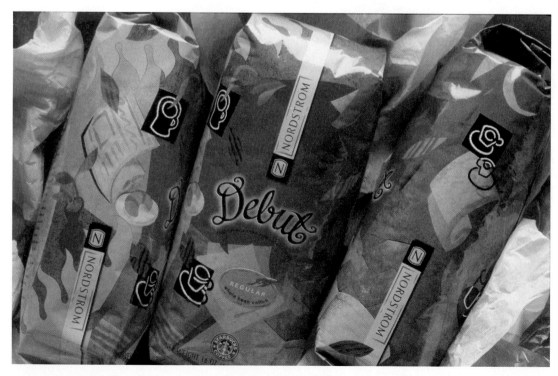

An important part of packaging is providing the consumer with information, as in this packaging design for Ensemble (Figure 9-3). "A combination of uniquely photographed products, a bright green border, package front text dotted with ingredient icons all signal a new entry and a new idea in consumer packaged foods," says Landor Associates of its Ensemble packaging.

The type and illustrations work very well together in this label and package design for the client HAM I AM, which produces sauces for pork, beef, and fish dishes as well as other food products (Figure 9-4). Color is an important design element. In the packaging of products like food, toiletries, and beverages, color often conjures up key associations.

Working with the strategy of "simple solutions with style," Landor created the new brand name "EverCare," and developed unique proprietary packaging structures and a dynamic graphic design flexible enough to work across Helmac's extensive product offering (Figure 9-5). The result is a synergistic branding system, which clearly positions Helmac as the leader in its category.

When asked, "How is your design a unique solution for your design objective?" slover [AND] company responded, "Typographic patterns incorporate the Saks Fifth Avenue name repeatedly.

Figure 9-3

Kellog's Ensemble Brand Identity

Design firm: Landor Associates, Branding Consultants and Designers Worldwide, San Francisco, CA

Creative director: Nicolas Aparicio

Design director: Christopher Lehmann

Designer(s): Christopher Lehmann, Julie Keenan, Brad Berberich

Kellogg's photographer: Richard Jung

Project manager: Jennifer Richardson

Consultant: Greg Warren

Production: Susan Steiner

Client: The Kellogg Company

The Kellogg Company created a new and unique concept for a food line to bring to consumers a line of great-tasting foods to be eaten throughout the day, foods that contain a natural soluble fiber that actively works to lower cholesterol. This new proposition, named Ensemble, was presented in a package designed to look like a dictionary definition, as though the product concept is being literally defined for consumers.

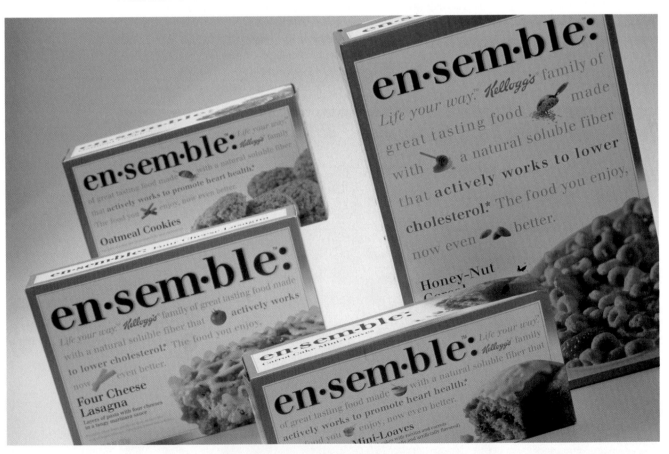

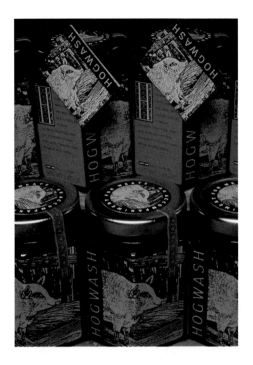

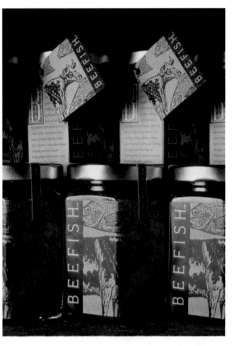

Figure 9-4

Hogwash Package Design

Design firm: SullivanPerkins, Dallas, TX

Art director: Ron Sullivan

Designers: Clark Richardson, Art Garcia

Illustrators: Art Garcia, Clark Richardson

Writer: Mark Perkins

Client: HAM I AM, Richardson, TX

Our client, HAM I AM, produces sauces for pork, beef, and fish dishes, as well as other food products. To keep with the upscale feeling and humor the client wanted, SullivanPerkins printed a kraft paper label with an old engraving of a hog. The labels and seals were printed with PMS colors red, kraft brown, black, and gold on adhesive stock.

— SullivanPerkins

Figure 9-5

Evercare Brand Identity

Design firm: Landor Associates, Branding Consultants and Designers Worldwide, San Francisco, CA

Creative director: Nicolas Aparicio

Design director: Carl Mazer

Designer: Anastasia Laksmi

Writer: Schuyler Brown

Photographer: Leigh Beisch

Client: Helmac Products Corporation

Helmac, a leader in the home and apparel care industry, decided to forge a bold position in the marketplace by making a unique fashion-forward packaging statement as innovative as their products. They challenged Landor with this task.

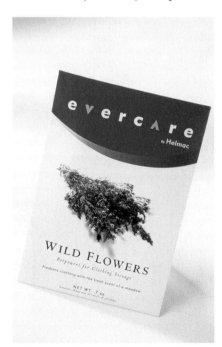

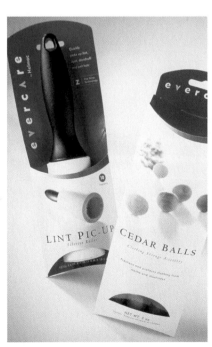

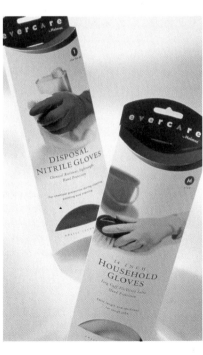

Private label packaging program for Saks Fifth Avenue's Gourmet Food Collection.

Objective: To create a strong Saks signature that would also accommodate an evolving product line.

The black S5A icon is used consistently to signify that this is an exclusive Saks product. Coordinated color palettes criss-cross and connect diversified food product categories at point-of-sale for the Gourmet Food Collection (Figure 9-6A), and coordinated color palettes in both product liquids and package design create strong allure at point of sale for the Spa Collection (Figure 9-6B)."

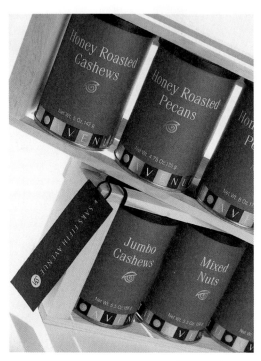

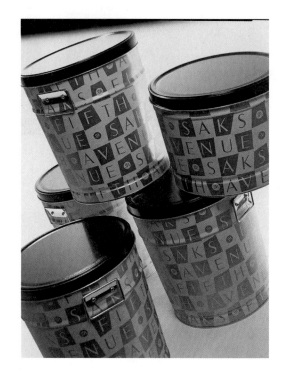

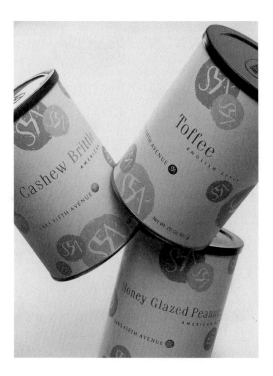

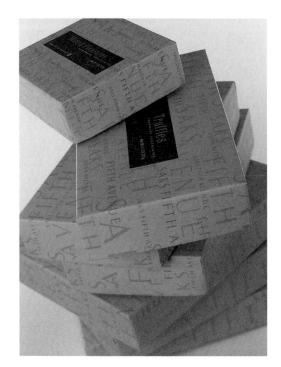

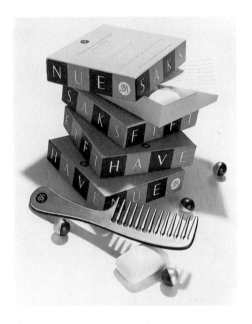

Figure 9-6B
Saks Fifth Avenue Spa Collection
Design firm: slover [AND] company, New York, NY
Client: Saks Fifth Avenue, NY

*Private label packaging program for Saks Fifth
Avenue's Spa Collection.*
 *Objective: To create a strong Saks signature
which would also accommodate an evolving product
line.*

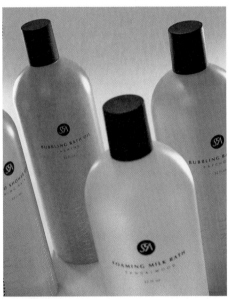

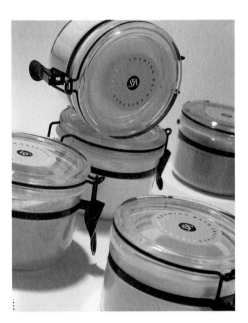

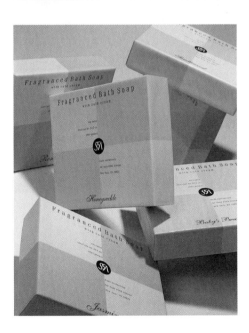

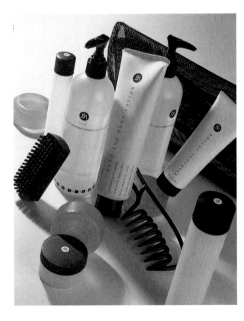

Figure 9-7
Package Design
Design firm:
Muller + Company,
Kansas City, MO
Client: Smartware

Figure 9-8
ACER Aspire Product Packaging,
Visual Identity Design
Design firm:
AERIAL, San Francisco, CA
Client: ACER Aspire

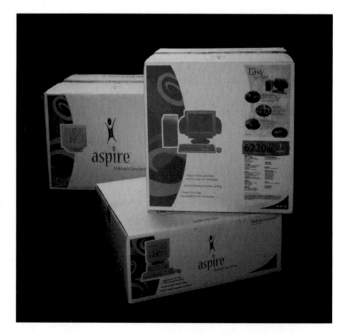

There are numerous software programs, each with a unique package design. The packaging for Smartware is intelligent and aesthetically pleasing; a colorful central square is the focal point of the design (Figure 9-7).

This packaging design for Aspire is a good example of a unified composition (Figure 9-8). Correspondence is established through repeating curves in the logo (little figure), the lower right-hand shape, and the large patterned shape on the left.

Health Providers Choice Packaging combines a linear illustration with typography and the color gray to create a brand look (Figure 9-9). Compare this to the whimsical design solution for Taboo (Figure 9-10) and you can see how a design solution must be appropriate for the product and client.

Figure 9-9

Health Providers Choice, Packaging

Design firm: Teikna Graphic Design Inc., Toronto, Ontario, Canada and Wycliffe Smith Design Inc.

Art directors: Claudia Neri, Wycliffe Smith

Designer: Claudia Neri

Client: Health Providers Choice

This line of packaging had to appeal to the medical profession. The product is not sold in pharmacies or drug stores — only through medical organizations. It also had to look upscale and elegant in keeping with its high price point. We used the Mercury symbol as a reference to the medical profession, and metallic ink to add a bit of luxury.

— Claudia Neri

Figure 9-10

Packaging for Taboo

Design firm: Sibley Peteet Design, Dallas, TX

Designer/Illustrator: Don Sibley

Client: Milton Bradley

The whimsical illustration and bright color blocks wrapping the box help portray the fun nature of the Taboo game. The simple, bold graphics are intended to grab attention on a crowded retail shelf.

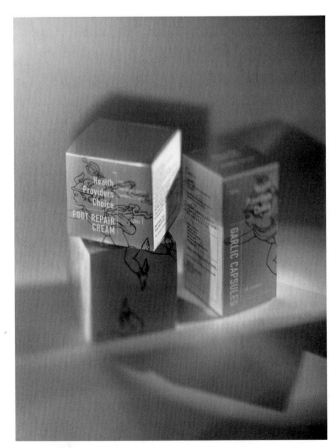

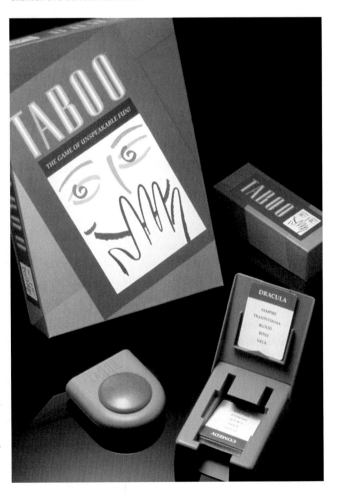

Chapter 9 Packaging and Shopping Bags

Figure 9-11

itcfonts.collection

CD-ROM and Kit Packaging

Design firm: DMA, Jersey City, NJ

Art director: Denise M. Anderson

Designers: Jenny Calderon/Denise M. Anderson

Copywriter: Jennifer L. Bohanan

Client: International Typeface Corporation

Being in the sometimes cluttered and colorful graphics industry, we went 180 degrees north and designed a minimal black, white, and red promotional identity for ITC. This "CD kit" housed a bright red disc with all ITC available fonts and a printed catalog in a vinyl case. Our intention was to create a simple, powerful, and recognizable image.
— Denise M. Anderson

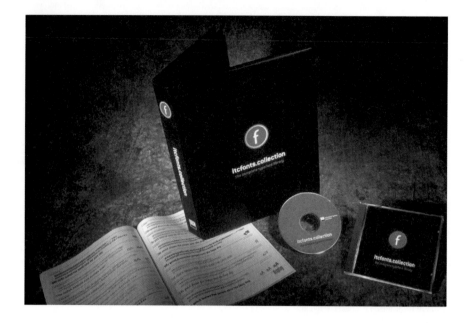

Figure 9-12

Anne Klein, Packaging, Identity

Design firm: Pentagram Design, New York

Partner/Designer: Paula Scher

Designer: Anke Stohlmann

Client: Anne Klein

The designers were commissioned to design a new identity for Anne Klein Co.'s rebuilt bridge lines. Previously known for 16 years as Anne Klein II, these lines will now simply be known as Anne Klein. The identity is comprehensive and used throughout all of the company's graphics, advertising, packaging, and retail display.

Anne Klein II's presence in the upscale women's clothing market had receded following the company's discontinuation of its collection level line. This designer collection had lost touch with Anne Klein's core consumer, and the bridge lines followed suit, resulting in a dilution of the company's identity.

The new identity elevates the brand through the use of a new logotype and reflective materials in packaging. The logotype is set in the bold, architectonic Trajan typeface, and displays a strong visual presence. The new logotype is an integral, structural part in each of the bridge line graphic identities, creating a cohesive and coordinated system that strengthens and refines the Anne Klein brand.

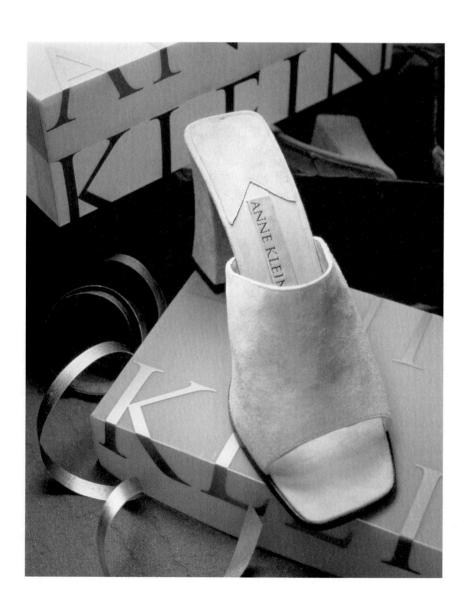

There are innumerable types of packaging. Here are several types of problems a designer might encounter: CD ROM (Figure 9-11), footwear boxes (Figure 9-12), toys (Figure 9-13), and wine (Figure 9-14).

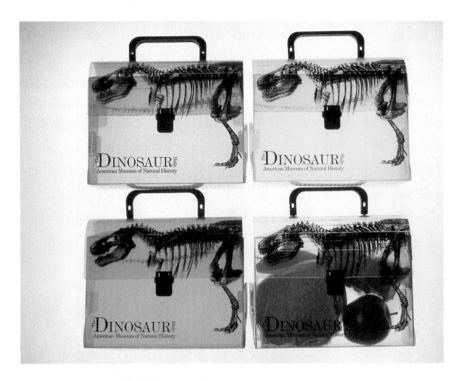

Figure 9-13
American Museum of Natural History
Dino Store Merchandise, Promotions
Design firm: Pentagram Design, New York, NY
Partner/Designer: Paula Scher
Designers: Lisa Mazur, Jane Mella
Client: American Museum of Natural History

Pentagram has been responsible for the New York museum's comprehensive graphic identity program, including a new logotype, printed materials, promotions, merchandise, and directional and exhibition signage. The reopening of the Dinosaur Halls inspired a new line of retail merchandise, which has contributed to a surge in profits for the institution.

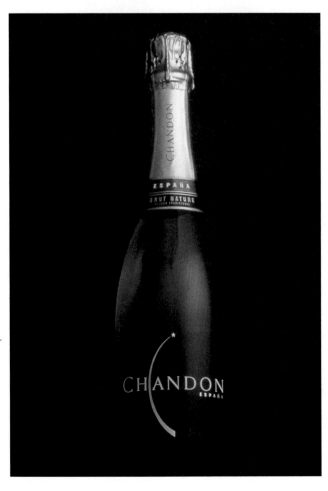

Figure 9-14
CHANDON
Design firm: Landor Associates, Branding Consultants and Designers Worldwide, San Francisco, CA
Creative director: Nicolas Aparicio
Design director: Chris Lehmann
Designers: Chris Lehmann, John Kiil
Client: Chandon Estates

Chandon Estates, which produces sparkling wine in five countries, did not convey the unified message of a truly global company in its packaging. A system was created that established a consistent presentation of the Chandon brand across all countries while allowing for country, flavor, and price point differentiation. It was also important that the new brand expression convey an "edgy elegance" that positions Chandon apart from traditional champagne and sparkling wine cues.

Figure 9-15

Identity System for Burlington Industries "esenzia"

Waterfall fabric selectors; tools for the trade; market invitation using macro-photography by Craig Cutler; showroom environment Touch Kits.

Design firm: slover [AND] company, New York, NY

Client: Burlington Industries, New York, NY

When America's largest mass manufacturer of fashion textiles wanted to embrace the luxury market, it needed a completely different product and selling approach. Slover [AND] company named the collection "esenzia" and developed selling tools and an enviroment that visually — and viscerally — reinforced the essential character of the collection. The result was a soft selling approach that produced cold, hard sales in a flat-end market.

Touch Kits — hand-sewn from textured papers and closed with a button and leather thong — were given to fashion editors and designers to reinforce the essential selling message.

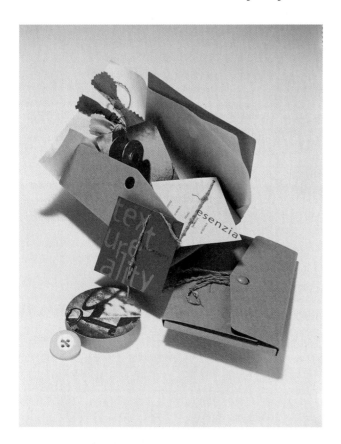
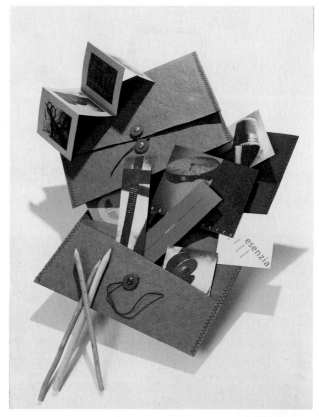

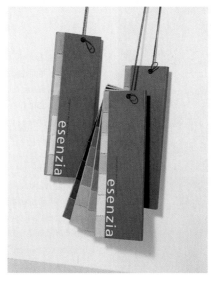

Often packaging is part of a larger identity system including branding and marketing strategies, as in this extensive design solution for Burlington Industries' new product "esenzia" (Figure 9-15)

Hangtags are part of packaging. In some cases, a hangtag is the only identification for a product, for example, this thoughtful design by DMA for Aris (Figure 9-16).

Figure 9-16
Aris Women's Leather Gloves Hangtags
Design firm: DMA, Jersey City, NJ
Art director: Denise M. Anderson
Designers: Laura Ferguson/Denise M. Anderson
Photographer: Greg Leshé
Client: Aris Isotoner

The objective of this project was to create a system of hangtags that distinguished the linings of a new line of high-end women's leather and suede gloves. Since the Aris name was being introduced without "Isotoner," a large letter "A" was designed in front of a neutral, fashionable purple/blue color. These elements created a cohesive look among all the tags and created brand identification. Photos were then shot creating a "feel" of the inside lining. Each image was then colored with a complementary palette of duo and tritones.

SUGGESTIONS

A package sitting on a shelf is in visual competition with the products sitting next to it. It must be attractive, legible, and appropriate for its audience and marketplace. Your objectives when designing a package are:

- to make it functional
- to be able to make a mock-up
- to research materials and construction
- to be aware of recycling and wastefulness
- to be aware of packaging as both a three-dimensional and a two-dimensional design problem
- to consider all sides of a package in the design
- to design an attractive, aesthetically pleasing piece that is appropriate for its intended audience
- to make it work with a larger visual identity system (if applicable)
- to ensure legibility and clarity

- to research the competition
- to make it stand out from the competition
- to consider it will be seen in multiples when on display
- to express the spirit or personality of the product and company or store
- to consider the appropriate color associations
- to coordinate it in color and design with other flavors or choices in a product line
- to identify its manufacturer, product name, contents, weight, and provide any other pertinent information

Shopping bags

Most people will use a shopping bag more than once, especially people who are environmentally conscious. The more unique, sturdy, and attractive a bag, the more likely consumers will use it over again. Think of a shopping bag as a portable store display.

There are no standard sizes for shopping bags, and although paper and plastic is used most often, other materials are suitable, such as cotton or burlap. The main thing to remember is aside from being attractive, a **shopping bag** must be functional — it must hold things. Bags often are designed in several sizes; proportions should be considered in relation to function and aesthetics.

Your choice of materials, your design of the bag, and what is on the bag all should be dictated by the design concept. Often, a shopping bag is part of a larger marketing strategy and is linked to other graphic design materials, like boxes, packaging, signage, or displays. If this is the case, the designer must coordinate everything in terms of design concept, style, colors, visuals, and type. In this design for Takashimaya, a complete packaging program was created (Figure 9-17).

This shopping bag for Strathmore's new paper grade, Renewal, is part of a promotional campaign to launch the product (Figure 9-18). Designframe Incorporated created several pieces, including a book, *Seeing: Details*, and sample boxes, as other parts of this colorful promotional design solution.

The SullivanPerkins design firm created this bold and contemporary shopping bag design for a mall (See Figure 9-19).

Figure 9-17
Takashimaya Retail Packaging Program
Design firm: slover [AND] company, New York, NY
Client: Takashimaya, NY

Objective: To create a collection of bags and boxes that reflect the store's East/West influence.

How is your design a unique solution for this objective?
Slip-sleeve boxes with end-locking devices/symmetrical lids and shapes/unique triangular shipping bags/hand-combed silk tassels/recycled paper with long fiber for lastability.

Are there any anecdotes that you think are appropriate to include about this project?
Triangular shopping bag is reordered more than any other shape and has become a street status symbol.

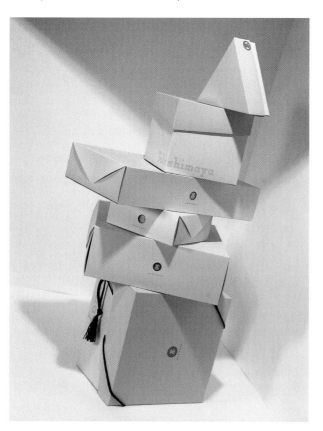

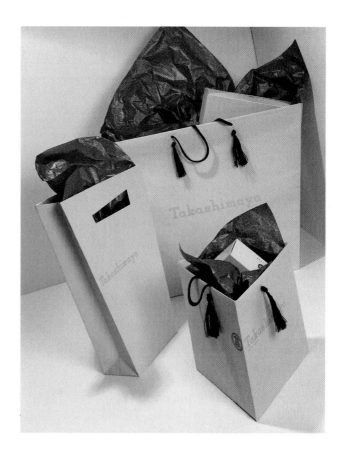

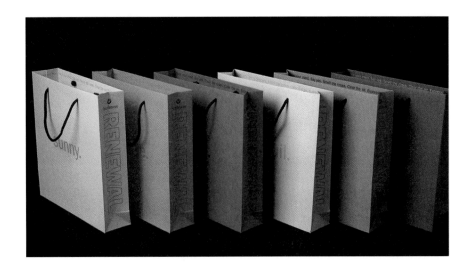

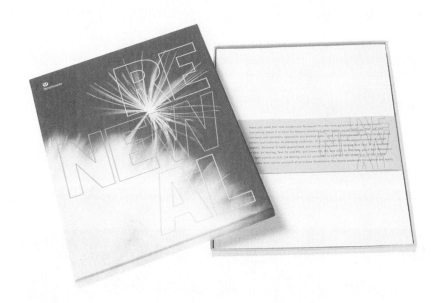

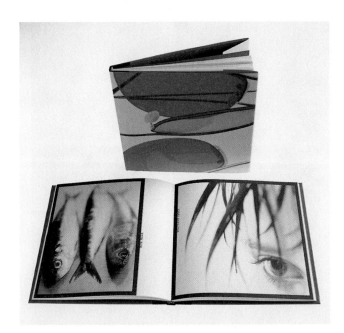

Figure 9-18

Renewal Promotional Campaign, pictured are: Renewal shopping bags, a Renewal sample box, and *Seeing: Details,* a book.

Design firm: Designframe Incorported, New York, NY

Client: Strathmore Papers

The unexpected is often revealed in details—this is the premise of Strathmore's latest publication Seeing: Details. *It's the second in a series from Strathmore examining the rich results achieved using traditional printing techniques and Strathmore's uncoated printing papers.*

While the first book of the series, Seeing: Doubletakes, *featured Strathmore Elements, this second volume features a selection of Strathmore Renewal stocks.*

Seeing: Details is a collection of images from 30 of today's most prominent photographers. Accompanying text runs through the book and reminds the reader of the beauty and value of seeing the details.

The discussion topic for Seeing: Details *is the importance of a thoughtful and thorough color separation process.*

— Designframe Incorporated

SUGGESTIONS

The logo or company name need not be the main visual on a bag. Anything can work as long as it is a sound design concept. Here are objectives to keep in mind when designing a shopping bag:

- design a bag that is easily folded
- design a sturdy bag with handles
- consider all sides of the bag in the design
- create a pleasing, interesting, functional shape
- coordinate it with any other graphic design material in the visual identity system
- express the store or company's spirit or personality
- think of it as a promotional display, kind of a walking billboard

Figure 9-19
Shopping Bag, NorthStar Mall
Design firm: SullivanPerkins, Dallas, TX
Art director: Ron Sullivan
Designer: Linda Helton
Client: The Rouse Company, San Antonio, TX

We have done shopping bag designs and other design and advertising for this San Antonio shopping center for some years. The "N and Star" motif was developed for a series of shopping bags so well liked, they replaced the mall's logo and now apear on letterhead and other identity items.
— SullivanPerkins

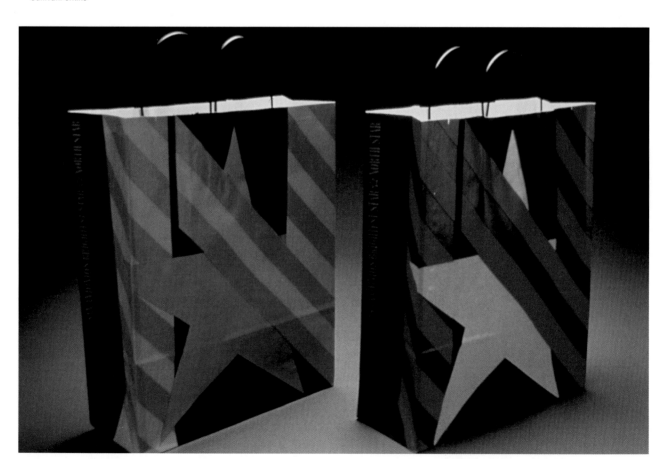

When you create a package for a food or beverage, it must be visually appetizing. Your objective is to create an attractive, functional, and legible design. Since the products are of gourmet quality, the packaging should look upscale. Make sure the line of packages has a similar style, that they look like they belong to the same group, and that they have similar distinctive characteristics. Consider how they will look next to one another on the shelf and next to the competition.

EXERCISE 9-1
Redesign a package

- Choose a low-priced (not the top-of-the-line brand) packaged product, such as a box of pasta or a package of cookies.
- Analyze the package design.
- Redesign the package so it looks expensive or upscale.

PROJECT 9-1
Create a package design for a gourmet snack food

Step I

- Invent a brand of gourmet nuts or snacks. (See Chapter 10 on inventing a brand name.)
- Research similar products.
- Find examples of gourmet food packaging.
- Write an objectives statement. Define the purpose and function of the packaging, the audience, and the information to be communicated. On an index card, write two or three adjectives that describe the line. Keep this card in front of you while sketching.

Step II

- Design a minimum of two packages for a line of gourmet nuts or snacks.
- The packages should include the following information: logo, brand name, and flavor.
- Design a logo. (See Chapter 6 on logo design.)
- Your solutions may be type only or type and visuals
- Produce at least twenty sketches.

Step III

- Produce at least two roughs for each package before creating a preliminary mock-up (a three-dimensional piece).
- Create a preliminary mock-up of one package to see how it will look in three-dimensions. **Optional:** Design an individual snack packet.

Step IV

- Create a finished mock-up for each package.
- The size of the package should be similar to the sizes of other products in its category.
- You may use two colors or full-color

Presentation

Create actual size mock-ups of the packages.

You should carefully consider your subject and audience. A package designed for a computer company would be markedly different than one for an on-line cosmetic company. Similarly, different types of computer companies might appeal to different audiences and therefore would be designed differently — for example, Macintosh versus Dell.

PROJECT 9-2
Design a packaging system for a computer mail-order company based on the world wide web.

Step I
- Invent a computer mail order company located on the world wide web.
- Research real computer mail order companies on the world wide web.
- Write an objectives statement. Define the purpose and function of the company, the audience, and what you have to communicate. In one sentence, define the spirit of the company.

Step II
- Invent a name (it should have ".com" at the end of it). Design a logo for the company. (See Chapter 6 on logo design.)

Step III
- Design the packaging system, including a shopping box, label, product box.
- The package should include the logo.
- Produce at least twenty sketches. *You should have, at minimum, three distinct ideas.*

Step IV
Create roughs and a preliminary mock-up.

Step V
- Make necessary changes and go to a finished mock-up.
- For your portfolio, have a good quality photograph taken of this project.

Presentation
Photograph of mock-ups mounted on black board.

comments

Whichever type of specialty company you choose, make sure the design concept is appropriate for the audience. You should try to avoid visual clichés, for example, type for a Chinese food store does not have to look like type from the Far East. Sometimes using unexpected type or visuals, or making a connection between unusual elements, makes something unique. Note: Although most design solutions can be executed on the computer and printed on a laser printer, some projects require hand skills, for example, cutting, gluing, and building. It is important not to lose touch with hand skills.

EXERCISE 9-2
Analyzing shopping bag design

- Find five examples of shopping bags for specialty stores.

- Analyze their designs and be aware of their materials: figure out the designer's objectives and design concept.

PROJECT 9-3
Design a shopping bag and box for a food store or company

Step I

- Find or invent a specialty take-out food or catering company. Invent a name.

- Research your client. Find out what makes them special or different.

- Write an objectives statement. Define the purpose and function of the bag and box, the audience, and the information and image to be communicated. On an index card, describe the image of the company or store in two adjectives.

Step II

- Design a logo for the client. (See Chapter 6 on logo design.)

- Your solution may be type only or type and visuals.

- Produce at least twenty sketches, including three different ideas.

Step III

- Design a shopping bag and box for a specialty take-out food or catering company.

- Produce at least two roughs.

- Create one preliminary mock-up to see how it will look.

Step IV

- Create finished mock-ups of the bag and box.

- Use as many colors as you like.

- The maximum size for the bag is 16″ x 18″. The box should easily fit in the bag.

Presentation

Photograph of the mock-ups presented on black board.

chapter
10

Visual Identity and Branding

OBJECTIVES

- comprehending the meaning of a plan that coordinates every aspect of graphic design material
- understanding the objectives of a visual identity system and its component parts
- being able to design a visual identity system
- understanding the nature of branding

Visual identity

When your local department store mails announcements to you about sales and special offers, they also are sending messages to you about the type of store they are and the type of customer they aim to please. The design of their logo, stationery, brochures, mailers, and shopping bags, product identification, and their own brand labels are all part of a larger plan. That plan is a **visual** or **corporate identity** system or program — a master plan that coordinates every aspect of graphic design material.

A visual identity system integrates every aspect of a company's graphic design including typography, color, imagery, and its application to print and television. Continuity must be established among the various designs in a visual identity system. There must be a "family resemblance" among the designs. Of course, you can have a certain level of variety and still maintain visual unity. The identity and graphics system for the International Design Center of New York, 1983-1989, includes graphics, invitations, publications, advertising, and signage (Figure 10-1). Vignelli Associates used Bodoni type and a limited color palette emphasizing black and red.

Most designers prepare a **graphics standard manual** that guides the client in the use of the identity system detailing the use of the logo, colors, and other graphics and imagery. This may seem stringent and restrictive, but it demonstrates just how crucial graphic design is to a client's image and success. Richard Danne was design director of the visual identity program for the National Aeronautics and Space Administration, Washington, D.C. (Figure 10-2). A comprehensive 110-page graphic standards manual was developed, designed, and written that included paint schemes for aircraft, the Space Shuttle, and other space vehicles as well as graphic systems for all publications, signage, forms, and media.

Figure 10-1
Identity and Graphics Progaram for the IDCNY
Design firm: Vignelli Associates, New York, NY
Designers: Massimo Vignelli, Michael Bierut
Client: International Design Center of New York,
Long Island City, NY

*IDCNY, the International Design Center of New York,
is an international furniture merchandise mart in
Long Island City. The logo portrays elegance and
strength by the choice of two contrasting typefaces.
The program includes graphics invitations,
publications, advertising, and signage. Based on
three very basic elements — Bodoni type with black
and red colors — the program is nevertheless
extremely articulated and vibrant, and has achieved
a very strong identity often imitated by similar
organizations.*
— Vignelli Associates

Figure 10-2
NASA Graphics Standards Manual
Design firm: Danne & Blackburn Inc.,
New York, NY
Design director: Richard Danne
Client: National Aeronautics and Space
Administration, Washington, DC
Material supplied by Richard Danne &
Associates, Inc., Eastham, MA

*A United States government agency dedicated to
aeronautics research and space exploration, NASA is
headquartered in Washington, DC, with ten
individual centers across the nation.*

*The firm of Danne & Blackburn Inc. was
selected to develop and design a unified visual
communications program for the agency. The
acronym NASA was more recognizable than either
the full name or its previous symbol. Building on this,
the NASA logotype was developed. A system was
devised that incorporates the logotype and sets
standard configurations for the full agency name and
the various centers.*

*This program was honored with one of the first
Presidential Awards for Design Excellence.*
— Richard Danne, Richard Danne & Associates

Figure 10-3
Levi's SilverTab
Graphic Identity
System
Design firm: Michael
Mabry Design, San
Francisco, CA
Advertising agency:
Foote Cone & Belding
Client:
Levi Strauss & Co.

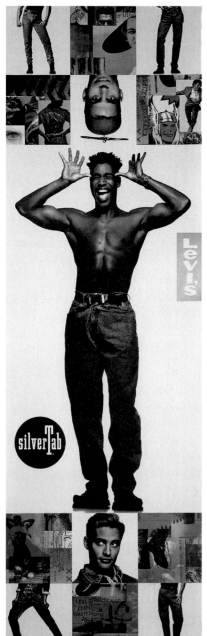

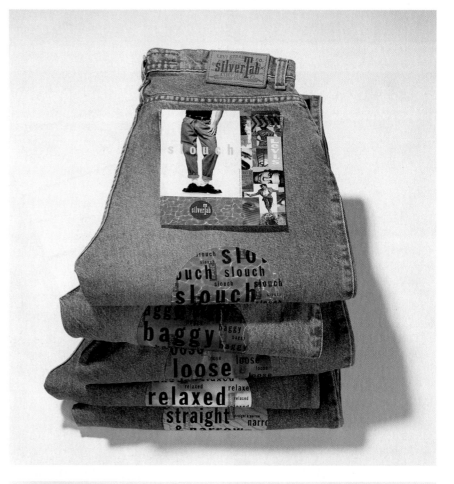

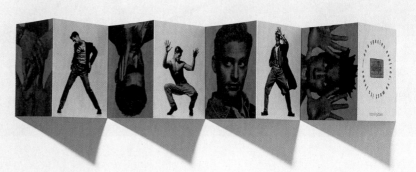

When designing an identity system, you must know your audience. Clearly, this identity system developed for Levi's SilverTab Jeans is aimed at a young audience (Figure 10-3). The models' poses, the use of patterns, collage, photomontage, and the contemporary typography all work together, contributing to the hip spirit of the visual system.

This corporate and brand identity and product packaging for Food Services of American communicates a high level of quality and service (Figure 10-4). The design is made up of a "kit of parts" that allows it to be reproduced in a variety of methods on a variety of surfaces.

SUGGESTIONS

Creating a visual identity system is an extensive design project and you will need a list of criteria to keep in mind. Your objectives are:

- coordinating all of a company's graphic design material

- establishing an image for the company

- expressing the personality or spirit of the company

- creating an appropriate design for the client

- creating a system that is flexible enough to work in a variety of applications

- creating a system with a long life span

- creating a system immediately identified with the company

- creating a system that will stand up against the competition

Figure 10-4
Corporate and Brand Identity and Product Packaging
Design firm: Hornall Anderson Design Works Inc., Seattle, WA
Designers: John Hornall, Jack Anderson
Client: Food Services of America, Seattle, WA

Because of a name change, the client was faced with new packaging. The overlapping, rich images on the can are interchangeable, allowing for diversity and individualization of contents. The color system of teal, red, and gold clearly delineates product levels and is easy to identify in crowded low-lit warehouses.
— Christina Arbini, Marketing Assistant, Hornall Anderson Design Works

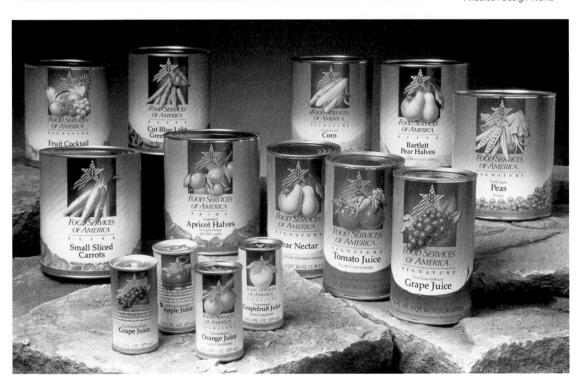

The elegance of the LS Collection of fine objects for the home is expressed through James Sebastian's minimalist use of type, choice of textured paper, exquisitely lighted photography, and of course, layout (Figure 10-5).

For the corporate identity created for the Hotel Hankyu (Figure 10-6), Pentagram Design developed a system of six stylized flower symbols, a custom alphabet, a coordinating color scheme, and decorative motifs. The program expresses luxury by differentiating each item in the hotel with special detailing. Applications include signage, room folders, stationery, labels, menus, and amenity packages for male and female guests.

Mastandrea Design created this branding program and signage for Loft Store (Figure 10-7). Visual and color juxtapositions communicate a polished yet light spirit.

Figure 10-5
LS Collection Identity System
Design firm:
Designframe Inc.,
New York, NY
Client: The LS Collection,
New York, NY

The elements of the LS collection were created to reflect the design and personality of the store, incorporating the corporate mark and copper color.
— James A. Sebastian, President, Designframe Inc.

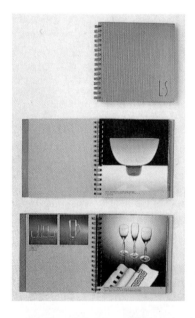
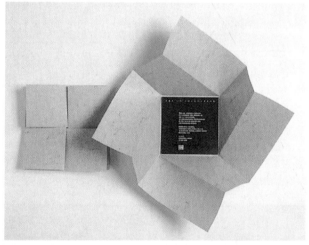
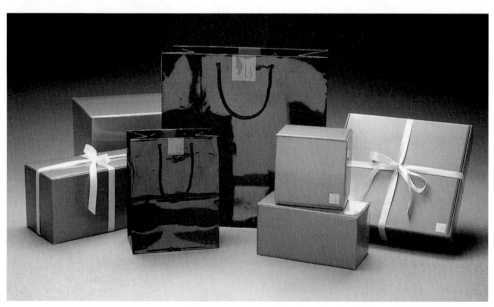

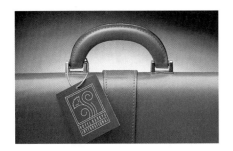
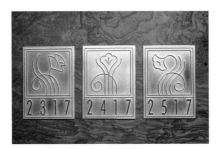

Figure 10-6
Identity and Packaging
Design firm: Pentagram Design Inc., New York, NY
Partner: Colin Forbes
Associate/Designer/Typograher: Michael Gericke
Designer: Donna Ching
Illustrator: McRay Magleby
Interior design: Intradesign, Los Angeles, CA
Client: Hotel Hankyu International
Produced with: OUN Design Corporation and Dentsu Inc.

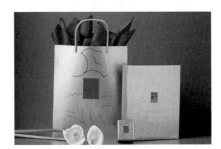

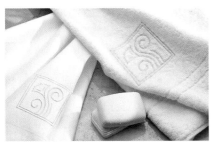
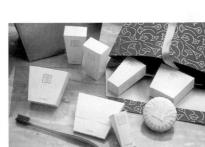

In a reversal of the usual procedure, the client comissioned the identity program before any other design project, and the graphic elements were used to guide development of the hotel's interior design and architecture. Pentagram New York coordinated the project with the client, consultants, and promotional advisers in Osaka as well as the Los Angeles-based interior designers.

Hankyu specified a distinctive emblem that would communicate quality, internationalism, and the "universal appeal of flowers." The visual concept is a modern interpretation drawing upon the glamour of steamer trunk labels from the art deco era. The program also expresses luxury by differentiating each item in the hotel with special detailing. Applications include signage, room folders, stationery, labels, menus, and amenity packages for male and female guests.
—Sarah Haun, Communications Manager, Pentagram Design

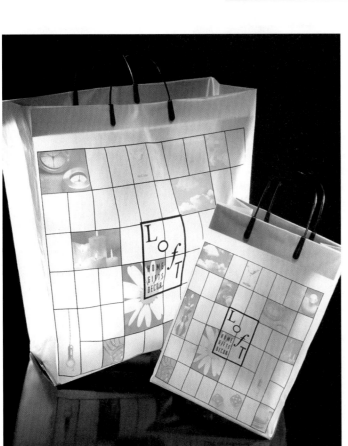

Figure 10-7
Loft Branding
Design firm: Mastandrea Design, San Francisco, CA
Art director/Designer: MaryAnne Mastandrea
Loft is a retail store offering innovative home furnishings targeted to the upscale consumer. The inspiration for Loft's brand identity came from the windows in our design studio. Our studio is in a 1920s loft building that features large windows sectioned into smaller panes of glass framed in black steel. By designing the Loft brand as a windowpane, I created a flexible system that can vary in size and use both product and conceptual images. The photos fit within and break out of the individual panes to add visual interest. This flexible approach keeps the brand fresh and conveys a sense of variety and style. Similarly, the shopping bags and business cards are printed on translucent plastic to simulate windowpanes.
— MaryAnne Mastandrea, Mastandrea Design

Figure 10-8
Muzak Identity
Design firm: Pentagram Design Inc., San Francisco, CA

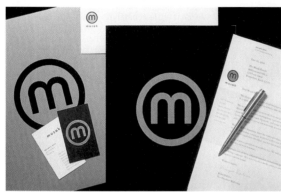

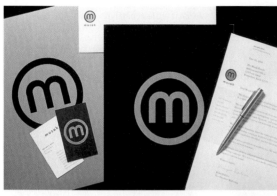

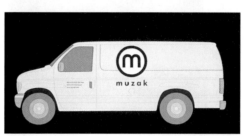

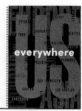

Figure 10-9
Z Contemporary Cuisine Menus
Design firm: Nesnadny + Schwartz Inc.,
Cleveland + New York + Toronto
Creative directors/designers: Joyce Nesnadny,
Mark Schwartz
Writer: Zachary Bruell
Photographer: Tony Festa
Client: Z Contemporary Cuisine

The client required a system of lunch, dinner,
dessert, and wine menus for a newly opened
restaurant. The design system had to reflect the
unique character of the physical space as well as the
inventive nature of the menu offerings. At the same
time, the entire system had to accommodate daily
updates to the content of the menus. We proposed a
system of menu covers that utilized a relatively
minimal design/color approach. The interiors
employed a more vibrant color palette as well as a
pattern of photographic images of food. All of this
was linked conceptually through the use of various
graphic permutations of the letter Z.
— Mark Schwartz, Nesnadny + Schwartz

GRAPHIC DESIGN SOLUTIONS

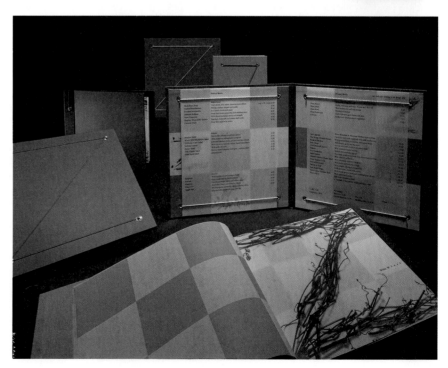

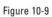

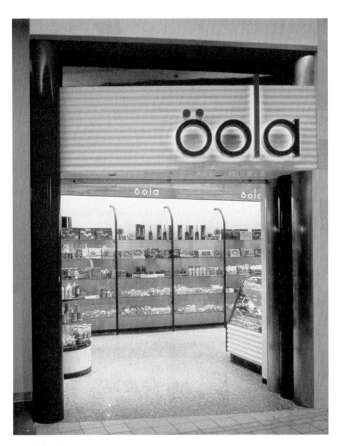

Pentagram's design solution for Muzak is comprehensive and memorable (Figure 10-8). The "Z" in the menu design and graphic identity system for Z Contemporary Cuisine is the focal point (Figure 10-9). Although there are several interesting variations of the "Z", its use as the focal point maintains an identifiable image.

The shapes and colors in this Paula Scher design for Öola, a chain of Swedish candy stores located in American shopping malls, project a fun-loving and playful image (Figure 10-10). Without being illustrative, its colorful positive and negative shapes almost look edible — like candy.

Some of the basic applications for a visual identity system are logos, stationery, packaging covers, editorial materials (folders, brochures, newsletters, annual reports), advertising, posters, signage, promotionals, invitations, and shopping bags.

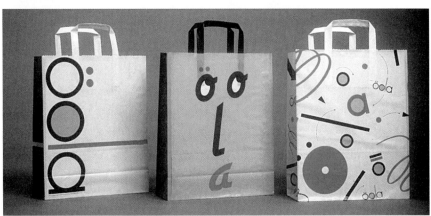

Figure 10-10
Öola Identity, Packaging, T-shirt, Poster, etc.
Design firm: Pentagram Design Inc., New York, NY
Partner/Designer: Paula Scher
Client: Öola Corporation, Boston, Philadelphia, New York, Washington, DC

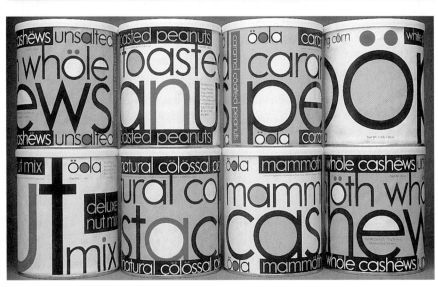

Öola is a chain of Swedish candy stores in American shopping malls. The company intended to enter the U.S. market under the name "Sweetwave," but when Paula Scher was commissioned to design their retail identity, she expressed a concern that the name would not be interesting enough to American consumers. Scher recommended playing up the company's European origins with a new name and a bright clean graphic look.

The word "öola" was invented and became the basis for the stores' entire visual identity. Öola was chosen for its Scandinavian sound, geometric letterforms, and the umlaut, which has become a central motif in graphic applications.
*— Sarah Haun, Communications Manager
Pentagram Design*

Turn your brand into an icon!

In the United States, there was a time when you bought crackers from a cracker barrel and flour from a bin. After the Civil War, trademarking and packaging became common with brands like Quaker Oats, Campbell's Soup, and Borden's Eagle Condensed Milk. During the 1950s, due to changes in the scope of corporations, visual identification systems and logos became crucial to a company's marketing message.

In today's marketplace, where, in almost all cases — there is more supply than demand *and* several brands in each product or service category *and* the world wide web is a new means of establishing brands — it is vital to a company's marketing strategy to establish a brand for their product or service.

Branding is a product or service's identity in the marketplace. A brand is a mixture of visual identity, advertising, and marketing, with emphasis placed on the logo, consistency of the visual identity, and the uniqueness and marketability of the product name. Businesses use brands as a way of establishing their foothold in a product category. If you have any doubts about how important a brand name is, just think of the power of Levi's, Xerox, or Band-Aid; we use these brand names as a generic reference to the category!

To establish a new brand, a designer and client must invent a product name. Once the name is invented, then the designer creates a logo and visual identity system, which could include a variety of design applications — from stationery to environmental design to packaging to truck signage. Then, advertising is created for the brand. Establishing consistency for brand use is vital; standards manuals are an imperative.

Designers are also faced with the challenge of reinventing a brand, renaming a brand, and/or redesigning a brand logo and visual identity. For example, Federal Express changed its name to FedEx to establish it as an international company. Esso was changed to Exxon, a more modern name with strong sounding "x's" to represent all of the parent company's new holdings. USAir was changed to US Airways to establish the brand as a global carrier because most people associate the word "air" with commuter airlines.

Inventing a company name

- The name should be appropriate for the client's product or service.

- The name should communicate the client's spirit or personality.

- The name should be memorable and creative. That is: edgy, fresh, funny, sweet, clever, colorful, or whatever makes sense for the product or service.

- The name could convey the product's or service's unique selling point.

- The name should have a long life span.

- If the company is national or international, the name should fit the status.

- If the brand is international, the name should be adaptable to foreign markets.

- Keep in mind any brand extensions, that is new products with the same brand, for example the variety of Arm & Hammer products including baking soda, toothpaste, deodorant, and cat litter.

Tips

- Think about using a metaphor.

- Brainstorm all words and things related to the product or service. Categorize the brainstorming list. Choose one in each category. Write three or four variations on each.

Landor Associates Branding Consultants and Designers Worldwide created this brand identity and environmental design for A.G. Ferrari (Figure 10-11). Warm earth colors appeal to our sense of taste, creating the feeling that the foods are delicious.

After defining the target audience, Liska + Associates worked with Revlon to develop a complete branding program, including all promotional materials. They established a visual language that defines the product as pure and simple. As a part of this language, the packaging parallels the clarity and neutrality of the line's vegetable-based contents (See Figure 10-12).

Figure 10-11

A.G. Ferrari Brand Identity and Environmental Design

Design firm: Landor Associates Branding

Consultants and Designers Worldwide

Client: A.G. Ferrari

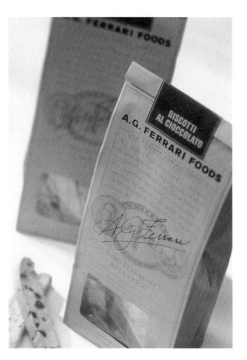

Figure 10-12

mop modern organic products Image Brochure

Design firm: Liska + Associates Inc., Chicago/New York

Client: mop modern organic products

As part of its complete branding program for mop, Liska + Associates created a comprehensive brochure and product overview to define the brand and support the line. These materials instantly define the mop product line to encourage recognition among salon owners, stylists, and patrons. A minimal image style reduces the products to the most basic elements — their natural ingredients. The promotional materials feature models intended to appeal to a targeted range of consumers seeking products that are part of a healthy lifestyle. To accompany mop's marketing materials, Liska + Associates designed a dealer kit for product promotion. The kit functions as both a sales tool for product representatives and as a trial for salon owners interested in the mop line. Its packaging is designed to resemble an egg carton and is constructed of similar material, referring to the line's natural, vegetable-based origin. The self-contained package includes small sample bottles of the mop product line, along with a product brochure explaining the samples.

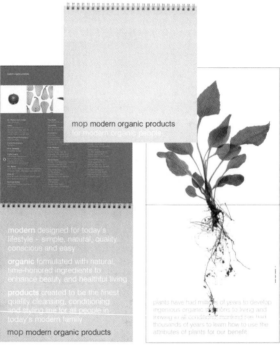
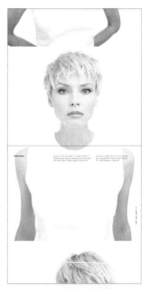
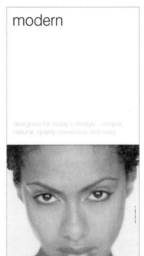
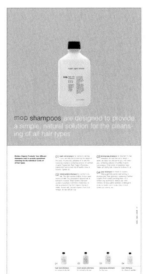

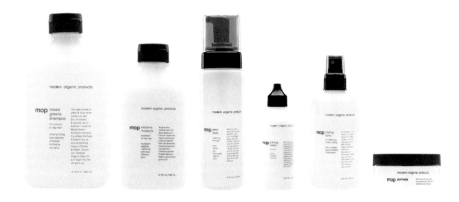

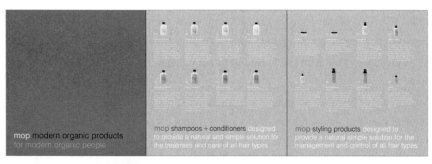

The foundation of an identity system is the logo. Your logo should establish the store's image and express its personality; it should also be flexible enough to be used in a wide variety of applications, such as packaging and store promotion. All the other pieces should continue in the same direction as the logo; they should enhance the store's image, making their products seem unique and superior to the competition. This project allows you to create a comprehensive identity for a store — from its marketing strategy to its packaged goods. It demonstrates your ability to be consistent yet creative.

This is a difficult and involved assignment. It demonstrates to potential employers your ability to formulate a strategy and design concept and follow it through with several design applications. The experience and knowledge gained here can be applied to any identity system. If your solution to this project is successful, it could be one of the most important pieces in your portfolio.

Designing a logo, or an entire visual identity system, is a creative activity, but do not forget the bottom line. To persuade, identify, and inform — these are the goals of the graphic designer. If you can create a design that communicates to a mass audience and has graphic impact and is creative, you are designing.

This is a multi-faceted project. Once you have completed it, keep going. Do variations of it. Create another visual identity system for a different type of business.

EXERCISE 10-1
Identifying a system

- Find an example of a visual identity system.

PROJECT 10-1
Designing a visual identity system for a pet supply store

Step I

- Invent a name for a pet supply store or supermarket. Try to be creative with the name (it does not need to have the word "pet" in it). For example, "Eat Your Biscuit" or "The Furry Zone." Decide on the type of pet supply store it will be (general, web-based, specialized, discount, family-run, part of a chain, upscale). Figure out what makes your store special, what sets it apart from the others. Where would your store be located — on the web, in a mall, a strip mall, or on a neighborhood street?

- Work on your strategy. Who is the audience? What is the competition and marketplace? What products are sold there? What is the interior design of the store like? What kind of atmosphere does it have? What is your store's image? Identify key descriptive words.

- Write an objectives statement.

- On an index card, write one sentence about the store using two adjectives to describe it.

Step II

- Design a logo for the store. Be sure to use your objectives statement and your strategy. (See Chapter 6 on logo design.)

- Design stationery consisting of a letterhead, envelope, and business card. Include store name, address, telephone and fax numbers, e-mail address, and manager's name. (See Chapter 6 on stationery design.)

- Design a store brand for packaged goods. Your designs must be consistent — you are creating an identity for the store.

- Design at least two packages, for example, a box for treats and a bag for a toy. The logo must appear on the packages. (See Chapter 9 on package design.)

- Design a shopping bag. (See Chapter 9 on shopping bag design.) **Optional:** Design at least one other promotional or informational item, for example, a website, a mailer, a poster, a T-shirt, a calendar, a mug, a food chart, or a direct mail piece.

- Produce at least twenty sketches for each design problem.

- You may use black and white or color.

Step III

- Refine the sketches and create two roughs for each design problem, the logo, stationery, packages, and shopping bag.

Step IV

- Refine the roughs and create one comp for each design problem.

Presentation

The stationery (letterhead, envelope, and business card) should be matted or mounted on one 11″ x 14″ board and the logo on a separate 11″ x 14″ board. Create mock-up packages and build the shopping bag with handles. (Make sure you can fold it.)

chapter
11

Advertisements

OBJECTIVES

- understanding the purpose of advertising
- learning how to create an advertising concept, and to design and write a print advertisement
- learning how to create an advertising campaign
- learning how to create a storyboard
- understanding the role of the creative team
- being able to distinguish different types of advertisements
- learning the elements and components of an advertisement
- understanding creative expression
- exploring creative approaches

Advertising is all around us. We are surrounded by outdoor boards, bus and train posters, internet banners, bombarded with television commercials, inundated with direct mail and print advertisements. They tell us what to eat and drink, what to wear, who to vote for, and where to go on vacation. Advertising is part of daily life — it is everywhere. It also is an integral part of commerce and is inseparable from American popular culture. Advertising brings commerce, mass media, and design together to create a unique popular art form.

We are so used to seeing television commercials and print advertisements in magazines and newspapers that we forget the powerful effect they have on us. Advertising is designed to inform, persuade, provoke, or motivate. Advertising moves us to buy things, calls us to action, and informs us about products, services, people, events, and causes.

How do the advertising professionals create effective ads? How do they create fresh ads that will break through the clutter and entice the consumer, or as Creative Director Tom McElligott says "…get through to the consumer in ways they haven't been gotten to before"? Let's see.

What's in it for me? This is what a potential consumer wants to know. Will this product or service make me happier, healthier, richer, more attractive, get me where I want to go, or make my life easier? The potential consumer wants a benefit and an ad should clearly communicate one. Whether the ad lets the viewer know that he or she saves money (Figure 11-1) or finds a thirst-quenching drink (Figure 11-2) — there has to be a benefit or the consumer will not be drawn in.

The client also wants a benefit. Advertising is a vehicle the client uses to increase sales, influence voters, promote causes, obtain contributions, and so on. Advertising is used in a free market system to promote one brand over another. Advertising sells things. Therefore, an ad should make you believe the product or service being advertised is superior to its competitors. Most competing brands are parity products and services, meaning they are equivalent in value. For example, even though many people prefer one cola beverage to another, most colas are the same. Cola beverages are one example of parity products. On the other hand, some products have a unique selling point or unique selling advantage (USP or USA), something special about a brand that the competition does not have.

Figure 11-1
Ad
Agency: Folis DeVito Verdi, New York, NY
Creatives: Sal DeVito, Rob Carducci, Arri Aron
Client: Daffy's

Objective: To do something fun and different for an otherwise forgettable holiday.
— Julie Rosenberg, Account Executive, Folis DeVito Verdi

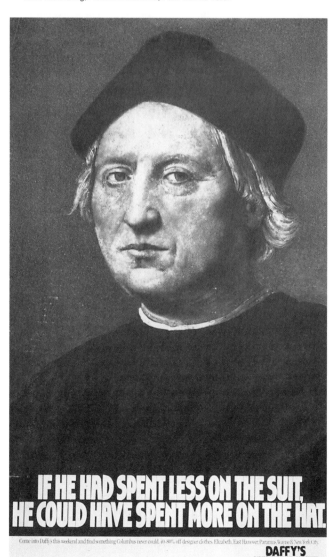

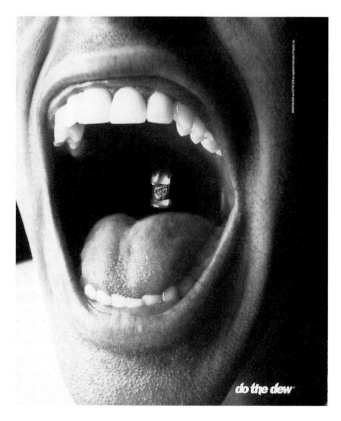

Figure 11-2
"Do the Dew" Ad
Reprinted courtesy of PepsiCo Inc.
Owner of the [Pepsi] [Mt. Dew] registered trademark.
© PepsiCo. Inc.

This newspaper ad campaign for "Charlotte.com" points out this service's USP — you can find anything you need on this site (Figure 11-3).

If the client does not benefit from advertising, there is no reason to advertise. A leading health care products manufacturer discovered through market research that advertising did not affect sales of dental floss — so it stopped advertising that particular product. For thousands of other products and services, advertising does promote sales.

Figure 11-3
"Charlotte.com" Newspaper Ads
"Crappie" 1/4 page
"Acupuncture" full page
"Spark Plugs" 1/4 page
"Goat Meat" 1/4 page
Design firm: Planet Design Co., Madison, WI
Client: Charlotte.com

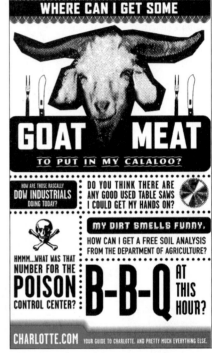

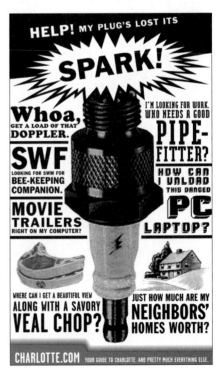

GRAPHIC DESIGN SOLUTIONS

The creative team

In advertising, **the creative team** is comprised of an art director and a copywriter. They are the people who create the ads. The **art director** is responsible for the art and design decisions, and the copywriter is responsible for the writing. Together they develop the idea behind the advertisement. The creative team usually is supervised by a **creative director** who makes the ultimate decisions about both the art direction and the copywriting. The creative team hopes their ads will benefit the client; if the client's profits do not increase, the client may switch to another ad agency or stop advertising. If the client does profit because of the ads, the agency may make more money and attract more or better accounts. The creative team also aims to create an ad that is aesthetically pleasing, interesting, provocative, or perhaps innovative — an ad that will squeeze through the competition and media glut and get to the potential audience. They want to create an ad that will be noticed — one that might even win awards from their peers. The creative team of Nancy Rice and Tom McElligott has won numerous awards for its creative ads. Their ads tend to take surprising approaches, as do these for the Church Ad Project (Figure 11-4).

Sometimes an ad may win awards and gain recognition from the advertising community, and still not meet the client's needs. Great design does not necessarily translate into sales. There can be many reasons for this: the ad may have been too esoteric; the timing may not have been right, the product or service may have been positioned incorrectly; and countless other predictable and unpredictable reasons. For example, Reebok positioned its shoes as fashion footwear in the extremely creative "Reebok lets UBU" campaign. Unfortunately, sales dropped. It seemed that people who bought Reebok athletic shoes preferred not to think of them as fashion footwear.

Figure 11-4 Ads
Agency: Fallon McElligott, Minneapolis, MN
Art director: Nancy Rice
Writer: Tom McElligott
Client: Church Ad Project

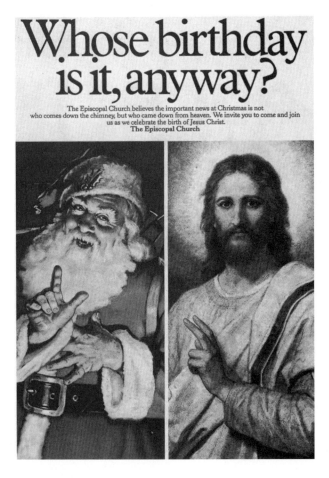

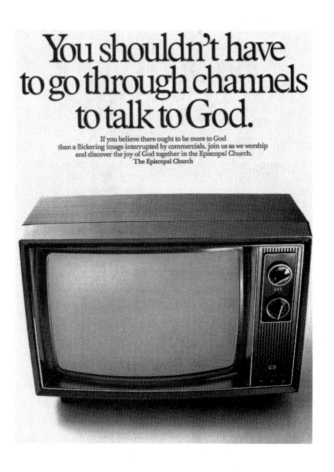

Types of ads

There are basically three major categories of ads: consumer, trade, and public service. Consumer ads are directed at the general public, for example, this ad for Mystic Lake Casino (Figure 11-5). Trade ads are directed at specific professional or business groups. This ad for Hush Puppies Professionals shoes is aimed at nurses (Figure 11-6). Public service ads are created for the public good, and include ads for charities, causes, and non-profit organizations. The Humane Society of Utah used a public service ad to encourage people to adopt pets (Figure 11-7). At times, profit-making companies will sponsor public service ads.

Every year there seems to be a new addition to the types of ads in existence. Most recently, the world wide web has added to the pot. There are also other visual communications formats, such as the poster, which can cross over into being an advertisement, for example this poster, "Rollerblade Grind Shoe" (Figure 11-8; see Figure 11-22).

All of these types of ads may appear in **print** — newspapers, magazines, direct mail, posters, or outdoor board displays — or on television, web, and radio. General interest or specialty newspapers and magazines, both local and national, usually carry consumer and public service ads. Trade or professional magazines, as well as other professional publications, tend to carry trade ads. Outdoor board (billboard) display is primarily used for consumer or public service advertising. Sometimes outdoor boards reinforce ads that we see in magazines and newspapers; other ads are created specifically for billboard displays. Hoping to attract outdoor advertisers, the Reagan Outdoor Agency used a clever and unusual outdoor board sequence (See Figure 11-9).

Figure 11-6
Ad, Hush Puppies Professionals
Agency: Fallon McElligott, Minneapolis, MN
Creative director: Pat Burnham
Art director: Bob Barrie
Writer: Mike Gibbs
Photographer: Joe Lampi, Dublin Productions
Client: Hush Puppies Shoes/Wolverine

Figure 11-5
Ad campaign
Agency: Hunt Atkins
Art director: Mike Fetrow
Writer: Doug Adkins

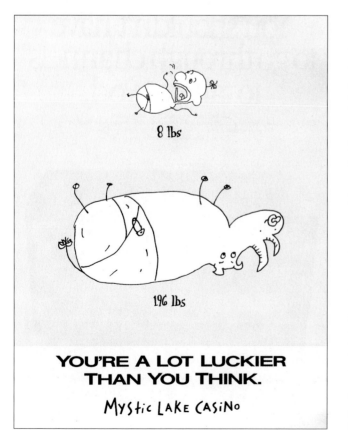

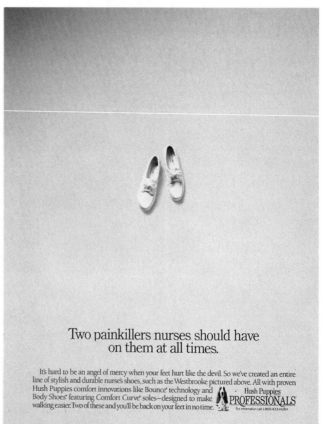

GRAPHIC DESIGN SOLUTIONS

Figure 11-7

Ad

Agency: Publicis, Salt Lake City, Utah

Art director: Steve Cardon

Writers: John Kinkead, Rebecca Bentley-Mila, Bryan De Young

Photographer: Chip Simons

Client: Humane Society of Utah

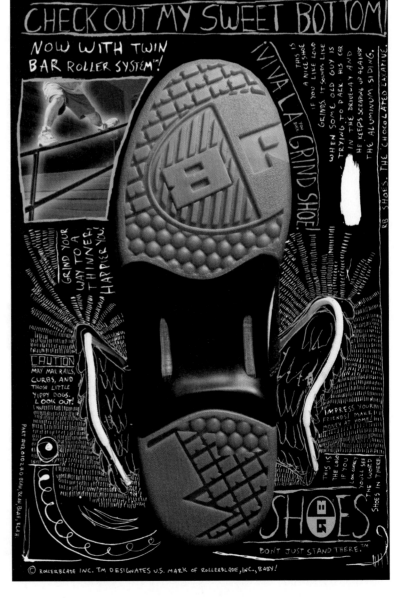

Figure 11-8
"Rollerblade Grind Shoe" Poster
Design firm: Planet Design Co., Madison, WI

Figure 11-9
Reagan Outdoor/Flies Board
Agency: Publicis, Salt Lake City, UT
Art director: Steve Cardon
Writer: Bryan DeYoung

Inspiration: If you stare at a blank billboard long enough, it starts looking like fly paper. (At least it did to us.)

This billboard was posted in June. Over the course of seven weeks, more and more mannequins were added each weekend until the board was full. This billboard was selected by Outdoor Advertising Association of America as one of the three best billboards of the year.

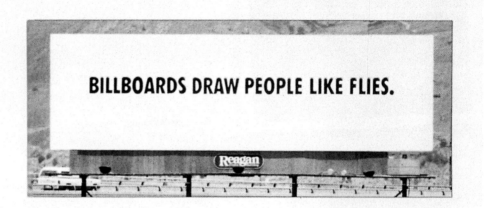

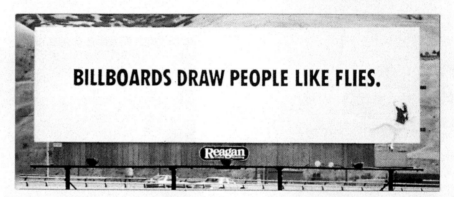

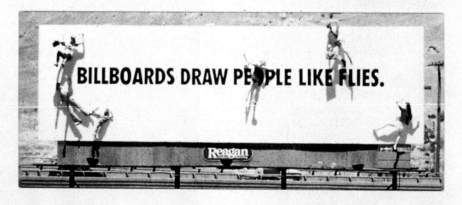

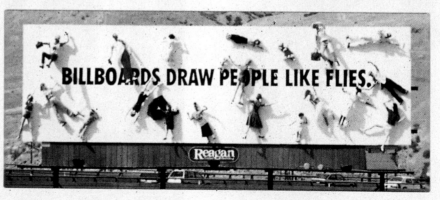

Rather than renting space in the magazine or newspaper or on an outdoor board, an advertiser may send an ad directly to you, which is called **direct mail**. The ad may be in the form of a brochure, a calendar, a package, or any other publication or piece that will catch your attention. This unusual piece is by the award-winning design firm Viva Dolan Communications & Design (Figure 11-10).

Usually, television commercials are either consumer or public service ads. Both local and national commercials appear on television. Ads are carefully placed on television to aim at the different consumer groups who watch different types of television programs. For example, situation comedies during prime time viewing hours (7:00 PM to 11:00 PM) appeal to families, and cartoons during morning hours on weekends appeal to kids.

How does one know which forum will be most effective? Several factors should determine where an ad is placed; whether the client needs a regional or national audience; whether there is a very specific audience; and cost effectiveness.

Elements of an ad

Most ads consist of the following elements: a visual, a line, body copy, a claim, and sign-off. In these ads for Lawson Software (Figure 11-11), the line appears on the left-hand side of the ad, the visuals and text type are on the right-hand side, and the claim and sign-off at the bottom right. The **visual** is the image, which may be a photograph, an

Figure 11-11
Lawson Software Healthcare II Ad
Agency: Martin/Williams Inc., Minneapolis, MN
Art director: Jeff Jahn
Copywriter: Cathy Ostlie
Photographer/Illustrator: Karel Havlicek

Figure 11-10
Butterfield & Robinson Millennium Brochure
Design firm: Viva Dolan Communications & Design, Toronto, Ontario, Canada
Designer: Frank Viva
Writer: Doug Dolan
Illustrator: Kim DeMarco
Client: Butterfield & Robinson

This initial mailer serves a dual purpose: to let prospective travelers know what special trips are being planned for New Year's Eve 1999, by a leader in biking and walking vacations; and to encourage bookings for the same destinations in the coming travel season. The design echoes a children's storybook, with simple, fun illustrations, a very hot color palette and large, bold typogprahy. The objective throughout is to convey a sense of energy and festivity in support of specific New Year's Eve moments, and as a reflection of B&R's overall approach to travel.

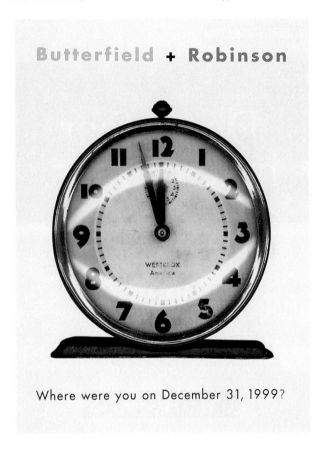

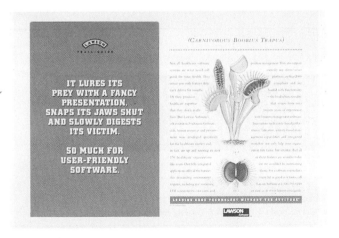

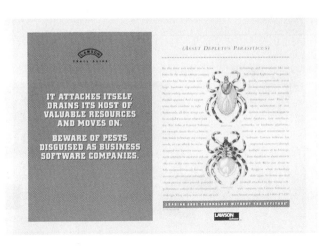

illustration, graphics, typography, or any combination. The **line**, which many people refer to as the headline, is the main verbal message. It may be positioned anywhere on the page, not just at the head. The **body copy** is the narrative that further explains the advertising concept and may provide more information. The **claim** — also called the end line, tagline, or slogan — is the verbal message associated with a product or service and is used in a cam-

paign of ads. The claim establishes a theme and captures the spirit, quality, and benefit of the product or service being advertised. The strategy behind the sales pitch is usually revealed in the claim, for example, "Hey, you never know" for New York Lotto. The **sign-off** is the product or service's logo, a photograph or illustration of the product, or both.

Sometimes the visual, by itself, conveys the advertising concept, so there is no need for a line. Sometimes the line says it all and there is no need for a visual. In this ad campaign created by Firewerks>>Advertising + Design, one of the ads is all type and the other strategically combines type with a "graffiti" visual (Figure 11-12). Also, sometimes the product is the visual and there is no need for a sign-off.

Four components of an ad

Advertising is different than other graphic design; it has the highest degree of persuasive intent. An ad must stimulate sales or motivate behavior. Words are important carriers of this kind of message; for this reason the art director works with a partner, the copywriter. In other areas of graphic design, where there are more formats, the designer usually is given the copy, and the design solution is not necessarily created to directly stimulate sales. The four main components involved with the creation of a print ad are slightly different than those mentioned earlier in this text, in relation to other graphic design applications. They are strategy, concept, design, and copy.

A strategy usually is provided to the creative team by the client or by the agency account manager (the liaison between the creative team and the client). Sometimes the creative team or creative director determines it. The **strategy** is the starting point; it determines who the potential audience is and how to position the product or service in

Figure 11-12

"Report Hate Crimes" Ad Campaign

Agency: Fireworks >> Advertising + Design, Minneapolis, MN

Art director: Rebecca White

Copywriter: Ross Phernettor

Sponsored by: St. Paul Human Rights, Out Front Minnesota, FIREWERKS and St. Paul Hate/Bias Response Network.

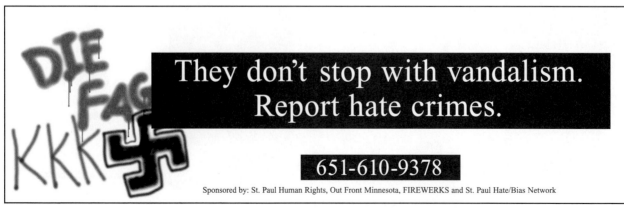

the market and against the competition. As creative director/copywriter John Lyons puts it, "A strategy is a carefully designed plot to murder the competition."

The foundation of any successful ad is a concept or idea. The **concept** is the creative solution to the advertising problem. The concept is the foundation 0f the advertising message; it answers the question, **"What's in it for me?"** and promotes the benefit. An ad concept should be creative enough (and flexible enough for a campaign) to allow you to communicate a message, establish a benefit, aim at your audience, and possibly establish a unique selling point. The concept has to be clear enough that the advertising goal — motivation, persuasion, or information — is achieved.

Together, the design and copy (the visual and words) express the concept in a visual/verbal relationship. Hopefully, this is a synergistic relationship where the image and type work cooperatively to produce a greater effect than that of either part alone. This is called a seamless ad. Visual/verbal synergy is established in a creative ad for Volkswagen (Figure 11-13). The headline and visual depend upon one another for the total ad message. Here is a way to test for visual/verbal synergy. Cover the visual and read the line. Do you get the meaning of the ad? Now reverse it; cover the line and look at the visual. Is the ad message communicated? Now look at the entire ad. The message should be clear because of the cooperative action of the visual and verbal components.

The design or art direction is the visual part of an ad. Everything you have learned about the fundamentals of design and the principles of graphic space should be used to create a visual that expresses the concept, complements the copy, attracts the viewer, is aesthetically pleasing, is current (captures the spirit of the time), establishes a visual hierarchy, and is appropriate for the client. The design includes the main visual, the layout, the typography, the sign-off, the style, and the presentation.

The copy is the verbal part of the advertising message. It should express the concept while working cooperatively with the visual. It should be clearly written, easy to understand, and written in everyday language. The line, body copy, and claim should be unified and based on a common strategy and concept. The language should be appropriate for the client. It is important to understand that the copy in an ad assumes a voice. The voice may be that of an authority, a maternal voice, the voice of science, or it may be the voice of a professional or the client's own voice.

Do we drive our mechanics too hard?

Figure 11-13
Ad, Volkswagen
Agency: BMP DDB, London, England
Art director: Mark Reddy
Writer: Tony Cox
Photographer: Andreas Heumann
Client: V.A.G. (United Kingdom) Limited

The creation of a print ad

Here is a short summary of the steps many students take in the creation of an ad.

The first step is research. Find out everything you can about your client's product or service. Try the product or service (if possible). Call the company to get more information. Ask people what they think of it. This step is important, but unfortunately many students do not take it seriously. This is not a step to skip. The more you know about your client's product or service and about the potential audience — the more solid your strategy and concept will be. Use the following questions as a point of departure for your research: What are the advantages of the product or service? Who is the audience, that is, who will use this product or service? What is the competition?

The second step is to develop a strategy to determine the benefit of your product or service, target the audience, and position your product or service in the market and against the competition. For example, let's say your product is yogurt. You may claim that the benefit of eating this brand of yogurt is getting calcium in your diet. You may want to target adult women who tend to need more calcium in their diets. Since most yogurts contain calcium, an ad based on this feature would not reflect a unique selling point. If your yogurt contains added live yogurt cultures and the competition does not, then you may want to emphasize this unique selling point as the benefit and aim at a different audience. Once you have decided on a strategy, you may want to write the claim or tag line. Writing the claim at this step of the process may help you clarify your strategy.

The third step is to develop a concept. Here is where the creative process gets tricky. As Anthony Angotti, art director at Angotti, Thomas, Nedge, said when judging the best ads of the '80s for The One Show, "My judging criteria consisted of three things: concept, concept, concept." The concept should communicate a benefit and persuade potential consumers to buy your product or use your service. (Please refer to the next section on Advertising concepts: What's the Big Idea?)

The fourth step is to think of a line and visual that will express your concept. Make sure there is a cooperative relationship between the verbal and visual and that there is *one* clear message — *one* clear benefit. Together, the line and the visual communicate the concept — the ad message. Your ad should not depend on the body copy to explain your idea; body copy only adds more information.

In the process of working, sometimes a visual comes to mind and you have to work at writing the line, or the line may come to mind quickly and you have to struggle for the visual. (See the section in this chapter on Creative Approaches for some ways to think about copy and visuals.) Some people say if a concept is really good it will generated (almost automatically and simultaneously) a visual and line that work as a unit.

The fifth step is writing the body copy. This copy should relate to and enhance the overall concept, giving more information or pushing the benefit. If you have not written a claim yet, now is the time to do so. (If you have trouble writing a line, try writing the body copy first. You might be able to pull a line out of the body copy.) Keep the body copy short and simple.

Finally, you have to design the page so it best serves your advertising concept. If you have a wonderful idea that is designed poorly, most likely it will not be noticed. Make sure your design works with your concept. The ad should be well executed and professional looking. Conversely, if you have a wonderfully executed ad that has no strong concept, it will not be remembered. Both the concept and the execution should be thoughtful.

These steps certainly vary from professional to professional, or from student to student. If you come up with great ideas, that is all that counts. If you are really having difficulty, try following the suggested steps.

Advertising concepts: What's the Big Idea?

In the advertising business, everyone talks about the elusive "Big Idea." The big idea is what will convince every consumer to buy the product or service you are selling. It's the mighty ad message that has pizzazz, memorability, uniqueness, and holding power. Ad professionals who come up with big ideas get the big bucks. The big idea is the advertising concept — it's the outstanding way you tell consumers what is unique or great about your product or service. However, it is not a gimmick. A big idea is an effective, relevant way to sell and create a spirit around your product.

The idea (or concept) connects the strategy to the product's or service's spirit. The big idea makes the con-

SUGGESTIONS

There are no hard and fast rules in advertising because it is a business that often breaks rules to get through to people. However, the novice needs some guidelines in order to know how to begin. Here are some suggestions that many students will find useful.

Concept development

- Establish a benefit

- Limit yourself to one message per ad

- Avoid clichés both in visuals and words

- Have a social conscience — do not use racist, sexist, or biased ideas, visuals or words

- Be original, fresh, and innovative (as long as it makes sense for the concept)

- Inform. Tell the consumer something they did not know

- The visual and line should not repeat one another

- The ad should make sense — it has to be understood

- The ad should be believable; it should not sound like an empty sales pitch

Copy

- Write in plain, everyday, conversational language, not hype. Avoid sounding like a sales pitch.

- Do not use a thesaurus — the language probably will sound contrived

- Break copy lines in logical places; line breaks should echo breaks in speech

- Do not use the product's or service's logo as the headline

- Avoid poems or rhymes

- Avoid philosophical statements; keep it simple and natural

- Avoid one word lines — it is difficult to get an idea across in one word

- Do not use lines, claims, or body copy from existing ads

- Do not insult or talk down to the consumer

- Avoid two-part headlines — they tend to break the flow of the idea

- Check spelling and grammar

- Keep it short — most people prefer to look at visuals

Design

- Establish a visual hierarchy

- The line and the visual should not be the same size; they will compete for attention

- Experiment with page design; all your ads should not have the same layout

- Render in markers or use colored copies/scanned images (not pencil or paint)

- Generate type on a computer and adjust the letter and word spacing

- Remember: Type has a voice

The best way to learn the rules, even if only to break them, is to immerse yourself in advertising. Watch television commercials, surf the web, and look through magazines and newspapers. You might also subscribe to professional journals such as *Archive*, *Print*, and *Communication Arts*, or look at award annuals like *The One Show* or the *AIGA's Graphic Design USA*. You can learn a lot by being a critic and analyzing the ads you see while also becoming aware of current trends in design, copywriting, attitude, approach, and style. Do not copy what you see — analyze it.

sumer audience notice, remember, and buy your product. If the consumer flips the page in the magazine, you've lost 'em. Don't let the consumer flip the page!

Where do big ideas come from?

No creative director, art director, or copywriter will give you the answer. Sometimes ideas simply appear. Other times you work, think, write, sketch, work, think, write, sketch, work, think, write, sketch, and, then, an idea comes to you. In between those times, you can try the following points of departure for developing a concept, and maybe, finding the big idea.

Points of departure for developing an advertising concept

Visual analogy. A visual analogy is a comparison based on likeness or similarities. We assume that if two things are alike in one respect, they are alike in other or all respects. You can draw an analogy between the acceleration speed of a car and an airplane (as did BMW in one of their television commercials), or draw an analogy between the flexibility of an acrobat and flexible eyeglass frames.

Visual metaphor. A visual metaphor uses a visual that ordinarily identifies one thing to identify another, thus making a meaningful comparison; for example, a rhinoceros to designate dry skin, or a Shar-pei dog to designate a wrinkled human face. For example, Lubriderm skin lotion's ad uses an alligator to symbolize dry skin.

You are more likely to attract a viewer with a visual metaphor than with a visual of the product you're selling. When the visual *is* the product, the ad immediately screams: "I'm an ad and I'm trying to sell you something." When the visual is a metaphor, you're more likely to seduce people into paying attention to your advertising message. Let's put it this way: an interesting visual is always better than an uninteresting visual. And the product, although the client may disagree, is usually uninteresting (with the exception of cars and motorcycles, which consumers find appealing).

Pun. A play on words can be funny. Years ago, the Chiat/Day agency created a great, fresh print and television campaign for the NYNEX Yellow Pages based on

puns. On the heels of their campaign, everyone used puns for a while. For a pun to work, it has to be brilliant, otherwise it often sounds trite. In fact, for the beginner, skip this category all together!

Pulling from life experience. If the consumer can relate to what you're saying, you're halfway home. "Yeah, that happens to me," should be the consumer's response. These ads behave as observational humorists, pointing out the humor in everyday life occurrences. Think of Goodby Silverstein & Partners' humorous milk board campaign, "Got Milk?" Someone is looking forward to having cookies and milk or cereal and milk and there's no milk to be found!

The problem is the solution. Often, the answer to an ad problem is looking at the problem itself. In the 1960s, Volkswagen faced a problem selling the VW Beetle in America; compared to American cars, it was small and ugly. American consumers were used to big, streamlined cars. Doyle Dane Bernbach's (DDB's) solution was to tout the problem: it's ugly and it's small, but it gets you there. Try to find the concept in the problem itself.

Real life reasons to use the product. It is very hard to dispute something that is proven or makes real sense. Prove the consumer needs your product or service through demonstration, endorsement, or explanation. Docker's Khakis commercial shows, with tongue in cheek, how well their pants hold up to repeated washings (an attractive young man, wearing Docker's Khakis, is dropped into a tank of water, as part of an amusement park game, by pretty young women).

Make them like the company. A likable company is a company you want to patronize. Wouldn't you rather buy from a friendly, helpful, or philanthropic shopkeeper than an impersonal or apathetic one? Making the company seem friendly, philanthropic or approachable establishes a character in the mind of the consumer. Old Navy uses passé television stars and likable characters and animals to create a friendly aura for their television campaign. In their print campaign, Kenneth Cole shoes donates some proceeds to charity.

Comparison. A comparison between parity products is usually boring and mean-spirited, like the old cola wars

or the fast food wars. However, comparisons to things other than the competition can be very seductive, for example, comparing the sensation of eating a York Peppermint Patty to skiing or being under a refreshing waterfall.

Exaggeration. Exaggeration is fun and can drive a point home like nothing else. There was a television commercial for Discover Brokerage, an on-line brokerage. A tow truck driver tells his client/passenger that he reads *Barrons* and uses Discover Brokerage. The passenger inquires about a photo of an island hanging from the dash. The driver responds with something like: "Oh, that's a country I own… Funny thing about owning a country, you have to name it." Clearly, he does well with Discover Brokerage. Obviously, his success is an exaggeration. Another great example, is the ad for Colombian coffee where the pilot turns the plane around because they forgot the Colombian coffee.

Insight. What's in it for me? is the essential advertising consumer position. If you can gain insight into what the consumer wants, needs, desires, or simply into the human condition, you've got a leg-up on the competition. Seeing an ad for a new car makes you want to get rid of your old jalopy, especially an ad that touts adventurous rides (as does Jeep) or speed; or an ad that tells you need a vacation or a getaway from real life, like the old Club Med campaign claiming, "the antidote to civilization."

Authenticity. People enjoy a genuine article. Russian vodka. Colombian coffee. American jeans. Idaho potatoes. Florida oranges. Israeli dates. Italian olive oil. And people make cultural associations. Think of the ad campaign for Stolichnaya vodka, created by Arnie Arlow/Margeotes/Fertitta + Partners. The campaign "…distinguishes the brand from all other premium vodkas, especially Absolut, with something instantaneously recognizable and uniquely 'ownable' to Stolichnaya," said Arlow. He continued, "Since Russia is considered the birthplace and home of vodka and associated with the finest quality vodka in the world, we decided to use authenticity as our concept."

Motivation. Nike's success with the "Just Do It" campaign is proof enough that people love motivational advertising. Nike and the ad agency who created the campaign, Weiden & Kennedy, didn't position Nike footwear as a fashion statement, they positioned it as an athletic shoe. Whether a person ran or worked out in his or her Nike shoes or not, didn't matter. The public preferred the illusion of being athletic and the motivational theme.

Lifestyle image. Most advertising for fashion, liquor, cigarettes and jewelry is image advertising. A desirable lifestyle or spirit is created. If you use this product, you, too, will enjoy this lifestyle, including hanging around with fun people, looking attractive, and being successful. Think of the "I Am" campaign for Esprit or the bucolic ads for Banana Republic chinos. It is important to note that ads should reflect diversity. Ads should reflect and respect the range of cultures and ethnicities of consumers.

The ad campaign

A **campaign** is a series of ads that share a common strategy, concept, design, spirit, style, and claim. Professional ad campaigns vary in the way they are structured. Some campaigns use the same line throughout and vary the visual, for example, the famous Absolut Vodka campaign that has been running for many years and the "Got Milk?" campaign (See Figure 11-14). Other campaigns vary the line and maintain the same visual. Yet other campaigns, while maintaining one strategy and concept, vary both the line and the visual. It is important to realize that you can have a good amount of variety in your designs, within a campaign, and still convey a similar spirit and establish a sense of unity throughout the campaign! For a student campaign, it is best to vary both the line and the visual, as well as the layout or design. A student needs to demonstrate the ability to establish variety within a campaign. The ability to create variety within unity is a very desirable one; it demonstrates creative and critical thinking skills and a clear understanding of "stretching" a design concept to its fullest. How do you establish variety?

- The visual and line do not have to be in the same position in every ad.
- Set up a flexible color palette.
- Determine two or three elements that will be constant while others can change.
- Choose two or three fonts and vary the way you use them.

Figure 11-14

Billboards: "Got Milk?/Gingerbread Man," "Got Milk?/Peanut Butter & Jelly"

Bus Shelter: "Got Milk?/Chocolate Chip Cookie"

Agency: Goodby, Silverstein & Partners, San Francisco, CA

Creative directors: Jeffrey Goodby, Rich Silverstein

Art directors: Rich Silverstein and Peter diGrazia (all except "Peanut Butter & Jelly,") Mike Mazza ("Peanut Butter & Jelly")

Writer: Chuck McBride

Photographer: Terry Heffernan

Client: California Fluid Milk Processors Advisory Board

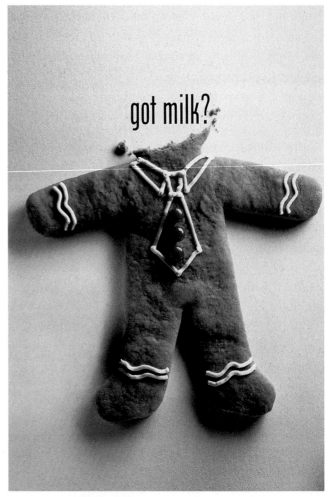

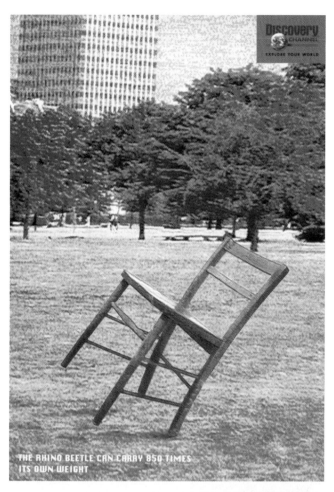

THE RHINO BEETLE CAN CARRY 850 TIMES ITS OWN WEIGHT

You may have variety, but you must establish continuity in the campaign.

To promote milk, this campaign points out all the foods people enjoy with milk (Figure 11-14). The line in all the ads is "Got Milk?" Humor is used in this playful campaign, "Koala," "Chair," "Termite" (Figure 11-15) for the Discovery Channel.

Advertising stratagems

Unique selling point (USP) or unique selling advantage (USA)

Your product is unique; it has a quality (qualities) that the competition does not have. It is indeed rare when a product has a unique selling point. Most products are parity products. If your client's product or service does have a

Figure 11-15
Discovery Channel/ "Koala," "Chair," "Termite"
Agency: Bates Dorland/UK
Creative director: Chips Hardy
Art directors: Roy Antoine/Derek Hass
Copywriters: Des Barzley/Alan Lofthouse
Client: Discovery Channel

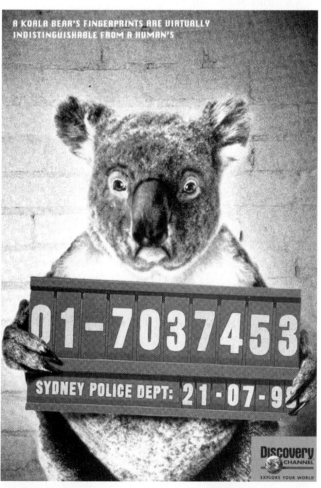

A KOALA BEAR'S FINGERPRINTS ARE VIRTUALLY INDISTINGUISHABLE FROM A HUMAN'S

01-7037453

SYDNEY POLICE DEPT: 21-07-9

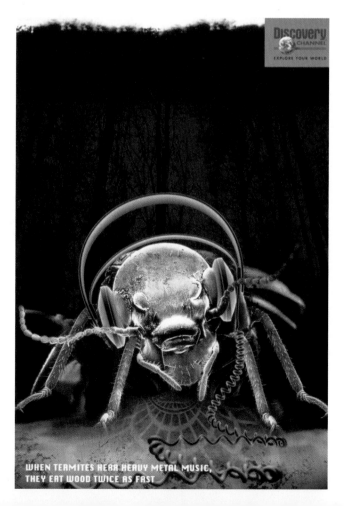

WHEN TERMITES HEAR HEAVY METAL MUSIC, THEY EAT WOOD TWICE AS FAST

233

unique selling point, then, most certainly, it behooves you to tout it in your ad. Keep in mind that as soon as a product with a unique feature is successful, imitators will be close behind.

For example, Comedy Central on cable television offers comedy programming 24 hours a day; Sprint offers wireless web phone service (competitors are soon to follow); Philips' Halogena bulb lasts for two years.

Ownership: The creation of a construct

A company or product owns a benefit, a word, or a selling point, in that product category, in the mind of the prospective consumer. Donny Deutsch, Deutsch Advertising, calls this stratagem a **construct**. Examples: Heinz owns "slow," Pepsi owns "youth," Volvo owns "safety."

It's established in the claim

Your product's or company's strategy is firmly expressed in the claim (sign-off, slogan, tagline, end line). All print and television commercials express the strategy.

For example, American Express clearly expressed the need of carrying a credit card in "Don't leave home without it." Pepsi positioned itself as the drink of the younger generation in "The Pepsi Generation" and all subsequent claims.

Image

Your product has an image in the mind of the prospective consumer; the consumer has an opinion about it based on the advertising. An image is the spirit projected to the public by the advertising. Your product doesn't have a unique selling point or particular advantage, but is the personification of something specified.

Types of image advertising:

- association with an abstract concept, for example, GE "brings good things to life"
- association with an individual (who acts as both image maker and endorser), for example, Nike with Tiger Woods
- association with an aesthetic or beauty standard, for example, any high-end cosmetic
- association with a lifestyle, for example, almost any beer or liquor
- association with "the beautiful people" (models) or the ultrafashionable people, for example, Guess? fashion

Emotional advertising: Get them to feel something

If you can get an emotional response from the prospective consumer when they see your ad, then he or she is likely to remember or relate to your product or company, to feel something about the company or product. Types of emotional advertising:

humor: make 'em laugh, make 'em laugh, make 'em laugh, for example, ads for Little Caesar's pizza.

bittersweet: the ad message is both bitter and sweet at the same time; it produces or expresses a mixture of sorrow and pleasure, for example, ads for the Special Olympics.

touching: Your ad message affects the emotions and creates a tender response, for example, Hallmark, Kodak "moments," and yes, even, McDonald's.

tranquil: Your ad message makes the consumer feel calm or relaxed, for example, ads for International coffees.

sex: Sex sells. We all know that. Your ad message makes the consumer feel that their sexuality will be enhanced by this product, for example, ads for Victoria's Secret lingerie.

Accessibility: You're one of us

The old marketing/advertising adage: Keep It Simple Stupid (KISS) or dumb it down. Record producer Phil Spector's advice to Sonny Bono on effective communication: "Is it dumb enough?" Sonny Bono's response: "He was saying: 'Is it simple enough communication to be just totally understood in just plain language?'" For example, ads for the New York Lottery with the claim, "Hey, you never know."

Differentiate your product

Set your product or company apart from the competition, for example, print ads for Altoids peppermints and Root 100 ginseng chew.

Originality

Your product is the original, the first in the category and that, essentially, makes it the best one in the public's mind. In fact, people say: "Do you have a 'Band-Aid'" instead of saying "Do you have an adhesive bandage?" For example, brands like Xerox, Levi's, Band-Aid.

Cutting edge or just edgy

Your product is on the cutting edge of technology in that category, which makes the consumer feel it's best, for example, Intel, CNN or ESPN2. Your product is edgy (what used to be referred to as hip), ahead of the curve, in with the in-crowd, for example, The Gap.

Homespun: You can relate to us

There's a family behind this operation, or it's a down home kind of product, for example, Orville Redenbacher popcorn, Quaker Oatmeal.

Nationalism

There's a country behind this product; your product is all-American, all-French, all-Russian, for example, Coke and Tommy Hilfiger are American, Stolichnaya Vodka is all Russian (and that's authentic when it comes to vodka).

Attitude

This product or service has a definite "attitude" (what is generally not expected or accepted; satirical), adopts a clear position or posture, which can be irreverent, arrogant, tough, tongue in cheek, in, for example, *Time Out* magazine, Crunch gyms, ABC TV, *Spy* magazine.

Your mother used it/ Your mother didn't use it

This product has a family tradition, your mother or father used it, so you use it; you want to keep the family brand loyalty: "It was good enough for dear old Dad, it's good enough for me." You rebel against what your mother or father used and find a product that is not traditional or older, for example, Sanka vs. Starbucks, Chevrolet vs. BMW.

Creating a USP

Your product has no USP — therefore, you create one, for example, the introductory campaign for Volkswagen touted the VW Bug as ugly but reliable.

Repositioning and creating a USP

Your product is becoming obsolete or has a small audience, thus, you create a new use for it. Originally, Arm & Hammer was used for baking. Now it is primarily positioned as a refrigerator air freshener. Noxema was used for skin irritations, then it was repositioned as a face wash.

Ad checklist

Who's the audience?

What's the strategy?

Who's the competition?

Is there anything unique about this?

What's the benefit(s)?

What's in it for me?

Is the visual compelling? Is it powerful?

Is the concept powerful?

Is it fresh?

Television commercials

Television is another interesting medium for designers. Television has several advantages over print. Television allows you to use sound (including music, voice, and special effects), movement (action, dance, demonstration, visual effects), and it gives you time to explain your concept. Since TV has some advantages over print, it would seem in some ways that it is harder to attract consumers with print advertising. With print, you get one visual and approximately two seconds of the viewer's attention or time. Creating ads for TV is like making mini-movies.

In one TV ad for Pizza Hut we watch a Little League game. The ball is coming at a pudgy little kid in the outfield and no one expects him to catch it, least of all himself. But he does catch the ball and his team wins. Everyone is equally surprised and thrilled and the kid becomes a winner. The team celebrates by going to Pizza Hut. We don't know the ad is for Pizza Hut until the very end, and, until then, we're taken in by the story. Will he or won't he catch the ball? We feel for the kid and want to know what will happen. Our curiosity and interest make us watch.

Some ads tell a story and the advertiser becomes invisible until the end. The TV commercial tries hard not to sound or look like an ad — like a traditional sales pitch. Why? "When consumers see an advertising message on television, they automatically assume someone is trying to sell them. And of course, their radar goes right up! Since consumers have their radar up when watching the most commercialized, ad-intensive program, TV, some of the best under-the-radar creative ideas are those that come from out-of-the-box thinking — specifically, the TV box.

This means that the team working to create the advertising has tossed out the conventions to which they might otherwise adhere," say Jonathan Bond and Richard Kirshenbaum in their book about talking to today's cynical consumer, *Under the Radar*.

If we knew we were watching an ad from the get go, we'd probably be less likely to watch. This wasn't true when television advertising began. The viewing audience found those dancing cigarette boxes and pitchmen or talking heads of the 1950s new and interesting. There wasn't yet an advertising glut. "Now, every ad competes with every other ad for attention," says Alan Robbins, multimedia designer of The Music Pen, New York, NY.

Great TV ads are ones people notice, remember, and relate to, like the funny one for the New York State Lottery (see Figure 1-12).

Until recently, television advertising has been one-way, a communication from advertiser to consumer. Now advertisers are investigating and using interactive technology, a convergence of television, telephone, and computer technology. For example, an interactive commercial may ask the viewer to answer questions using a video prompt and remote control; the information superhighway opens up a whole new realm of interactive advertising for businesses to explore. Due to the proliferation of cable channels, network advertising is suffering. Also, people "zap" through and around commercials with their remote controls. Using interactive technology for advertising is one way for advertisers to ensure their message is getting across to potential consumers.

Visualizing an ad for television begins with a storyboard. A **storyboard** illustrates and narrates key frames of the television ad concept. The visuals are drawn in frames, in proportion to a television screen, and the action, sound, or special effects, and dialogue are written underneath each frame. Here is one example of a storyboard for Pizza Hut (Figure 11-16).

Television advertising is very expensive and usually is saved for seasoned professionals. Due to the proliferation of cable television and multi-media, beginners in advertising agencies may have the early opportunity to work on television commercials. Interactive television will present new opportunities as well. Working on a TV ad would require knowledge of many things — like production, direction, casting, and post production — that are learned from years on the job and rarely are taught in college or university programs. It is a good idea to take video, film, and multimedia courses and to create a few storyboards while in school.

Critique guide

Here is a guide you can use while creating ads. It will keep you on target. After you finish, use it as a critique before you show your work to others.

Concept development

- Did you develop a concept?
- Did you establish a benefit? Did you take the viewer's position and ask, "What's in it for me?"
- Did you communicate a clear message?
- Do your visuals and copy express your concept?

Design

- Did you establish a visual hierarchy?
- Did you design the page using the principles of design, including balance, rhythm, and flow?
- Did you experiment with layout?
- Did you include a sign-off?
- Did you present your work professionally?
- Is your design fresh? Is it innovative? Is it cutting edge?

Copy

- Is your writing clear?
- Did you use everyday language?
- Is your copy, line, body copy, and claim unified by a common concept and writing style?

Design and copy

- Did you establish a visual/verbal relationship?
- Does the ad have visual/verbal synergy?
- Is it a seamless ad?

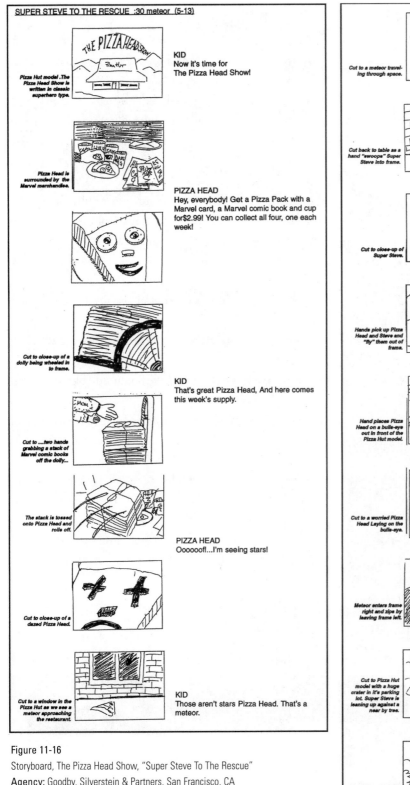

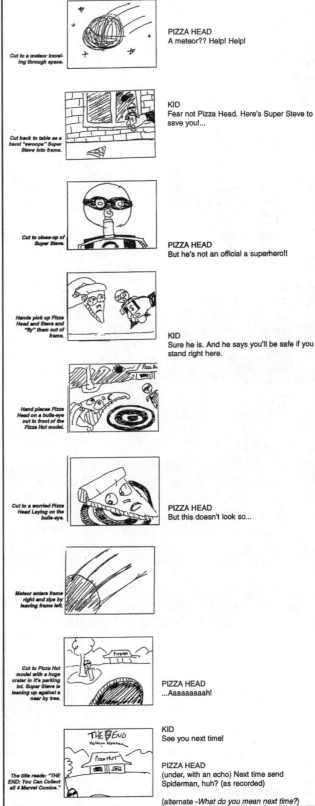

Figure 11-16

Storyboard, The Pizza Head Show, "Super Steve To The Rescue"

Agency: Goodby, Silverstein & Partners, San Francisco, CA

Creative directors: Jeffrey Goodby, Rich Silverstein

Art director: Paul Renner

Writer: Erik Moe

Producer: Cindy Fluitt

Client: Pizza Hut

GRAPHIC DESIGN SOLUTIONS

Figure 11-17
Electrolux Vacuum Cleaner/"Mouse"
Agency: Delvico Bates, Madrid, Spain
Creative directors: Pedro Soler/Enrique Astuy
Art director: David Fernandez
Copywriter: Natalia Vaquero
Client: Electrolux Vacuum Cleaner

Electrolux has the greatest suction power, as demonstrated by a mouse being sucked away.

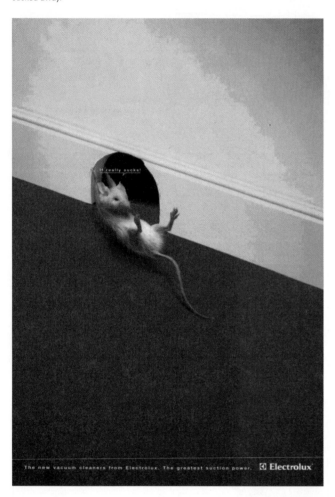

Expression

Advertising is visual and verbal communication. The advertiser wants to communicate a message to the potential consumer; how well the message is communicated is a matter of creative expression. The creative team's job is to find the best way to express the ad message. To accomplish this, the team might use demonstrations, endorsements, declarations, narratives, recognition, association, or emotional appeals.

An ad may demonstrate how a product or service works. Here you see a demonstration of the power of an Electrolux vacuum cleaner (Figure 11-17). An ad may feature a celebrity who uses or endorses the product or service, or it may feature an endorsement from an everyday person with whom the potential consumer can identify (Figure 11-18).

An ad may declare its product or service is best, is scientifically proven to work, was chosen above all others in taste tests, and so on. In this brilliant ad (Figure 11-19), IBM declares its support for programs designed to strengthen women's skills in areas such as math and science. An ad may tell us a story, a narrative, which may take many forms: it may look like an editorial; it may look like a cartoon; it may be a single, story-telling picture; it may look like photojournalism; or it may be a sequential illustration. These funny ads for the EverFresh Juice Company are narratives (Figure 11-20). (Ads using cartoons tend to have high readership.) An ad may use a symbol, logo, or

Figure 11-18
Dexter Shoes
"In Dexter, Maine, Our employees think nothing of taking their work home with them."
Agency: Pagano Schenck & Kay Inc., Boston, MA
Creative director: Woody Kay
Art director: Hal Curtis
Copywritier: Steve Bautista
Photographer: Harry DeZitter
Client: Dexter USA

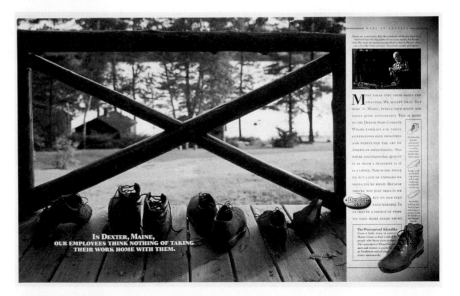

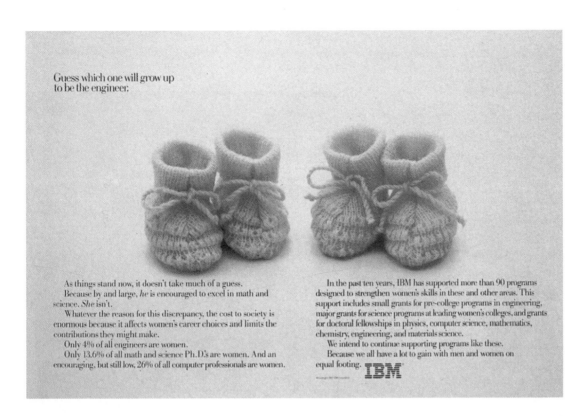

Figure 11-19

Ad, "Guess which one
will grow up to be the
engineer"

**Creative director/
Writer:** Bob Mitchell,
Mitchell Advertising,
Millwood, NY

Art director:
Seymon Ostilly

**Associate
creative director:**
Dentsu Advertising
Courtesy of IBM
Corporation

Figure 11-20

Ads, "Cool Down"

Agency: Arian, Lowe, Travis & Gusick Advertising, Chicago, IL

Creative director: Gary Gusick

Art director: Mike Fornwald

Writers: Gary Gusick, Mike Fornwald

Client: EverFresh Juice Co.

*We decided to target women for the Cool Down product. After all, 62% of all
people who exercise three times a week or more are female. We retained the
services of Nicole Hollander, creator of the "Silvia" nationally syndicated cartoon
strip, to help with the executions. The ads are designed to poke gentle, gender fun
on behalf of women and to demonstrate to women that Cool Down understands
them. It worked.*

— Daryl Travis, President, Arian, Lowe, Travis & Gusick

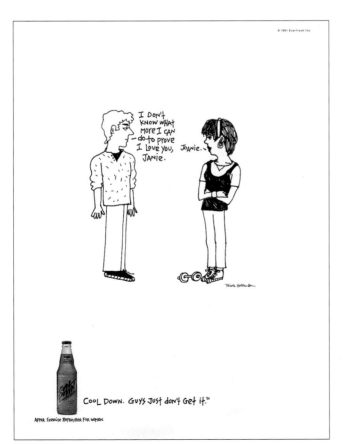

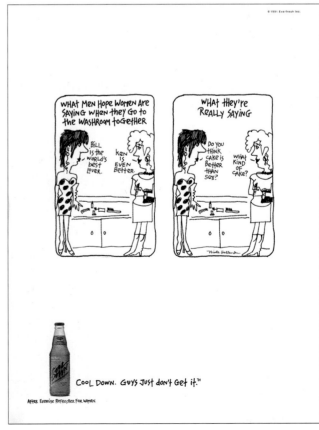

Chapter 11 Advertisements

Figure 11-21
Ad, Hush Puppies
Agency: Fallon McElligott, Minneapolis, MN
Art director: Bob Barrie
Writer: Jarl Olsen
Photographer: Rick Dublin
Client: Hush Puppies Shoes/Wolverine

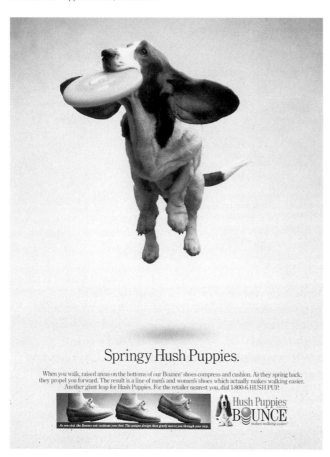

Figure 11-22
"Rollerblade" Poster
Design firm: Planet Design Co., Madison, WI

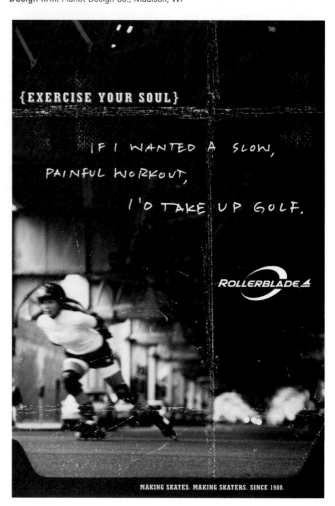

Figure 11-23
Varma/Cutty Sark Scots Whisky/
"Altamira Cave"
Agency: Delvico Bates, Madrid, Spain
Creative directors: Pedro Soler/
Enrique Astuy
Client: Varma/Cutty Sark Scots Whiskey

*Cutty Sark is always distinguished from
the crowd. Yellow signifies its persona.*

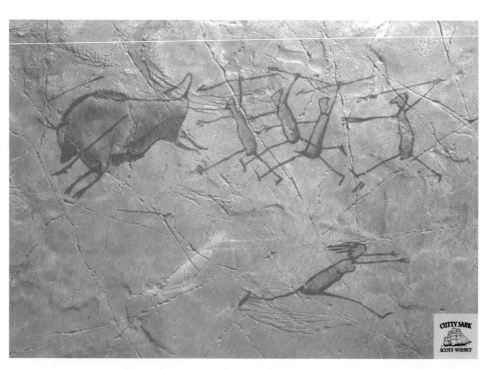

something we recognize and come to identify with the produce or service, like the dog in this ad for Hush Puppies (Figure 11-21).

An ad may create an association for us with a particular lifestyle or look. This also is called image advertising. Rollerblade is not just selling you their product; they are selling you an attitude (Figure 11-22). Ads that have emotional appeal tend to be very memorable, like this one for Cutty Sark which makes you chuckle (Figure 11-23). The stories are so moving in a campaign for the United Way, they might move some people to tears (Figure 11-24). Compassion for animals certainly is provoked in this cam-

You get back from your honeymoon even more in love than the day you left. If that's possible.

He's your "husband" now. And you smile as you say the word silently in your head. So you make him his breakfast and you pour him his coffee, and you laughingly say that he shouldn't get used to this.

Then, as you share an amusing story from the morning paper, he looks at you and says, quite seriously, that his eggs are burned.

You laugh, which, to your surprise, angers him. And from out of nowhere, his fist flies toward your face. And the wedding band that you so lovingly placed on his finger just 2 weeks ago, slices your chin wide open.

It happens. Just like that.

There are more than 20,000 reports of domestic violence each year in St. Louis. You can help. Please give to your United Way. It hits home.

Figure 11-24
Ad Campaign, "It Hits Home"
Agency: DMB & B, St. Louis, MO
Creative director/Writer: Steve Fechtor
Art director: Vince Cook
Photographer: Scott Ferguson
Client: The United Way

We tried to make the posters poignant. We felt the copy had to be read and dwelled on, so we dropped the visuals behind the words. The effect was dream-like, as if the images were reminiscences in the mind of the person who had suffered. It must have worked, because more than one person choked up when they read it.
— Vince Cook, Art director, DMB & B

Your father dies of a heart attack at the age of 54. You loved him. And you miss him. And you hate him for leaving you so suddenly.

But he's gone. So you grieve. And life goes on.

Then one day you're doing the dishes, and there's something about the way the soap suds look that makes you sob uncontrollably.

And even when the sobbing stops, it never stops in your head. So the dishes go undone. And the grass goes unmowed. And the kids go uncared-for. And the dog never gets let out.

Because you're spending all of your time in your room. In your bed. In the dark.

It happens. Just like that.

There are more than 200,000 cases of severe depression in St. Louis. You can help. Please give to your United Way. It hits home.

You're packing your bags, and you're loading the car, and you're moving out of your house. The kids try to help, but they're just in the way. And the baby is crying, and needs to be changed. And it looks like that last bag won't fit in the car. And all you can think of is, "What will we do with the goldfish?" Because you can't take it with you where you're going. Because you don't know where you're going. Because you once had a husband, who had a job, that paid the mortgage, and fed the kids. And now, you don't.

It happens. Just like that.

There are more than 8,000 homeless people in the St. Louis area. You can help. Please give to your United Way. It hits home.

Figure 11-25
Circus Posters: Elephants/Horses
Agency: Pagano Schenck & Kay Inc., Boston, MA
Creative director: Woody Kay
Art director: Kevin Daley
Copywriter: Tim Cawley
Illustrator: Archival
Client: World Society for the Protection of Animals

paign (Figure 11-25). Of course, you have heard that sexy ads can sell anything, and unfortunately, sex is used inappropriately and too often. When used for appropriate products, however, it can be clever, as in these ads for Tabu lingerie (Figure 11-26).

If an ad makes you feel something — anything — you are more likely to be persuaded by it. The best way to create ads that have emotional appeal is to think of the most human reactions to events or situations. The approach to this type of creative thinking is very similar to the approach most comedians take. They illuminate the little things in life we take for granted and show us the inherent humor in our own behavior. They draw upon human experience — life's little dreams and comedies. This is true in advertising as well. If your concept is believable, then it may make the viewer think "That is really true — that

happens to me!" Or, "Wow, I would love for that to happen to me." Or even, "I would hate for that to happen to me."

When an ad sounds like a sales pitch or looks like a traditional ad, it screams: "I'm an ad and I'm trying to sell you something!" You're less likely to believe the benefit that is being touted when the advertiser is hitting you over the head with it. Also, you'd probably be much less likely to watch an ad that focuses on the product in a conventional way and doesn't entertain you. We'd all rather be entertained than sold a bill of goods by an advertising pitch.

REMEMBER. MEDICAL EXPERTS RECOMMEND INCREASING YOUR HEARTRATE AT LEAST THREE TIMES A WEEK.

TABU

ACTUALLY. THERE IS ONE KNOWN CURE FOR SNORING.

TABU

JUST FOR THE RECORD. BASEBALL ISN'T AMERICA'S FAVORITE PASTIME.

TABU

Figure 11-26
Posters, Tabu Lingerie
Agency: The Richards Group, Dallas, TX
Art director: Jeff Hopfer
Writer: Todd Tilford
Photographer: Richard Reens
Client: Tabu Lingerie

Warning: People don't like ads. People don't trust ads. People don't remember ads. How do we make sure this one will be different?
Why are we advertising?
To generate awareness for Tabu by making customers feel more comfortable about buying sexy lingerie.
Who are we talking to?
Men who buy lingerie for a wife or girlfriend, and women who buy lingerie for themselves (to please the men in their lives).
What do they currently think?
"I'm a little uncomfortable about buying sexy lingerie; lingerie is very intimate and private."
What would we like them to think?
"This is a friendly, uninhibited store. I wouldn't be embarrassed to ask for anything."
What is the single most persuasive idea we can convey?
Tabu makes buying lingerie fun.
Why should they believe it?
Because we're honest about why people buy it.
Are there any creative guidelines?
Sexy and intelligent. Not sexist and crude.
— The Richards Group

Creative approaches

Great ads can be truly memorable. How do award-winning art directors come up with all those great visuals? First and foremost, the visual expresses the concept. Second, if you do not rely on a photograph or illustration of the product or service as the main visual, you have a world of visuals from which to choose. Here are some approaches to think about. They are not suitable for every concept, but when they are, they can yield exciting results.

- Borrow from language, try visual puns, similes, metaphors, and analogies. (If you use puns, use only one pun in your entire portfolio.) (See Figures 11-27 through 11-33).

Figure 11-27
Poster, NYNEX
Agency: Chiat/Day, New York, NY
Creative director: Dick Sittig
Art director: Dave Cook
Writer: Dion Hughes
Client: NYNEX Yellow Pages
Courtesy of NYNEX

1st posting

2nd posting

3rd posting

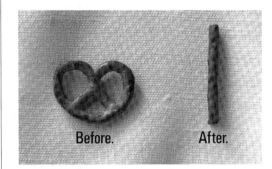

Look at it this way. Your back is the center of your whole body.

That's why when your back gets all twisted up, you seem to hurt all over. If you have chronic back problems, give me a call at (213) 749-6438 and we'll arrange an appointment.

Chiropractic is a proven, altogether safe technique. Which is why many insurance plans now cover it.

I think that after you see me, you'll feel a lot better than you did before.

Orlando Pardo D.C.
DOCTOR OF CHIROPRACTIC

Figure 11-28
"Pretzel Ad"
Agency: Leonard Monahan Lubars & Kelly, Providence, RI
Creative director: David Lubars
Art director: Michael Kadin
Writer: David Lubars
Photographer: Paul Clancy
Client: Orlando Pardo, PC

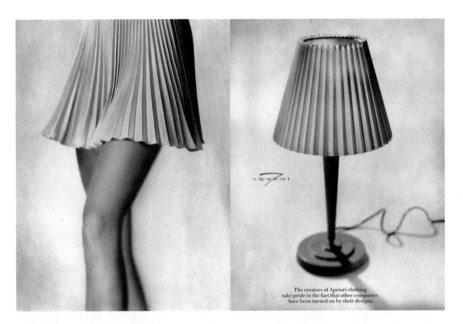

The creators of Apriori clothing take pride in the fact that other companies have been turned on by their designs.

Figure 11-29
Ad Campaign, "Lampshade"
Agency: Weiss, Stagliano + Partners Inc., New York, NY
Creative directors: Marty Weiss, Nat Whitten
Art director: Ellen Steinberg
Writers: David Statman, Paula Dombrow, Ernest Lupinacci
Photographer: Guzman
Client: Apriori

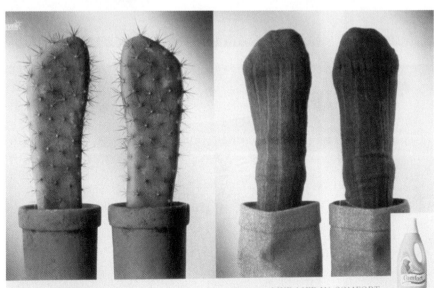

DON'T ROUGH IT LIVE LIFE IN COMFORT

Figure 11-30
Ad, Comfort "Cactus"
Agency: Ogilvy & Mather London Ltd.
Photographer: Peter Rauter
Client: Lever Bros. Ltd.

Figure 11-31

3M Zaris/It's Whitening Made Simple

Agency: Martin/Williams Inc., Minneapolis, MN

Client: 3M Dental

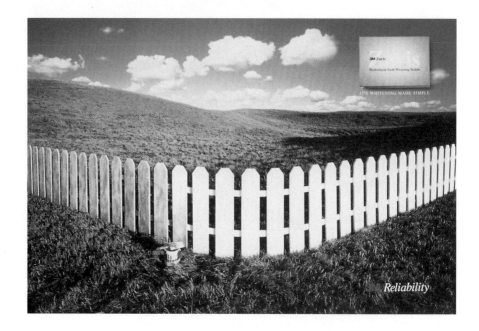

Figure 11-32

"Tattoo remover," "There's nothing quite like the feel of the open road," "The road won't protect you. You have to do it"

Agency: Martin/Williams Inc., Minneapolis, MN

Client: MN Motorcycle Safety Center

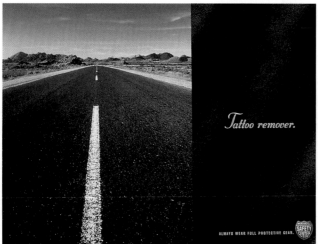

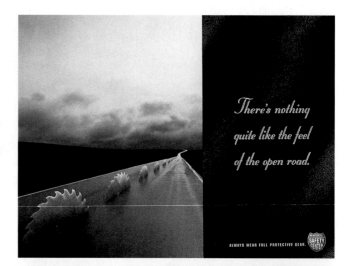

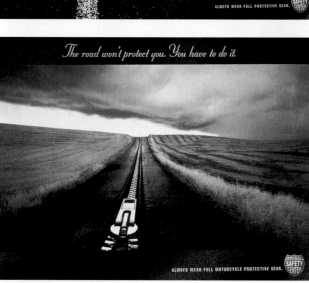

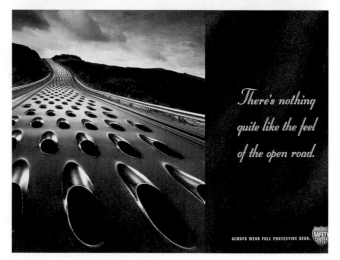

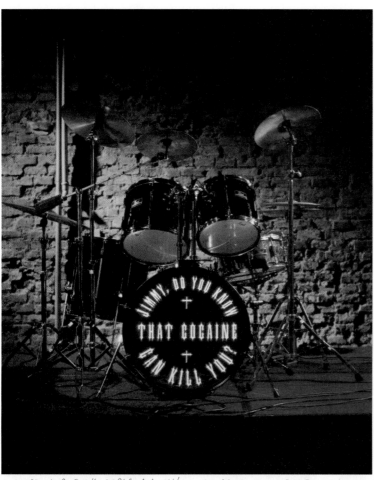

ENTER YOUR SON'S WORLD AND TALK TO HIM ABOUT DRUGS. Consejo Publicitario Argentino 322·6303

Figure 11-33
Consejo Publicitario Argentino/Entre al mundo/ "Drums," "Game," "Magazine"
Agency: Verdino Bates Fernando Fernandex, Argentina
Creative director: Fernando Fernandez
Art director: Carlos Brana
Copywriter: Sebastian Alfie
Client: Consejo Publicitario Argentino

This campaign encourages parents to participate in their children's lives, in order to be candid about drug problems.

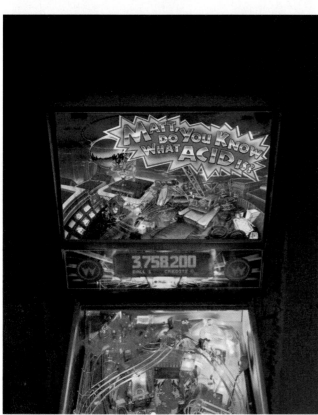

ENTER YOUR SON'S WORLD AND TALK TO HIM ABOUT DRUGS. Consejo Publicitario Argentino 322·6303

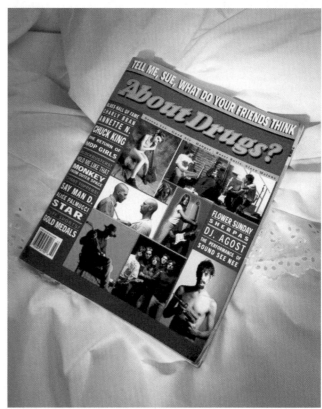

ENTER YOUR DAUGHTER'S WORLD AND TALK TO HER ABOUT DRUGS. Consejo Publicitario Argentino 322·6303

Figure 11-34
Ad
Agency: Fortis Fortis & Associates, Chicago, IL
Client: Partnership for a Drug Free America

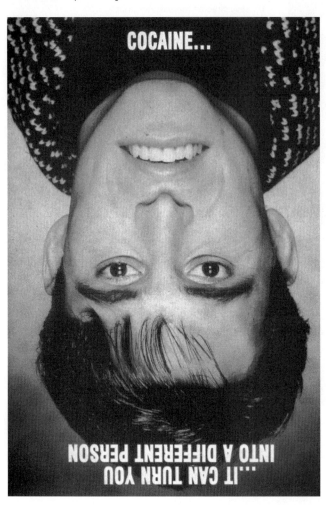

- Reverse things and statements. Look at something in a mirror. Turn a mouth upside down. Reverse a popular phrase (Figure 11-34).

- Do the unexpected. Use an unusual visual or one that is unrelated to the product or service (See Figure 11-1).

- Use an allegory, like the exciting prospect shown here in the ad for Lottery Commission of Western Australia, "Taps" (Figure 11-35).

- Merge things. Bring two different things, images, or objects together to make a new one. Merge a tennis ball and a croissant. Merge a fish and a carrot (Figures 11-36 through 11-39).

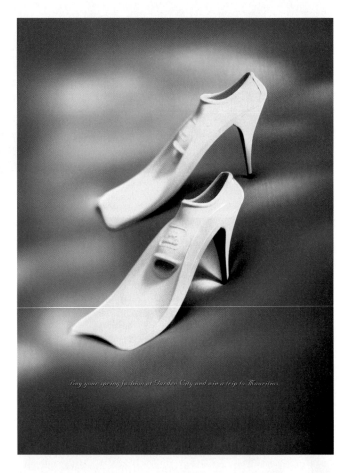

Figure 11-36
Garden City Press/ "Flippers"
Agency: Marketforce/Australia
Creative directors: Adam Barker/Lori Canalini
Art director: Natlie Fryer
Copywriter: Matthew Garbutt
Client: Garden City Press

A high fashion store has a promotion to Mauritius, famous for scuba/snorkeling.

Figure 11-35
Lottery Commission of Western Australia/"Taps"
Agency: Marketforce/Australia
Creative directors: Adam Barker/Lori Canalini
Art director: Lori Canalini
Copywriter: Adam Barker
Client: Lottery Commission of Western Australia

Allegory of good life if you win the lottery.

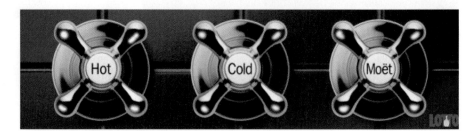

GRAPHIC DESIGN SOLUTIONS

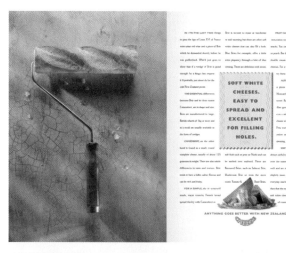

Figure 11-37

New Zealand Cheese/ "Roller"

Agency: The Bates Palace/ New Zealand

Creative director: John McCabe

Art director: Lindsey Redding

Copywriter: Sion Scott-Wilson

Demonstration of softness of New Zealand cheese.

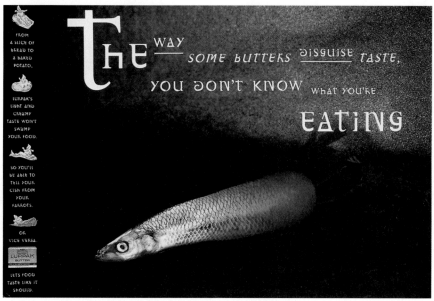

Figure 11-38

Ad Campaign

Agency: GGT Advertising, London, England

Creative team: Kate Stanners, Tim Hearn

Typography (specially cut typeface):
Len Cheeseman

Photographer: John Parker

Retoucher: Lifeboat Matey

Client: Lurpak Butter

Figure 11-39

Smithkline Beacham/Odol/"Cigarette Butts," "Toilet," "Sardines"

Agency: Netherlands/Bates Not Just Film

Creative director: Bas Coolwijk

Art director: David Bergaman

Copywriter: Ron Witebel

Client: Smithkline Beacham/Odol

Odol mouth refresher gets rid of the worst breath problems.

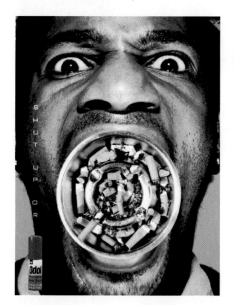

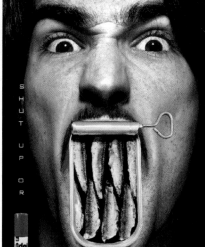

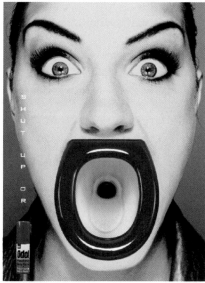

- Use a new or strange point of view. See something from an unusual or unexpected angle (Figure 11-40).

- Compare things (*not* products — like Coke and Pepsi), like a man to a mouse; or compare fishing to another pastime (Figure 11-41).

- Ask yourself: "What if...?" What if a cow barked? What if a tree grew upside down? What if you had more time on your hands? as demonstrated in the Lighthouse spread "Think Outside the Rectangle" (Figure 11-42).

- Personify things. Give inanimate objects human qualities (Figure 11-43).

Figure 11-40
Ad
Agency: Franklin Stoorza, San Diego, CA
Art director: John Vitro
Writer: Bob Kerstetter
Illustrator: Mark Fredrickson
Client: Thermoscan
Thermoscan is a registered trademark, and the "Timmy" character is a registered copyright of The Gillette Company.

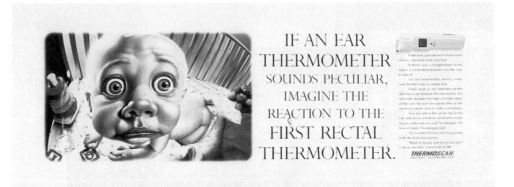

Figure 11-41
Agency: Martin/Williams Inc., Minneapolis, MN
Client: Coleman
© The Coleman Company Inc.

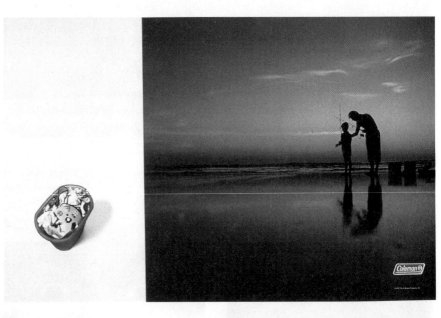

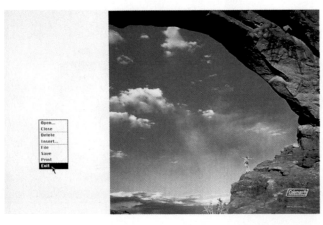

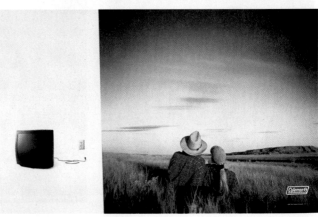

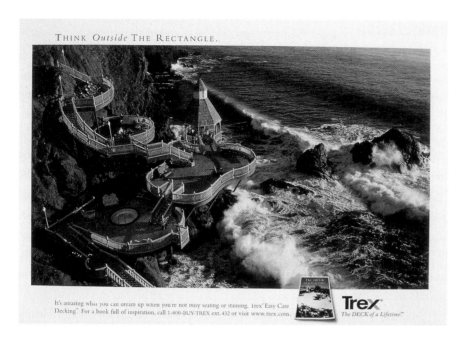

THINK *Outside* THE RECTANGLE.

It's amazing what you can dream up when you're not busy sealing or staining. Trex® Easy Care Decking.™ For a book full of inspiration, call 1-800-BUY-TREX ext. 432 or visit www.trex.com.

Trex
The DECK of a Lifetime™

Fiugre 11-42
Lighthouse Spread "Think Outside the Rectangle"
Agency: Carmichael Lynch, Minneapolis, MN
Photography: Ripsaw
Client: Trex Company

Figure 11-43
Ad Campaign
Agency: Bartle Bogle Hegarty (BBH),
London, England
Client: Sony Walkman

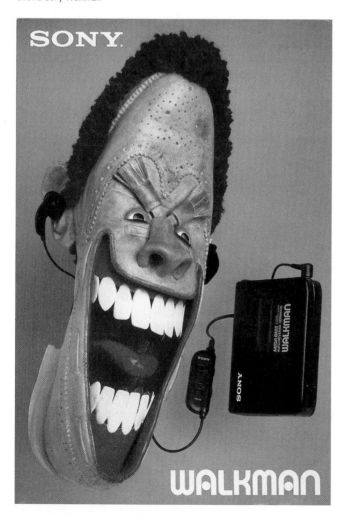

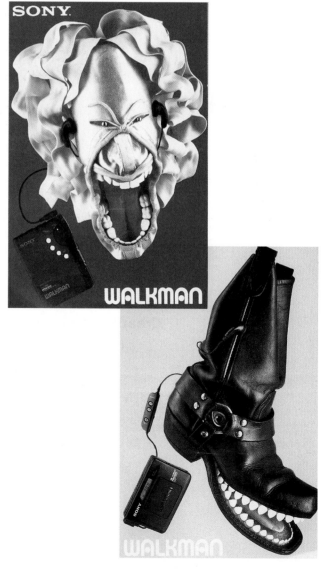

Stimulation

Most agencies want to hire people who take fresh approaches. How do you make sure your work is innovative? First you have to know what has been done (the history of advertising and graphic design) and what is currently being done. Then you will know what is old, new and retro (a look back).

You probably know the saying that there is nothing new under the sun. If you believe that, the only thing to do is recycle. Take something from the past and make it new. For example, if you look at experimental type design in the '90s, it is reminiscent of Dadaist type design from the early 20th century. Now some advertising agencies and graphic designers are using visuals from the '50s because there is a whole generation out there who is not familiar with them.

Take cues from the other arts, such as dance, music, fashion, painting, film, and literature, and create visual responses. Similarly, politics, world events, and social change can prompt visual ideas.

Be eclectic. Gather material and inspiration from various sources and bring them together. Examine other cultures and draw inspiration from diverse styles, imagery, and compositional structures. Go to the movies, look at magazines, listen to comedians, surf the world wide web, read humorists' works, watch music videos, look at all graphic design, observe human behavior. Be a critical observer, listener, and reader. Being well-read, well-educated in many subjects, observant, and in tune with the spirit of the time will enhance your creative abilities.

COPY EXERCISES

EXERCISE 11-1
Creative writing exercise — an autobiography

- In essay form, write your autobiography (no more than one page). It may start at any point in your life. Establish an angle — emphasize one benefit of your life.

- Condense the essence of the essay into one paragraph.

- Write one line (not a title) that captures the essence of the autobiography.

EXERCISE 11-2
Creative writing exercise — a "how-to" essay

- Write an essay about "How to lose someone at a party."

- The opening line should hint at the purpose of the essay.

- The middle of the essay should be the turning point for the reader — now he or she should know how to get rid of an annoying person at a party.

- As you wrap it up, the essay should still hold your reader's attention.

- The last line should be strong and almost carry the spirit of your message on its own.

EXERCISE 11-3
A humorous story

- Write about something funny that happened to you.
- Write for five minutes without stopping. Do not worry about spelling or grammar.

DESIGN EXERCISES

EXERCISE 11-4
A redo

- Find a bad print ad.
- Analyze the design concept (or lack of one).
- Rethink it and redesign it.

EXERCISE 11-5
Recognizing differences

- Find ten different examples of layouts. Diagram the layouts.
- Find five ads with examples of different types of visuals, for example: illustration, photography, cartoon, diagram, montage, typography, etc.

CONCEPT EXERCISES

EXERCISE 11-6
Analyzing ads

- Find a few good ads on the web, TV, and in print.
- Identify the concept in each one; determine how the visual and copy express the concept.

EXERCISE 11-7
Product research

- Choose a produce or service.
- Research it.
- Brainstorm strategies for selling it.

EXERCISE 11-8
The creative team

- Choose the role of an art director or copywriter. With a partner, create an ad for the client of your choice in a limited amount of time (for example, one hour).
- Exchange the roles of art director and copywriter.

When the product, service, or client's logo is the main visual in an ad, the potential consumer immediately is alerted to the fact that they are being sold something. That kind of visual might as well read, "I'm an ad — do not bother to look at me." Learning not to depend upon the product as the visual is an important early lesson. (Thanks, Bob Mitchell, for teaching this to me.)

Presentation

Most instructors do not mind when ads are presented as roughs. If you are interested in using ads in your portfolio, they should be presented as tight comprehensives — simulating finished, printed pieces as closely as possible. Photostats, color copies, and computer-generated type are recommended. Your comp should be mounted on foam core without a border or on a black board with a 2″ border. The format of your ad, whether it is a single page or a spread, should be determined by your concept. Save your thumbnail sketches; most art directors like to see them as examples of your creative process.

PROJECT 11-1
The search for a creative visual

Step I

- Choose a client.

- Do research. Find out everything you can about your client's product or service. Survey people — ask them what they think of it.

- Determine the benefit of your client's product or service. For example, if your product is cookies, is your client's product sweetened with sugar or fruit juice? If it is sweetened with fruit juice, then the benefit for the consumer is that they will be eating a healthier cookie.

- Determine the audience for your client's product.

- Write a claim for your product.

Step II

- Create an ad for your client's product or service.

- Do not use the product, service, or logo as the main visual.

- Brainstorm. Write down everything you can think of that is related to your product. Think of analogies, metaphors, and similes.

- Think of situations where the product or service might be used.

- Create at least ten sketches.

Step III

- Refine the best sketches and create two roughs.

- Remember: The main visual cannot be a photograph or illustration of the product or service.

- You may show the product, service, or logo in the sign-off.

Step IV

- Create a comp.

So often we see ads that have rather commonplace visuals. An ad for tissues shows a tissue box. An ad for pain reliever shows someone with a headache — nothing interesting or unpredictable. However, if the visual is unusual, perhaps even completely unrelated to the product, then we might notice the ad. After all, you will not sell people anything unless you get their attention first.

PROJECT 11-2
Get wild

Step I

- Choose a product, for example, a pain reliever.

- Do research. Find out everything you can about your client's produce or service. Try the product or service (if possible).

- Determine the audience.

- Determine the benefit. Will your client's product or service make the consumer more attractive, healthier, richer, or offer some other benefit?

- Write the benefit down on an index card.

- Write a claim.

Step II

- Create an ad; once again, do not use the product, service, or logo as the main visual.

- This time you must use an unusual or extraordinary visual — a visual that is uncommon or unexpected.

- Produce ten sketches with at least three possible visuals. **Creative approach:** If your product is a headache remedy, try thinking of visuals that symbolize headaches, like a monster, or try thinking of ludicrous headache remedies, such as using a guillotine.

Step III

- Create a rough.

- You may use a visual of the product or logo in the sign-off.

Step IV

- Create a comp.

If a product or service has a USP, that is something solid the creative team can promote. Although most products do not have a USP, advertisers sometimes come up with a claim to make about their product simply to pre-empt the competition. Sometimes, an advertiser can take a unique disadvantage and turn it to their advantage, for example, the famous campaign for the Volkswagen Beetle that claimed, "It's ugly but it gets you there."

PROJECT 11-3
The unique selling point (USP)

Step I

- Choose a client whose product or service has a unique selling point (USP).
- Research it and its competition.
- Tout the USP as the benefit.
- Write a claim.

Step II

- Create an ad for your client's product or service based on the USP.
- Produce ten sketches.

Step III

- Refine the sketches. Create two roughs.
- Remember: always establish a visual hierarchy.

Step IV

- Create a comp.

This assignment pushes you to think of alternative layout solutions. Most students are quite happy with their first layout and do not explore other possibilities.

PROJECT 11-4
Varying the layout

- Take an ad that you have already created and lay it out five very different ways.

A campaign demonstrates your ability to create a flexible idea and run with it. It also demonstrates your ability to be consistent with strategy, concept, design, writing, and style.

PROJECT 11-5
An ad campaign

Step I

- Choose your best ad.

- Determine whether you think the design concept can be expanded into a campaign. Can you think of two other ads that communicate a benefit? As stated earlier, a student campaign consists of three ads that share a common goal or strategy. The campaign shares a common spirit, style, claim, and usually, very similar layout.

- Write a claim for all three ads.

Step II

- Produce twenty sketches for the campaign.

- Remember: the layouts should be similar.

Step III

- Create two sets of roughs for the campaign.

Step IV

- Create a comp for each ad in the campaign.

Preparing a verbal presentation teaches you to use everyday, informal language. You might be tempted to write trite phrases such as, "introducing the most amazing..." or "take the taste test..."; but you would probably realize they sound like sales pitches if you say them aloud. Sound, movement, and time are the advantages of television over print. Make the most of demonstration, music, sound effects, close-ups, cuts, and every other wonderful thing television offers. Television should be entertaining, funny, dramatic, bittersweet; think of a TV ad as a mini-movie. You may want to create a print ad and web banner to coordinate with your television commercial.

PROJECT 11-6
Creating a storyboard for a television commercial

Step I

- Choose an inexpensive product.

- Create a verbal presentation that will convince an audience your product has a benefit. Make sure it is entertaining.

- Make sure your presentation does not sound like a sales pitch. (You may want to videotape the presentation.)

- Use strong opening and closing lines.

Step II

- Create a storyboard for your presentation consisting of four to six frames.

- The frames should describe the key actions or visuals in the commercial.

- The frames should be in proportion to a TV screen.

- Under each frame, design the action seen on the video and audio being heard.

- Create a rough.

Step III

- Create a comp.

Annual Reports

OBJECTIVES

- understanding the purpose of an annual report
- comprehending the many components and themes of annual reports

An annual report, a company report to stockholders, is an important corporate document. Some designers specialize in the design of annual reports. "This field is specialized to the point that most clients want you to have experience in doing an annual report before they will ever trust you with one, which of course, makes getting the experience rather difficult," says Denise M. Anderson, Design Director of DMA.

Looking at the design projects in this chapter, you can see the importance of good compositional skills. Juggling many components, such as graphs, charts, lists, a good deal of text, photographs, product information, sub-headlines, and other graphic elements, is part of designing an annual report. Annual report design is always a challenging layout problem.

Themes

With the client or on her own, a designer (usually) chooses a theme as part of the development of a design concept for an annual report. A theme is "an implicit or recurrent idea; a motif." A chosen theme may relate to future growth, the people who make up the corporation, or any other related (or sometimes arbitrary, yet interesting) subject. Photographs and/or illustrations play a major role in the communication of the theme.

Design principles

Before attempting annual report design, you must be comfortable with the principles of design — balance, emphasis, rhythm, and of course, unity. Finding a way to unify a multi-page document is crucial. Using a flexible grid, selecting an interesting and clear numbering system, selecting colors that help establish unity, choosing or designing graphic elements, all contribute to coherence. Unifying this type of document — with a measure of variety — is a formidable creative endeavor.

Here is a range of examples of interesting and successful annual report design:

For the Esterline Technologies annual report (Figure 12-1), Leimer Cross used the following unusual elements:

- a metal tag on the cover

- colored close-up images (such as circuit boards and cockpit switch light) on vinyl inserts to make different important points of information

- the inserts lift to reveal graphs

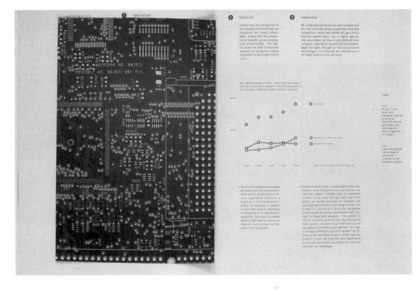

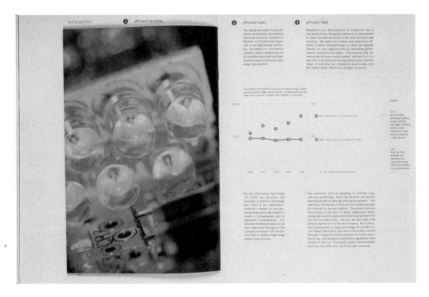

Figure 12-1
Esterline Technologies
Annual Report
Design firm: Leimer Cross
Design Corporation, Seattle, WA

Nesnadny + Schwartz used cropped visuals and type to create a very graphic and contemporary look for the Progressive annual report (Figure 12-2). "Each year, Progressive commissions an artist or a group of artists to create a body of work for our annual report, which is inspired by Progressive theme. This year, our inspiration is the American passion for car travel and the culture born from it. The artist is photographer Stephen Frailey. Stephen works by collaging found images to create new meaning from their juxtaposition. Frailey's work will become part of Progressive's growing collection of contemporary art."

The unusual format of Heartport's annual report captures one's attention immediately (Figure 12-3). More than 800,000 people undergo conventional open-chest heart surgery each year, and Cahan & Associates utilized two holes in the report to symbolize the fact that Heartport Port-Access Systems enable surgeons to perform a wide range of heart operations through small incisions between the ribs.

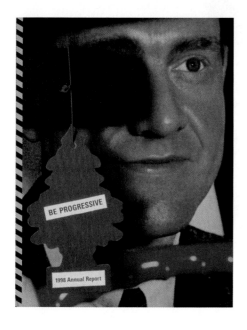

Figure 12-2
"Be Progressive" The Progressive Corporation 1998
Annual Report
Design firm: Nesnady + Schwartz, Cleveland + New York + Toronto
The tree design is a federally registered trademark owned by Julius Samann, Ltd. and is used here with permission.
Art directors: Mark Schwartz and Joyce Nesnadny
Designers: Joyce Nesnadny and Michelle Moehler
Artist: Stephen Frailey
Writer: Peter B. Lewis, The Progressive Corporation
Client: The Progressive Corporation

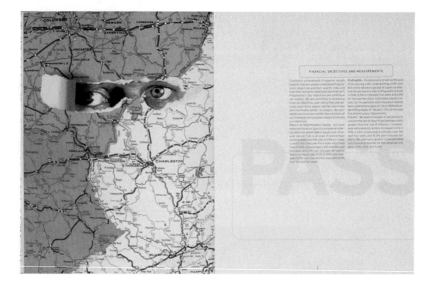

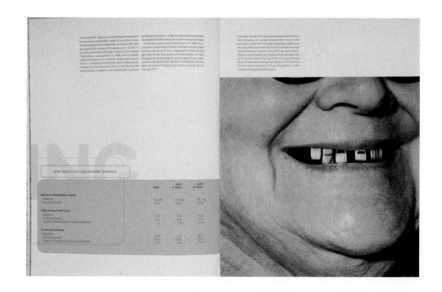

Unity is created by the clear use of grid and the typographic design in this annual report, "Critical Research," designed by Nesnadny + Schwartz (See Figure 12-4). Red is used for the headlines, subheadlines and introductory sentences, which establishes an element of continuity. An unusual color palette in the statistical part of this annual report gives it a lively feeling.

For a company that leads the market in voice-enabled services, General Magic, Cahan & Associates used an accordion-fold to link a wide variety of visual "voices" on one side of the report and reported all the vital annual report information on the opposite side (See Figure 12-5).

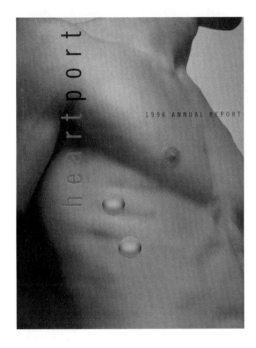

Figure 12-3
Heartport Annual Report
Design firm: Cahan & Associates, San Francisco, CA
Art director: Bill Cahan
Designer: Craig Bailey
Client: Heartport
© Cahan & Associates

Heartport develops minimally invasive cardiac surgery systems. Their revolutionary procedure, Port-Access, allows surgeons to perform many procedures through small openings between the ribs without cracking open the chest of the patient. The result is improved quality of life, quicker recovery times, and much less trauma than with conventional open-chest surgery. Because the past year saw a critical mass of patients having this new minimally invasive procedure, we created a small by many paged book. The book is an examination of the return to normal life through personal photography and recovery stories told by the patients themselves.
— Cahan & Associates

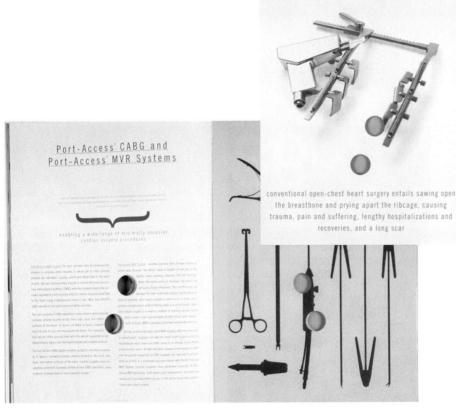

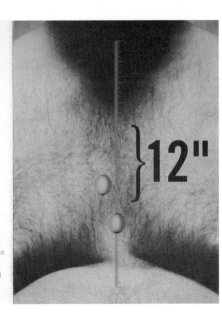

Figure 12-4

"Critical Research" Cleveland Clinic Foundation 1998
Annual Report

Design firm: Nesnady + Schwartz, Cleveland + New
York + Toronto

Art directors: Tim Lachina and Brian Lavy

Designers: Brian Lavy and Tim Lachina

Writer: Steve Szilagyi, The Cleveland Clinic
Foundation

Client: The Cleveland Clinic Foundation

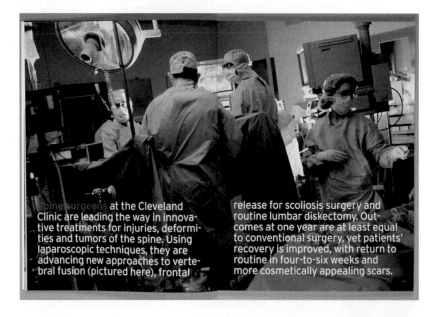

Figure 12-5

"Everyone has a voice"

General Magic 1998 Annual Report

Design firm: Cahan & Associates, San Francisco, CA

Art director: Bill Cahan

Designer: Bob Dinetz

Client: General Magic

© Cahan & Associates

*Though General Magic has interesting technology
and product ideas, what seemed most compelling
was the idea of your own voice being the next
interface with the digital environment. People have
been talking to their televisions, cars, and computers
for years, and the human voice is the logical
replacement from the graphical user interface (GUI).
We made a case for voice as the most natural way to
communicate throughout the world.*
— Cahan & Associates

(In fact, one trick per site design is really all anyone has time for.) For inspiration, research well-designed web sites. The best way to see what is possible in designing navigation buttons is to visit web sites.

Core pages and subsequent linked pages

Core pages are mini-home pages. Once visitors select a main category, they are whisked to a page with yet another list of selections. Or, if the site is small and uncomplicated, the core page is not necessary. The home page navigation buttons will move visitors directly to a page of relevant information. Again, electronic buttons provide a way to move visitors around the site. Core pages and subsequent linked pages provide information and should also contain the full navigation system or a mini-navigation system that guides visitors back to previous pages or forward to areas that have not been visited. A **link** is a connection from one web page to another. By maintaining your visual grid, the visitor will have an easy time locating titles, information, and navigation buttons, thus enabling a smooth passage around the site.

Contact information

Simply, this is phone, fax, e-mail, and address information. Visitors should have easy access to this information from a number of different venues. It's best to include it in the main navigation system and have it contained on its own page.

Design considerations

The fundamental graphic design elements and principles apply to web design. You must understand how to use the formal elements of line, shape, color, value, texture, and the principles of balance, emphasis, rhythm, and unity. Web technology may be changing rapidly, but graphic design principles are here to stay.

The main challenge of web design over print is that it is interactive. The visitor can jump around the site indiscriminately. Different visitors will enter and exit the site differently. A visitor needs to stay on the site and do a lot of exploration in order to get the entire site experience. If a comparison must be made to print, it is most similar to someone randomly thumbing through a magazine or book. Like a magazine, it is best to establish a visual grid (repetitive layout) to create an identity, help maintain order, and make it easy for the visitor to quickly locate various options and information. With a strong grid the visitor will have a smooth passage through a dense amount of information.

Visual hierarchy

A visual hierarchy is as important on a web site as it is in print. You must direct the visitor's attention. Establishing a visual hierarchy allows the visitor, at a glance, to see informational or decorative graphic elements (visuals or type) in order of their importance.

Begin by choosing a focal point and go from there. Remember to ask yourself:

A. What do I want the visitor to see first?

B. What do I want the visitor to see second?

C. What do I want the visitor to see third? And so on, right down to the details.

Using the same factors you would in print, such as size, value, color and visual weight, establish a visual hierarchy, a flow of information.

Layout

Since people use a variety of types of computers, monitors and web browsing software, a designer creates a web site keeping in mind that a visitor may not see exactly what the designer intended.

Type sizes are not viewed at a single basic standard (would somebody please create a standard!). Macintosh systems display type (HTML formatted*) at 12 points in height. The same type on non-Mac systems is a whopping 16 points in height. Letterspacing, line breaks, and leading all correspond to this difference in point size. It's best to look at your design on both types of systems and browsers to ensure your text columns align properly.

Using a grid is the best way to ensure your creative efforts are also functional for the visitor. All the special effects and animation will only annoy visitors if they can't get quickly to the information they are seeking.

As with any layout, you have several goals in a web design:

1. to fit elements into a limited space

2. to arrange elements so that they are functional and accessible

3. to arrange elements attractively

Before deciding on a grid or layout, consider:

- The audience. The nature of the audience will help you determine how eccentric or classic a grid or layout you can utilize.

- The amount of information. If you need to post a great deal of information in a limited space, then a grid is essential. A small amount of information allows you greater freedom to use visuals and play with a layout.

- The purpose of the web site guides your layout. An informational site may restrict you because it is primarily practical; the visitor is interested in getting information quickly and clearly. The visitor is there because he or she wants or needs the information.

A promotional site might allow for greater freedom because it can be more expressive and more fun; it establishes an identity or spirit. The playfulness of a promotional site engages the viewer; the viewer is there because he or she is curious about what is being offered.

- What message needs to be communicated. The tone or substance of your message may help you decide on the type of layout you want to use.

- How often it will be updated and who will update it. If the web site needs to be updated very frequently, you want to keep the layout easy to change and simple to change, depending on the web master.

Color

A web page designer does have special considerations about type and color. When you design for print and see your design through production at the print shop, you have control over the final color. Not so with web design — you can't control the color on the monitor of every web user. (Also to consider is that Macintosh systems display color at a lighter value than non-Mac systems.) It's best to look at your design on both types of systems and browsers to ensure your color is balanced. Consult a technology-based manual on web color for limitations and cross-platform use.

Style

The style of a web site can be as varied as that of a print ad. It can utilize photography or illustrations or a combination thereof. It can be classic in composition or avant-garde. The tone may be irreverent, humorous, formal, or provocative. Certainly, the tone should work cooperatively with the style. Please keep in mind this advice from Landor Associates Branding Consultants and Designers Worldwide: "Keep it clean and simple."

Approach to Promotional sites

Apply the same rules of advertising (see Chapter 11, Advertisements) about capturing the visitor's attention. Advertising on a web site is no different than advertising in print or on television in this way: If it's not attractive, seductive, or interesting, no one is going to pay attention

HTML is Hypertext Markup Language — the computer code in which Web sites are created.

to it. In fact, at this point in time, web advertising has to be a little more seductive because it requires downloading time and more patience on the part of the visitor.

According to Giles Felton of *The New York Times* E-commerce section, a good site is one that has "stickiness," a current marketing buzzword. "A sticky site is one that keeps users glued to it, either through sheer intrinsic niftiness or by piling layer upon layer of more-or-less-related offerings, like stock quotes, weather updates, or interactive whiz-bangs like sports trivia quizzes," writes Felton.

A designer can use all his or her advertising know-how to promote a product, service, or company on the web. Take a look at this irreverant and fun site by Planet Design Company, which is aptly aimed at a young audience (Figure 13-1), in contrast to this sophisticated site aimed at an upscale adult audience by Liska + Associates (Figure

Figure 13-1

"Moose" Web Site

Design firm: Planet Design Company, Madison, WI

13-2). Here is kirshenbaum bond & partners' home page (Figure 13-3) and banners and landing pages for Sony (Figures 13-4 and 13-5).

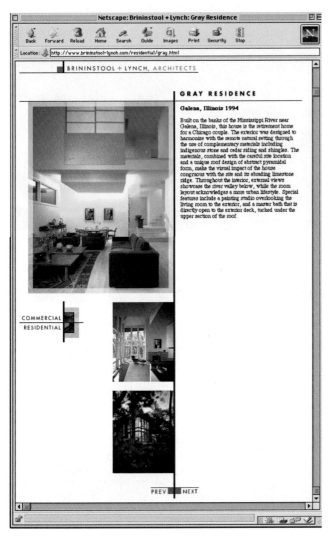

Figure 13-2

www.brininstool-lynch.com

Brininstool + Lynch, Architects Web Site

Design firm: Liska + Associates Inc., Chicago/New York

Figure 13-3

kirshenbaum bond & partners Home Page

Ad agency: kirshenbaum bond & partners, New York, NY

Figure 13-4

Sony — Boxer Banner and Landing Pages

Ad agency: kirshenbaum bond & partners, New York, NY

Figure 13-5

Sony — Dating Game — Slider Banner and Landing Pages

Ad agency: kirshenbaum bond & partners, New York, NY

Best advice: Get them to react

If you can get a reaction from the visitor when they see your web site, then he or she is likely to remember or relate to your product or company, to feel something about the company or product. You may utilize emotional advertising: humor, bittersweet, touching, tranquil, sexy, haunting, etc.; image ads; unique benefits; family tradition; attitude; owning a benefit; differentiating your product, company, or service; touting the originality of your product, company, or service; appearing to be cutting edge; appearing to be homespun; touting a nationality, like French wine or American baseballs; or any other advertising stratagem or approach.

Please note that often the web site will be a companion to the print, television, direct mail, and radio created for a product or service.

Web checklist

- Who's the audience? You must know what interests your audience and what they need.
- What's the strategy? Make sure the strategy comes through. Be clear. Emphasize what's important.
- Who is the competition?
- Be sure to allow your objectives to be primary, not the technological bells and whistles.
- Make sure your benefit(s) is clear. What's in it for me?
- Keep it simple and clean.
- End note: Good graphic designers will apply the same good sense they use in print to web design.

EXERCISE 13-1
Becoming familiar with web sites

Obtain access to the world wide web and check out several major company's web sites as well as the web sites of several advertising agencies and graphic design studios.

PROJECT 13-1
Web site

Step I
- Choose an existing corporation, or choose one of the following:
 - an internet auction house
 - an online magazine
 - a state or city tourist board
- If you choose one of three listed above, invent a name for the company.
- Design a logo for the corporation, even if you've chosen an existing corporation.

Step II
- Choose a theme for the web site.
- Collect visuals to support your theme.

Step III
- Design a home page.
- Design a core page.

Presentation

Present either on CD-ROM or mat on one 11″ x 14″ board with a 2″ border.

The Portfolio and Job Search

OBJECTIVES

- understanding the purpose of a portfolio
- being able to compile a graphic design or advertising portfolio
- being able to conduct a job search

A **portfolio** is a body of work. It is used in the graphic design and advertising professions as the measure of one's professional ability. Whether you got A's or B's in your design courses does not matter nearly as much as the work that ultimately goes into your portfolio.

A portfolio consists of anywhere from twelve to twenty pieces of exceptional work. Some of the pieces should be related, for example, a poster, brochure, and invitation for the same event. These pieces, which are called companion pieces, demonstrate your ability to formulate a design concept for several applications.

If you want to specialize in an area of graphic design, such as packaging or information graphics, the work in your portfolio should reflect that area of interest. If all areas of graphic design interest you, your portfolio should include a range of projects that reflect your ability to solve different types of design problems.

There are four key components to a good portfolio:

1. Twelve to twenty professionally executed pieces

2. A book of working sketches

3. A résumé

4. A knock-out presentation

While a portfolio may contain anywhere from twelve to twenty pieces, fewer is better as long as they are excellent. If you do not get a potential employer's attention with your first twelve pieces, the last few probably will not get attention. Quality counts far more than quantity. Do not put a piece in your portfolio unless it is good and well-executed. You may be remembered by your weakest piece rather than by your best.

Begin your portfolio with your best work and end it with your next-to-best work or the other way around. Put a very strong piece in the middle (to maintain interest as someone flips through the work). Also, include a binder of working sketches you made while searching for the creative design solutions in your portfolio. These sketches demonstrate your ability to work through a concept and generate more than one solution to a problem.

Design a résumé you can send to potential employers and leave behind after an interview. It should be well-designed (after all, you are looking for a job as a designer), neat, and legible. You may choose to reflect your style or spirit in the design of the résumé. You also may want to create a self-promotional piece — something that will demonstrate your abilities, illustrate your work, and highlight your creativity.

Your work should be presented in a neat, clean, consistent manner. There are three basic types of portfolio presentation cases. One has plastic sheets or pages to slide your work into; another is an attache-like case, and the other is a clam shell box. If you choose the one with plastic pages, make sure the plastic is clean, not torn or scratched, and secure all work inside the plastic (you do not want it sliding around). If you choose an attache-like case or clam shell box, all the pieces should be mounted on the same size and color boards, which should fit easily and neatly into the case. Include a ringless binder of working sketches and a résumé. It is a good idea to have two portfolios. If you need to leave one at a studio or agency, you still have one on hand for another job prospect.

Advertising portfolio

Portfolio contents

- A student advertising portfolio (also called a book) should contain at least five excellent speculative campaigns and a couple of one-shot advertisements. At the very least, you need four excellent campaigns consisting of three ads each. Each ad in the campaign should be able to stand on its own, yet belong to the campaign as a group, sharing a common strategy.

 A campaign demonstrates your ability to create a flexible strategy and related concepts, sustain it throughout a series, and run with it in a creative direction. Most advertising students can come up with one outstanding one shot ad. It's far more difficult to create a superb campaign!

- Your ads should cover a variety of goods (hard and soft) and services, including nationally known brands. Avoid doing ads for tiny, local clients, like Joey's Barber Shop or Aunt Edna's Florist. Choose real products; don't do ads for widgets or other invented products or services. Avoid doing ads for products or services that have current brilliant campaigns; the brilliance of the current campaign will probably create a creative roadblock for you. Also, avoid product categories like perfume, liquor, cigarettes, most vehicles; these products are very difficult to promote. Only do one public service ad; they're too easy to do. Also, don't include a public service ad unless it's great.

- Print ads will demonstrate your ability to conceptualize and think creatively. You don't need to include a storyboard or television commercial. Advertising juniors do not usually create television commercials. However, if your school has a video facility and you have put together an excellent commercial, include it. Know how an ad would play out in different media.

- Put your personality into your book — your own vision. Have a fresh perspective on things. Don't mimic the ordinary.

- Have a variety of ads. Your ads should have different voices depending on the products you're advertising: humorous, tough, tongue-in-cheek, bittersweet, serious, etc.

- One bad ad brings down the whole book.

- Include an outdoor board ad.
- You should vary the size of the ads, for example, full-page ads, some spreads, some half-page, third of a page, etc.

Contents organization

The rule for organizing an ad portfolio is the same as for graphic design — best ad campaign first and next-to-best ad campaign last or the other way around. Place a strong campaign in the middle. If you have a weak campaign, toss it away and start again. Never include anything weak in a portfolio; it will stand out and you will be remembered for the weak link, rather than the strong!

Advertisements are usually mounted on foam core and placed in a clam shell box. Some students laminate their work, however, it's an unnecessary expense. An alternative is to mount the ads on black board with a 2" border. Or you can use a ringless binder as your main portfolio, or put it all on disk or CD-ROM.

Always have at least two portfolios. If you leave one at an agency for review, you must have another one at the ready for a possible interview. You could have your entire portfolio on CD -ROM.

Have a set of mini-portfolios that are copies of two campaigns bound together with a résumé.

Depending on the nature of the ad agency — it may be a full-service agency — you may need to include a couple of good graphic design pieces in your portfolio to demonstrate your design abilities. Some agencies require their creatives to know graphic design as well as advertising.

General tips

- Know what's current.
- Know which agencies are doing which work.
- Your ads should be illuminating, telling us something we didn't know before.
- Your ads should change the way we think about a product.
- Your ads should make us feel something about a product.
- Change the consumers' minds about a product.
- Make the consumer say, "Ah!" or "Oh!"
- A good ad is an insight!
- Entertain people with your ads.

Advice from three graphic design professors

When I asked my esteemed colleagues to prepare a statement addressing the question, "What do you think makes a portfolio good?" they answered as a group, "Twelve great pieces." When asked again, they insisted, "Twelve great pieces." They are right; however, they finally offered more advice.

Portfolio: Your talent in a bottle by Alan Robbins

The problem most students have is assuming the portfolio presents their work. It does not. That is not enough. It has to compress your work. It has to hold an essence, like a bottle of perfume.

Therefore, you cannot just mount your twelve best pieces and hope for the best. You have to deal with your portfolio as though it were your most important work to date. Make it capture the essence of your talent.

That means redoing pieces that are not up to snuff, combining pieces that look lonely, giving yourself new assignments that draw out your creativity, reshooting pieces that are out of focus, refocusing in general. You are trying to make the portfolio explode with your individuality.

If there is something you can do that is not in the book, put it in. If some things are mediocre, fix them, change them, or junk them. Pretend that you are making the portfolio for a great grandchild you will never meet, and this is all they will ever know of your art. Let it stand by itself and charm, delight, or challenge. If it does not compress your talent, then it is just a bag of stuff, easily forgotten.

Tips on the most important things for a portfolio by Martin Holloway

Consider the presentation a project in itself. The presentation should have:

- Consistent board color and size
- A logical sequence
- Immaculate and great craft — edges, backs, corners

Cover basics in portfolio content — logos, folder, posters, covers, editorial, corporate visual identity, packaging, etc. Show your personal strengths and interests — your book should show *individuality*.

Figure 14-1 Sample résumé

Name
Street Address
City, State, Zip Code
Phone number
E-mail address

OBJECTIVE
Seeking a position as a (graphic designer) (junior art director).
If you want to write something else, keep it succinct.

EXPERIENCE
- Start with your most recent position first (see examples).
- For entry level candidates with little or no experience, it is necessary to list any work experience (to demonstrate that you can hold a job), and to list any design-related experience, such as internships or freelance experience. For candidates with at least five years experience, be sure to include responsibilities, skills and clients.
- Include job titles.
- Very briefly describe your responsibilities (what you do).
- Include a client list when applicable.
- Examples:

1997 – present	The Design Studio at Kean University: Student designer/intern
	Responsibilities include design concepts; execution and presentation of comprehensives; client contact; production preparation; on-press supervision; and monitoring and maintenance of computer lab. Projects include newsletters, posters, brochures.
	Clients include: The Theater Department at Kean University; Morris County Park System; Liberty Hall Preservation; The Office of the President at Kean University.
1997	Dunkin Donuts: Store Manager
	Responsibilities included employee scheduling; customer relations; accounting; and quality control.
1994-1997	The United Way: Volunteer/Graphic Designer
	Responsibilities included graphic design of fundraising materials; exhibit design for fundraising events; community liaison.
1994-95	Remark Studios: Production Intern
	Responsibilities included execution and presentation of comprehensives; production preparation; and computer maintenance. Projects included assisting in the production of annual reports, newsletters, advertisements, and brochures.
1993-94	Justin Advertising Agency: Student Assistant
	Responsibilities included design concepts; execution and presentation of comprehensives; client contact. Projects included print ads; direct mail, and electronic media ads.
	Clients include: The Chubb Group; Atlas Tires; Barney's.

EDUCATION
- College and graduate school only. Include degree, date of degree, major and honors, if any.
- Advanced course work, specialized training and workshops.

2004	Kean University, Union, NJ. B.F.A.: Visual Communications/Graphic Design Any academic awards.
2002	Brookdale Community College, Brookdale, NJ. A.A.: Graphic Design
May 2001	New Jersey Art Directors Workshops: Design Strategies

SPECIAL SKILLS
For entry-level candidates, listing special skills, especially computer and technical expertise, is crucial to securing a job. Include design skills, computer knowledge (hardware and software) and technical expertise. Examples:
- Design from concept to production
- Macintosh and PC, using drawing, photo editing, page layout and web page layout software; and other skills

ETC.
- Listing professional awards, for example, The One Club student advertising award, demonstrates that your work has been recognized as outstanding. Simply list the award and year; do not include the actual award.
- Ability to speak a second language. Advertising agencies or design studios with global clients may be especially interested in a bilingual candidate.

(FINAL LINE) Portfolio and references available upon request.

Show *several* ideas for a problem in rough form — ideas, ideas, ideas. Show that you can have more than one good idea for a problem.

Show sketching skills — this is especially important now in the computer age. Pencil and paper are for idea generation. Computers are for developing an idea, pushing it, and creating multiple variations.

Pay particular attention to type, especially now that you can show real type in comp form generated by the computer (a real improvement). Think of type as the visual equivalent of the sound of the voice. Some messages should shout, some whisper, some be expressed with passion, some as a footnote. Sounds of the voice can add great richness and express layers of meaning about the same subject — type should do the same.

Make your résumé a design problem — excellent typographically! Make it clear, easy to read, with good visual hierarchy.

Have more good pieces than you may use in one presentation so you can tailor the presentation to a particular interview. For example, have an extra ad campaign, package or logo to accommodate a potential employer's business specialization.

Learn as much as you can about a potential employer's design clients so you can speak intelligently to them.

Do a special piece for a particularly important interview.

Make the presentation beautiful, but do not let it overwhelm the work.

Show a variety of mock-up techniques — thumbnails, full-size roughs, rough dummies, marker comps, and super comps (tight comps).

For conversation with prospective employers, be knowledgeable about the field, production, and designers. Be able to speak with interest and enthusiasm about your profession.

Never apologize for your work.

Always leave something behind after an interview — a résumé, at least, or a promotional piece, something with your work on it.

Learn to explain what you did and did not do for each piece (for a complex piece, elements on a page or surface may in themselves be impressive solutions to problems — maps, spot illustrations, graphic devices). Do not assume a reviewer will know what you did (some people may use clip art, some may create the elements themselves). Learn to be concise in these explanations.

Know how much salary you want (or will settle for), instead of appearing befuddled by the question.

A quality portfolio by Rose Gonnella

A great portfolio displays a range of qualities — quality use of type, quality compositions, quality ideas, quality presentation, quality organization. Now to understand quality, see the contents of Professor Landa's book. (I still hold to the great twelve-piece theory.)

Self-promotionals

In addition to sending a résumé to, or leaving a résumé with, a prospective employer, some students send or leave self-promotionals. A self-promo usually is a small version of your best work — a mini-portfolio — consisting of two to five pieces. It is a creative, inventive piece that showcases your talent, sort of a self-advertisement. It is usually too expensive and time consuming to make a self-promo for every prospective employer; use them wisely.

A self-promo should always include your name and phone number. Like your portfolio, a self-promo represents you, your talent, intelligence, and abilities. Do not create anything that will be annoying to a prospective employer. For example, do not make something difficult to open or have glitter or confetti fall out all over someone. It must be well-thought out and well-crafted.

SUGGESTIONS

When creating and crafting a self-promo, consider the following suggestions:

- distinctive paper and envelope
- handmade, interesting bindings and clasps
- unusual materials
- experimenting with folds
- unusual sizes and shapes
- moving parts
- distinctive packaging

portfolio projects

Some suggestions for additional portfolio pieces (All the projects, except those in Chapter 2, suggested in this text are suitable for inclusion in a portfolio.)

PROJECT: HANGTAG DESIGNS

Design hangtags for a line of specialty goods made in different states, for example, western shirts made in Texas. The purpose of these tags is to promote goods made in America.

1. Select five states, for example, "Made in Texas," "Made in Idaho." "Design the "made in…" typography.

2. Select and design the typography of a quote to be placed on the back of the hangtag, for example, "Imagination is more important than knowledge. Albert Einstein" You may want to choose quotes from people famous in their states.

Presentation

CD-ROM or mounted on one mat board with a 2" border.

PROJECT: BOOK JACKET SERIES

Design a series of three book jackets or any of the following:

> Great American writers
> Great British poets
> Great Latin-American writers

1. Research three great writers in any of these categories.

2. Design an imprint for the series.

3. Design three book jackets that can stand alone as well as look like they belong to a series.

4. Establish variety within the unity of the series.

Presentation

CD-ROM or reduce them to half size and mount on one mat board with a 2" border.

PROJECT: LOGO

Design four logos for the same product, for example, a specialty tea or a body and bath line.

1. Name the product.

2. Design three logos:
 - one in type only
 - one abstract visual logo
 - one pictorial logo
 - one that combines type and visual (abstract or pictorial)

Presentation

CD-ROM or mounted on one mat board with a 2" border.

PROJECT: SNOWBOARDS OR SKATEBOARDS

Design five them-related visuals (abstract or pictorial) for snowboards or skateboards.

Presentation

CD-ROM or mounted on one mat board with a 2" border.

PROJECT: BROCHURE

Design a folded brochure for a physical therapy center or a sports medicine facility.

1. Create a logo for the physical therapy center or the sports medicine facility.

2. Find or create visuals.

3. Choose text type and sub-heads.

4. Design the brochure.

Presentation

CD-ROM or dummy slipped into a mat board with a pocket.

Contents of a generalized graphic design portfolio

Recommended by the Kean University Department of Design

- Logos: five distinct designs mounted on a single board or contained in a hand-made book

- Symbols and pictograms: a unified series for one program

- Visual identity system, including an original logo

- A folded brochure (featuring the arrangement and choice of text type and sub-heads)

- A book jacket series

- A booklet, such as a CD insert or any promotional piece

- Packaging system

- Labels, for example, wine labels, jelly jar labels, carbonated beverage, fruit crate labels

- Annual report, catalog, or a promotional piece

- Editorial spreads for either magazines, books, or newspapers

- Additional suggestions:
 - Web site
 - Calendar
 - Advertisement
 - Invitations
 - Direct mail
 - Map
 - More of any of the above

Please note that it is advisable to use original logos for all pieces. In other words, when you create a packaging system it should utilize an original logo rather than an existing one.

Presentation: Either mounted on black board with 2" border or on CD-ROM

Figure 14-2
Morris Museum Invitation
Designer: Tony Ciccolella, AARP Creative Group,
AARP, Washington DC

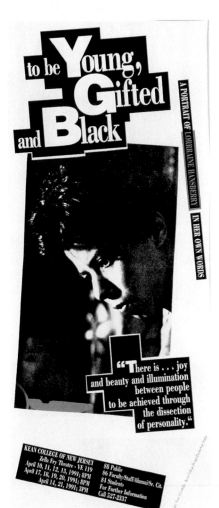

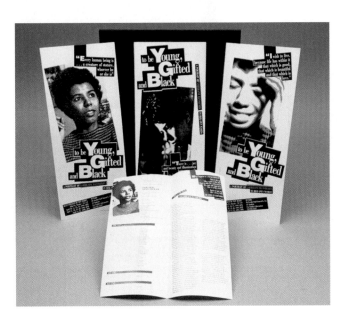

Figure 14-3
To Be Young, Gifted and Black Playbill
Designer: Tony Ciccolella, AARP Creative Group,
AARP, Washington DC

Figure 14-4
"I communicate visually" Promotional Button and T-
shirt for the Fine Arts Department, Kean University
Designer: Tony Ciccolella, AARP Creative Group,
AARP, Washington DC

Figure 14-6
Children's Counting Book
Designer: Tony Ciccolella, AARP Creative Group,
AARP, Washington DC

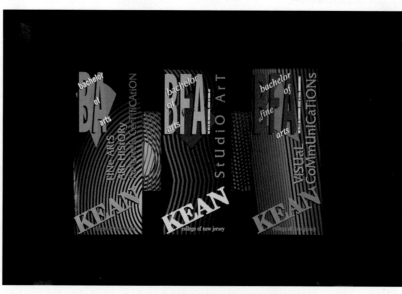

Figure 14-7
Promotional Brochures, Fine Arts
Department, Kean University
Designer: Tony Ciccolella, AARP
Creative Group, AARP, Washington DC

Figure 14-8
Logos
Designer: Tony Ciccolella, AARP Creative Group, AARP, Washington DC

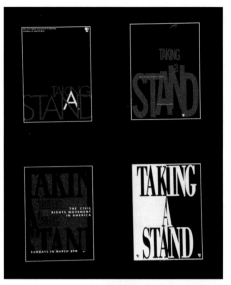

Figure 14-9
"Taking a Stand" Posters
Designer: Tony Ciccolella, AARP Creative Group, AARP, Washington DC

Figure 14-11
Editorial Spreads for a music magazine
Designer: Tony Ciccolella, AARP Creative Group, AARP, Washington DC

Figure 14-10
Cachets for First Day Covers
Designer: Tony Ciccolella, AARP Creative Group, AARP, Washington DC

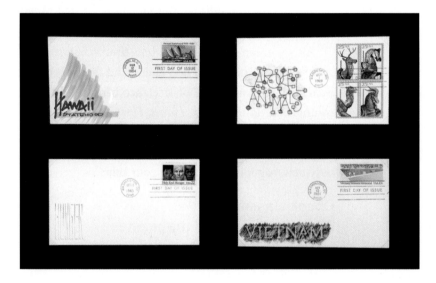

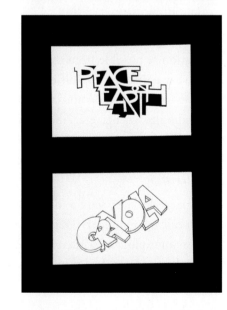

Figure 14-12
Performing Arts Brochure, Kean University
Designer: Tony Ciccolella, AARP Creative Group, AARP, Washington DC

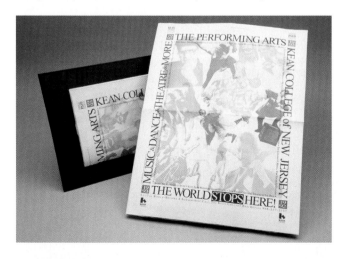

Figure 14-13
Hand Lettering
Designer: Tony Ciccolella, AARP Creative Group, AARP, Washington DC

The career search process

Where are the careers?

>Corporate in-house design departments
>Publication editorial departments
>Public institutions in-house design departments
>Graphic design studios
>Advertising agencies
>Full service agencies
>Pharmaceutical companies

Set short- and long-term goals for yourself. Then make a plan. The career search process starts with:

Research

Find out which studios specialize (or generalize) in the areas you want to work. Make a comprehensive hierarchical list.

A. Compile your list of design studios or ad agencies from a variety of sources:

- magazine award annuals featuring the best work of the year
- award books
- graphic design magazine web sites
- design studio web sites
- the Source Book in your state
- Agency "Red Book" (Standard Directory of Advertising Agencies)
- *Adweek*'s Agency Directory
- the *Yellow Pages*
- Art Directors club membership listings
- American Institute of Graphic Arts (AIGA) membership directory

B. Make calls to studios and agencies. Get as much information as possible from the receptionist. Ask if they have a portfolio drop-off day or review. Ask for the names of art directors and creative directors. Ask about studio size, clients, etc. Find out something about the studio or agency and include it in the cover letter. Put anything in the cover letter that makes you sound interesting.

Two weeks later, send a follow-up letter or postcard. Or call as a reminder: "May I see you for an information (or exploratory) interview? For just ten minutes?" "Is there anyone else I may talk to? Is there anyone else

you can send me to?" Get back to them to see if any positions have opened up. "I've done some new work, may I send it to you?" Send or fax résumés.

C. Make calls to corporations and public institutions' personnel officers to see if they have in-house creative/design departments, for example, Toys R Us, Johnson & Johnson, and UPS have in-house departments. Follow the same advice as above. Send résumés.

D. Check the credits listings in magazines and newspaper for the art directors and creative directors. Send résumés.

Check newspapers

Check the classified ads under: graphic designer, designer, graphics, electronic media, web sites, publishing, editorial, advertising, art director.

Read the business section of any newspaper and note companies that are expanding, hiring, changing management, etc.; these are the studios and agencies that might be hiring.

Also, you can get an issue of *Adweek* or *Advertising Age* to see which agencies have new clients and therefore might need to hire new people or freelance people. Check ad columns in: *Business Week, Forbes, Fortune, The New York Times*. Check out *Ad Age*'s Top 100 Agencies issue.

Check any professional design or advertising quarterly newspaper or magazine in your state.

Check classifieds in newspapers and magazines

Ad Week
Advertising Age

Web sites

Through the world wide web you can search for employment under design listings. *Communication Arts* magazine (www.commarts.com) has a particularly good site.

Employment agencies

This is an extremely important resource

- No fee for the job applicant.
- Call the agency, ask for an appointment to review your portfolio.
- Check with your college or university career placement center.

Internships

One of the best ways to gain experience and entry into an agency is through an internship. Some agencies have internship programs; others occasionally will hire an intern.

- Ask your professor if your school offers internship credits.
- Call the top agencies in your local area and ask if they have internship programs. If they say no, ask if they ever have any interns. If so, you'd be interested.
- Treat applying for an internship like applying for a job. Give it the same respect and attention.
- Have a résumé prepared. You may or may not need a portfolio.
- Some agencies pay interns; some do not.

Network

Ask the design faculty at your college or university for leads. Also — the adjunct instructors are a good resource. Then tell *everyone* with whom you are acquainted that you are looking for a design career. You never know when someone will say, "Oh, my sister-in-law is an art director, maybe she can help."

Stay in touch with your peers — one placement leads to another.

Pursue part-time, temporary or freelance work. This road is a great way to get a feel for different avenues.

Join professional organizations. Most professional design and advertising organizations have student memberships at reduced rates. Go to portfolio reviews, meetings, lectures, and workshops at:

- your state's Art Directors Club
- your state's Advertising Club
- AIGA – American Institute of Graphic Artists
- Society of Illustrators

Once on the job

- Find a mentor.
- Stay if you're learning, even if the money isn't good.
- Leave if you're not learning. Find a place where you'll grow.

Tips

On personality
- Be flexible.
- Find one point you want people to remember about you.
- Respect people's time.
- Be curious.

Skills
- Know as much new technology as possible.
- Know how to read between the lines at an interview. For example, "Good luck," usually means they're not interested. "Are you available for a second interview," means they are interested.

During the interview
- Get to an interview early.
- If you're bilingual, say so.
- Maintain a good energy level during an interview.
- Listen.
- Think.
- Get people's names right.

Looking for the job
- Be prepared to put in many hours "pounding the pavement" looking for a job.
- Send a personalized, typed "thank you" after an interview.

Choosing a job
- Work around people you admire.
- Only change agencies/jobs for the work, not for the money. Doing creative work is far more important, especially at the beginning of your career.

On the job
- Demonstrate leadership capabilities.
- Be a self-starter.
- Learn to take criticism.
- Make yourself indispensable.
- Listen.
- Think.
- Join the agency softball team.

- Take advantage of a situation. For example, one of my former students got onto the elevator with the ad agency president. She offered him a piece of her candy and they started talking!

- Get people's names right.

- Always make sure that you're more valuable than your salary.

General

- Read books written by advertising and design professionals.

- Know what's current.

Preparing for the interview
Preparing your portfolio

Go over your portfolio. Make sure everything is in order and neat. Tailor your portfolio to the company; for example, include more editorial pieces for an interview with a publishing company. Bring a copy of your résumé to leave with the interviewer and, perhaps, a self-promotional piece. Prepare a mini portfolio to leave behind, that is, a résumé with several copies of your work neatly attached to it. It can be bound in a variety of ways as long as it is neat and easy to handle and read.

If possible, tailor your résumé to emphasize key accomplishments related to the job position. Your résumé should be clean, legible, and well-designed. These characteristics are far more important than creating a "gimmicky" résumé.

Hang a name tag with your phone number on your portfolio in case you have to leave it behind.

Make it clear that you were responsible for all or any of the work done on a piece. During an interview, it's important to clarify what part of a project you did — whether you created the illustrations, took the photographs, created the layout — for a design project in your portfolio. Be honest.

If you include a self-promotional piece, it should be easy to read and clearly demonstrate your design and creative thinking skills. Gimmicky and annoying self-promos only alienate potential employers.

Being in the know

- Know something about the company, especially the kind of work they do and who some of their clients are.

- If possible, try to get information about the person who will be conducting the interview.

- Be able to state the rationale for all your design projects.

- Prepare a list of educated questions.

Read up on the profession. Know what's going on in the visual communications industry. Be on top of the latest trends, hot designers and classic master designers. Don't be afraid to have an opinion. (Of course, don't insult anyone's work.)

Preparing to answer interview questions

- Be ready to honestly discuss your professional experience.

- Know what salary you are willing to take.

- Clearly advertise your unique capabilities and qualities, such as professional experience, internships, credentials, academic standing, and attractive personal qualities, such as eagerness or being a quick learner.

The interview

Before the interview

Get enough sleep.
Dress appropriately.
Be clean (including hair and nails).
Give yourself enough time to be prompt.

During the interview

Be enthusiastic. The right attitude is extremely important.
Be energetic.
Listen.
Make yourself seem indispensable.
Sound like you have a full life, that is, you read, you are up on current events, see films and plays, participate in sports or social dance.
Be prepared to do the low-end work.
Please remember: A career in visual communications, whether it's advertising or graphic design, requires communication skills and requires that you work well with people.

Questions to ask at the interview

How is your studio/agency run?
Do designers work alone or in teams?
What software do you use?
What are your current projects?
What are the essentials necessary to succeed in this - studio/agency?
What are the average work hours?
To whom would I report? to an art director, creative director, or senior designer?
Do you provide health benefits?

Questions that might be asked of you

Are you willing to work as many hours as needed?
What salary do your require?
What do you think you can contribute to this agency/studio?
Why do you want to work for us?
What software do you know?
Are you interested in learning new software/technology?
How quickly can you learn it?
Do you have any hobbies?

After the interview

Send a thank-you letter.
Ask personnel officer for any positive or negative feedback.
Assess your performance and portfolio.
Warning: Your portfolio is bound to be criticized by each interviewer. (It happens.) Don't start pulling your portfolio apart each time. If you rearrange or toss work after every criticism, you'll go crazy and destroy your portfolio. However, if more than one or two people don't like the same piece, then consider tossing it. Keep in mind: a portfolio is an ongoing project. It should always be modified and improved.

Graphic Design Materials, Tools, and Processes

OBJECTIVES

■ becoming familiar with the tools, equipment, paper, films, drawing tools, adhesives, and processes used to create graphic design

■ becoming familiar with key production terms

Years ago you could have solved graphic design problems with traditional hand tools, like a T-square and a ruling pen. Now, newer technology, like the computer, has changed everything. Some designers design everything on the computer — they never tough pencil to paper. Other designers still create their thumbnail sketches with markers, pencils, and paper, and use the computer for comps and production. And, there are still some designers who do almost everything by hand, using the computer as a typesetter only.

Almost anything that can be done by hand can be created on the computer. You must learn to use a computer — especially since technology will be moving ahead at a very fast rate in the near future. But, of course, you also still need to learn about some traditional tools and materials.

Tools and equipment

Computer hardware

Computers: There are two basic platforms for designers: Macintosh and PC.

Keyboard: The main input device which connects to the computer, similar in appearance to a typewriter keyboard.

Monitor: Hardware that displays information, text, and visuals on a screen in full color or grayscale.

Mouse: A hand-sized input device, used in addition to the keyboard, which connects to the computer with a cable.

Printer: Hardware that allows you to produce a hard copy, type, and visuals on paper, of what appears on the computer screen.

Scanner: Hardware used in conjunction with software, that allows you to scan a visual or document onto the screen.

Computer software

Draw and paint: A two-dimensional graphics program used to create images with the line, shapes, colors, textures, and type.

Page layout: A graphics program used to create a layout (arrangement) of type and graphic elements; used in the creation of brochures, newsletters, annual reports, and editorial design.

Image-processing: A graphics program that is primarily used to import photographs (through a scanner) for retouching, editing, and adding special effects such as mosaic patterns, textures, and distortions.

Multimedia: Creates dynamic, interactive presentations; combines text, graphics, animation, sound and video.

Equipment and hand tools

Copiers: This camera creates inexpensive copies in black and white or color. Most copiers can enlarge and reduce images. Copiers have become essential tools for the creation of comps. (Students should experiment with copiers.)

Cutting tools: Single-edged razor blades or X-acto knives are used for cutting in conjunction with T-squares and triangles. The most commonly used X-acto knife blade is the #11.

Ruler: A straight edge used for measuring and drawing. Stainless steel rulers are best with point, pica, and inch measurements.

Triangle: A tool used in conjunction with a T-square and drawing or cutting tool; used to rule or cut straight vertical lines or angles. Triangles are available in plastic and metal at different degrees; the most often used triangle is the 30°60°90° or 45°90°. Metal triangles are best for cutting — they will not get nicked.

T-square: A tool used in conjunction with a drawing tool or cutting tool; used to rule or cut straight horizontal lines. Metal T-squares without incised measurements are preferable over ones with numbers. The incised measurements can interfere with ruling and cutting. Metal T-squares will not nick, while wood T-squares will get nicked and possibly warp.

Papers

There are two categories of paper the designer uses: printing paper and artist's paper.

Printing paper is the paper a designer chooses for the printed piece. Choosing the right paper for a design is crucial. Different papers take ink differently. The ink prints better and runs less on some than on others. Paper can affect the legibility of type, the texture, tone, and personality of a piece. There are different paper finishes: antique, eggshell, vellum, and machine finish. Papers can be coated or uncoated; uncoated paper can be coated after printing to improve the finish and increase the smoothness. Printing paper is available in different weights, measured in pounds per ream (500 sheets). Several factors should be considered when choosing paper — color, brightness, weight, smoothness (surface), and opacity. Paper companies provide samples for designers.

Paper comes in different grades, which means that it is usually used for different purposes.

Alternate-fiber paper: stock made from cotton, denim, beer, banana stems, plastic, hemp, etc.

Book: general use, especially for books

Bond: usually used for stationery and business forms

Coated: paper that has been coated for a smoother or glossier finish, usually used for higher quality pieces

Copier: used primarily for copier machines

Cover: heavier weight coated and text papers used as covers for reports or brochures

Laser: used for laser computer printers

Newsprint: primarily used for newspapers

Offset: similar to coated and uncoated book paper with added sizing

Recycled: paper that has been recycled, usually bond paper

Text: papers available in many colors and textures, usually used for brochures, announcements, and promotional pieces

Artist's paper: The paper available to artists for inking, drawing, and making comps. Artist's paper comes in various textures, weights, and finishes and is available in single sheets, rolls, and pads. Hot press paper has a smooth texture or surface, cold press paper has a rough texture or surface. The quality of paper is determined by the rag content, which refers to the amount of cotton or linen fibers in a paper. Papers of 100 percent rag content are the highest quality and most expensive. Papers with a combination of ingredients, such as wood pulp, rag, and chemicals are less expensive and of a lower quality.

Acetate: used as a drawing surface and protective surface. Acetate is available in different thicknesses (weights) and in different finishes: clear, frosted (matte), and prefixed.

Boards: There are three basic types of boards: illustration, mat and museum, and foam core. **Illustration board** is used for layouts, drawing, mechanicals, and inking. It comes in two categories: hot press (smooth surface) and cold press (rough surface). It is available in different qualities (grades), surfaces, and sizes. **Mat and museum board** is used for mounting and matting work and is available in various colors, grades and surfaces. Most design students choose black, gray, or white mats. Museum board is usually acid free. Note: Cold press boards should never be used for mounting or mechanicals. **Foam core** is a lightweight board used for mounting; it is available in various thicknesses, sizes, and in black and white. (Most ads are mounted on foam core.)

Colored paper: Paper with color on one side is available in a variety of colors, qualities, and brands.

Cover stock: A heavier weight paper used to cover art, which can also be used for comps.

Ledger bond: Smooth, opaque paper used for inking, drawing, and comps. Available in a few different weights.

Tracing paper: Nearly transparent paper used for tracing or drawing. Available in pads and rolls, and in various qualities. It is great for thumbnail sketches, layouts, flaps (covers), and slip-sheets.

Visualizer or marker paper: Less transparent than tracing paper; used for drawing with pencil, marker, and pen; available in pads and in various qualities. It is great for roughs, comps, and layouts.

Vellum: Heavy, high-quality tracing paper used for layouts and inking.

Drawing tools

Markers: Tools used for sketching and comps. They are available with various nibs (tips): pointed, regular, flexible, and broad, which create different width marks. Markers contain pigments or dyes in a liquid. Different liquids, water or solvents, are used. Water-based markers are safest. Ethyl-alcohol based markers, which are now used most frequently by designers, are the least harmful of the solvent-based markers, but should be used in a well-ventilated room. Other solvent-based markers are more hazardous to your health and should always be used in well-ventilated rooms. You should experiment with markers and papers to see which brands and types work best together.

Pencils: Tools used for sketching, ruling guidelines, and drawing which are available in a wide range of cores that yield different types of marks. There are synthetic graphite pencils, charcoal pencils, chalk pencils, colored pencils, metallic pencils, and plastic pencils. Synthetic graphite pencils come in vary-

ing degrees of softness and hardness; for example, a pencil marked 6H is very hard and makes a light mark, and a pencil marked 6B is very soft and makes a dark mark. Charcoal pencils are generally darker than, and blacker than, synthetic graphite pencils. Colored pencils come in a great many colors, qualities, and brands. Mechanical pencils are available with interchangeable leads that come in various hardnesses and thicknesses. Most pencils can be sharpened with single-edged razor blades or sharpeners.

Technical pens: Tools used for drawing and ruling. They have ink cartridges and are available with different nibs which yield different line widths.

Adhesives

Glue sticks: Non-toxic glue used as an adhesive. Although not considered a professional material, it is a safe adhesive.

Rubber cement: the most commonly used semi-permanent adhesive, available in jars and cans. Elements that have been adhered with rubber cement can be dissolved with rubber cement thinner, removed, repositioned, and re-adhered. Excess can be removed with a rubber cement pickup. Two-coat cement, a mixture of three parts rubber cement and one part thinner, is best; both surfaces are cemented. The consistency of rubber cement is important; it should not be thick. Rubber cement is available in cans and a mixture (of rubber cement and thinner) can be kept in a jar with a brush attachment, which is sold separately. Rubber cement thinner is available in cans, but should be transferred, as needed, to a thinner dispenser which is sold separately. **Note:** Although rubber cement and thinner are commonly used, they should be used in a well-ventilated room.

Spray can adhesive: similar to one-coat cement and used for large areas. This adhesive can be messy. **Note:** This product **must** be used in a well-ventilated room or spray booth.

Tapes: Used for adhering. Drafting tape is used to adhere overlays on mechanical boards, and to tape your board or paper to a drawing table or surface. It comes in various widths and colors and can usually be removed without damaging board surfaces. White and black tapes are used to adhere cover stock to boards and to create mat presentations.

Processes

Copies: Images made on copy machines in black and white, single colors, or full color.

Laser prints: Images generated by a computer and printed on a laser printer at various DPI (dots per inch) — 300, 600, or 1200.

Production

Bleed: Color or art that runs off the edge or edges of a page.

Color separation: the mechanical process where colors that are not continuous tone are separated in preparation for printing.

Continuous tone: Art that contains a range of values (grays), such as a photograph or a wash drawing.

Halftone: Continuous tone art that has been screened in preparation for printing.

Line art: Art, such as type or black and white drawings, that contains no grays.

Pantone Matching Systems (PMS): A standardized system of numerically coded color mixtures used in printing.

Process colors: Cyan, magenta, yellow, plus black; the colors used in four-color process printing.

Screen: A film made with diagonal cross-hatched lines, varying from 55 to 160 lines per linear inch; it is used to convert continuous tone art into a dot pattern.

Silhouetting: When the edges of an image are silhouetted, the background is cut away. This is done with an image-processing program.

Note: There are several books about health hazards related to art materials and the proper use, handling, and storage of materials. It is strongly recommended that you read one of them (as listed in the bibliography).

Glossary

accents: supporting or secondary focal points.

advertisement: a visual/verbal message that is intended to inform, persuade, provoke, or motivate us, for print, web, television, and radio.

art director: the person in an advertising agency responsible for ideation and the art and design decisions.

ascender: the part of lowercase letters, b, d, f, h, k l, and t, that rises above the x-height.

asymmetry: the arrangement of dissimilar or unequal elements of equal weight on a page.

alignment: visual connections made between and among elements, shapes, and objects where their edges or axes line up with one another.

balance: an equal distribution of weight.

baseline: defines the bottom of capital letters and of lowercase letters (excluding descenders).

benefit: something in an advertisement that promises improvement.

body copy: the text, the narrative that further explains the advertising concept and may provide more information also called text type.

calligraphy: letters drawn by hand with the strokes of a drawing instrument — literally "beautiful writing."

campaign: a series of advertisements, which share a common strategy, concept, design, spirit, style, and claim.

capitals: the larger set of letters, also called uppercase.

character: a letterform, number, punctuation mark, or any single unit in a font.

claim: the verbal message that is associated with a product or service and is used in a campaign of ads for that product or service; also called end line, tagline, or slogan.

collage: the cutting and pasting of different bits of materials onto a two-dimensional surface.

comp or comprehensive: a detailed representation of a design.

copywriter: the person in an advertising agency responsible for ideation and writing.

correspondence: when an element, such as color, direction, value, shape or texture is repeated and a visual connection or correspondence among the elements may be established, or when style is established; for example, a linear style.

craft: the physical handling and use of materials.

creative director: the person in an advertising agency with the ultimate creative control over art direction and copy; usually the supervisor of the creative team(s).

creative team: in an advertising agency, an art director and copywriter.

critique: an assessment or evaluation of work.

cropping: cutting an element so the entire element is not seen.

descender: the part of lowercase letters, g, j, p, q, and y, that falls below the baseline.

design: the arrangement of parts into a coherent whole.

design concept: the creative solution to the design problem. The concept is expressed through the combination and arrangement of visual and verbal materials.

direct mail: an advertisement sent directly through the mail to the consumer.

display type: type usually used as headings; type over 14 points in size.

editorial design: the design of publications, such as magazines, newspapers, books, and newsletters.

emphasis: the idea that some things are more important than other things and that important things should stand out and be noticed.

flow: elements arranged in a design so the viewer's eyes are lead from one element to another, through the design. Also called movement.

focal point: the part of a design that is most emphasized.

formal elements: fundamental elements of two-dimensional design: line, shape, color, value, texture, and format.

format: whatever substrate you start out with in graphic design, like a business card, book jacket, or poster.

graphic design: the application of art and communication skills to the needs of business and industry; the visual/verbal expression of an idea.

graphic standards manual: a guide for the use of the visual identity system detailing the use of the logo, colors, and other graphics and imagery.

grid: a layout device used to achieve unity; a subdivision of a format into fixed horizontal and vertical divisions, columns, margins, and spaces, that establish a framework for the organization of space, type, and visuals in a design.

headline: (the line) the main verbal message in an advertisement (although it literally refers to lines that appear at the head of the page).

high contrast: a wide of range of values.

HTML: Hypertext Markup Language — the computer code in which web sites are created.

hue: the name of a color, that is red or green, blue or yellow.

illusion of spatial depth: the appearance of three-dimensional space on a two-dimensional surface.

impasto: the buildup of paint on the surface of a board or canvas.

information design: informs and identifies; includes logos, identity systems, symbols, pictograms, charts, diagrams, maps, web sites, and signage.

kitsch: art that has popular (not critical) appeal.

layout: the arrangement of type and visuals on a format or page.

leading: in metal type, strips of lead of varying thickness (measured in points) used to increase space between the lines; line spacing or interline spacing.

letterform: the particular style and form of each individual letter of the alphabet.

lettering: letters that are custom designed and executed by conventional drawing or by digital means.

letterspacing: the space between letters.

line: a mark made by a tool as it is drawn across a surface.

line direction: describes a line's relationship to the page.

line quality: refers to how a line is drawn.

line spacing: leading; or interline spacing; the distance between two lines of type measured vertically from baseline to baseline.

line type: (line attributes) refers to the way a line moves from its beginning to its end.

linear: a predominant use of line to describe shapes or when line is used as a way to unify a design.

link: a connection from one web page to another.

logo: an identifying mark for a product, service, or organization; also called a trademark.

logotype: an identifying mark where the name is spelled out in unique typography.

low contrast: a narrow range of values.

lowercase: the smaller set of letters. The name is derived from the days of metal typesetting when these letters were stored in the lower case.

mock-up: a facsimile of a printed three-dimensional design piece.

objectives statement: a clear, succinct description of design objectives which summarizes the key messages that will be expressed in the design; for example, facts or information, desired personality or image, and position in the market.

package: encloses a product.

parity products: products that are equivalent in value.

perspectives: a schematic way of translating three-dimensional space onto the two-dimensional surface. This is based on the idea that diagonals moving toward a point on the horizon, called the vanishing point, will imitate the recession of space into the distance and create the illusion of spatial depth.

pictogram: a simple picture representing an object or person.

picture plane: the blank, flat surface of a page.

portfolio: a body of work used by the graphic design profession as the measure of one's professional ability.

poster: a two-dimensional, single-page format used to display information, data, schedules, or offerings, and to promote people, causes, places, products, companies, services, groups, or organizations.

presentation: the manner in which comps are presented to a client or in a portfolio.

print advertisements: type of advertisement — newspapers, magazines, direct mail, posters, outdoor boards — as opposed to television and radio advertisements.

promotional design: is meant to promote sales or to persuade. It includes advertisements, packaging, point of purchase, display, brochures, web sites and banners, sales promotions, posters, book jackets, and CD covers.

rhythm: a pattern that is created by repeating or varying elements, with consideration to the space between them, and by establishing a sense of movement from one element to another.

roughs: sketches which are larger and more refined than thumbnail sketches and show the basic elements in a design.

sans serif: letterform design without serifs.

saturation: the brightness or dullness of a color, also called intensity and chroma.

scale: the size of one shape or thing in relation to another.

serifs: ending strokes of characters.

shape: the general outline of something.

sign-off: the product or service's logo; a photograph or illustration of the product, or both, in a print advertisement.

stationery: consists of a letterhead, envelope, and business card.

storyboard: illustrates and narrates key frames of the television advertising concept.

strategy: the goals and objectives behind a design solution; how the graphic design fits into the larger marketing, promotion or communication plan.

style: the quality that makes something distinctive.

symbol: a sign or a simple, elemental visual, that stands for or represents another thing.

symmetry: the balanced arrangement of similar or identical elements so that they are evenly distributed on either side of an imaginary vertical axis, like a mirror image.

tactile texture: real texture that can be felt.

text type: set type used for text, usually in sizes ranging from 5 points to 14 points.

texture: the tactile quality of a surface or the representation of such a surface quality.

thumbnail sketches: preliminary, small, quick, rough designs or drawings of ideas.

trompe-l'oeil: literally, "to fool the eye"; a visual effect on a two-dimensional surface where one is in doubt as to whether the thing depicted is real or a representation.

type alignment: the style or arrangement of setting text type, for example, flush left/ragged right.

typeface: the design of a single set of letterforms, numerals, and signs unified by consistent visual properties. These properties create the essential character which remains recognizable even if the face is modified by design.

type family: several font designs contributing a range of style variations based upon a single typeface design. Most type families include at least a light, medium, and bold weight, each with its italic.

type font: a complete set of letterforms, numerals, and signs, in particular face and style, that is required for written communication. In metal type, every available size of this set of characters is a separate font of type.

type style: the modifications in a typeface which create design variety while retaining the essential visual character of the face. These include variations in weight (light, medium, bold), width (condensed, regular, extended), and angle (Roman or upright, and italic), as well as elaborations on the basic form (outline, shaded, decorated).

typography: letterforms produced by mechanical means, usually computer. It is by far the most common means of using letterforms for visual communication.

unique selling point: something special about a brand that the competition does not have; also called the unique selling advantage.

unity: when all the elements in a design look as though they belong together; an integrated whole. Also called completion or composition.

uppercase: the larger set of letters or capitals. The name is derived from the days of metal typesetting when these letters were stored in the upper case.

value: the range of lightness or darkness of a color, that is, a light red or a dark red.

visual: the image in a graphic design or ad, which may be a photograph, illustration, graphics, typography, or a combination thereof.

visual hierarchy: arranging elements according to emphasis.

visual identity: a master plan that coordinates every aspect of graphic design material; also called corporate identity.

visual texture: the illusion of texture or the impression of texture created with line, value, and/or color.

visual weight: the illusion of physical weight on a two-dimensional surface.

volume: on a two-dimensional surface, the illusion of a form with mass and weight.

word spacing: the space between words.

x-height: the height of a lowercase letter excluding ascenders and descenders.

Bibliography

Arnheim, Rudolf. *Art and Visual Perception.* Berkeley: University of California Press, 1974.

_____. *The Power of the Center: A Study of Composition in the Visual Arts.* Berkeley: University of California Press, 1982.

Barthel, Diane. *Putting on Appearances: Gender and Advertising.* Philadelphia: Temple University Press, 1988.

Beaumont, Michael. *Type: Design, Color, Character and Use.* Cincinnati, OH: North Light Books, 1987.

Bond, Jonathan and Richard Kirshenbaum. *Under the Radar.* New York: John Wiley and Sons, Inc., 1998

Brady, Philip. *Using Type Right.* Cincinnati, OH: North Light Books, 1988.

Bruno, Michael H., ed. *Pocket Pal: A Graphic Arts Production Handbook.* Memphis, TN: International Paper, 1988.

Cardamone, Tom. *Advertising Agency and Studio Skills.* New York: Watson-Guptill Publications, 1981.

Carter, David E. *Branding: The Power of Market Identity.* New York: Hearst Books International, 1999.

Carter, Rob. *American Typography Today.* New York: Van Nostrand Reinhold, 1989.

Carter, Rob; Ben Day; and Philip B. Meggs, *Typographic Design: Form and Communication.* New York: Van Nostrand Reinhold, 1985.

Craig, James. *Basic Typography: A Design Manual.* New York: Watson Guptill Publications, 1990.

_____. *Designing With Type.* New York: Watson Guptill Publications, 1992.

Dooley, Michael. "Kicking Up A Little Dust." *Print*, September, 1992.

Elam, Kimberly. *Expressive Typography: The Word As Image.* New York: Van Nostrand Reinhold, 1990.

Felton, Giles. "How to Talk Dot-Com Like A Webmaster." *The New York Times,* Wednesday, September 22, 1999, E-Commerce, p 3.

Frederick, Diane. "Direct Mail: Up & Running." *Art Direction*, June, 1992.

Friedman, Mildred, et al. *Graphic Design In America: A Visual History.* Minneapolis, MN: Walker Art Center and New York: Harry N. Abrams, 1989.

Gill, Bob. *Forget All the Rules You Ever Learned about Graphic Design Including The Ones In This Book.* New York: Watson-Guptill Publications, 1981.

Glaser, Milton. *Milton Glaser: Graphic Design.* Woodstock, New York: Overlook Press, 1973.

Goldfarb, Roz. *Careers by Design: A Headhunter's Secrets for Success and Survival in Graphic Design.* New York: Allworth Press, 1997.

Gonnella, Rose and Denise Anderson and Robin Landa. *Creative Jolt Inspirations.* Cincinnati, OH: North Light Books, 2000.

Greiman, April. *Hybrid Technology: The Fusion of Technology and Graphic Design.* New York: Watson-Guptill, Publications 1990.

Haley, Allan. *Photo Typography.* New York: Scribner's Sons, 1980.

Heller, Steven. *Graphic Design: New York.* Rockport, MA: Allworth Press, 1993.

Heller, Steven and Gail Anderson. *Graphic Wit: The Art of Humor In Design.* New York: Watson-Guptill Publications, 1991.

Hinrichs, Kit. *Typewise.* Cincinnati, OH: North Light Books, 1990.

Hofmann, Armin. *Graphic Design Manual.* New York: Van Nostrand Reinhold, 1965.

Holland, D.K.; Michael Bierut; and William Drenttel. *Graphic Design: America.* New York: Rockport Publishers, Inc. and Allworth Press, 1993.

Hurlburt, Allen. *The Design Concept.* New York: Watson-Guptill, 1981.

_____. *The Grid.* New York: Van Nostrand Reinhold, 1978.

_____. *Layout: The Design of the Printed Page.* New York: Watson-Guptill Publications, 1977.

Labuz, Ronald. *Contemporary Graphic Design.* New York: Van Nostrand Reinhold, 1991.

Kanner, Bernice. *The 100 Best TV Commercials.* New York: Times Books, a division of Random House, 1999.

Landa, Robin. *Thinking Creatively.* Cincinnati, OH: North Light Books, 1998.

Landa, Robin and Rose Gonnella and Denise Anderson. *Creative Jolt Inspirations.* Cincinnati, OH: North Light Books, 2000.

Landa, Robin and Rose Gonnella. *Visual Workout: Creativity Workbook.* Albany: Delmar Thomson Learning, 2000.

Levenson, Bob. *Bill Bernbach's Book.* New York: Vintage Books, a division of Random House, 1987.

Livingston, Alan and Isabella. *Graphic Design and Designers.* New York: Thames and Hudson, Inc., 1992.

Lyons, John. *Guts: Advertising from the Inside Out.* New York: AMACON, 1989.

Marquand, Ed. *Roughs, Comps, and Mock-ups.* New York: Art Direction Book Company, 1985.

Meggs, Philip B. *A History of Graphic Design.* New York: Van Nostrand Reinhold, 1983.

_____. *Type and Image: The Language of Graphic Design.* New York: Van Nostrand Reinhold, 1989.

Minick, Scott and Jiao Ping. *Chinese Graphic Design In The Twentieth Century.* New York: Van Nostrand Reinhold, 1990.

Ogilvy, David. *Confessions of an Advertising Man.* New York: Crown, 1985.

_____. *Ogilvy on Advertising.* New York: Crown, 1983.

Paetro, Maxine. *How to Put York Book Together and Get A Job in Advertising.* Chicago: The Copy Workshop, 1990.

Pearlstein, Steven. "Adman Tom McElligott." *Inc.* July, 1986.

Perfect, Christopher and Jeremy Austen. *The Complete Typographer.* Englewood Cliffs, NJ: Prentice-Hall, 1992.

Remington, Roger and Barbara J. Hodik. *Nine Pioneers in American Graphic Design.* Cambridge, MA: The MIT Press, 1989.

Richardson, Margaret. "Best Selling Design: Book Jackets and Covers: Three Case Studies." U&lc, Vol 20, Number 2, Summer/Fall, 1993.

Ries, Al and Jack Trout. *The 22 Immutable Laws of Marketing.* New York: HarperBusiness, 1993.

Rossol, Monona. *The Artist's Complete Health and Safety Guide.* New York: Allworth Press, 1990.

Scher, Paula. *The Graphic Design Portfolio.* New York: Watson-Guptill, 1992.

Siegel, David. *Creating Killer Web Sites.* Indianapolis, IN: Hayden Books, 1996. www.killersites.com

Snyder, Gertrude and Alan Peckolick. *Herb Lubalin.* New York: American Showcase, 1985.

Spencer, Herbert, ed. *The Liberated Page.* San Francisco: Bedford Press, 1987.

Sullivan, Luke. *Hey Whipple, Squeeze This: A Guide To Creating Great Ads.* New York: John Wiley and Sons, Inc., 1998.

Swann, Alan. *Designed Right!* Cincinnati, OH: North Light Books, 1990.

Wilde, Richard. *Problems: Solutions.* New York: Van Nostrand Reinhold Company, 1986.

Wong, Wucius and Benjamin Wong. *Visual Design on the Computer.* New York: Design Books, 1994.

Wrede, Stuart. *The Modern Poster.* Boston: Little, Brown and Company, 1988.

Warlick, Mary, ed. *Advertising's Ten Best of the Decade 1980-1990.* New York: The One Club for Art and Copy, Inc., 1990.

Endnotes

Chapter 5

1. Michael Dooley, "Kicking Up a Little Dust." *Print*, September 1992, p. 49.

Chapter 7

1. April Greiman, *Hybrid Imagery.* New York: Watson-Guptill Publications, 1990, p. 122.

Chapter 11

1. Pearlstein, Steven, "Adman Tom McEllegott." *Inc.,* July, 1986, p. 36.

2. Warlick, Mary, ed. *Advertising's Ten Best of the Decade 1980-1990.* New York: The One Club for Art and Copy, Inc., 1990, p. 5.

3. Lyons, John, *Guts.* New York: AMACON, 1989, p. 124.

4. Barthel, Diane, *Putting On Appearances.* Philadelphia: Temple University Press, 1988, pp. 39-56.

5. Warlick, Mary, ed. *Advertising's Ten Best of the Decade 1980-1990.* New York: The One Club for Art and Copy, Inc., 1990, p. 8.

6. Landa, Robin, *Thinking Creatively.* Cincinnati, OH: North Light Books, 1998, pp. 146-147.

7. Bond, Jonathan and Richard Kirshenbaum, *Under the Radar.* New York: John Wiley and Sons, Inc., 1998, pp. 33-34.

8. Hurlburt, Allen, *The Design Concept.* New York: Watson-Guptill Publications, 1981, pp. 48-65.

Chapter 13

1. Felton, Giles. "How to Talk Dot-Com Like a Webmaster." *The New York Times,* Wednesday, September 22, 1999, E-Commerce, p. 3.

index

GRAPHIC DESIGN SOLUTIONS

GRAPHIC DESIGN SOLUTIONS

GRAPHIC DESIGN SOLUTIONS

promotional design, 46

promotional web sites, 266-270

pun, 230

Q

Quon, Mike, 91

R

Rand, Paul, 34, 156

Ray, Man, 159

Rea, John, 26

repetition, 27

rhythm, 27

Rice, Nancy, 221

Riefler, Julie, 186

Robbins, Alan, 274

Roman, 65-66

roughs, 9, 50

S

Sagmeister, Stefan, 152, 173

Sans Serif, 66, 89

saturation, 17

scale, 32

Scher, Paula, 83, 148, 211

Script, 66

Sebastian, James, 208

secondary colors, 18

secondary meaning, 88-89

self-promotional, 276

serifs, 64, 66

Sethiadi, Riki, 109

set width, 64

Shahn, Ben, 142

shape, 16

Shapiro, Ellen, 107

Shapiro, Meyer, 53

shopping bags, 198-199

 design suggestions, 200

 exercise, 203

 project, 203

sign-off, 226

sketches, 50

slab serif, 66

Sommese, Lanny, 31, 103

space manipulation:

 illusion, 32-35

 positive and negative space, 30-32, 76

square serif, 66

stationery, 130-136

Stauber, Joy Panos, 135

stem, 64

Sterling, Jennifer, 28

"stickiness," 267

storyboard, 236-237

strategy, 44-48, 226-227

stress, 66

stroke, 64, 68

substrate, 103

symbols, 122-126

symmetry, 22-23

GRAPHIC DESIGN SOLUTIONS

X